**OVER
HERE**

NEW MUSEUM

New Museum of Contemporary Art, New York
Documentary Sources in Contemporary Art

Art after Modernism: Rethinking Representation, edited by Brian Wallis

Blasted Allegories: An Anthology of Writings by Contemporary Artists, edited by Brian Wallis

Discourses: Conversations in Postmodern Art and Culture, edited by Russell Ferguson, William Olander, Marcia Tucker, and Karen Fiss

Out There: Marginalization and Contemporary Cultures, edited by Russell Ferguson, Martha Geever, Trinh T. Minh-ha, and Cornel West

Talking Visions: Multicultural Feminism in a Transnational Age, edited by Ella Shohat

Over Here: International Perspectives on Art and Culture, edited by Gerardo Mosquera and Jean Fisher

OVER

International Perspectives on Art and Culture

HERE

edited by Gerardo Mosquera and Jean Fisher

artist project by Francis Alÿs

New Museum of Contemporary Art
New York, New York

The MIT Press
Cambridge, Massachusetts
London, England

This book was set in Minion and Akzidenz Grotesk by Graphic Composition, Inc., and was printed and bound in Spain.

This volume is made possible by a generous grant from The Rockefeller Foundation. The anthology is also made possible by the Penny McCall Publication Fund at the New Museum. Donors to the Penny McCall Publication Fund are James C. A. and Stephania McClennen, Jennifer McSweeney, Arthur and Carol Goldberg, Dorothy O. Mills, and the Mills Family Fund.

Project coordinator: Francesca Pons

Library of Congress Cataloging-in-Publication Data

Over here : international perspectives on art and culture / edited by Gerardo Mosquera and
 Jean Fisher ; artist project by Francis Alÿs.
 p. cm. — (Documentary sources in contemporary art ; v. 6)
 Includes bibliographical references and index.
 ISBN 0-262-13440-3 (alk. paper)
 1. Art and society. 2. Multiculturalism in art. I. Mosquera, Gerardo. II. Fisher, Jean.
III. Alÿs, Francis, 1959–. IV. New Museum of Contemporary Art (New York, N.Y.) V. Series.
N72.S6O93 2004
709'.05—dc22

 2003069083

Rangoon, 1997

CONTENTS

TRANSCULTURAL CIRCUITS

DIS-POSITIONS

Foreword

Over Here: International Perspectives on Art and Culture is the sixth volume in the series Documentary Sources in Contemporary Art, launched in 1984. These publications, which have introduced key theoretical positions and current cultural perspectives, have become standard reference books in the field, indispensable to scholars, students, artists, and anyone interested in contemporary art.

Over Here brings together essays by curators, critics, and artists working outside of the West from such diverse places as India, South America, Russia, the Far East, Africa, and Australia. Their perspectives fall outside of a typical Western framework for interpreting and classifying cultural production—and such viewpoints are increasingly shaping our understanding of art in this new century.

This critical anthology was conceived and edited by Gerardo Mosquera, adjunct curator at the New Museum and freelance curator and writer, with Jean Fisher, independent critic. Together they have assembled a fascinating, distinguished group of authors who are well known in their regions and are becoming better known in the international cultural community.

The writers in this book specifically address what it means to work outside of mainstream circuits and why First/Third World, margin/mainstream, and global/local

binary dichotomies are no longer adequate to describe the current situation of world culture. Recognizing the plurality of viewpoints and voices, they call for new critical approaches that address complex cultural entanglements in a shifting global landscape. Some of these complexities include transnational communities, transplanted cultural histories, diasporic experiences, and the process of translation and syncretization. Finally, this anthology suggests that the West no longer has priority over intellectual innovation partly as a result of the unprecedented access and mobility of information due to mass media and the Internet.

I would like to thank Gerardo Mosquera and Jean Fisher for their great contribution in conceiving and editing this book; the MIT Press, and Roger Conover in particular, for their ongoing relationship with us as publisher of the series; Melanie Franklin, Curatorial Coordinator at the New Museum, and Erin Barnett, Joanne Leonhardt Cassullo Curatorial Fellow, who oversaw the details of assembling the book; and The Rockefeller Foundation for its generous funding and support of this important and groundbreaking work.

Lisa Phillips
Henry Luce III Director

San Jose, Costa Rica, 1994

Acknowledgments

The editors are grateful to The Rockefeller Foundation and its associate director Tomás Ybarra-Frausto, and to the Penny McCall Publication Fund at the New Museum. We also warmly thank Lisa Phillips, Dennis Szakacs, Dan Cameron, Erin Barnett and, especially, Melanie Franklin, at the New Museum.

We wish to acknowledge the contributions of the authors published here, the artists who gave permission to include their works as illustrations, the publishers who allowed us to reprint texts, and Francis Alÿs, who created an artistic project for the book. We are indebted also to Roger Conover at the MIT Press, Middlesex University, inIVA, the Prince Claus Fund, the Rijksakademie van Beeldende Kunsten, Arpa. Fundación Arte>Panamá, Francesca Pons, Michelle Piranio, Gabriel Pérez-Barreiro, Apinan Poshyananda, Hou Hanru, Mai Ghoussoub, and Cuauhtémoc Medina.

**OVER
HERE**

Introduction

Jean Fisher and Gerardo Mosquera

In 1990, the New Museum in collaboration with the MIT Press published *Out There,* an anthology of critical writings on the "marginalization of contemporary cultures," "marginality" defined in relation to the Western metropolitan economic and intellectual centers of power. *Out There,* an invaluable handbook widely disseminated throughout the art world, had emerged from a decade of postfeminist, postmodern, and postcolonial debate, in which many of the foundational premises and some of the consequences of Eurocentric enlightened modernity—the self-identical (Cartesian) subject, technological progress, colonial patterns of social engineering, universality of Western values—were systematically dismantled or discredited. Although *Out There* was not solely concerned with the visual arts, it recognized an ongoing ambivalence in "marginalized" artists and critics toward the Western mainstream institution and its exclusionary policies, which possessed at that time the only sustainable legitimizing power: Did one beat at the gates hoping to be admitted, or did one make a virtue of marginality and risk reifying it as a transcendent, if still disempowering, position?

After almost a decade and a half since the book's publication, in some respects nothing has changed, but everything has changed. Whereas there has been an increase in the number of artists, not only from the various diasporas but also from all corners of the globe, circulating through a seemingly internationalized art world, this has made little impact on the institutional structures of power that manipulate financial, intellectual, and aesthetic decisions. And despite accusations that globalization has led to artistic

homogenization, there have been signs of shifts in the epistemological ground of contemporary artistic discourses based not in difference but *from* difference. It has thus been the task of *Over Here: International Perspectives on Art and Culture* to take up the legacy of *Out There* and to bring together a modest selection of artists, curators, and critics to explore some of these shifts, not from the position of the Western metropolis but from a diversity of critical sites around the world. If a genuine paradigm shift in the way we construct a truly democratic, international exchange is to take place, there needs to be both the *will* to make it happen and the acceptance that it cannot occur under the sole guidance of mainstream agents but rather that it must be a collaborative, multivalent interaction. Power has to be relinquished and redistributed. Its vision clouded by myths of universalism, Western art scholarship too long persisted in seeing modernism as the invention and property of the West, rather than as a global effect of radical difference in the encounter between Europe and other peoples. There have in fact been many modernisms, each with its own temporalities and local inflections, and each with contributions to make to the reconfiguration of global critical and aesthetic discourse. Among the changes that make these modernisms more accessible have been the paradoxical effects of globalization.

In a wider sense *Out There* was a product of the twentieth century's preoccupation with migration and displacement: whereas if the exile was the figure of early modernity, the diasporan or immigrant was the figure of postmodernity with its decentered and deterritoralized subject. With few exceptions, the "new cultural politics of difference" foregrounded marginalized, First World diasporan agents, but quickly segued into the institutional reification and commodification of expressions of "cultural hybridity."

Edward Said was among the most distinguished advocates of the "exilic" position. "Seeing 'the entire world as a foreign land,'" he maintained, "makes possible originality of vision. Most people are principally aware of one culture, one setting, one home; exiles are aware of at least two, and this plurality of vision gives rise to an awareness of simultaneous dimensions."[1] Elsewhere, while he concedes that "new alignments are being made across borders, types, nations, and essences," and that all cultures are "hybrid, heterogeneous, extraordinarily differentiated, and unmonolithic,"[2] Said nonetheless conveys the sense in these passages that he is speaking from the rather privileged position of the cosmopolitan, academic high ground, as one able to survey the international scene with greater clarity than those who remained in the place of origin.

We would not challenge the validity of Said's perception at that time; nor would we dispute that considerable unproductive debate has been engendered over the years from the narrowly focused perspectives of "First," "Second," and "Third World" nationalism, separatism, nativism, various geographic and cultural "centrisms," and indeed from the myopic alignments and affiliations that too often inscribe Western academia and the art world. But how did this position the voices of those who remained "at home"? The relationship between the exile and place of origin was not without ambivalence, as Geeta Kapur reminded us, berating the diasporan intellectual in Western academia for presuming to speak for those back home. And yet, in the ten years or more that have elapsed since Said made his observation, the complex cultural entanglements that have been part of the process of globalization make any claim for exilic and diasporan intellectual privilege rather less secure. This is also the case regarding Western mainstream scholarship: nowadays, a mainstream text on contemporary aesthetic theory and art practice that acknowledges only Western modernist or postmodernist examples reveals an almost shocking parochialism.

Over the past few years, the extent to which humanity has become incorporated into a world system has dramatically accelerated, such that we are all virtually subjects of (or to) both the local and the global. This transformation has prompted some quarters to speak, perhaps too glibly, of the "glocal," a convenient coupling that would seem to suggest an equally smooth slippage between these two configurations. But globalization does not mean that between the local and the global all power relations are now equal, or that there is a seamless flow of knowledge unified by any consensual principle or claim to truth. On the contrary, there is a multiplicity of diverse systems of thought that may or may not peaceably coexist or exchange with others.

At the same time, in some Heizenbergian manner, there is no event in one "local" that does not have repercussions on a global level; we are all now neighbors, if not yet "brothers," our fates inextricably entwined, irrespective of space-time differentials. Indeed, with the dissemination of technologies like the mobile phone, e-mail, and satellite TV, gossip, rumor, and opinion are no longer confined to the barrio, nor, for the moment at least, can they be wholly contained by state agencies. News travels fast through transcontinental links forged among not only migratory routes, but also ideological or special-interest identifications that traverse the old traditional affiliations of nationality, ethnicity, class, gender, and so forth. Reciprocal expansion and contraction mean that "there" is now also "here." Undoubtedly we are all now more or less fluent in the lingua franca of globalism wherever we are positioned in the power structure, and

whether or not we are able to take advantage of its systems of exchange. For better or worse, *pace* Said, we can all see "the entire world as a foreign land" because it is no less so at home than it is abroad. This increased complexity of both the signs and sites of culture has enormous significance for art and critical practices because they have long understood that controlling representation also conveys the power to control meaning. Whether through violent imposition, by osmosis, or by design, migration and miscegenation of ideas, images, and bodies do take place across epistemological borders, forging new transcultural dialogues and formations that no longer necessarily look to the old Western metropolitan "centers" for legitimation or meaning.

Industrial capitalism and that of services, colonial systems, modernity, and the information revolution have been managed by the West, and this has implied the generalization of Western culture—not so much as an ethnic culture but as a "metaculture." However, the objectives of conversion and domination of this metaculture have also necessarily opened its information circuits to wider access, making it in turn vulnerable to exploitation by the "Other" for its own, different, ends, transforming the metaculture from within and without. Western metaculture has paradoxically become a medium for the affirmation and globalization of differences beyond their local referents. The inspired intervention over the Internet by the Zapatistas of Chiapas on the eve of the NAFTA agreement between Canada, the United States, and Mexico in 1994 taught us that with modest means but some imagination the "local" can plug into the sophisticated circuits of the "center-global" to broadcast its concerns, a point made rather less benignly on September 11, 2001. And yet, each "illegitimate" breach of the system of hegemonic power brings into play a counterforce of even tighter controls.

Over Here is divided into four thematically linked sections: "Unbounded Totalities," "Transcultural Circuits," "Dis-positions," and "Heteroglossia: The Hermeneutic Trap." According to Edward Said (in *Culture and Imperialism*), "traditional" cultures are those perceived as sharing languages, experiences, histories, and so forth, over a defined space and time: they are "bounded totalities." The mistake of modernity was to interpret signs of tradition in a culture as conservatism and resistance to "progress." While a certain intransigence in the face of aggression may at times have been the popular response to the new, it is also true that the very success of "tradition" is its ability to transform under changing conditions while retaining different values. What has substantially altered the landscape are the rate of change and the nature of its transmission, rendering these totalities "unbounded." How do the globalization of

communication technologies and information affect the integrity of "local" life worlds, their perceptions and experiences? What points of insertion and resistance do they discover in the global circuitry? And, importantly, where and how may tradition manifest itself in contemporary artistic and critical practice?

Globalization has dynamized and pluralized cultural circulation, but it has done so following the same routes as the economy, to some extent reproducing power structures. While there is an increasing number of international exhibitions and biennials, some even in poor nations, they frequently follow mainstream—or, by contrast, a sort of anti-mainstream—criteria. The curator has a problematic role in this situation, particularly in deciding how transcultural projects are conceptualized and what models of globalization are appropriate in the packaging of exhibitions. The questions are still who organizes, who curates, who pays, and who hosts? Is it possible to conceive of a truly internationalized, "horizontal" art circulation, together with a decentralizing of artistic legitimation? Is it possible to identify forms of artistic and critical strategies that challenge the very foundation of museological and exhibition architecture, and to open up shared creative experience to the new global communities?

Whereas earlier diasporas followed the old colonial trade and labor routes, the more recent economic and political migrations of peoples open other pathways that further complicate the meaning of national boundaries and ethnic identification. If the older settlements may be characterized by patterns of assimilation (usually enforced by the host nation), the more recent ones may be more aptly described as "adaptation and resistance," maintaining "cultural corridors" to the place of departure and a multiple national identification that is more than a hyphenated identity. The cultural connections wrought by the movement of peoples south to north in the Americas are paradigmatic of these complex relations: "American" *and* "Mexican," "American" *and* "Puerto Rican," and so forth. To be sure, there is a certain irony here—a hijacking of the very term "American" by the USA, where, as the artist Jimmie Durham once said, those to whom the title "American" does not apply are the indigenous peoples themselves. "Transcultural Circuits" looks at how cultural debate has become a space of political struggle, as much in the symbolic as in the social. Power no longer seeks to repress or homogenize diversity, but to control it. However, this strategy itself responds to a different distribution of power, and disadvantaged groups become increasingly capable of exerting pressure and infiltrating dominant structures of power.

As "Dis-positions" seeks to demonstrate, this shift is evident in the cultural readaptations of subaltern and peripheral sectors and cultures, as well as in the heterogenization that immigrants produce in the contemporary megalopolis. What has

been called postmodernity was, in great measure, the result of the imbrication of all these contradictory processes. They determined an extraordinary dynamic of identities, with complex reaccommodations: multiple identities, identities in the form of Chinese boxes, neo-identities, fake, invented and masquerading identities . . . Although "identity politics" was the fashionable debate of the 1990s, far from enabling the potential for active agency, it entangled artistic practice in multiculturalism—the institution's attempt to manage difference. Globalization—or more properly "antiglobalization"—has in fact revitalized the possibility of subjective agency. This is neither the modernist self-identical subject nor the postmodernist decentered subject (both a source of suspicion in postcolonial discourse), but a neutral subject capable of responding independently and spontaneously outside of established political positions and therefore capable of opening up a new ethical and collective space of action.

The border was also one of the critical and aesthetic models of the 1990s. As the border controls between rich and poor countries were reinforced, so the border and its culture became paradigms for processes of appropriation, resignification, displacement, and cultural hybridization. But to what extent do the paradigms of border and hybridity also run the risk of supporting accounts of a harmonization of diversity that level out contradictions and mask conflicting interests? Much of the discussion in *Over Here* suggests that it is more useful to explore expressions of heteroglossia and the innovative play of the untranslatable. Far from producing a world of synchronized signs and meanings, as the hegemony of the Western metaculture might presuppose, translation and appropriation are imperfect acts of coupling and uncoupling: they undergo an inexorable process of combination and differentiation. Likewise, the process of globalization is an intricate, conflictive articulation of forces, rather than just a dual dialectic. Globalization implies multiple contaminations, mixtures, and contradictions. All cultures "steal" from one another, be it from situations of domination or subordination. Such is their behavior as living organisms, whose health depends on their dynamism, their capacity for renovation, and their positive interaction with their context. These appropriations may often be "incorrect" according to their usage in the culture of origin, but they are nevertheless put to work in an original manner that, especially in communities of subordination, reinvents the language of dominance.

How to summarize the diverse visions presented in *Over Here*? The increased mobility, both physical and virtual, of new global actors speaking from sites of production beyond the axes of power introduces a different vocabulary, one forged not only in the space of intertextuality but also too frequently in the traumatic sites of cultural mutilation, conflict, and violence. As a result, their productions are disturbed by

the ripple of emotions—frustration and anger, irony and humor, hope and despair—usually smoothed out of the Western canon. What has been reintroduced into artistic and critical discourse by the "locals" of the world, after being expelled from the postmodern, is a renewed concern with ethical and political agency, and an insistence that the postcolonial debate tended to homogenize a heterogeneity of experiences. To give voice to such complex genealogies demands various forms of expressive and hybrid writing—testimony, allegorical fiction, documentary reportage—as well as the academic essay. From cultural dynamics born of mobile transcultural alliances and networks that might include, but might equally bypass, the hegemonic West, new narratives are invented, a process that Gilles Deleuze calls "fabulation." While often making use of Western intellectual capital, fabulation is nonetheless engaged in integrating its own "local" meanings and insights, reintegrating traditional perspectives with the currency of global exchange, testing the hermeneutic limits of Western artistic and intellectual hegemony. It is therefore in attending to the unique critical insights and positioning of these cultural producers that we may better understand how the new global conditions affect artistic, cultural, and social practices.

"Over here" is an English expression designed to draw attention primarily to oneself, or one's location, although its contrariness seems barely translatable. These two words identify simultaneously a stable point and an indeterminable one, distance and proximity, while appealing for the gap to be closed. The addressee is not absent and clearly not out of earshot (not "ex-otic"), but is not near enough either. At the same time, "over here" is just about everywhere. As an expression commonly used in games of hide-and-seek, it somehow seemed appropriate to the nature of this book, as a response to a world in an unprecedented state of transition, where each day produces a new topography of cultural configurations that demand a constant reassessment of our relations with one another.

Rangoon, 1997

Notes

1. Edward Said, "Reflections on Exile," in Russell Ferguson et al., eds., *Out There: Marginalization and Contemporary Cultures* (New York: New Museum of Contemporary Art; Cambridge, Mass.: MIT Press, 1990), p. 366.

2. Edward Said, *Culture and Imperialism* (London: Chatto and Windus, 1993), pp. xxviii, xxix.

UNBOUNDED TOTALITIES

Just What Is It That Makes the Term "Global-Local" So Widely Cited, Yet So Annoying?

Lee Weng Choy

My title derives, of course, from the Richard Hamilton collage *Just What Is It That Makes Today's Homes So Different, So Appealing?* (1956)—you know, the one with the muscleman holding a gigantic Tootsie Pop, the one that inaugurated the appearance of the word "pop" in modern art. Initially, I had thought to call this essay "Citing and Re-siting Singapore in the Global-Local Spectacle." That title, while less catchy, would have better described my theme. But I decided against it because I didn't want to add to the circulation of the term "global-local" without at least qualifying it with some sarcasm. My problem with the term is that, for the most part, the global-local tensions it refers to are already subsumed by the logic of globalization and late capitalism. It signifies the further penetration of global capitalism into the "local," then presents this "local" as *authentic.* "Global-local" reminds me of that other buzzword, "New Asia." These terms suggest an increasing conflation of arts and cultural discourse with the idiom of national—even "transnational"—tourism boards. (What are today's spectacles—art biennials, world expos—if not *also* a form of transnational tourism?) The phenomena these terms refer to are arguably less the local vis-à-vis the global, or the contemporary renaissance of tradition, than, to coin another term, the "authenti-kitsch."[1]

But why Singapore? What could this small island city-state be representative of? How does it figure in the imagining of the "Pacific Rim," particularly in terms of topography and landscape? And what are the relationships between the "global-local," "spectacle," and "landscape"? I intend to address these questions by taking a look at

certain images of Singapore. In the process, I hope to reveal the dynamics involved in *looking,* not just at this island that aspires to be a global city, but at the more global desire for the "local" and for "location." Moreover, I hope to look not just *at* Singapore, but *from* and *through* it.

To start an essay about Singapore and the global-local by citing pop art may seem like forcing a tenuous connection. Singapore does not figure much in the history of pop, nor does pop figure all that much in Singapore art. What is at stake, however, is the condition of world art after pop. Arthur Danto argues that pop, together with minimalism, marked a mutation in the historical nature of art itself. For Danto, "Pop and Minimalism were in effect philosophical exercises, for each was groping toward something that had finally to be recognized by philosophy itself: whatever was to distinguish art from reality was not going to be something evident to the eye."[2] Andy Warhol's *Brillo Box* looks exactly like a commercially manufactured one. Danto privileges pop and minimalism not just because—like all modern art—they confront the art movements that precede them, but because they confront the *entire* self-revolutionizing history of modern art. Pop and minimalism usher in the final break between "art" and "image," a break initiated decades earlier by Marcel Duchamp and his readymades. This break between "art" and "image" radically opens up the field of art; as Danto sees it, this opening is so radical, it marks the "End of Art," that is, the end of a particular history of art. Contemporary art, what Danto calls "posthistorical art," is the art of radical pluralism: everything and anything, from every- and anywhere, can be, and does get cited and re-sited as art.

Contemporary art in Singapore is emblematic of this "posthistorical" condition. On the one hand, this seems the most obvious point to make. Singapore, like any other contemporary metropolis, is a hyperreal city of signs—although thankfully the forces of late capitalism haven't quite finalized the break between "reality" and "image." On the other hand, the claim seems complicated, for how does the end of modern Western art history converge with contemporary art practice in a place like Singapore?

Throughout the 1990s, the Singapore government increasingly emphasized the importance of the arts for the nation. In 1989, a landmark report by the Advisory Council on Culture and the Arts led to the creation of institutions like the National Arts Council, the National Heritage Board, the Singapore Art Museum, and the $300-million-plus arts center, the Esplanade. In March 2000, another report, the ostentatiously named "Renaissance City Report," presented an update of the government's vision to promote arts and culture. As Minister for Information and the Arts Lee Yock Suan announced,

there are two aims: "First, it is to establish Singapore as a global city of the arts. We want to position Singapore as a key city in Asia and as one of the cultural centers in the world. The idea is to be one of the top cities in the world to live, work and play in. . . . Second, it is to provide cultural ballast in our nation-building efforts."[3]

To those familiar with Singapore, this script yields no surprise. Like most everything else, the arts are circumscribed by the instrumentalist logic of the trinity of state/government/ruling party (in Singapore these three political mechanisms have effectively merged into one). The development of the arts is subsumed by the always more primary agenda of fueling a vibrant economy and maintaining a politically "stable" society. As to be expected, the rise of East Asia's fortunes during the 1980s was accompanied by assertions from various quarters about the ideology of "Asian values." Disproportionate to its size in global affairs, Singapore claimed a place in the world's imagination by staking a vanguard role in articulating an *Asian* modernity. But developing an economy that, after a generation, can boast a per capita gross national product higher than that of Great Britain, its former colonizer, is not the same as becoming a cultural capital of Asia.

No doubt various individual artists and arts groups from Singapore will become better appreciated inside and outside the country. And in more than a few cases the acclaim will be well deserved. As for the Singapore "arts scene," the commonplace criticism is that one cannot *plan* the development of art and culture. Another criticism often made about the government's plans for the arts is that its dominant position and relatively closed-minded disposition is what will hold the arts back in the end, notwithstanding all the investment and hype. So if one compared Singapore with a city that has indeed "arrived" as a cultural capital—say London, Paris, or New York—one would expect the latter to have a more open society, the arts scene to have developed over time organically, and so on. Such a comparison, however, obscures other issues at stake.

I'm not sure if anyone talks about Brisbane as a "global city of the arts," but in the 1990s this relatively unheard-of Australian town put itself on the world art map as the host city of one of the most significant art events to represent the Asia-Pacific region. What Singapore says it wants to do, Brisbane seems to have done, at least in terms of contemporary visual art. Brisbane's Queensland Art Gallery (QAG) has been exhibiting the Asia-Pacific Triennial of Contemporary Art (APT) since 1993. Over 230 artists and 280 curators, advisers, and writers from twenty countries and regions have participated in the three triennials to date, and more than 350,000 persons have visited the exhibitions.[4]

Singapore has yet to make the material, social, and intellectual investments in the visual arts that Brisbane has made. And the support from the Queensland government is far more hands-off than that of Singapore's government. Given time, however, Singaporean society will become more open—even the government admits that. But rather than signaling an impending transformation, this expectation belies a continuity. Since independence, Singapore has embraced globalization, and while globalization requires a certain openness (to foreign investment, markets, and business innovation), it has always also come with a high degree of control (of labor, politics, and society). When it deals with the arts, the government still reveals the will to discipline and is devising ever more sophisticated forms of control. Nonetheless, rather than emphasizing their differences in achievement, strategy, and agenda, my juxtaposition of Brisbane and Singapore is meant to suggest a common underlying logic: both cities are attempting to position themselves as gateways to "Asia"—and, in Brisbane's case, the "Pacific" as well.

In her APT3 catalog essay "Journey without Maps: The Asia-Pacific Triennial," QAG deputy director Caroline Turner contends that

> Geography has not been an objective in itself, but a means of achieving a focus and allowing opportunities for artists from this region who had, and indeed still have, fewer opportunities for their work to be included in international exhibitions, although this is changing. Many of the artists represented in the three Triennials have an international reputation and, for some at least, the Triennial has played a part in bringing their work to world attention. The Triennial has never been a government-to-government project about official exchanges, and nor have artists been chosen to "represent" a country. Rather, invitations have been extended to them to participate as individuals, and this has meant that they can at times express their ideas in ways that are not possible in official exhibitions.[5]

Yet for all these assertions and efforts to emphasize "crossing borders"—a newly introduced curatorial category in addition to the previous national ones—APT3 still came across mainly as a collection of representations of ethnic and cultural geography. It's just that some of the stars of the show are now framed by cross-cultural rather than monocultural maps. APT3's curatorial interventions weren't radical enough—they didn't cut deep enough into the roots of the encompassing global-local spectacle. The APT—if

not by expressed intent, then by structural default—still functions as a discursive and event center for geo-graphing the arts and culture of the Asia-Pacific in ways that maintain rather than undo boundaries.[6] The spectacle of the global-local is precisely about *consuming difference.* It's as if these hubs of global-local consumption—"hub" especially in the sense that there is a claim for a certain neutrality, universality, or openness—take "nourishment from the margins," as Lucy Davis has put it.[7] The "Other" has to be maintained as different in order to be "Other," and yet this difference is homogenized through consumption; for rather than any *real* local, it is the reframed and reconstituted global-local that is displayed for global and local consumption.

So how does one move beyond the consumerist geography of the global-local? I'm not sure. For APT3, I was the Singapore-based co-curator, and at the conference, my "representation" of the island city-state was deliberately problematic, although I didn't explicitly criticize the APT as a global-local spectacle. (At events like these, there's always at least one conference panelist who will present a critique of the whole thing. It's as if they are invited to do exactly that: the criticism of the spectacle is the last ingredient without which the spectacle could not be constituted.) For my own presentation, one could say that I speculated grandly on the future of world contemporary art. Although I didn't speak about Singapore, I did speak somewhat like a Singaporean. Speculating about the future is what political and business leaders here like to do, even though their notion of the future is not always matched by a deep understanding of the past— Singapore is a society of "tomorrow." (Incidentally, Hamilton's *Just What Is It* was first exhibited at a show called *This Is Tomorrow.*) But the sense of time in Singapore is not like the time of pop art; it is more like that of the *popularization* of pop—an ahistorical contemporary.

Time in Singapore is unlike time anywhere else I've been. Whenever I visit, for example, the San Francisco Bay area, a place where I used to live, I experience multiple times—decades. If I were to visit, say, London or Beijing, I'd expect to experience centuries; in Delhi, maybe millennia. But in Singapore, there seems to be only one time, the present, a hurried one, on the verge of tomorrow. This relentless "present" in Singapore is of course not entirely omnipresent; if it were, then this truly would be utopia. As an ideal it characterizes a city of appropriation par excellence; past, future—all time is only one time, the present time. It is an ideal vividly manifest in Singapore's wish to become the most global-local place of them all. Sanjay Krishnan has written how "scaffolding seems the only unchanging feature in a city that sees itself in permanent

transition . . . [it] is at once a symbol of the ugliness and the breathtaking energy of the desire for renewal or 'speed,' the desire to change rapidly and without remorse."[8]

In Lucas Jodogne's book of photographs *Singapore: Views on the Urban Landscape*,[9] there is a picture of an open-mouthed, Chinese dragon statue covered by an almost delicate net of bamboo scaffolding. In the background are a few loading cranes, which resonate subtly with the bamboo stakes in the foreground. (Jodogne deliberately didn't caption his photos, so as to avoid mapping locations with their names and to give primacy instead to the pictorial composition.) Early traders found it difficult to sail into Keppel Harbor because of the rough tides, currents, and rocks, but also because of the *kelongs* and *pagar* (fish traps and wooden stakes) that radiated out from the capes at both entrances to the harbor. These fanglike *kelongs* and *pagar* gave rise to its old nickname, the "Dragon's Mouth."[10] The dragon statue in the photo is from the theme park Haw Par Villa, which means "Villa of the Tiger and Leopard." Created by Haw Boon Haw, who with his brother started the highly successful Tiger Balm ointment brand, the park has a collection of over 1,000 painted cement statues and 150 giant tableaux based on Chinese folklore, legends, and history, and Confucian and Taoist ideology. Haw intended for the park to help teach and preserve Chinese values. In 1985, the government acquired and leased it to a publishing company, which then reconstructed it as a commercial theme park enterprise. I think the aspiration was to turn it into something like a Disneyland of Chinese mythology, but the park has not been very profitable. Undaunted, the Singapore Tourism Board still pushes the park as a major tourist attraction; its official pocket guidebooks beckon tourists to "enjoy the beautiful landscaping."

Jodogne's photos juxtapose the Singapore state's reflex to turn its cultural heritage into global-local authenti-kitsch with his own interest in classical, European landscape composition. While "landscape" is not "nature" so much as a convention of presenting it, the function of this convention has been to give the viewer not an image but a *sense* of rootedness. By "sense" I mean an embodiment of memory; landscapes are psychological constructions of a certain duration or permanence. In Singapore, "landscape" is almost an oxymoron—not so much because the landscape changes rapidly, but because development has been so relentless that the island has become a global-local hub or interzone. Indeed, spectacle—which is about the triumph of the image over everything else—is a form of antilandscape.

Of Singapore, one could exaggerate a little and say there is landscaping but no landscape. Of all the capital cities in Southeast Asia, Singapore is the greenest. The tree-lined drive from the airport into town certainly gives a good impression to the newly

arrived. But somehow, I want more—this *is* the tropics. One of my fantasies is for the city's "Main Street," Orchard Road, to be covered by a canopy of tropical forest, with the buildings punching through. Nature is everywhere in Singapore, but the enduring experience of this city is of the single-minded will for mastery over it. This will is of course what has characterized urbanization. What is notable about Singapore is how thorough this will has been: hills have been flattened and land reclaimed to expand its surface area, and even time—arguably nature at its most abstract—seems to have been "mastered."

The society of the spectacle isn't an invention of Singapore, of course, as much as it may sometimes feel that way for those of us who live here and read French theory. Miles Orvell, in "Understanding Disneyland: American Mass Culture and the European Gaze," argues that the quintessential American spectacle, Disneyland, is "a fateful symptom of postmodern culture." The occasion for Orvell's commentary was the opening of EuroDisney in France, which, obviously, did not please many of Europe's intellectuals. According to Orvell, for Jean Baudrillard "America functions, vis-à-vis Europe, as a kind of deliberate oxymoron . . . it is a sign of the primitive, yet also a sign of the future." Whereas Baudrillard still registers a distance between Europe and America, Umberto Eco, in contrast, "*connects* the two cultures, offering us a view of America that assimilates it to the popular European sensibility." That is, America is Europe remade as popular culture. Yet Orvell believes that EuroDisney is not simply "low" culture, but "a convergence of spheres, if not an erasure of the boundaries between the playful, historically allusive tendencies of postmodern art and the playful, thematically allusive nature of Disney." No longer just kitsch, Disney has evolved into authenti-kitsch.[11]

Orvell's use of the term "postmodern" may no longer be adequate for theorizing globalization. The "post" tends to presume particular conditions of modernism from which it then takes off. Perhaps "schizo-chronic" might better describe how modernity continues to revolutionize itself of late. The "newest" arenas of modernity simultaneously advance the cultural forms of the past even as they lag behind the previous arenas in cultural development. For example, the triumph of American painting in the 1950s was an overtaking of Europe without a catching-up. New York can never match the density of Paris's cultural history. But a certain erasure of boundaries does occur: "Europeanism" was modernity's first universalism, and while "Americanism" may have surpassed Europeanism, we don't use the phrase "American modernity" so much as "Western modernity." America has both assimilated Europe and been assimilated by the grand trajectory of Europe. And Asia? Or the rest of the world for that matter? The European

gaze on America is now reproduced not just as a EuroAmerican but a *global* gaze on Asia. Asia is the new sign of the primitive and the future. Asia assimilates and has been assimilated. And Singapore? Singapore is the exemplary sign of Asian authenti-kitsch.

Can there be art in a world dominated by authenti-kitsch? I don't see why not. But for the contemporary artist who necessarily deals with representations always already inside the global-local spectacle, there is no "outside" from which to present a critique— though that doesn't mean one has to sit neatly within the boundaries. As part of Nokia Singapore Art 1999, the equivalent of the Singapore Biennial, Lim Tzay Chuen placed a gigantic, pink toy ladder up against the front of the Singapore Art Museum (SAM). Through a sheer contrast in scale, the oversized ladder reframed the entire museum, making it look like a big white dollhouse. *Time* magazine may have deemed, to the Tourism Board's delight, that Singapore is now "fun," but "play," in the fullest sense of the word, is arguably still something almost foreign to this society. There is an uneasy tension between the museum and Lim's installation. It is as if the staid colonial building can't stop taking itself seriously, even as it is being "belittled."

Lim's work, titled *"and the boy asked . . .",* evokes Duchamp's *Fountain* (1917). Today, one finds all kinds of readymade and found objects in art spaces—stuffed goats and rubber tires, basketballs and aquariums—but that is not what links Lim to Duchamp; one doesn't find readymade gigantic ladders. One does, however, find readymade museums, and like Duchamp, Lim is concerned with the power of the institution to determine art. Found objects, as the name suggests, can be any objects that an artist "finds" instead of "makes"; they are visually interesting, to the artist at least, if to no one else. But Duchamp's readymades were chosen to evoke a reaction of visual indifference. So if one reads Lim's work as a reframing of the museum as a readymade, the implication is that SAM, as the state's official art institution, cannot sustain visual interest. Instead of housing art, the museum renders whatever it frames as authenti-kitsch (though many of the over three hundred works shown at Nokia were arguably kitsch to begin with). Lim's work is especially provocative because it leans, both literally and metaphorically, against the boundary of the art institution.

Also at Nokia was a brilliant parody of Singapore's obsession with the global-local: Lee Wen's video installation *World Class.* It comprised a stuffed white globe with wings, a stuffed star in a glass case, a bunch of survey forms posted onto a wall—asking people what they thought constitutes "world class"—and a TV covered with a long cloth funnel, through which one could peer in. On screen was Lee Wen himself, preaching like a possessed propagandist. By virtue of the force of his insistence, he called forth

Singapore as a "World-Class Society . . . with a world-class airport . . . a world-class government . . . world-class artists . . . and a world-class museum." Make no mistake, there are those in Singapore who take very seriously the question "Just what is it that makes certain cities so world-class, so global-local?" In a 1997 National Day Dinner Speech, Prime Minister Goh Chok Tong highlighted the role of "foreign talent" in Singapore's future: "To be a world-class business center we must seek out world-class foreign talent to supplement our own. We must get them to work here, and better still, encourage some of them to sink roots here. The world-class foreign talent will help us to make Singapore a world-class city and best home for Singaporeans."[12]

Statements like Goh's are a hard act to follow. The problem with parody is that sometimes the thing itself is inadvertently far more self-parodying than any intervention. Yet for all its inadvertent self-parody, Singapore sometimes seems like a nation without irony. It is as if irony is only latent and needs awakening, remembering, or defamiliarization. Parody, as Walter Benjamin once said of criticism, is a matter of the right distance. Mimic too closely and the mimicry and its object are indistinguishable. Mimic too outrageously, and the joke is only one-dimensional. Lee Wen's video is almost hypnotic in its concentrated repetition, its language almost interchangeable with that of the state. The white cloth funnel only intensifies the experience, making it less like watching a screen than like being inside the dream world of ideology. Lee Wen's commentary/parody on the state's efforts to interpellate Singaporeans unmasks "world-class" as ideological, but in its ironic way then shows how pervasive this ideology is— laughing at it doesn't distance us too far from it. It cuts very close.

Given the state's low tolerance for criticism from anyone, let alone "foreigners," the American Ray Langenbach could be described as a not-so-desirable "foreign talent." An interesting juxtaposition is Lee Wen's performance of *Yellow Man* with Langenbach's performance of a "yellow woman," Lan Gen Bah. For APT3, Lee Wen presented the thirteenth edition of his *Journey of a Yellow Man* series. As Yellow Man, Lee Wen performs painted yellow all over, with his head shaved bald, and usually stripped down to yellow painted briefs. His actions have ranged from walking around Brisbane carrying an ox's heart, to presenting a paper at a conference at The Substation arts center in Singapore. Yellow Man is an ambiguous and ironic figure. The all-over yellow may read as an exaggeration of ethnic identity, but more than that, Lee Wen poses and destabilizes all kinds of categories.

Unlike Yellow Man, who appears in the flesh, Lan Gen Bah exists only in the digital realm. She is purportedly a Chinese woman born in Singapore, a theorist and

artist whose area of research is cognitive engineering and propaganda. Juxtaposing Lee Wen with Langenbach's double drag—"white man" as "yellow woman"—provokes the question: Is *Yellow Man* a form of drag as well? And a double drag at that? On the surface we have a "yellow" man posing as a "yellower" man, but who is posing as the "yellow" man in the first place? Langenbach asks, does Lan Gen Bah function as a persona of "a particular author or of the (Singapore/American) body-politic and the state? Does she represent white desire for yellow attributes, or yellow desire for white attributes and privileges?"[13]

The question of "whiteness" in Singapore is indeed apropos. At APT3 I closed my conference presentation with a "thought performance": I asked the audience to imagine me doing something of a "white man" performance right there and then. I said that unlike Lee Wen, I did not need to cover myself in white poster paint and wear a white business suit. To *pose* as this "white man," all I had to do was appear as the curator from Singapore, to reveal Singapore as modernity's idealized tabula rasa.

Langenbach has commented that my argument

> not only lays out "appropriation" as Singapore, but your own need, Lan Gen Bah's need, and other people's need to appropriate Singapore. In fact, Singapore remains the place that everyone believes can be defined, described, nutshelled, reduced, objectified. From [former Sex Pistols manager] Malcolm McLaren to [international curator] Hou Hanru to [architect] Rem Koolhaas, and [sci-fi writer] William Gibson, and on and on, and especially the [ruling] People's Action Party. And each of us assumes that we are the only ones who've got it right. Somehow, we all eat this meal, regurgitate it and then consume it again or derive pleasure or horror in the fact that someone else is doing it too. So your argument, aware of its appropriational strategy, could, in a sense, end by appropriating itself.[14]

In the land of appropriation, is the only appropriate option to parody appropriation? Can one criticize Singapore without also somehow reproducing "Singapore"? Does everything come full circle: "late capitalism" = "appropriation" = "global-local" = "spectacle" = "authenti-kitsch"? Terms lose their specificity, equivocating one another when rendered equivalent. Yet that is the thing about spectacle: it is the ultimate view from above; it flattens out the panorama, conflates everything with everything else, yielding a spread of images that appear to vary but make no difference.

I am not, however, proposing the construction of a critical landscape for Singapore, so as to give some sense of rootedness in this global-local hub, some authenticity in this city of authenti-kitsch. Spectacle may be antilandscape, but I don't think landscape is the antidote to spectacle. Perhaps I can respond to Langenbach with yet another trope—one he's used himself. (I'm being Singaporean-like here, mixing as many metaphors as I can, instead of using only one.) The parody of appropriation is a viral strategy: it aims to replicate levels of parody faster than the reappropriations of parody into the spectacle. Although it's not just a game of speed, where artists have to be oh-so-modernist in being cutting edge, advanced guard. To replicate furiously and subversively is also to interrupt the host organism's functions. This strategy isn't new; the critical faculty has traditionally been about both thinking ahead and slowing down.

What I've tried to do in this essay is not to frame Singapore as representative—of the global-local, the authenti-kitsch—but to play with a certain reading of Singapore as an abstraction of these phenomena. At the same time, I've tried not to be reductive. On the contrary, my hope is to be suggestive, to open up looking—at Singapore, and at looking itself.

Sao Paulo, 1997

A shorter version of this essay was first published in *Artlink* 20, no. 2 (June 2000).

1. I have taken the term "authenti-kitsch" from a conversation with Lucy Davis.

2. Arthur C. Danto, *The Wake of Art: Criticism, Philosophy, and the Ends of Taste* (Amsterdam: G&B Arts International, 1998), p. 59. See also Danto, *After the End of Art: Contemporary Art and the Pale of History* (Princeton: Princeton University Press, 1997).

3. The full text of Lee Yock Suan's speech was originally found on the Singapore government's Web site. The Renaissance City Report can be found at <http://www.mita.gov.sg/renaissance/FinalRen.pdf>.

4. Statistics are from the Queensland Art Gallery and taken from Caroline Turner, "Journey without Maps: The Asia-Pacific Triennial," in *Beyond the Future: The Third Asia-Pacific Triennial of Contemporary Art,* exh. cat. (Brisbane: Queensland Art Gallery 1999), p. 22.

5. Turner, "Journey without Maps," p. 21.

6. In her dissertation on culturalism, visual culture, and political-aesthetic strategies in Singapore, "Making Difference—So Easy to Enjoy, So Hard to Forget" (Roskilde University, Denmark, 2000), Lucy Davis notes: "The trope of the pure organism, the boundaries of which are to be protected from the dangerous corruptions from outside, was theorized by Geoffrey Benjamin in 1970s as a trope that was analogously transferred to all aspects of Singapore life, from ethnic divisions to the length of male hair." (Benjamin, "The Cultural Logic of Singapore's Multiracialism," in Riaz Hassan, ed., *Singapore: Society in Transition* [Kuala Lumpur and New York: Oxford University Press, 1976].) Such technologies of boundary maintenance of the local, the specific, the particular, and the policing of these "natural" boundaries against external, "unnatural" corruptions, are of course not unique to Singapore, and are themselves part of the particularist logic of the eighteenth-century romanticist episteme. This split and struggle between the particular and the universal—in this case formulated as global and local—is of course the *constitutive split* of modernity itself. Technologies of boundary maintenance also occur in the late-capitalist celebration of the "hybrid," "nomad," "creole," "mongrel," "inter-," and "multi-," whereby the declaration of any one of these "bastard metaphors" is usually followed by a retroactive listing of all the various, clearly defined "identitarian components."

7. Ibid.

8. Sanjay Krishnan, "Singapore: Two Stories at the Cost of One City," *Commentary* (National University of Singapore Society) 10 (1992), p. 81.

9. Lucas Jodogne, *Singapore: Views on the Urban Landscape* (Antwerp: Pandora, 1998).

10. See Geraldene Lowe-Ismail, *Chinatown Memories* (Singapore: Singapore Heritage Society, 1998), p. 26.

11. Miles Orvell, "Understanding Disneyland: American Mass Culture and the European Gaze," in *After the Machine: Visual Arts and the Erasing of Cultural Boundaries* (Jackson: University Press of Mississippi, 1995), pp. 147–59.

12. The English text of Prime Minister Goh Chok Tong's National Day Dinner Speech (in Mandarin), 31 August 1997, was originally found on the Singapore Government Web site.

13. From e-mail correspondence with Ray Langenbach.

14. Ibid.

Globalization or Endless Fragmentation?
Through the Shadow of Contradictions

Carlos Vidal

Body, Art, Technique: Uncertain Artifactualities

According to T. S. Eliot, any artwork of the present is a continuous *rereading* of a work of the past (thereby forcing us to reread it). Rodin reconfigures Michelangelo, or, to give a more contemporary example, Robert Morris rereads and modifies Duchamp's formal, conceptual (and semiotic) identity. This continuous rereading creates the need for an understanding of the *historicity of the artwork* to replace the historical-mythical narrative of "ruptures."[1]

In many ways we still have a mythical understanding of the idea of rupture. This "rupture myth," generally associated with the avant-garde, relies on the possibility of a pure and originary moment (which is refuted through the work of any serious deconstructionist, like Jacques Derrida). It consists of the notion of an original rupture, the creation of a "New World," that is then diluted and absorbed, or assimilated and controlled by a series of economic and social forces, and through the legitimizing mechanisms of aesthetics, history, or taste.

However, this thesis is increasingly considered to be inaccurate. Hal Foster, for example, reinscribes the avant-garde as a concept of the past that always returns to a starting point in the future. On this reversibility of time in art history, he writes: "Crucial here is the relation between *turns* in critical models and *returns* of historical practices. . . . How does a *re*connection with a past practice support a *dis*connection from a present practice and/or a development of a new one?"[2] Foster proposes models that analyze signs of continuity and not merely of rupture in the evolution of historical practice, past or present.[3] A work of art develops or appropriates models and moments from the past.

Harold Bloom speaks of an "anxiety of influence" in which the "strong poets" of all times exercise "tyranny" over the others, fragmenting time itself, but above all proving the inevitability of writing and creation as forces (or fields in which forces are constantly subjugating other forces, and times subjugating other times). This flux transforms the poem into a zone of tension and compression in which the work of the author seems to be *naturally* "writing" the work of his or her precursor.[4]

For Clement Greenberg there was also no progress in art; he saw only developments, folds, and evolutions within the heart of a tradition.[5] This thesis is the root of a particular view of history in which, as I mentioned above, Duchamp is understood as a "founder" of modernity only if the effects of this "foundation" can be traced in the work of Robert Morris; this process—called "trauma" in psychoanalytic theory—has been recovered from Jean Leplanche by Hal Foster. According to Massimo Cacciari in *Dell'inizio,*[6] such historization aims to show that art is also a deconstruction of itself (another way of not coinciding, of subverting itself), incorporating its own "death." This *negativity* (as in Theodor Adorno) is, above all, a historization of truth (Cacciari). The process of the production of truth in art is essentially the fulcrum or mirror of the contradictions of any era.

Globalization and/or fragmentation? In these times of apparently unstoppable acceleration, we should look to a critique of progress and of definitive ruptures in art, be they ideological, formal, or technical. We live in a time in which "truth" is a synonym of "contradiction," and in which the rematerialization and dematerialization (conceptual or digital) of art can coexist. Now is the time to rethink a potential critical emancipation of art after an age of obsessive homologization.

The fact is that before our very eyes—the same eyes that anticipate a much-heralded cyberworld—we see an art that is increasingly *rematerialized.* At least since the 1960s, rematerialization in art has connected and disconnected artists from their materials. In effect, the gap between "medium," world, and visuality continues to increase. This return of the real and of the body questions and refutes any kind of cyber-euphoria. What, then, is art (or "When is it Art?" in Nelson Goodman's words) and culture in this age of constant rematerialization? And what do we mean here by "rematerialization"?

Let us ask the same question in relation to youth culture. What are art and aesthetics in this turn of the millennium, in which acid house parties, Reclaim the Streets and the Night Marches, anti–car culture, raves, and "do it yourself" culture overlap in a totally nontechnological manner (in a nontechnology from which surprisingly there is no aspiration toward hypertechnology)? In other words, why do most of these "tribes" not aspire to cyberspace, and why will many not occupy it? Maybe it is more instructive

to consider raves (and Ecstasy and techno) as a high form of unpredictability that, in spite of the apparent "technical structures" of reality as "absolute power," can slip in and out of this instrumentalization or any kind of determinism. We can see escapism, an orgiastic exhaustion, and archaic physicality as being alien to cyberspace. According to Michel Maffesoli, "Nous vivons une forme de démocratisation de la pensée bataillienne."[7] Utopian digital dematerialization (which to some is realization of total democracy, and to others excessive control) coexists alongside a hyper(re)materialization.

Art that takes the body as its principal reference exhibits a notable tendency toward rematerialization and a critical resistance against an industrialization of ideas. Just as we see what Hal Foster calls the "return of the real," we have what I call a "return to the body."[8] In this age of mutations, from the hyperreal, organic, and ecological through techomutation and cyberspace, the body returns again and again as a central subject of aesthetic debate. It is even more significant to note that this issue emerges from peripheral cultural spaces, and that these very spaces are *recentering* the world of contemporary culture. It would be a great thing if globalization were challenged by this new force of peripheral voices.

The body is at the forefront of representation. This issue lacks its own methods or discipline, even though we live in a system that is destroying the environment while creating genetic engineering, cybernetics, disasters like those at Three Mile Island and Chernobyl, new systems of agricultural and food processing, artificial intelligence, biotechnology, and the industrialization of single life and its resulting *polar inertia*. Given that the body is considered a zone of indefinition rather than a "spectacle" in aesthetic terms or in its surrounding reality, we may ask ourselves whether the body appears as a subject of debate precisely because systems of technomutation can transform it within seconds. Alternatively, is it because in advanced capitalism the development of life and society becomes "artificial nature" (reducing "natural nature" to weekend archaeology), forcing the body to lose it *physical mold?*

Despite the emergence of these questions, or as a result of their emergence in this context of *threats*—against the body and against art—this same body, our body, returns to the heart of artists' concerns (from which in fact it never left). Corporality is situated away from the inherent materiality of the body (once again we find ourselves speculating about immateriality), like the immateriality of the soul that inhabits it. Thus we can say that the body is always the fulcrum of aesthetic representation and the most reliable barometer, not only in historical terms, of its manifestations.

The body establishes, through Form or ways of forming, an *informal* factor (Bataille), which is one of the most effective modalities through which to perceive the

development of representation. The issue is how to verify, in the formation of any particular Form, a self-corrosion *from inside to inside,* in the way that death acts from within a (living) body and is part of it from birth.[9] (Another way to achieve this result would be through an excessive formalist essentialism so that the form would correct itself in silence and nonpresence.)

We can say that body and art—considering the "artistry" of any body as much as the more evident "corporality" of art—are not entities that exist to illustrate an immediate opposition to technology but at the very least, as discussed here, are inseparable from any kind of technological determinism.

According to Heidegger, "The artist is the origin of the work. The work is the origin of the artist. Neither is without the other. Nevertheless, neither is the sole support of the other. In themselves and in their interrelations artist and work *are* each of them by virtue of a third thing which is prior to both, namely that which also gives artist and work of art their names—art What art is should be inferable from the work. What the work of art is we can come to know only from the essence of art. Anyone can easily see that we are moving in a circle." Heidegger gives his "solution" in the following terms: "we must follow the circle."[10]

For Heidegger, art, unlike science, is not created through technology. It is created *without a plan* and cannot be reduced to technology or to political pragmatism (which, as we know, feeds on popular "needs"). Art avoids any exclusively media-based relations, given that it invents itself and its "media," and locates itself both *within* and *without.* We also find ourselves within and without cyberspace, cyberculture, and the cyberworld; in other words, they escape us as real things until we overcome the "age of the cyberworld" by theorizing about the "return of the real" or the "return of the body." Alternatively, one could say that we are not there yet, as affirmed by Julian Stallabrass, basing his arguments on what Fredric Jameson calls William Gibson's "orgy of language." Thus we can begin to map out the introduction to a space of immense contradictions because if cyberspace is, according to Hegelian and Platonic ideas, a virtual concretion of future and ideal worlds, it also evokes structures and power alliances that are all too familiar:

> Cyberspace is also allied with an unashamed consumerism. . . . V. Sobchack has analyzed the mix of New Age spiritualism and New Age technophilia in which sixties political activism and social consciousness have been resolved into "a particular privileged, selfish, consumer-oriented and technologically dependent libertarianism," which fulfills "the dreams of 'mondoids' who, by day, sit at

computer consoles working for (and becoming) corporate America." It is cyberspace which will allow this becoming to complete itself, uniting the worlds of work and leisure in an environment plied by virtual alter-egos. In this light, cyberspace appears as less the end of history than the ultimate business environment, being stockmarket, warehouse and shopping center all in one.[11]

Stallabrass seems to establish a semitotalitarian scenario in which countercultural development leads to a renewed apotheosis of consumerism. Even more disturbing is the idea of a *fusion* of the above-mentioned divisions between a nontechnological and nonbusiness counterculture and the corporate digitalization of the world. In other words, we are facing the *surrender* of what until recently were unpredictable forms of counterculture (and also uncontrollable, in as much as everyday life and art were separate from a programmed technology) and an art of "poor mediations" (associated inevitably with the "returns" of the body and of the real) in the face of the unstoppable actions of large corporations and multinationals.

Before the (initially literary) fiction of cyberspace and a cyberworld, immateriality was already one of the forms of existence for art. We can see immateriality as a common feature of art history from the Renaissance "cosa mentale" through neo avant-garde conceptual and phenomenological dematerialization and from the spirituality of previous centuries (Aby Warburg's "God is in the details"), passing through poststructuralist and neofeminist conceptualization and neoconceptualization. We could add that now there is a (totally?) new face to the immateriality-dematerialization-rematerialization relationship.

I would suggest that not only culture but also contemporary democracy could benefit from this very contradiction precisely because rematerialization and hypermaterialization do not now appear merely as phenomena of resistance. We could say that in contemporary culture the rematerialization of art is not a front or a strategy of resistance against dematerialization (analog or digital), or even phenomenological, conceptual, or neoconceptual processes. Materialization and rematerialization are a priori conditions for the existence of art, or rather of representation. Our era is as much about a general realization of digital immateriality as it is about the physical existence of abundant and accessible aesthetic possibilities of rematerialization.

For Julian Stallabrass, cyberculture *as fiction* raises the question of whether technology is/was captured by human creation or whether human creation is being silenced and thus itself becoming technological. Stallabrass goes on to describe hypermaterialization within the field of economics as a reaction springing from a market

that sees the ghosts of cyberculture—in other words, a market that foresees a global crisis in the institutional system of art objects, the same system that determined the connection between aesthetic autonomy and monetary value.

"Low-down," "Poverty," "Organic": "Other Aesthetics"

In the context of what I call "rematerializational poverty"—the most evident form of underlining the physicality of matter in art, its *reduction to pure existence,* to a simplicity that denies mediation as in the work of Francis Alÿs, Gabriel Orozco, Jimmie Durham, and others—one can detect a certain critical resistance to global technological homologation. This resistance consists not only of asserting the "local," but also of mapping out the "near future" as an alternative (or *alternation*) to an undifferentiated preeminence of the global. We can trace these intentions in the work of other artists, specifically in Nan Goldin's poor (in terms of process) appropriation of life: "for me, taking a picture is a way of touching somebody . . . it's a caress."

For Goldin, this desire to "caress" the other can only be achieved (we can only approach its realization) through an aesthetic impoverishment of the photograph's formal aspects such as color or composition. This overcoming of mediation has nothing to do with any desire to *dematerialize;* it brings us closer to a strong sense of physicality. To caress the other leads to an act of *cooling the mediation,* which is inversely proportional to the temperature of the emotional content (*cold* mediation, *intense* content). As Goldin has said, "I'm looking with a warm eye, not a cold eye. I'm not analyzing what is going on—I just get inspired to take a picture by the beauty and vulnerability of my friends."[12]

In these terms we can conclude that Goldin's work posits the possibility of a poor aesthetic mediation. It is helpful at this stage to recall the canonic definition of mediation penned by Étienne Souriau in his *Vocabulaire d'esthétique:* to mediate is to place something between the two poles of a work.[13] Whether one wants to mediate or not, mediation always takes place within aesthetics. To reject mediation is to risk an "impoverishment" of the work.

We could say the same of works by William Kentridge, the South African draftsman, set designer, and video artist (animator). Although Kentridge uses video, he simultaneously refuses the technologization of art in favor of his poor and direct drawings, animation, and, obviously, video (using techniques *politically* based on drawing), creating a body of work of remarkable coherence. When he chooses poor media, he creates an illusion of innocence that unexpectedly and obviously becomes a weapon of rejection—critical, analytical, anthropological—and of sociological awareness.

Besides citing William Kentridge, one could list, as I did earlier, other artists from cultural contexts that have recently redefined what we mean by "ethnocentric representation" and by representation *tout court*: Lygia Clark, Helena Almeida, Mona Hatoum, Jimmie Durham, Francis Alÿs, Gabriel Orozco, Cildo Meireles, Santiago Sierra, Jac Leirner, David Hammons, Shirin Neshat, and also Abbas Kiarostami, Hou Hsiao Hsien, or the surprising Portuguese filmmaker Pedro Costa.[14] Some, in their radical claim for alterity ally themselves with the most stimulating theories of postcolonialism. Others propose a radical rereading of the concept of representation, far beyond the meager "representation" that weighs on contemporary economic-bourgeois democracies.

Let us now turn to the question of postcolonialism. Postcolonialism has contributed to the redefinition of certain established categories in aesthetics and in politics, such as "culture," "vanguard," "ideology," "representation," "left-wing," "identity," and "nation." Postcolonial theory has established a simple and global fact that applies to all periods: there is no pure art, whether in formal systems (painting, video, theater, dance, etc.) or in terms of content.

The most challenging contemporary art posits a specific decolonization of culture itself, which implies two areas of work. First, we must understand the processes through which the colonial Western world defined itself through the aesthetic mechanism of the Other (this has been a central thrust in the work of Edward Said, from *Orientalism* in 1978 to *Culture and Imperialism* in 1993, in which he analyzes the work of authors such as Rudyard Kipling, Joseph Conrad, V. S. Naipaul, Frantz Fanon, and Giuseppe Verdi as cultural "symptoms"). Second, we must show how, having lost its overseas empires, the West has itself shifted its cultural (and political) paradigms, acts, and definitions.

But we should not think that cultural democracy will be exhausted through the application of a bureaucratized policy of cultural differentiation through which alterity immediately becomes reduced to its own "identity" (a critique led by Gayatri Spivak), or that, within a context of ever-increasing technological democracy, the Other will eventually be expressed on the Internet, thus concluding a perfect process of democratization and linear progress. The mechanisms of domination and circulation created by the decision-making centers of global capitalism have become increasingly restrictive, despite the Internet. A truly cosmopolitan policy will have to overcome these mechanisms, whether they are those of cyberspace inasmuch as we can understand them, or of the State of Law, as so well explained by Alain Badiou and by Jacques Derrida, who in recent books contrasts the idea of hospitality and the "refuge city" with that of the State.

In recent texts on politics of friendship, hospitality, and cosmopolitanism (simultaneously "singular" and "universal"), and "refuge cities," Derrida develops ideas from Hannah Arendt and Kant to call for a truly cosmopolitan politics.[15] These politics can only exist by breaking through the impasses of a hypothetical "world government," and by redefining the role of states and of cities, making the latter (once transstate, transgovernmental, and transnational politics have been established) a parallel and autonomous power structure, an *intermediate* instance of freedom and hospitality, overcoming the limitations of the nation-state and its unitary government.

Derrida considers, as did Arendt in the 1950s, that the rights of refuge and hospitality are constantly under attack: "today, in Europe as in the rest of the world, we should reassess the roles of States, Unions, Federations, and Confederations on the one hand, and those of cities on the other." In other words, we could ask, "can a city rise above a Nation State, or at least gain independence within certain limits to become an *open city,* according to a new use of the term, in regard to hospitality and refuge?"[16]

A deep postcolonial critique should consider some of Derrida's most recent theories and demand a radical cosmopolitanism (one that does not refound the Other in a new centrality), in which all the exiles of the world can exist without being fixed into a status of nonbelonging (European emigration policies tend to establish the right of asylum exclusively to those who can prove that they will not benefit economically from emigration). Such a theory would need to describe a world following the collapse of the nation-state, while also acknowledging that this collapse has not led to a multiplicity of identities, but rather, as Ernest Renan warned, to a concentration of identities according to a single "master" and a single order.[17] In other words, instead of an articulation of the problematic unity of the nation through cultural difference, as proposed by Homi Bhabha, today we are faced with the forced triumph of a single planetary law.

This single law is the greatest threat to "any singularities," to use Giorgio Agamben's term, as it is to the very idea of liberty, as theorized by Renan in his famous 1882 text on the definition of "Nation":

> The nations are not something eternal. They had their beginnings and they will end. A European confederation will very probably replace them. But such is not the law of the century in which we are living. At the present time, the existence of nations is a good thing, a necessity even. Their existence is the guarantee of liberty, which would be lost if the world had only one law and only one master.[18]

For Alain Badiou, a radical critique of traditional representations cannot take place without a cosmopolitanism born of a weaving together of radical singularity with universalism. In other words, the I-Other is, above all, an I-not-Other that says *my identity is the impossibility of losing it;* thus, this unlimited experiencing of identities need not be circumscribed to any stereotypical "differentiation." As Badiou writes in *Saint Paul, la fondation de l'universalisme:* "Everything that circulates falls into a unit of calculation, and inversely, nothing circulates unless it can be measured this way. Nonetheless, this rule sheds light on an underlying paradox: just as we reach an instantaneous form of cultural circulation, a series of prohibitions on the movement of people emerge from all sides."

Badiou then focuses his criticism on the vulgarization of "human rights" and of "minority rights," a categorization that he urges us to resist in order to avoid a colonization of cyberspace and of any other sector of global democracy:

> They create the impression of nonequivalence so that equivalence can itself become a process. What a glorious future for all market investors, who can target several vindications and cultural specificities: women, gays, handicapped Arabs! With such infinite combinations of attributes, what luck! Black gays, handicapped Serbs, pedophilic Catholics, moderate Muslims, married priests, young quadriplegic ecologists, obedient unemployed people, and young old-age-pensioners! There are more and more authorized images of new products, specialized magazines, and appropriate shopping malls, "free" radio stations, directed advertising networks, and countless "social debates" at peak time. Deleuze has defined it accurately when he says that Capitalist deterritorialization requires constant re-territorialization. In order to consolidate its field of influence, capital demands a constant emergence of subjective and territorialized identities that, at the end of the day, require no more than an equality of exposure according to the uniform prerogatives of the market. Thus we have the Capitalist logic of general equivalences and the cultural logic of community and minority identities coming together in an articulated whole.[19]

But we must raise another objection. Even if we accept that this new democratization of alternative voices, albeit fragmented to an absurd degree, can take place within any financially controlled arena (as cyberspace is to a large extent), we have to face the limited access to technology that is still commonplace in our globalization of interests. As

Trinh T. Minh-ha has said, there is always a "Third World" within the "First World," and vice versa.

Rehabilitation of Representations

I propose that we look back at this point and conclude that the rematerialization of art (or the "return of the real" combined with the physical "return to the body," whether the body is human or the artwork itself) should be seen simultaneously as a critique and a reconsideration (or better, a *radical emancipation*) of the concept of representation, as much as of representational reality. Therefore, representation literally becomes a nonsubstitutable *reality*.

Representation is a method of transmission: a very peculiar kind of communication. Given that all art distances itself from and approaches reality in one unintelligible movement, uniting and separating without synthesizing, representation can be judged and condemned as substitution/separation and alienation. However, without doubt it is also one of the inevitable faces of the reality of the world.

We must look to history to understand this total lack of homogeneity and the difficulty of finding forms that define us. We must consider the equivalence between representation and impression in the Stoic philosophers; representation and imagination in Aristotle; representation, perception, and apprehension in Leibniz and Spinoza; and representation, sense apprehension, and conceptual apprehension in Kant. Later, in the work of Schopenhauer, we come across representation as the objectification of will.

The author of *Parerga und Paralipomena* classifies representations as either sensorial—those apprehensions and perceptions triggered through the senses, which he designates as "intuitive representations"—or formal, those which are born of ideas or concepts, or even emotions and volition, which he terms "abstract representations." From these infinite possibilities of definition, comprehension, and realization, two tendencies have emerged which we will contrast, while being fully aware of the risk involved in assuming that they can in any way explain the essential "lives" of representation (in art, aesthetics, or the world). First, in Guy Debord's analysis of contemporary life and forms of production, representation is the chimerical reason for the "society of spectacle." This line of reasoning is born in Marx and Feuerbach, where the expropriation of identity, singularity, and individuality is, at the end of the day, the representational expropriation of *everyday life,* which is at the heart of the most subliminal and secret oppression. (According to the "Enragés-Internationale Situationniste" Committee of the Sorbonne in May 1968, "those who speak of class warfare without referring to everyday life have a corpse in their mouth.")[20] Second, we

can quote Jean-Luc Godard, who said that representation is "a condition of liberation in response to the subjection imposed by the world."[21]

Let us focus on the first part of this duality. In the first case, representation is consubstantial with capitalism, whether in a "centralized" bureaucratic society or in an "integrated" or "diffuse" society of the spectacle. For Debord, contemporary representation (in economics, politics, and aesthetics), or the representation that we know as means of communication and imperative everyday administration—usually of the "integrated" type—does not try to coincide with reality, nor produce reality, but rather tries to substitute for reality to avoid the emergence of any form of life or knowledge beyond its totalitarian limits. In other words, *spectacular representation* becomes the only possible language with which to describe existing reality which, in a perfect circularity, is "reality" only in as much as it can be reduced to the limits of that representational language:

> The integrated spectacle appears sometimes as concentrated and other times as diffuse. After such a fruitful union, it begins fully to adopt one or the other of these qualities. Its previous mode of application has changed considerably. In the concentrated formulation, the directing center is hidden, one will never find there a known ruler or clear ideology. In the diffuse version, the influence of spectacle has never been as strong in the development of social behavior and artifacts. Thus, the ultimate aim of the integrated spectacle is to integrate with reality in as much as it speaks of it, and reconstructs this reality while defining it.[22]

Debord's judgment is, above all, a fierce *constructive* criticism; and what is its visible face? First of all, theory, followed by cinematography. Debord's cinematographic work shows us that *there is nothing external to representation,* or that there is no way to manifest what is external without once again passing through the web of representation. According to Debord, it is within this circle (simultaneously open and closed) that we should work, so that we can see the image in general, and cinematography in particular, both of which reduce and rescue the representation of alienation. The way to alienation can also lead to liberation. Here is a fundamental paradox: because representation generates its own critique, freedom of representation could be said to move us toward artistic creation, which aspires to metarepresentationality. This is one way to synthesize the art of our century, from the avant-garde to the contemporary: art moving constantly in an anxious dematerialization within a necessarily materialized representation.

With regard to Debord's films, we could say the same: he searches for an anticinema of the cinema. What this type of cinema announces is an *infinite* (and invisible? let us not forget that he was seduced by the idea of "invisible subversion"), active, current, and nonnostalgic "second way" that critiques the mechanisms of representation. We must engage with representation as it is now and was previously, without regressing to a mythical past in which representation did not exist: a paradise lost of originals without copies. Given that this "paradise lost" does not exist, we have a writer like Debord who works on film and the image of his and our age—which coincides with the time of cinema itself and of images in general.[23]

Seen thus, Debord's production points to a possibility of *representation without separation or alienation.* This artist-philosopher (who defined himself as a strategist), goes in search of what Walter Benjamin called the "refuge of all images," the "being-image" of the image. According to Giorgio Agamben in a lecture of November 1995, Debord searches for the sign that signifies nothing other than its own process of signification, the being (body) of signification.[24] Elsewhere, Agamben speaks of "pure means" in the political field, referring to those means that are not subsumed to the ends, and therefore allowing a continuous definition of "means." Returning to Debord's films, he writes, "what cannot be signified or said in a discourse, what is in a certain way unutterable, can nonetheless be shown in the discourse."[25]

This is where the ethics and politics of film as a whole should act. Some filmmakers—proposing the centrality of the practice of montage, through repetition and interruption—reactivate memory and possibility as central conditions in their art, through which possibility becomes reality and reality becomes possibility. Debord (and Kiarostami, for example) oppose the emphasis of the mass media on "facts" *without possibility,* through which we lose power: "The media prefer a citizen who is indignant, but powerless. That's exactly the goal of the TV news. It's the bad form of memory, the kind of memory that produces the man of resentment."[26] Thus we have two types of representation: that of creation (cinematography) and that of televised current affairs. Debord analyzes the reactivation of cinema, launching one of the most effective radical critiques of televised news: that of the society of integrated spectacular representation.

This view leads, as noted above, to another definition of representation that, while seeming to contradict the one we have just laid out, complements it by reformulating the critique and directing it no longer specifically at representation, but rather at life itself seen as the result of a productivist representational instrumentalization. In this context, we can recall the voice-over in Godard's movie *For Ever Mozart* (1996):

"Knowledge of the possibility of representation provides comfort through the slavery required by life. Knowledge of life comforts because representation is like a shadow."

Here there is an overlap of assumptions, between liberation and falsification, which complicates the structure of representation. This ambiguity has two sides: at one level, all representation grows and develops from a signification of truth; representation is truth itself, therefore any representation can only be a *representation of itself.* Nonetheless, in order to make this self-representation effective, we must conceive of a "fault" through which each thing is reflected as though in a mirror, but the resulting coincidence is always diverted.

For example, that which represents something can only do so if it diverts from the original. Each thing "is" only what it "is" in the context of an unintelligible alterity. As Sartre noted, we only know what a thing "is" through a relationship of alterity, in relation to other things.[27] (Postcolonial debates should consider this correlation of forces.) On the other hand, it is essential to simulate that things "are," in fact, for representation to be effective. Thus representation becomes a desire and a force, freeing itself from the condition of substitution. Finally, the eye itself is an event, not a physiological circumstance: if I am seen by the world that surrounds me and exteriorizes me, others see me. The others are those who see me and force me to lose my centrality. To see is to be seen, as only by confronting the other's gaze can I acquire my own. We can say that in Sartre, to "be" is to "represent" what each one "is." Or, "it is" is only so in representation. To be something is part of the truth of that thing; therefore, to "be" is to represent. Thus we move ahead, through this connection between truth and representation.

Truth and Intention

Let us start by defining the issue of representation as one of *finding* the a-intentional essence of truth and of the idea. This philosophical model ensures that only those who free themselves of an "original sin" can deal with and adopt the issues of representation. This original sin has two faces: we atone for our unique ability to deceive ourselves with images, but we also know that there is no mythical reality that is *more real* than that which for now seems to be merely shadow and illusion.

The rescue of representation in these terms implies a freedom from guilt. According to the allegories of Massimo Cacciari in *L'angelo necessario:*

> Only the Angel, free from demonic destiny, poses the problem of representation. Demonic destiny is "der Schuldzusammenhang des Lebendigen" . . . , the guilt

context of the living. For the demon, the constitution of the living is guilty: it refers back to an originary guilt that condemned to the first generation and set in motion the *rota generationis* (cycle of rebirths). Life itself is the penalty. The daimon nails life to the laws of destiny, which have nothing in common with those of justice.[28]

There is a condemnation that subjugates the character of those who live with guilt. For this reason Cacciari, like Walter Benjamin, describes a simultaneous liberation of character and of the name (which represents) in relation to its being-signification, to the imitation-image of what it signifies: "The name unfolds 'in the brilliance of its single trait' (Benjamin), in the solitude of its 'temperament.' The character 'freely' wanders through names and their etyma, combining and varying them in a game of intelligence and invention that challenges the original resonance of the word."[29]

Speaking of this disconnection, Cacciari quotes Plato in *Cratylus* where he underlines the absurdity of the coincidence of words and things, and of image with things ("Do you not perceive that images are very far from having qualities which are the exact counterpart of the realities which they represent? . . . But then how ridiculous would be the effect of names on things, if they were exactly the same with them! For they would be the doubles of them, and no one would be able to determine which were the names and which were the realities").[30] According to Cacciari, the truth of the thing is a given, without representation or mediation. However, in spite of this, there is a potential identification between truth and representation in which, as we will see, representation moves beyond a mere connection. This given (of truth) is a representation in a world in which there is nothing outside representation:

"Truth is the death of intention"; any theory that wants to reduce truth to the ambit of the international relation is destined to miss "the peculiar giving of itself of truth from which any kind of intention remains withdrawn." The forms of the analytic-conceptual connection presume to represent truth just as names presume to possess in themselves the thing itself. In reality, this conception betrays only an ignorance of the problem of representation. If representation stands for the identical image of the thing, we return to the aporia of the "double" in the *Cratylus*. We would then have to say that the forms of the connection are truth itself. But these forms are made up of names and verbs; they form the world of the experience of the entity in its oscillation. That is why they must be rigorously differentiated from the forms in which truth gives itself.

If we were to produce these forms, truth would be the product of our intention; but our intention, again, cannot develop itself except through names and verbs. That is why the problem of representation can be understood only as the problem of the giving-itself on its own of truth itself.[31]

Thus we arrive at Walter Benjamin: "The object of knowledge, determined as it is by the intention inherent in the concept, is not the truth. Truth is an intentionless state of being, made up of ideas. The proper approach to it is not therefore one of intention and knowledge, but rather a total immersion and absorption in it. Truth is the death of intention."[32]

Representation will stop functioning as totalitarian separation, to also become simultaneity, a portrait of the common ground of art, reality, truth, and falsity (beyond time, with no past or future), as Goethe wrote in a brief reflection: "It is as certain as it is wonderful that truth and error spring from one and the same source. For this reason it is often wrong to do violence to error, because truth would at the same time be made to suffer."[33] Representation is at the heart of this contradiction, and it can free us from *determination.*

translated from the Portuguese by Gabriel Pérez-Barreiro

Brussels, 1999

1. For more on this subject, see Carlos Vidal and Benjamin H. D. Buchloh, "Historia, resistencia y utopia: Entrevista con Benjamin Buchloh," *Lápiz* (Madrid) 122 (May 1996).

2. Hal Foster, *The Return of the Real: The Avant-Garde at the End of the Century* (Cambridge, Mass.: MIT Press, 1996), p. x.

3. See Hal Foster, "Trauma Studies and the Interdisciplinary," interview by Alex Coles, in Alex Coles and Alexia Defert, eds., *The Anxiety of Interdisciplinarity* (London: Backless Books, 1998), pp. 156–68.

4. Harold Bloom, *The Anxiety of Influence* (Oxford: Oxford University Press, 1973).

5. On Greenberg and the thesis of nonprogression in art, see Ann Hindry, "Entretien avec Clement Greenberg," *Les Cahiers du Musée National d'Art Moderne* (Centre Georges Pompidou), nos. 45/46 (Fall/Winter 1993); Saul Ostrow (interviewer), "Clement Greenberg—L'indéfinissable qualité," *Artpress* (Paris), special issue no 16:

Où est passée la peinture? (1995); and Thierry de Duve, *Clement Greenberg entre les lignes, suivi d'un débat inédit avec Clement Greenberg* (Paris: Disvoir, 1996).

6. Massimo Cacciari, *Dell'inizio* (Milan: Adelphi, 1990).

7. Michel Maffesoli, "L'interprétation des *raves*," interview by N. Bourriaud and Philippe Nassif, *Artpress* (Paris), special issue no. 19: *Techno, anatomie des cultures électroniques* (1998), pp. 157–62.

8. In *The Return of the Real,* Hal Foster proposes a distancing from the Baudrillardian model, on the one hand, and the Lacanian model of representational *écran,* on the other. He writes: "Contemporary art has turned from the world view of my generation of artists and critics, in which (to put it crudely) everything seemed to be an image, an effect of representation. The Baudrillardian notion of the simulacrum permeated much work of this time. But the next generation, the one active now, has a different idea of the real. 'The return of the body' is a cliché, but like some clichés it conveys some truth. The body has reasserted its claim that it cannot be elided in representation, that it will not disappear in cyberspace." Hal Foster, "The Return of Shock and Trauma," interview by Rubén Gallo, *TRANS* > (New York) 3, no. 4 (1997).

9. See Georges Bataille, *Documents: Archéologie, beaux-arts, ethnographie, variétés 7* (1929). Facsimile issues are in *Documents,* vols. I and II (Paris: Jean Michel Place, 1991).

10. Martin Heidegger, "The Origin of the Work of Art" (1935–1936), in *Martin Heidegger: Basic Writings,* ed. David Farrell Krell (New York: Harper and Row, 1977), p. 149.

11. Julian Stallabrass, *Gargantua: Manufactured Mass Culture* (London: Verso, 1996), p. 48.

12. Nan Goldin, "On Acceptance: A Conversation—Nan Goldin with David Armstrong and Walter Keller," in *Nan Goldin: I'll Be Your Mirror,* exh. cat. (New York: Whitney Museum of American Art, 1996), p. 450.

13. See the definition in Étienne Souriau, *Vocabulaire d'esthétique* (Paris: PUF, 1990), p. 993.

14. On one of her own films (co-produced with Danièle Huillet), *Chronik der Anna Magdalena Bach* (1967–68), Jean-Marie Straub has written: "I am convinced that *Chronik* . . . is one of the most visual films that exist, in the sense that one can see more in this film than in a good American movie full of movement, chases, and gunshots. You have a scene in which at first it seems that nothing is going on, but after a while one can see a finger moving twenty meters away, or a wig moving from the tension of the brain underneath, working, or an arm battling with a bow, or a mouth battling with the words of a text, there are countless visual events in a single scene. We see a thousand things, while in an action movie, at best we can see six or seven" (*Straub-Huillet* [Lisbon: Cinemateca Portuguesa, 1998], p. 84).

 Pedro Costa, a younger filmmaker, takes Straub and Huillet's process even further toward the possibility of an *essential* and *democratic* cinema that rejects the pressures of spectacle and commercialism (two factors that depend on capital and immediate communication, and are therefore external to the language of film). For *No quarto da vanda* (2000), Pedro Costa lived for almost two years in one of the poorest areas of Lisbon, filming without a script, almost as a documentary, with the inhabitants of the neighborhood. Then, in the editing process, Costa created a surprising cinematographic narrative (distant from a conventional sense of fiction). Despite the drama and extreme situations of the people he filmed, Costa's movie has a remarkable serenity; the neighborhood emerges as a microcosm in which human relationships are articulated through the smallest gestures. These gestures are alien to the opulence of the financial city. The global film industry survives thanks to this lack of knowledge.

15. See Jacques Derrida, *Politiques de l'amitié suivi de L'oreille de Heidegger* (Paris: Galilée, 1994), *De l'hospitalité* (Paris: Calmann-Lévy, 1997), and *Cosmopolites de tous les pays, encore un effort!* (Paris: Galilée, 1997).

16. Derrida, *Cosmopolites*, pp. 24, 25.

17. See Ernest Renan, *Qu'est-ce qu'une nation?* translated into English as *What Is a Nation?* in Homi K. Bhabha, ed., *Nation and Narration* (London and New York: Routledge, 1990), pp. 8–22.

18. Ibid, p. 20.

19. Alain Badiou, *Saint Paul, la fondation de l'universalisme* (Paris: Collège International de Philosophie/PUF, 1997), p. 11.

20. This was a famous cry from the May '68 barricades. On the revolutionary groups see the collection by Guy Debord, Mustafa Khayati, René Riesel, Raoul Vaneigem, and René Vienet, *Enragés et situationnistes dans le mouvement des occupations* (Paris: Gallimard, 1968; rpt. 1998).

21. Voice from the film *For Ever Mozart*, written and directed by Jean-Luc Godard, 1996 (35 mm, 84 min.).

22. Guy Debord, *Commentaires sur la société du spectacle* (Paris: Éditions Gérard Lebovici, 1988), pp. 18, 19.

23. Guy Debord's cinema is therefore antirepresentational—he rejected the cinema as a "factory of dreams" but, and this is equally significant, neither did he consider the possibility that the camera can reproduce reality. Thus the hybrid sophistication in the structure of his films and their peculiar impersonality, due on the one hand to their appropriations, and on the other to the combination of appropriated and truly personalized material. Through sophistication (not technological; this is far from "special effects"), he responds with hurried montage and a simultaneity of stimuli that risk a global impossibility of reading (so that each reading can be a rereading); a "sea of images" (and texts) is summoned to create an anticinema, in a magma of contradictions in which a voice-over confirms and denies what we see, and ultimately what we see is the transfiguration (and not merely the "recontextualization") of what we saw elsewhere (see Debord's short text, "Note sur l'emploi des filmes volés," in *In girum imus nocte et consumimur igni, suivi de Ordures et décombres* [Paris: Gallimard, 1999], pp. 65–7). It is a game of the unconscious: we know we have seen it but we don't remember where or when. When in the film *In girum imus nocte et consumimur*

igni we see the arrival of the U.S. Cavalry (a sequence appropriated from Michael Curtiz's *Charge of the Light Brigade*) and we hear a voice-over saying, "A beautiful moment, in which the order of world is under attack," we are at a crossroads. It is clear that the image is not confirmed by the voice and the text. However, at the same time, the opposite is not totally true; we cannot say that the image and the text are absolutely separate (Debord has said that this sequence is a homage to the Situationist International). The richness of these images (with their intervening captions) and of the battle scene lies in their ambiguity. This moment accurately represents Debord's aspirations regarding the recurrence of familiar and available media and materials. We are faced with a labyrinth of remissions. The arrival of the army allegorizes the assault on an existing order (the text says as much), inasmuch as the army, a military institution, is the guarantor of that order. A subtext is destroying the image: the energy of rebellion placed in a hypothetical "attack on the world order" is equivalent to the "conservative" energy of the charge of the army. The image is more than decontextualized beyond recovery; it could, for example, be a brigade of rebel soldiers, obeying the rigorous principles of strategy (strategy is not the same as discipline). In the context of the film, and for a particular group of viewers, the image is the energy of an assault against a "world order." For others, it signifies the preservation of that order by force. Those who see the film will develop their own reading. It is many things at once, and without a doubt there is a certain irony, the labyrinth apparently has no exit. Irony and strategy seem to be two essential elements to understand either this cinema or Debord the thinker.

24. See Giorgio Agamben, "Repetition and Stoppage: Guy Debord's Technique of Montage" (1995), in *Documenta X, Documents 2* (Ostfildern-Ruit: Cantz, 1996), pp. 68–75.

25. See Giorgio Agamben, *Means without End: Notes on Politics,* trans. Vincenzo Binetti and Cesare Casarino (Minneapolis: University of Minnesota Press, 2000), pp. 71–72.

26. Agamben, "Repetition and Stoppage," p. 70.

27. Reference to Jean-Paul Sartre, *L'être et le néant. Essai d'ontologie phénoménologique* (1943; reprint, Paris: Gallimard, 1991).

28. Massimo Cacciari, *The Necessary Angel,* trans. Miguel E. Vatter (Albany: State University of New York Press, 1994), p. 39.

29. Ibid., p. 43.

30. Plato, *Cratylus* (360 B.C.E.), trans. Benjamin Jowett, on <http://ethics.acusd.edu/books/plato/cratylus/plato_cratylus.htm>.

31. Cacciari, *The Necessary Angel,* p. 45.

32. Walter Benjamin, *The Origin of German Tragic Drama* (1925; reprint, trans. John Osborne, London: NLB, 1977), p. 36.

33. Johann Wolfgang von Goethe, "Reflections and Maxims," in *Criticisms, Reflections, and Maxims of Goethe,* trans. W. B. Rönnfeldt (London: Walter Scott Ltd., n.d.), p. 162.

Autonomy, Nostalgia, and Globalization: The Uncertainties of Critical Art

Gabriel Peluffo Linari

> Modern criticism was born from a fight against the Absolutist State, but has resulted in a group of individuals re-reading other people's books.
>
> Terry Eagleton, *The Function of Criticism*

1

In 1963, Rubert de Ventós wrote of "self-absorption in art." Seen within the perspective of the twentieth century, this characterization is nothing new, nor was it then. What Ventós registered was an increasing awareness of a final crisis in the aspirations attributed to art as an active agent in the social and cultural transformations of modernity, and the consecration of the limits of this art in the process of its own discursive and institutional autonomy. This awareness, developed above all in the 1970s, has been accompanied by one of the more common assertions of postmodernity: the absorbing and neutralizing power of late capitalism.

Self-absorption implies endogamy, and therefore a certain inefficiency of art to relate to social life and to comment critically on historical processes. Nonetheless, the modern concept of the "autonomy of the artistic sphere" from this moment on seems to change in meaning. First, we are witnessing a recognition that the codes of understanding and legitimizing art are no longer a continuous narrative monopolized by a hegemonic

gaze. This self-absorption becomes—paradoxically—a condition of openness to the intersection of visions and languages being continually reworked in different parts of the world. Also, although art as an institution maintains or accentuates the concentration of power within restricted circuits, these same circuits become more complex as intercultural artistic practices increase. This change does not imply a denial of the criteria of legitimation and cultural appropriation that the hegemonic powers have always managed. Instead, the critical strategies of art and the position of the artist with regard to the new conditions of power have been modified as a result of the increasing cultural permeability of the system.

Even in the case of international Latin American events, for example, in which the presence of critics from various locations provides a new "horizontal" exchange among our countries (and among the countries and their diasporas, wherever they may be located), we are still haunted by a model of values whose visual and conceptual habits are deeply connected to the criteria of legitimation operating in the hegemonic centers.[1] This is not a cause for alarm, but a fact of the global reality that should be used strategically in different local contexts.

Terry Eagleton also speaks of this tendency to self-absorption, in the sense of self-validation and self-consumption of critical thought and discourse.[2] Could this tendency be a modality adopted by this discourse to perpetuate itself, but now without its aspiration to be an active moderator between personal text, great humanist narratives, and the historical experience of a social collective? What is more, seen from the perspective of the academic institution, the very definition of this collective tends increasingly to be reduced to the exclusive group of each intellectual. Such exclusivity also occurs in other sectors of society, especially with artists. Among artists we see—in the rare case in which they come together—the formation of ephemeral groups, in which members share certain types of cultural complicities—icons, habits, gender, sexuality—that make these groups true communities of meaning, albeit for a short period. Today's society, more than ever, is evidence of this "society of remnants," or rather this *kaleidoscopic* structure, which is never static, but always in dynamic transformation.

But let us return to the self-referential condition that is as essential to art as it is to contemporary cultural criticism. If, as Eagleton asserts, cultural criticism has been absorbed into cultural industry as part of the needs of any industrial project, something similar has occurred within art, although there the risk is less the association with this industrial project, and more its absorption into national and transnational marketing strategies.

Therefore, to what extent can we speak of a "critical function" in contemporary art, when both concepts (art and criticism) have been blurred and devalued within the framework of a public sphere exposed, through the market, to the erratic logic of financial capital and of consumption as a fundament of identity?

Despite these difficulties, it seems possible that contemporary art can develop critical and counterutopian strategies to face the state of *realized utopia* that has emerged through euphoric global consumption. Within each conformist and uncritical person who follows the rhythm of the culture of the new world order, there lies a hidden "utopia-other" who believes in infinite technological development associated with financial capital, and in the salvationist mission of the free market.[3] This person sees no difference between utopia and reality. Utopia is real, utopia *is* reality and the only possible alternative; this view leads us dangerously to the most conservative sacralization of the present, also in art.

Several theoretical positions concerning this area postulate that critical thought should take advantage of the terribly faulty situation in which we live. They suggest that we should exploit its dead ends in one of several ways: through ambivalence, repositioning, or various types of negotiation.[4] This proposal is born of the fact that, from the late 1970s through the early 1990s, art—and here I am referring primarily to the art and culture of Latin America—has gone through a very significant change. Whereas art in the 1960s was still essentially *pontificatory* (which was to be expected from an art that positioned itself nationally and internationally using the aesthetic-political strategies of the Cold War), there was a shift in the late 1970s toward an *articulatory* discourse, in which local and global situations were mediated. This mediation has led to a greater awareness of specific human and cultural contexts, in which art can intervene in microsituations of everyday life by finding transitory alliances with other areas of knowledge and social representation.

I would like to underline the conceptual shift from a *representation of politics in art* to *the politics of representation through art* because this is what made possible a new convergence, for example, of art, anthropology, and politics in the 1980s and 1990s. In other words, this process allowed for a reevaluation of social contexts no longer understood as stagnant containers of essential values from the past, but now seen as processes of adaptation, juxtaposition, and recomposition that accompany not only human migrations, but also the social fragmentation created though marginalization, repression, and genocide in Latin America.

However, this shift has a double function: on the one hand it involves a process in which art can manifest itself in specific situations, in strategies of memory, and in

rupturing interventions in everyday life. But on the other hand, its inscription into a globalizing system demands a certain complicity with the evaluative parameters of that system. In other words, the need for a conceptual self-absorption and discursive abstraction can threaten the possibilities for a local connection. By "local," I do not necessarily mean a geographical location, but a characteristic social-cultural place from which the artist can design his or her own strategies of production, and with which he or she can maintain an active dialogue.

This feeling of local belonging is important in the construction of identities today, not so much for any radicalized essentialism (although we must note that often such essentialism is there), but for the potential to generate exchanges with different and parallel notions of place. In other words, the ability to create "translocal cultures," to use James Clifford's term.[5]

2

To analyze the potential persistence and actualization of a critical component in our cultural production through the 1990s, we should look beyond the internal structure of artistic discourse. Cultural production depends above all on the communicational circuit, that is to say, the institutional web through which it circulates, and in which this production can develop roots. It also depends on the social space that this art can generate, or that the art in some way nurtures.

What we need today—although the idea may appear ambitious or against the grain—is to socialize the artistic experience; not in the sixties' sense of "bringing art to the masses" (something that many others have done successfully), but rather in the sense of socializing new constructs of meaning at a microgroup level through representations that can provide frames of reference to necessarily changing and unstable imaginaries.

Faced with the new cultural conditions that arise from the globalization of markets, we need—also through art—to socialize a critical awareness of *action in the world,* a critical awareness that asks itself in which world and from which place to act (and again I insist that I do not mean "place" only as geographical location, but as a mental territory constructed in ideological and cultural terms). However, without a specific institutional structure that can transfer into art the meanings of individual experience in the community and vice versa (in other words, an institutional structure that can incorporate the material and theoretical production of art), the promotion and configuration of emergent art forms will remain almost exclusively subject to market tendencies and strategies.

Beyond the informational updating that every artist needs regarding what is taught, thought, and produced in the world, we must reformulate the local-regional institutional infrastructure to establish an active network between political, artistic, curatorial, and historiographic practices. The Latin American curator must have an ideology based on these other three areas of social practice. The possibility that art in this new world can adopt the cultural critical meanings it had under different historical conditions is no longer a question merely of aesthetics, the invention of new "languages," but rather of discursive strategies that are necessarily encompassed within institutional structures, with their own cultural politics, defined from the margins. This is why the encouragement of a critical art practice in our countries implies the creation of institutions that start to activate a local and regional social dialogue in this field, locating the symbolic production of art in concrete issues of identity and collective imaginaries, whose flexibility to change is part of the necessary reconstruction of our social bodies.

The conquest of these institutional spaces is the first gesture toward a critical strategy for contemporary art, a strategy that in Latin America cannot tend toward the reformulation of the institutional field of art as an end in itself, but as an end toward the reconstruction of the public sphere as an area of social integration, in an especially fragile moment of our so-called liberal democracies.

3

I am from a subregion of the continent known as the Southern Cone. There is a latent imaginary that recognizes a predominantly European ethnic-cultural composition in this region, which makes it a kind of pivot not so much between the European and the Latin American, but rather between the "authentic" European and the European-*Criollo*.[6] The geographical triangle of the Southern Cone, with its incisive apex, has a peculiar symbolic force that was materialized in Torres-García's 1935 cartographic version (or rather, inversion) in which he reversed the map and proclaimed that "Our North is the South," thus establishing an "other-place" from which to reformulate the gaze and discourse of modern art. Nonetheless, the power relations that currently control contemporary art, added to the international social mobility in the continent (including North America), make it impossible to speak of the Southern Cone, or any other subregion of the globe, with the same redemptory confidence in the subversive and messianic potential of geography shown by Torres-García. Our current cultural problem is how to establish a dynamic web between local memories and the dislocation of the contemporary world, which would lead us to a repositioning, as I said earlier, of the relations between political, artistic, and historiographic practices.

The image of the Southern Cone as an area of cosmopolitan modernity coincided historically with an image of the Oriental Republic of Uruguay that was fairly representative of that supposed universalist vocation. According to the Mexican José de Vasconellos, who visited the Río de la Plata region in 1923, Uruguay was North American in foreign policy, British in business, and French in culture. In fact, the Uruguayan government had supported U.S. intervention in Mexico, had opened its doors to the British railroads, and in 1850 gave grants to the last three remaining indigenous chiefs to visit the Museum of Anthropology in Paris, where they remain to this day.

A highly integrated country, Uruguay had the fantasy of being a small laboratory for universal culture. This imaginary of a "model country," developed for over fifty years, was erased by state violence in the 1970s and was never recovered through the neoliberal project. Since the final years of the military dictatorship in the early 1980s, we Uruguayans have increasingly been engaged with the question of who we are collectively beyond our historical, geographical, and political condition, after the radical break in social memory caused by the military coup, and through our continuing national functional and symbolic crisis. This question became obsessive in the 1990s as the debates on cultural identities (ethnic, labor, social, gender, etc.) emerged in the new spaces of power.

The most notable discursive axis in Uruguayan art since the mid 1980s thus has been that of memory: social memory as a victimized body, the reconstruction of a critical memory, the reconfiguration of the boundaries between public and private memories, and even the ironic negation of collective memory, a syndrome of the cultural parricide characteristic of many who grew up during the military dictatorship (1973 to 1984). In art, the space for memory is presented, above all, as a territory of ethical negotiations appropriate to the development of a cultural critique from artistic production. Rather than taking the subject of memory as a theme, Uruguayan art of this period treats it as a place from which to install a gaze, resulting in a zone of articulation between very diverse discursive languages and strategies.

It is worth noting that this gaze is also contradictory, with two antithetical agendas at work: on the one hand, a desire to recover a lost utopian-critical horizon; on the other, a resignation to the inevitability of dystopia.[7] Both attitudes result in an artistic practice that tries to construct identity from an imaginary negotiation between collective memory, autobiographical memory, and social heterotopy.

This multiplicity of personal conducts corresponds to a division between individual and collective destinies, in other words, to the tendency to disconnect "personal cures" from "social cures" (to paraphrase Joseph Beuys). Let us not forget that in most of our countries, the "social cure" consists of a collective clarification of the civil wars and

state terrorism. When this does not happen, sooner or later we face a pathological balkanization of the cultural field, which can lead (together with other social factors) to individual alienation, even while living within a collective. This autobiographical introspection by artists has been very significant, as has the need to separate the personal existential sense from the historical collective one during the 1980s and 1990s.

The political repositioning of memory in the art of the 1990s began to feel somewhat lacking by the end of the decade. Right now we are witnessing a difficult discursive move in the art of our region (and particularly in the case of Uruguay) away from referents of memory and toward strategies of insertion into the global world. In other words, there is a movement from iconicity to ubiquity, or from the shelter of old common identity referents to the symbolic uncertainty contained in individual insecurity and in contemporary social and cultural mobility. This shift is born of a critique of nostalgic and essentialist constructs of identity, while artists search for operative strategies to transform them. We could also define it as a shift from *enunciation* to *discursivity,* from *representation* to *strategy.*

Thus, nostalgia is no longer a useful tool for the critical function of art. Graffiti on the walls of Montevideo sums up this exasperating phenomenon in a perfectly postmodern-conceptual manner: "Nostalgia isn't what it used to be."

translated from the Spanish by Gabriel Pérez-Barreiro

Tijuana, 1999

1. Gerardo Mosquera, "El síndrome de Marco Polo," *Lápiz* (Madrid), no. 86; and "Power and Intercultural Curating," *TRANS>arts, cultures, media* (New York), no. 1 (Spring 1995).

2. Terry Eagleton, *The Function of Criticism: From "The Spectator" to Post-Structuralism* (London and New York: Verso, 1996).

3. Franz Hinkelamert, "El falso realismo de la utopía neoliberal," *Brecha* (Montevideo), 10 December 1993.

4. Ticio Escobar, "Los parpadeos del aura: Consideraciones sobre ciertos apuros de la crítica actual," in Kevin Power and Fernando Castro, eds., *Diálogos Iberoamericanos: Continente de crisis y promesas, puzzle no resuelto* (Valencia: Generalitat Valenciana, 2000). "Acerca de la modernidad y del arte," in Gerardo Mosquera, ed., *Adiós identidad. Arte y cultura desde América Latina* (Badajoz: MEIAC, 2001).

5. James Clifford, *Itinerarios transculturales* (Barcelona: Gedisa, 1999), p. 18.

6. *Criollo* in Spanish has a slightly different meaning from "Creole" in English. *Criollo* refers to a Latin American of peninsular Spanish descent. During the colonial period, the *criollos* largely comprised the local ruling class. [Translator's note.]

7. Adriana Bergero, in Adriana Bergero and Fernando Reati, eds., *Memoria colectiva y políticas de olvido: Argentina y Uruguay 1970–1990* (Rosario, Argentina: Ediciones Beatriz Viterbo, 1997), p. 78.

When Was Modernism in Indian Art?

Geeta Kapur

> The innovations of what is called Modernism have become the new
> but fixed forms of our present moment. If we have to break out of the
> non-historical fixity of *post*-modernism, then we must search out and
> counterpose an alternative tradition taken from the neglected works left
> in the wide margin of the century, a tradition that may address itself not
> to this by now exploitable because inhuman rewriting of the past but,
> for all our sakes, to a modern *future* in which community may be
> imagined again.
>
> Raymond Williams, *The Politics of Modernism*

Material Conditions

Taking the cue from Raymond Williams's "When Was Modernism?," we need to reiterate that we in the Third World continue to commit ourselves to the immanent aspect of our complex cultures. We persist in trusting the material status of meaning manifest, in Williams's words, as a "structure of feeling."[1] We commit ourselves to relating forms of art with social formations, for this kind of a grounded relay of cultural history will help the process of survival within the new imperialism that the late capitalist/postmodern world sets up.

Whatever the chances of that survival, modernism as it develops in postcolonial cultures has the oddest retroactive trajectories, which make up a parallel aesthetics. It is crucial that we do not see the modern as a form of determinism to be followed, in the manner of the Stations of the Cross, to a logical end. We should see our trajectories crisscrossing the Western mainstream and, in their very disalignment from it, making up the ground that restructures the international. Similarly, before the West periodizes the postmodern entirely in its own terms and in that process also characterizes it, we have to introduce from the vantage point of the periphery the transgressions of uncategorized practice. We should reperiodize the modern in terms of our own historical experience of modernization and mark our modernisms so that we may enter the postmodern at least potentially on our own terms.

Modernization in India is a real if incomplete historical process. Dating from the British colonial enterprise, the process dovetails with the efforts of the postindependence Indian state to establish, through a large public sector and a planned economy, a balanced growth of industry. Despite the nomination of postindustrial societies as global arbiters in the management of capital, the process of industrialization is still in progress in this predominantly agricultural country, because, it need hardly be said, class politics is still relevant in India. The communist movement in India supports the irreversible project of modernization with a reasonable, secular nationalism. It also supports the struggles of religious minorities and of women. The left fronts in India, given the growth of fundamentalist reaction, may now be the only organized movements to speak the language of modernity. To the First World, this may seem paradoxical: in a postmodern world where not only cultural initiative but even the historical modern is taken out of the hands of Marxism, it may be worth recalling these forceful anomalies in the developmental process of the Third World. Here indeed the modern continues to be placed nowhere more correctly than along visibly socialist trajectories.

Modernity is a way of relating the material and cultural worlds in a period of unprecedented change that we call the process of modernization. It is also an ontological quest with its particular forms of reflexivity, its acts of struggle. Modernity takes a precipitate historical form in the postcolonial world, while its praxis produces a cultural dynamic whereby questions of autonomy, identity, and authenticity come to the fore. These are desired individually but are sought to be gained in collectivity. Even the tasks of subjectivity, so long as they are unresolved, require acts of allegorical exegesis—often via the nation. There is a chronological fix between nationhood and modernity so that both may stand in for a quest for selfhood. Ever challenged in the postcolonial world,

modernity continues to provide a cutting edge; it marks necessary historical disjunctures in the larger discourse on sovereignty.

The characteristic feature of Indian modernism, as perhaps of many postcolonial modernisms, may be that it is manifestly social and historical. But Western modernism in its late phase is not the least interested in this diachronicity and opposes it in the name of a *sublimity of the new*—or, to put it another way, by a hypostasis of the new. Consider the high modernist argument as it shifts from Clement Greenberg to the postmodernist Jean-François Lyotard. When late modernist art is not metaphysically inclined, it is, as we know, absolutely formal. Late modernism finds in the work of Greenberg a peculiar cathexis in and through sheer opticality. Lyotard in turn prefers epiphany to materiality and process and thus leaves out historical representation, considered to be too grossly accountable within something so local and involute as national cultural identity.[2]

Given this obstacle course of history, it is possible to argue that Indian artists have only now become fully modern—in what is characterized as the postmodern age. I mean "fully modern" in the sense of being able to confront the new without flying to the defense of tradition; of being able to cope with autonomy in the form of cultural atomization by invoking *and* inverting notions of romantic affiliation. That is to say, the mythology of an indigenous "community" and the lost continent of an "exile"—both alibis borrowed from the grander tradition of the romantic—are allowed to shade off into the current form of identity polemics. This already mature modernism means accepting the "dehumanization" and decentering of the image. It means being self-conscious through an art-historical reflexivity; that is, through overcoming the anxiety of influence by overcoming the problem of originality itself. In a country like India with its cultural simultaneities, its contradictory modes of production, it is not surprising that modernism should have been realized through the promptings of postmodernism. For, in economic terms, modernization declares its full import when it comes to be propelled by global capitalism.

This development is not unrelated to the fact that India is now, after five decades of protective nationalism, opting for integration in the world economy via what is called liberalization—the stage and style of capitalism that the International Monetary Fund and the World Bank dictate to the developing world. It is an internationalism under duress, in that its first condition is the delinking of growth from any form of nationalism. With this precipitate internationalism, the Indian artist is now, for the first time, shocked out of the nationalist narrative of identity that makes certain overt demands for

authenticity in the existential and indigenous sense. The very achievements of the modern Indian artist can begin to appear too conscientious: first, because they are secured by forms of realism instituted like a reverse mirror image within the modern; second, because this euphemistic modernism keeps in tow a notional ideal of a people's culture. Folk/tribal/popular art becomes a heritage that can stand in for, even usurp, the vanguard forms of the modern.

As the national/modern moves in tandem into the late capitalist age, this double bind of authenticity is virtually abandoned. The grand narrative of civilizational transformation that haunts the progressive sections of the Indian modern now appears to the younger generation of Indian artists as simply anomalous. Not so surprisingly, they echo Lyotard who, in a rhetorical manner, designates realist criteria as pernicious.[3] Even if Lyotard's moves are equally pernicious to our cultural considerations, it is possibly true that these older terminologies of representation and identity connected with the modernizing function have become seriously problematized. Moreover, by maintaining, even in rhetoric, the notion of a people's "authentic" culture, we may jeopardize avant-garde interventions based on surreal and other subversions. So that indeed one might ask again: *when,* if the avant-garde has been thus blocked or deferred or deviated by what one may call the national cause, was modernism in Indian art?

The Politics of Modernism

The "when" in the title of this essay is of course polemically placed. It refers to a period of self-reckoning locked in with a commitment to collective social change. It refers to the project of figuring subjectivity as a locus of potential consciousness. The "when" is a site of vexed doubling within colonial/postcolonial identity and the permanent ambivalences that it launches.

The painful debate on identity, nowhere more viscerally handled than by Frantz Fanon,[4] is a debate within the modern consciousness at the last juncture of decolonization when the question of freedom is lifted out of an existential universalism and cathected upon the subordinated yet intrepid body-presence of the "other." A condensed unit of humanity drawn from an overwhelming demographical explosion caused by the emergence of the colonized people, this other displaces the safe space occupied by the pristine self in Western ontological discourse. The entire Western project for authentic being thus comes to be historicized differently in the moment of decolonization. Identity is seen not simply as a rational individuating project within the

utopian plenitude of romantic community; it also involves reclaiming the ground lost (or never found) in history, the ground where the self may yet recognize itself in the form of a collective subject.

The debate on how to politicize one's otherness seems now to be given over to a politics of negotiation. It remains to be seen how a further project shall be set up to match that moment of modernity when a reflexive and revolutionary critique of its own deformities can still be mounted. The chips are down and there has to be some way, a political not a countermetaphysical way; there has to be an alternative project whereby this nonidentity between the self and the other, which was once a call to rewrite history, has to be given a function larger than that of differential play. Or, that play itself has to gain a praxiological motive through a cultural avant-garde.

In the postcolonial dialectic of modernity, the term "avant-garde" is often subsumed by the term "progressive," which refers more properly to the debate on realism/modernism. That is why I begin with Raymond Williams. But when realism turns rigid, it is worth recalling with Fredric Jameson that the modern itself had a politicality far greater than we are taught to recognize.[5] Jameson notes the persistent use of the vocabulary of political revolution in the aesthetic avant-gardes that complemented, perhaps even compensated for, the deep subjectivity to which modernist works were committed. That subjectivity itself prefigured a utopian sense of impending transformation where society was seen to be moving toward a greater democracy.

This politicality is worth remembering because there is a further case for reinforcing the fact in non-Western societies where the modern, occurring in tandem with anticolonial struggles, is deeply politicized and carries with it the potential for resistance. Such resistance is progressive as also polemical, so that there is a tendentious angle on modernity within our cultures, whether they draw out theories of domination/subordination from the subaltern point of view (after Antonio Gramsci), or build an identity politics in a rhetorical mode (after Frantz Fanon). Indians have, in addition, a profoundly paradoxical entry into the modern: the entire discourse against the modern (after Gandhi) gives us another utopian option to consider, one which is in its own way a negative commitment of tremendous force in the achievement of modern India.

The discrepancies in the stages of capitalist development in India remain so huge that the modern is charged with strong anomalies. Modernization, both desired and abhorred throughout the nationalist period, was continually contested even during the postindependence leadership of Jawaharlal Nehru. Indian modernity is often quite circumspect, mediated as it is to a point of handicap by negative evaluations of the very practice that it is evolving.

A further question is what categories Indian modernism adopts. Is it the aristocratic/high art category or the more historicist one found in modernism's conjuncture with realism? Or does Indian modernism satisfy the condition of romantic radicalism in its bid to align with the "liberating vanguard of popular consciousness"?[6]

The moderns anyway stage a mock confrontation between the mandarins and the Luddites, a tantalizing play between the classical and the popular, which is worth our while to consider. More specifically, the modern period cherishes great artists who, as Fredric Jameson suggests, are seen to be holding over some archaic notions of aesthetic production, a handcraft aesthetic within a modernizing economy, and in the process valorizing perhaps for the last time a utopian vision of a more human mode of production.[7] This tendency is especially true for Third World cultures. In India primitive techniques, artisanal skills, iconographic references are much valorized; and the modern, comprising the indigenous and the avant-garde, has a two-way relay and a paradoxical politics.

There was of course a strictly left-wing intervention in the process of defining Indian modernity. A movement charged with a radical popular consciousness provided, through the 1940s—a period when the communist movement posed a real alternative in political and cultural terms—the ground for a great many innovations in theater, cinema, literature, and to a lesser extent the plastic arts. I am referring to the Indian People's Theatre Association (IPTA), which broke away from the innate conservatism of a civilizational discourse.[8] IPTA broke with the brahminical/sanskritized resources privileged as the Indian tradition and thereby gave the emerging *tradition of the modern* in India the possibility of *not* being trapped in the citadel of high art. However, even though "the people" are invoked in the discourse and practice of Indian left-wing movements in the arts through their very forms (especially in theater) and through their participation as an alert audience, the Indian left produced its own conservatism, even an incipient Stalinism. Something like a slogan of "national in form, socialist in content" is built into the program. Thus while it is modern and in the Indian context also avant-garde, the movement represented itself as realist and progressive and tilted the definitional balance of Indian modernism. This emphasis obviously prevented it from trying out more daring formal innovations.

Caught in the Cold War division between freedom and commitment during the first decade of independence, the progressive movement tended, as it proceeded, to ground aesthetic discourse. For, if in the heyday of socialism we did not designate art practice in avant-garde terms, we cannot in postmodern times so readily invent a vanguard discourse that has an appropriate historical import. We should have to use the

term "radical" rather than "avant-garde," but do we thereby scuttle the diachronic model with free signifiers; do we beg the question of modernism itself?

Indian Modernism

If Indian artists have often appeared to be hamstrung over the progressivist as against "correctly" modernist definition of modernism, if they have seemed to be stuck at the crossing-over, it is not so surprising. They are living out the actual material transition, as can be illustrated by summarizing the history of the modern in Indian art.

Indian artists have been tardy in making a direct avowal of modernism. They have moved on from the sceptical position held by Ananda Coomaraswamy and Abanindranath Tagore through the first three decades of the twentieth century to a more complex engagement that was developed in Rabindranath Tagore's university at Santiniketan, and taken over at different levels of complexity by Nandalal Bose, Ramkinkar Baij, and Benodebehari Mukherjee since the 1930s. Precisely at this juncture a modernist vocabulary was introduced in several brave gestures, building upon initiatives of the preceding half century that had laid down propitious ground for modernization. A rural boy in Tagore's Santiniketan, Ramkinkar Baij, introduced with reckless optimism a postcubist expressionism and through that means openly valorized primitive/peasant/proletarian bodies, giving them an axial dynamic. He thereby sought to bring through the ruse and reason of indigenous subject matter a methodological shift in constructing the image.

This was differently taken up by Jamini Roy in Calcutta during the 1930s. Roy "objectified" the tradition by bringing the question of folk iconicity and urban commodification face-to-face. Exactly at the same time an alternative arose in the form of the interwar realism initiated by the part-European, Paris-trained artist Amrita Sher-Gil. With her intelligent masquerade as the oriental/modern/native woman, she gave to this emerging modernism a reflexive turn. She died suddenly in Lahore in 1941, in the same year as the octogenarian savant Rabindranath Tagore. By then Indian art had begun to pose considerable formulations on modernism.

A flamboyant form of cultural symbiosis was enacted by the Bombay-based artists in the late 1940s. The Progressive Artists' Group, initiated in 1947 by the Goan-born Francis Newton Souza, brought Maqbool Fida Husain, Sayed Haider Raza, Krishnaji Howlaji Ara, and, of course, Souza himself into quick prominence. Alike in their youthful poverty, they represented, quite significantly, a cross section of religious, class, and caste backgrounds, and they offered distinct motifs to designate their sense of

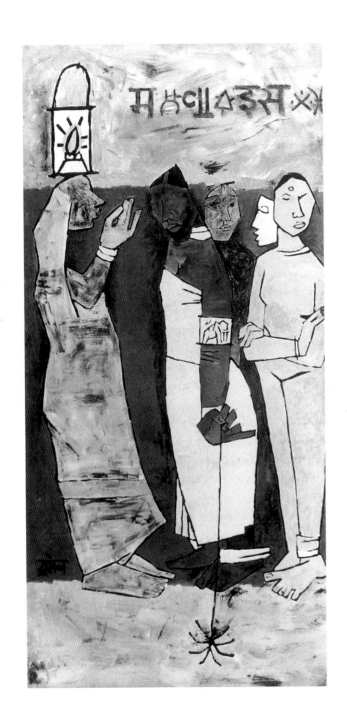

M. F. Husain, *Between the Spider and the Lamp*, 1956, oil on board, 244 × 122 cm. Collection of the artist, New Delhi.

identity and dispossession. As a group they pitched into the heroic narrative of modern art and produced a formalist manifesto that was to help the first generation of artists in independent India to position themselves internationally. Several artists' groups claiming to be modernist came into existence during the 1940s and 1950s in Calcutta, Bombay, and Madras. Of these the Bombay Progressives achieved, in the first decade of independence, a "properly" *modernist* stance.

The two enactments of modernism are seen developing together in India. In the romantic antecedents of that term, the heralds and witnesses to social change ought to be carrying the flag of modernization (and thus also of modernism), which includes expressionist realisms of different shades. Thus in India that position was maintained until the early 1960s by Maqbool Fida Husain, K. C. S. Paniker, the Mexico-trained Satish Gujral, and Ram Kumar, who was briefly inspired by the French left. Just as artists with a commitment to social transformation set the terms of revolt each in his or her context of community or nation, the outriders created the necessary disjuncture: the artists who established themselves in India became cultural emblems within a progressive national state, and those who left for Paris and London became equally emblematic outsiders of modern fiction. They embodied the modernist impulse of choosing metropolitan "exile"—the first criterion of modernity, according to Raymond Williams.[9] Like hundreds of struggling artists in Paris and London, these early "settlers"—prominent among them Souza and Tyeb Mehta in London, and Raza, Akbar Padamsee, and Krishna Reddy in Paris—celebrated their solitude, their radical estrangement, and the immanent "truth" of art language, to become the first heralds of internationalism in India.

The premise of international art was not of course innocent of ideology. Even as it led the nonaligned movement, India stood closer to the Second World than to the First and the West continued to be marked as imperialist, however alluring its cities, its citadels of modernism, may have been for Indian (and myriad other) artists. The older imperialist markings were transferred to the postwar United States where, as we know, it had become ideology proper. From the boldly original and freedom-loving artists grouped together as American abstract expressionists, the American cultural establishment elicited the slogan of cultural "freedom" vis-à-vis the socialist bloc. In the bargain, New York with its immense energy won the day even over the erstwhile Parisian fix. Those who had been part of the School of Paris, among them some of the best Indian artists of the 1950s, turned sympathetically to New York in the 1960s. They gained a fresh painterly ground and the poetics of an authorial gesture.

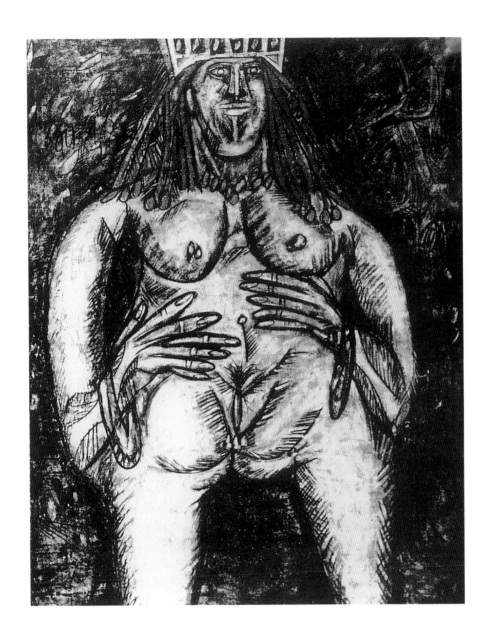

F. N. Souza, *Nude Queen,* 1962, oil
on canvas, 110 × 90 cm. Private
collection.

At the ideological level, one may add that the U.S. agenda to export cultural freedom came to India late. Fellowships for artists' residencies in New York were made available in the 1960s and 1970s to well-known Indian artists by the John D. Rockefeller III Fund as a kind of postscript to its blatant strategies of intervention in Latin America; and the American side was highlighted by Clement Greenberg's visit to India in 1967 when he accompanied a large official exhibition of modern American painting sent by the Museum of Modern Art, New York. But the ideology as such did not make headway because of the nationalist self-regard persistent among even the most international of Indian artists.

Meanwhile there was a divergence in the Indian art scene itself. A generation of Indian modernists came to be attracted once again to a European—more precisely Italian and Spanish—rather than an American aesthetic. Artists like Jeram Patel, J. Swaminathan, Jyoti Bhatt, Himmat Shah, and Ambadas responded to the informal aesthetic (of Antoni Tàpies, Lucio Fontana, Alberto Burri, for example), and this showed up in the *Group 1890* exhibition of 1963. The exhibition manifesto was written by Swaminathan and the catalogue was introduced by Octavio Paz, then Mexican ambassador to India. The attraction of the eleven-member Group 1890 to material/ritual/occult signs reissued the modernist enterprise in the coming years. It came to be situated with peculiar aptness in a visual culture of iconic forms still extant in India. This indigenism produced a playful modernist vocabulary replete with metaphorical allusions, such as in the work of Nagji Patel. But the surrounding rhetoric of Indianness also grew apace in the 1970s and 1980s. It acquired official support both in the National Gallery of Modern Art and the Lalit Kala Akademi, with artists like Gulam Rasool Santosh gaining national status. This institutional aesthetic tended to short-circuit some part of the enterprise, leaving a pastiche in the form of an overtly symbolic art proffered as "neotantrism."

One is tempted to plot a tendentious narrative of oriental transmutation from the 1960s through 1980s: to show how the Parisian aesthetic was surmounted by the hegemonic American notions of freedom in the matter of world culture, how these ideas were questioned by the liberationist rhetoric of the Latin world, and how all this contributed to form a distinct (rather than derivative) entity called modern Indian art. And how it acquired a national seal. For at the level of painterly practice, many tendencies were recycled within the Indian sensibility. Exuberant forms of abstraction blazoned forth in Raza, Ram Kumar, Padamsee, and V. S. Gaitonde. Abstract artists of the erstwhile Group 1890 and the so-called neotantrics held sway, especially the freer among them like K. C. S. Paniker and Biren De, who contributed a subliminal, even ironic

V. S. Gaitonde, *Untitled*, 1974, oil on canvas, 177 × 101.5 cm. National Gallery of Modern Art, New Delhi.

symbolism. At the same time, the work of artists with an informal sensibility, like Mohan Samant and Bal Chhabda, surfaced. Finally, artists with an indelible *écriture* shone out: I am referring to Somnath Hore's inscription in paper pulp of the social wound, and Nasreen Mohamedi's capture of private grace in her ink and pencil grids.

These complex developments are only noted here to fill out the contours of the larger narrative of the modern. By 1978, when the relatively old-style modernist Harold Rosenberg was invited by India to sit on the jury of the Fourth Triennale India, the more

Nasreen Mohamedi, *Untitled*, 1986,
pencil and ink on paper, 27 × 34 cm.
Collection of Rukaya Dossal,
Mumbai.

strictly modernist style in Indian art, especially abstraction, was on the wane. Rosenberg
saw what he was to describe in his generously mocking manner as a "much of a
muchness" of representation by younger artists. He was referring to artists positioned
against modernist formalism: late expressionists with a social message, and artists trying
to tackle the problem of reification in art language and the objects/icons of late
modernism who had moved into popular modes and narratives, turning objects into
fiction, icons into discourse.

Narrative Extensions

Noting that an interest in allegory had developed across the board but especially in the
Third World—from Gabriel García Márquez to Salman Rushdie—Fredric Jameson
provides an ideological twist to the impulse:

> Fabulation—or if you prefer, mythomania and outright tall tales—is no doubt
> a sign of social and historical impotence, of the blocking of possibilities that

leaves little option but the imaginary. Yet its very invention and inventiveness endorses a creative freedom . . . agency here steps out of the historical record . . . and new multiple or alternate strings of events rattle the bars of the national tradition and the history manuals whose very constraints and necessities their parodic force indicts.[10]

During the 1970s, not only Third World writers but also filmmakers and artists moved into magical realism, courting narrative abundance for deterministically motivating desire. In India this form of quasi-historical representational practice led equally deterministically to a variety of social realisms featuring artists as varied as Krishen Khanna, A. Ramachandran, Gieve Patel, and Bikash Bhattacharjee. By the end of the 1970s an affiliation was formed with what was at the time the School of London after R. B. Kitaj—anathema indeed to Paris and New York but seen by several Indian artists of this generation as an antidote to the formalist impasse of late modernist art. This move also tried to take into account the lost phases of twentieth-century art: Mexican muralism, German new objectivity, American regionalism—that is to say, all those artists left in the wide margins of the twentieth century that a too-narrow definition of modernism ignores. This was the virtual manifesto of the 1981 exhibition *Place for People*, featuring Bhupen Khakhar, Gulammohammed Sheikh, Jogen Chowdhury, Vivan Sundaram, Nalini Malani, and Sudhir Patwardhan.

The narrative move activated the strong traditions in Indian art itself, including its revived version in the nationalist period. At this juncture K. G. Subramanyan, the wise and witty father-figure linking Santiniketan with Baroda, took up genre painting (on glass) as a form of parody of the high modern. Parodying as well the ideologies of the popular, he slipped over the cusp—beyond modernism—and made a decisive new space for Indian art. This space was extended by subversive tugs in social and sexual directions in the hands of an artist like Bhupen Khakhar. A regionalism developed in Baroda and combined with the urban realism of Bombay. A representational schema for cross-referencing the social ground was realized. A reconfiguration also took place of the realist, the naive, and the putatively postmodernist forms of figuration. Indian art, even as it ideologized itself along older progressivist terms, came in line with a self-consciously eclectic and annotated pictorial vocabulary.

If we argue that Indian efforts at finding an identity were reinforced by a kind of ethnographic overspill into fabulous narratives and new ideologies of narration, it can also help position the interest in pictorial narration of Indian contemporary art during the 1970s and 1980s in a more provocative stance. To the traditions of K. G. Subramanyan

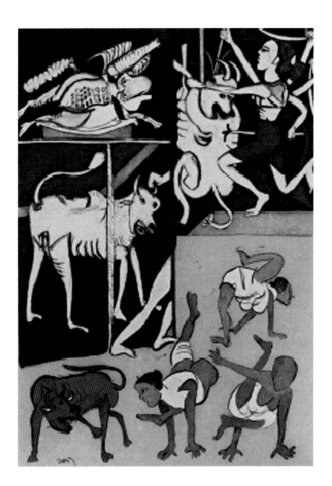

K. G. Subramanyan, *Training for a Bullfight*, 1986, reverse painting on acrylic sheet, 85 × 59.5 cm. National Gallery of Modern Art, New Delhi.

and Bhupen Khakhar add Gulammohammed Sheikh, and we can see how these artists moved via pop art into a representational excess of signs to renegotiate several traditions at once. The intertextuality of their images, the art-historical references, the popular idiom serve as a more confident avowal of a regional and properly differentiated national aesthetic. Art language now affirms its multivalence, opening up the ideology of modernism to the possibility of alternative realities. By its transgressions, what is retroactively called the postmodern impulse opens up the structure of the artwork, too neatly placed within the high culture of modern India. The new narrators rattle the bars of national tradition and let out the parodic force suppressed within it.

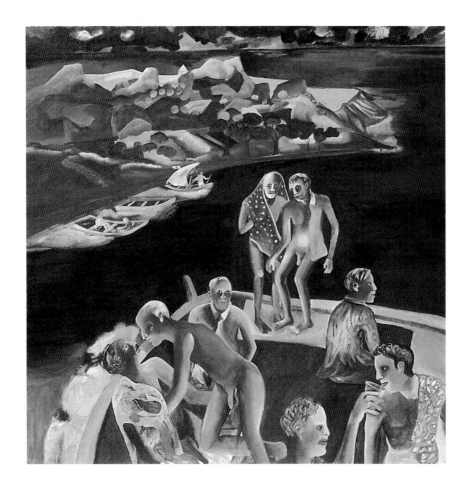

Bhupen Khakhar, *In a Boat,* 1988, oil
on canvas, 170 × 170 cm. Private
collection.

During the 1980s a number of Indian artists assumed the authorial confidence
to handle multifarious references, to deliberately disrupt the convergent philosophy and
language of Indian modernism. Prominent among them were female artists of a
figurative turn: Arpita Singh, Nalini Malani, Madhvi Parekh, and Nilima Sheikh were
active in the 1980s; Anupam Sud, Arpana Caur, and Rekha Rodwittiya reinforced the
turn. These artists introjected a subjectivity that is existentially pitched but does not
devolve into the currently celebrated schizophrenic freedoms. Gender interventions have
come to mean that the narrated self is inscribed into the social body through allegorical
means with a secret intent that exceeds its textual character. For there is always in our

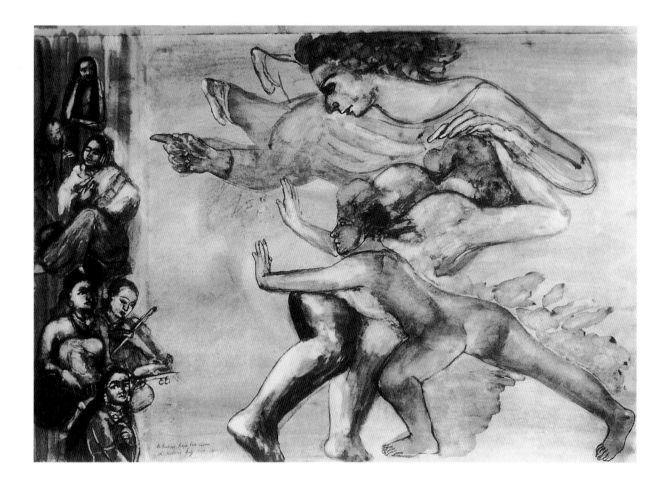

Nalini Malani, *Re-thinking Raja
Ravi Varma,* 1989, watercolor on
paper, 51 × 74 cm. Collection of
Shikha Trivedi, New Delhi.

unresolved modernity and in our postmodern retroaction the haunting need to release a
repressed consciousness and, in the case of the more politically inclined artists, to
introduce a mode of intervention.

Postmodern Pros and Cons

The adventures of the aesthetic make up one of the great narratives of
modernity; from the time of its autonomy through art for art's sake to its status
as a necessary negative category, a critique of the world as it is. It is this last

moment (figured brilliantly in the writings of Theodor Adorno) that is hard to relinquish: the notion of the aesthetic as subversive, a critical interest in an otherwise instrumental world. Now, however, we have to consider that this aesthetic space too is eclipsed—or rather that its criticality is largely illusory (and so instrumental). In such an event, the strategy of an Adorno, of "negative commitment" might have to be revised or rejected, and a new strategy of interference (associated with Gramsci) devised.[11]

Such an avant-garde form of interference was most nearly attempted in India by the Indian Radical Painters' and Sculptors' Association (1987–89). This was composed of young Kerala artists—like Alex Mathew and the charismatic K. P. Krishnakumar, who committed suicide in 1989—who were affiliated for the most part with ultraleft groups in a province of India frequently governed and consistently influenced by the communist movement. Their mode of intervention and how they pitched themselves into the practice and discourse of radicalism make an exemplary story of the end of the modernist project.

It is often argued that the antiaesthetic in the modern-postmodern conjuncture suits the Third World very well. This is the position of the Third World cinema protagonists, the crisis in modernism itself being attributed to revolt by cultures outside the West. Black ideologues and feminists also have found the possibility of conceptualizing a far greater degree of freedom through an understanding of postmodernism, through an understanding of the operations of power in relation to which their own art activity is inevitably positioned. The task of the politically inclined artist is precisely to make this conjunctural moment more profoundly ironic; to once again question the existential status, the indexical ramifications of signs in the politics of our times. This has to do, as Hal Foster points out, "with a critical deconstruction of tradition, not an instrumental pastiche of pop or pseudo-historical forms, with a critique of origins, not a return to them. In short it [postmodernism] seeks to question rather than exploit cultural codes, to explore rather than conceal social and political affiliations."[12]

At this point it becomes more than a polemical strategy to say that the advent of the postmodern brought a release of new productivity in India and that it provided a relief from Indian modernism's developing according to its so-called inner logic. It is worth noting, therefore, that this entire discourse might mean something quite precise within a continuum of Indian art: strongly imagist and almost always covertly symbolic, Indian art may already have come into crisis through the too easily assimilated modernist principle of metaphoricity. Since the pop divide took in surrealism and dada—specifically

their critique of representation and reification—the image has been questioned persistently (by the forms of theatricality in minimal art, for example, and by the "idea" in conceptual art) in the West. Not so in India. It is worth asking whether our own fixation with the past as image, with the heavy claims for cultural condensation, does not now require an urgent sorting out of the oversignified image. This is where the sculptor N. N. Rimzon, by positioning an iconic image that is in its contemplative mode *reflexive* rather than contestatory in relation to India's "high" culture, may offer a relevant hermeneutic.

But the postmodern aesthetic now plays with the image of images, the simulacrum—it plays through parody and pastiche. With the market entering Indian art practice on an institutional plane, the factor of commodification is firmly on hand. In fact Indian artists may be nearer than they know or acknowledge to postmodernist kitsch through "instrumental pastiche" and exploitation of "cultural codes." In India, now, one may find a mock-surreal confrontation between the protagonists of the real as against those of the simulacra over the live body of the modern—a confrontation to claim the very sublime that Lyotard attributes to the postmodern avant-garde.[13] All avant-gardes have to take account of the market now; all art practice has to reckon with forces that sully the sublime. For this reason, in place of Lyotard's illusory account of transcendence, the term "interference" may be more accurate.

For myself, I hope to find affinities for Indian art beyond the simulacra and toward a historically positioned aesthetic. There is a strong chance of this possibility: if postmodern art, preferring the spatial over the temporal dimension, produces a flattened version of time and narrative, a cut-out image of the contemporary without its historical referent, there is already in Indian art an appreciation of these problems by artists like Nalini Malani and Vivan Sundaram. Such artists are attempting a radically different structuring of the part to the whole so that the different ordering of the relationship between metaphor and metonymy is worked out as a form of "cognitive mapping."[14] They seek a utopian vision to be articulated and critiqued by allegories that go beyond the overworked ground of mythopoetic symbolisms favored in indigenist versions of modern art. The immense imaginary, always seductive to the Indian psyche, is now consciously transfigured into open structures, paradoxical signs.

The cue for a complex handling of the postmodern may come, more than anywhere else, from cinema. The cinema of Kumar Shahani, for example, uses the fictive device of epic narration not only to keep a hold on history, on the dimension of time and memory that the postmodern age is determined to displace; it also poses the question

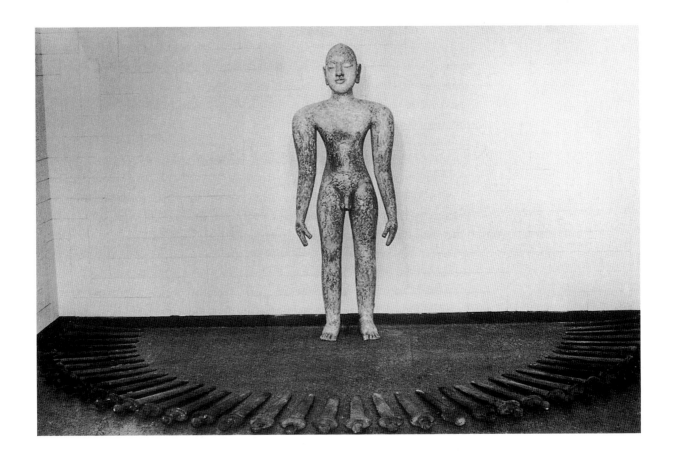

of aesthetics and reification within the narrative itself. The conditions of hypostasis are staged precisely to resist the unadmitted stasis of the commodified image. Thus the image that Shahani so sumptuously nurtures as a cinematic privilege, or rather as cinema's privileging of the imagist realm that constitutes the unconscious itself, this image is made profoundly ironic in its very beauty in films such as *Tarang* (1984) and *Kasba* (1990).

Ground Realities

At this juncture I would like to *reverse the argument.* Having gone through the logic of art history in an optimistic mode—anticipating further complexities within what I called the modern-postmodern conjuncture—I believe it is worth asking whether all questions

N. N. Rimzon, *The Inner Voice,* 1992, resin fiberglass, marble dust, and cast iron; height of figure 207 cm, diameter of arc 456 cm, each sword 71 × 17 cm. Fukuoka Asian Art Museum, Fukuoka, Japan.

of aesthetics might not be mocked out of discussion at the level of ground realities and in the current play on lifestyles as differential culture. The postmodern has as many cosmopolitan conceits as the modern ever had and requires over and above that a command of technology and media and of international market transactions far exceeding the modern. We do not, in the Third World, have command of the mechanisms that may be used to undo the terms of this reified culture which offers so many seductions. We do not even have the backing of the historical avant-garde that Europe conceived as its dialectical method for battling reification and other vagaries of capitalist culture.

The political discourse of the postmodern promises to undo the totalizing vision of the historical universe and, with that, the institutionalizing of the modern. But it subsumes nevertheless the politics of actual difference based on class, race, and gender into a metadiscourse of the "one world order" rivaling, despite its protestations to the contrary, any global hegemony sought or established by the modern. This postmodernism supersedes the kinds of cultural praxis historically possible in different parts of the world to such an extent that one might say that *our* cultures in the Third World do not at the moment stand a chance. Thus the cultural manifestations of the postmodern may be something of a false gloss on the hard facts of the political economy to which these are related.

All this is further contextualized by the fact that India has now been pulled into the logic of multinational capitalism, a fact only lately declared and now openly celebrated. The Indian government now puts out posters showing a great elephant breaking free of his chains. Whether the elephant is the people, the nation, the state, or the big bourgeoisie is not clear, but perhaps that is the whole point. There is this deliberately conflated representation of an Indian identity hitherto signified entirely, even defensively, in nationalist terms, terms that are now seen as fetters.

The government of India has accepted "solutions" for its economic crises in full accord with global prescriptions for "stabilizing" the less developed countries, when in fact the experience of a majority of the countries that have accepted "structural adjustment" packages has been disastrous.

What metropolitan capital demands via the IMF and the World Bank . . . [is] an "open-door policy," namely that it be treated on a par with domestic capital itself, which inevitably entails encroaching upon the latter's extant economic

territory. The transition demanded and enforced is not one from Nehruvian state intervention to an alternative regime of state intervention in favour of domestic monopoly capital, as in the case of the metropolitan economies, but to a regime of state intervention in favor of monopoly capital in general, both domestic as well as foreign, in which the foreign element inevitably constitutes the dominant component.

We thus have a switch: of the state acting as a bulwark against metropolitan capital . . . getting transformed into a defender of its interests against the domestic working masses.[15]

What we are doing under the tutelage of the International Monetary Fund and the World Bank involves not only antipoor, proconsumption policies but also the virtual surrender of national sovereignty (which is operable only on the basis of a welfare state). It predicates surrender on all fronts including the basic right inscribed in every anti-imperialist and nationalist agenda: the right to make our own economic laws. The specific pressure by the United States (via GATT and Intellectual Property Rights legislation) commoditizes all knowledge. Discussion of the cultural logic of late capitalism thus has to be contextualized so that the new imperialisms are kept fully in sight. For whether or not nationalism as such can be upheld any longer, the new globalism has to be seen for what it does. It seeks the disintegration not only of socialism but also of postcolonial national formations.

Ironically, even contemporary radicals will say that what is happening to the Indian nation is what ought to happen to national formations in good time: they must break up to give long-needed space to new social movements, to subaltern groups and their struggles. The entire discourse from the liberal democratic to the radical is now, especially after the defeat of socialism, arraigned against large collectives, against the national, against the nation-state. It is as if the nation-state presents an even greater danger than imperialism as such. This, however, is far from the historically experienced truth of colonial and postcolonial nations, especially as the neoimperialism of the West is happy to let reactionary nationalisms thrive—on the basis of fundamentalism, violence, territorial fracture.

Even as all categorization is now ranged on the level of majority and minority communities, all discourse proceeds thereon—as a politics of communitarian difference. Within the First World plurality is nothing more than liberal tolerance and neoethnicity

is another face of antisocialism. It needs to be said that painfully wrought nations in the Third World cannot be subsumed in that discourse. We are beginning to be taught the lesson that religion and its call for difference, even in a democratic country like India, can quickly bring us to the brink of fascism—precisely, perhaps, if we capitulate on the national. Whatever else it may have failed to achieve, the national is still constitutionally (and experientially) predicated on modern, secular values and produces, therefore, a democratic polity.

Metaphoric Recall

Not so long ago socialism, its history interwoven with that of bourgeois culture and therefore with modernity, transmitted strength and hope from its different registers of radical opposition. Without the socialist narrative and without national allegories, what will sustain a symbolic order of collectivities in our imagination? And how shall we oppose the collectivities forged in the name of the holy by the religious bigots of the day? Nationalism along with socialism may for the moment be a lost cause, but as for the more dangerous forms of totalization—racism, religious fundamentalism—these grow apace and will not be contained by postmodernism's preferred metaphors of schizophrenia, the unassimilable feature of nihilist freedom. The terror of religious revivalism is very real. However, when the East is demonized, it should be placed face-to-face with the rise of reactionary conservatism, indeed of neofascism in the West and the terror that it spells. With the politics of emergent ethnicities, with the noncontextual appropriation of traditions and the obscurantism of religious militancy, we are increasingly held to ransom by a fundamentalist or racial consciousness.

In an age of political retrenchment it may be useful to place nostalgia for socialism to the fore and designate it as properly symbolic. There is good reason to recall that the modernist project was engaged in an affirmative act of desacralization; it was engaged in a decoding and a secularization of works of the past and the present. This fact is of the greatest importance in evaluating the significance of that modernism.[16]

In India for the moment it looks as though there is a modernism that almost never was. The more political among Indian artists may be right after all in believing that the as yet unresolved national questions may account for an incomplete modernism that still possesses the radical power it has lost elsewhere. Positioned as an intrepid form of the human, signified in an order of verticality, Picasso was thus introduced into the arena of the modern by John Berger: as a vertical man.[17] Despite this male imagining of the modern, it may be useful to place, like an Archimedean point, a stake on an

anthropomorphic truth of the modern revolution. For the Indian artist, this stake is beyond irony and also beyond the proclaimed death of the subject. Mapping the chronological scale of realism/modernism/postmodernism onto the lived history of our own deeply ambivalent passage through this century, we may find it useful to situate modernity itself like an elegiac metaphor in the "new world order."

Slovenia, 1998

Notes

This essay was first presented as the Ashby Lecture "When Was Modernism in Indian/Third World Art?" at Clare Hall, University of Cambridge, in 1992. It was also presented that same year at the conference "Theories of the Visual Arts," organized by the Institute of Higher Studies in Art, Caracas. Earlier published versions appeared in *South Atlantic Quarterly* 92, no. 3 (Summer 1993); and in *Journal of Arts and Ideas,* nos. 27–28 (May 1995). The present revised version was taken from Geeta Kapur, *When Was Modernism: Contemporary Cultural Practice in India* (New Delhi: Tulika, 2000).

1. See Raymond Williams, *Marxism and Literature* (New York: Verso, 1977), pp. 133–34.

2. See Clement Greenberg, *Art and Culture* (Boston: Beacon Press, 1965); and Jean-François Lyotard, *The Postmodern Condition: A Report on Knowledge* (Manchester: Manchester University Press, 1986).

3. Lyotard, *Postmodern Condition.*

4. The following discussion takes off from Homi Bhabha, "Remembering Fanon: Self, Psyche, and the Colonial Condition," in Barbara Kruger and Phil Mariani, eds., *Remaking History* (Seattle: Bay Press, 1989).

5. Fredric Jameson, *Postmodernism, or, The Cultural Logic of Late Capitalism* (London: Verso, 1991), p. 311.

6. Raymond Williams, *The Politics of Modernism: Against the New Conformists* (London: Verso, 1989), p. 35.

7. Jameson, *Postmodernism*, p. 307.

8. Information on the IPTA is available in *Marxist Cultural Movement: Chronicles and Documents*, compiled and edited by Sudhi Pradhan, published by Mrs. Pradhan and distributed by Pustak Bipani, Calcutta, 1985.

9. Williams, *Politics of Modernism*, p. 34.

10. Jameson, *Postmodernism*, p. 369.

11. Hal Foster, ed., *The Anti-Aesthetic: Essays on Postmodern Culture* (Port Townsend, Wash.: Bay Press, 1983), pp. xv–xvi.

12. Ibid., p. xii.

13. Lyotard, *Postmodern Condition*, p. 77.

14. Jameson, *Postmodernism*, pp. 417–18.

15. Prabhat Patnaik, "A Note on the Political Economy of the 'Retreat of the State,'" in *Whatever Happened to Imperialism, and Other Essays* (New Delhi: Tulika, 1995), p. 206.

16. See Jürgen Habermas, "Modernity—An Incomplete Project," in Foster, ed., *The Anti-Aesthetic*.

17. John Berger, *Success and Failure of Picasso* (Harmondsworth: Penguin, 1965).

Vanguard of the Middle Way

Chang Tsong-zung

If one looks back to the beginning of the twentieth century, when the crusade for modernity started, it seems as if the key to understanding contemporary Chinese art still rests in issues arising from the radical change of worldview: from a coherent, traditional cultural world into the modern age. I should like to argue that, at least until the early 1990s, Chinese avant-garde art, or radical art, has not been truly subversive, in that it shared a similar worldview with the status quo and served a sociopolitical function in the enterprise of modernization. My question is: What is the visual marker of the transition to "modernity" of China's visual culture? One revealing area to look at is the visual language of power; in this area, China has undergone a radical change from a word-based culture to one based on figurative icons.

Until the arts were "secularized" after the death of Chairman Mao in 1976, they formed an integral part of the state machinery in communist China. The state dictated the purpose and subjects of art. After 1976 artists slowly developed in directions that reflected personal sentiments not bound by government policies; the more radical among them subsequently evolved into what was later called the Chinese avant-garde. The importance attached to radical artists has mainly been based on the assumption of their role as voices of social conscience and as critics against prevalent state ideology. However, the fact that they have not posed a real threat to the status quo, while providing a voice for the disenfranchised, suggests that the phenomenon of radical art serves a function

within the workings of the government. This is a social function comparable to, say, that of the institution of monasteries in imperial China, in that it provides a safety valve for an otherwise airtight ideology (for example, the literati often used the term "escape into zen" when wishing to avoid the turmoil of politics). Casting a glance back to "revolutionary" art of Mao's era, and seeing it as a historical precursor of the avant-garde, perhaps enables us to find a place for radical art's spirit of transgression in the workings of state ideology.

For state ideology to work, elements of incongruity have to be allowed to propagate. Inherent in an efficient ideology are elements of transgression, necessary for maintaining its human dimension. A famous case is Mao's love poetry: instead of diminishing his godlike image, it endeared him to the masses. True believers are often dangerous to a totalitarian system, as they push it to a logical absurdity. The most fully integrated ideologue is probably one who believes he can maintain a wider vision by keeping a foot outside the door. I am not claiming that radical artists are ideologues, but that their significance can be measured by seeing how they integrate with the Chinese schema. Within such a context the articulations or fantasies of art make visible the desires underlying a culture; but ultimately one must also rely on true art to explode such myths and secret fantasies.

One perfect example of a true believer was the soldier martyr Lei Feng, cited in schoolbooks. However, communist China could not work with too many Lei Fengs; Lei Feng had to die to become a martyr and a saint because he was too naive. By contrast, secret service chief Kang Sheng, a cynical intellectual with a deep attachment to traditional culture, who cleverly played the game and maintained a double life as a Marxist and a literati connoisseur, became its most efficient cadre. By the same token, Chairman Mao himself was the perfect ideological convert. Radical art maintains a distance from the explicit symbolism of state ideology, but in many ways it has helped to make this ideology current by providing the complex ironic dimensions that must be acknowledged to make any ideology credible.

My premise is that radical art has, until recently, shared a common worldview with the status quo, not in doctrinal ideology but in the "ideology" of modernity. Through this ideology the spirit of iconoclasm and fervent belief in the future have come together both in politics and art (remember that "to progress from backwardness" has been China's motto throughout this century). The most memorable spectacle of the Cultural Revolution (1966–1976) to an observer was not the "revolutionary" violence and

upheaval but the theatricality of it all. Violence was meted out to the accompaniment of the "model" operas, festive campaigns for "going down into the countryside," colorful parades, plus all the song and dance that went with it. Apart from practical political ends, in many ways these celebrations parodied traditional village festivals, suggesting festivities surrounding the changing of seasons, signifying the forward march of time. The cyclical return of seasons was replaced by endless political movements, marking the irreversible march of history. In the 1980s, when Chinese intellectuals seized upon radical art as the emblem of the new era, what was most emphasized was the spirit of "dispassionate reason" and "ultimate concern" (the terms that came to represent the spirit of the '85 New Wave and the '89 Avant-Garde). On the surface the new art movements aimed to correct the damaging fervor of revolutionary zeal; in effect, they furthered the old underlying message of progress and modernity. The iconoclasm of the avant-garde was celebrated to sustain the myth of China's revolution by supplying it with a new narrative. The "perpetual revolution" advocated by the gospel of Maoism was easily overwritten by a new narrative of the avant-garde rebellion, in agreement with many artists' simplistic view of the Western avant-garde as a succession of revolts each usurping its predecessor (see *Meishu Xincaho* 1984–1989 for examples).

Another point of comparison is that, like Marxism, the authority and weight of authenticity of this new faith came from foreign Western sources, power to be admired, absorbed, and shunned. The spirit of the time was very much about renewal and consolidation. In the 1980s, national purpose was very much on the mind of the intellectuals as well as the masses, and conscientious intellectuals were on the search for a new future. While art and politics in Mao's years were conducted like public religious campaigns, subsequent radical art usurped the role of intellectual pioneers until 1989. With its high profile among cultural circles, radical art became the spectacle that illustrated the transgression that inadvertently validated China's ideology of revolution, rather than challenging its assumptions. This revelatory function also makes radical art valuable in the study of China's modernity, in that artworks illustrate in concrete images and symbols the desires and fantasies underlying China's pursuit of "modernity."

In the exercise of power, state censorship is an expression of endorsement as much as of repression. It is important to note that in the years before 1989 radical art was not banned or hounded. Radical and orthodox artists in fact coexisted under the same shelter of establishment: art academy, art magazines, and even government stipend. Censorship and restrictions exercised by the government did not restrict the creativity of

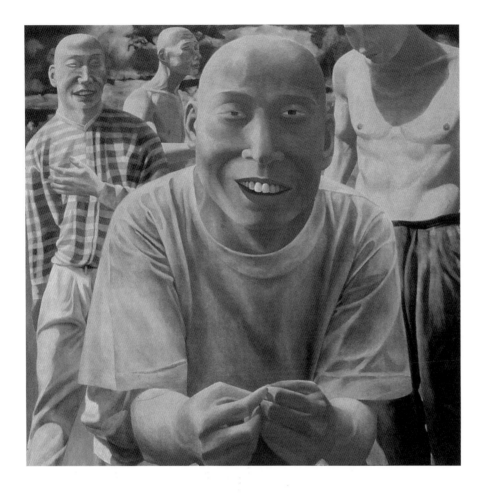

Fang Lijun, *Series II, no. 1*, 1991–92,
oil on canvas, 200 × 200 cm.
Courtesy of the artist.

the avant-garde as much as contain it within parameters of safe interpretation. On the
contrary, being frowned upon by the government gave the avant-garde its credibility.
To this day the government continues to be more wary of art's critical writings and
exhibitions reaching the public than of the art itself.

 After the Tiananmen crackdown in 1989, the edict of silence in the early post-
1989 years changed the nature of radical art. While state censorship can equally be an
expression of endorsement as of repression, true censorship only comes from rendering
certain issues unspeakable. Radical art was suddenly thrown out of the discourse of

power, lifting from its artists the burden of history. The often noted cynicism and lightheartedness of the post-1989 artists reflect this state of weightlessness. (In terms of sexual dynamics, the repression making law—and art—possible had previously been replaced by the artists' sense of historical burden, a burden that became a sort of perverse pleasure. The edict of silence removed this repression but at the same time drove art into the realm of unanchored libidinous fantasy, which best illustrates the structure of desire constituting the ideology of modernity.) Another feature of the post-1989 period was the revival of Mao's icon through pop language. Since all reinterpretations in fact validate their subject and bring it up-to-date, Mao in pop style should probably be interpreted as a true reassertion of this icon of authority in reaction to the sudden loss of orientation during the post-1989 period, rather than as a cynical debunking of state authority.

The crisis of the post-1989 years was a crisis of the hitherto unquestioned worldview: a view that lauded progress and the march of history as the new ideology of China. In this light, radical art of the 1990s truly plays out fantasies informed by the desires that constitute a state ideology no longer regulating itself according to the machinery of repression. On the other hand, a radical critique of China's modernity is still not under way. This would have to come from a different frame of reference. It is worthwhile to ask how a critique of modernity would be expressed in art. At this point, there have been curiously few radical artworks referring to prerevolution, premodern China in a meaningful way, even though the great upheaval for the nation was exactly that fundamental change from traditional China to the modern age. Why has the loss of that world not interested the artistic community? The reason is probably that there has been such a fundamental shift in the Chinese value system that the measure for loss and gain also became lost in the confusion. As a result, artists lack both a proper way to measure this loss and appropriate forms of articulating it. This is perhaps why there is no true critique of the nature of Chinese modernity in contemporary art. As a consequence, art tackling the theme of history has often turned premodern days into a haze of clichés. (A typical example would be the Central Art Academy version of Chinese beauties in the style of European classical portraiture.)

For a critique of modernity in art, perhaps we should first ask, what marks "modernity" in visual culture? One important point of comparison between the old and new worldviews is the way in which political authority is portrayed. To look at this I wish to isolate two themes in art: the human figure and the written word.

In modern times, one of the most striking changes in China's visual culture has been the rise of the figurative image as the symbol of power. Traditionally, political power had always marked its presence by writing. Imperial presence was made through the

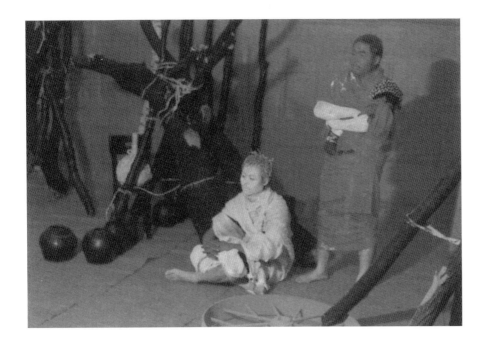

Song Yongping and Song Yonghong, *Experiences of a Certain Day*, 1989, photograph. Courtesy of the artists.

emperor's own calligraphy rather than his pictorial image or sculpture. Furthermore, most public art incorporates writing: poetic names over archways, commemorative plaques, engraved colophons, etc. Today the reverse is true. The pictorial image, especially the human figure, is now predominant. This change in the representation of power in visual culture marks a radically new worldview, in turn marking "modernity." In the 1990s, changing views in contemporary art showed a systemic breakdown of the human figure, which we may interpret as signifying changing attitudes toward China's modernity.

Western figurative painting in the spirit of nineteenth-century realism was finally accepted into China's newly founded art academy in 1928, and of course the message of this turn in artistic taste was part of a new love affair with the sciences, positivist science being at the root of the authority of artistic realism. By the same token realistic portraiture carried with it the message of "modern" power and authority. The use of iconic portraits of political leaders started in the republican days of the 1910s and reached a climax with Chairman Mao in the 1970s. In the 1980s the art academy style heralded a return to a form of European classicism (which is represented by the Central Art Academy), while radical art pursued different courses. Overall, in the 1980s the

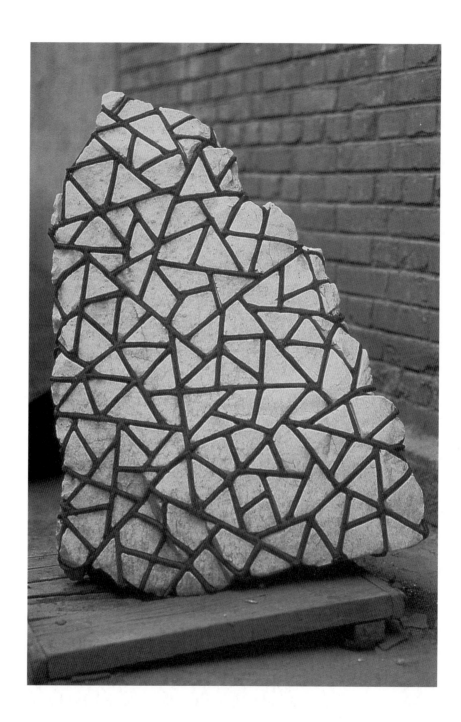

Sui Jianguo, *Bound Structure*, 1991,
marble and iron, 94 cm high.
Courtesy of the artist.

human body was presented intact, whether in the style of expressionism, surrealism, or late Malevich. In the 1990s, the depiction of the human body widely showed disintegration, especially internal disintegration.

We may go back to the 1980s to look at a striking recurrent theme, images of bondage. This is a concrete image of the eroticization of power through repression, a parody of the power structure. Bondage was shown in performances as well as in paintings (for example, Kang Mu, Zheng Yuke, and others' performance *Concept 21* on the Great Wall in 1988; and Song Yongping and Song Yonghong's performance *Experiences of a Certain Day* in 1989). The theme refers to manipulation and control, but it is also about wounding and healing. White cotton gauze wrapping a body suggests both wounded and healing skin, while the underlying message is still the wholeness of the body. In the post-1989 art of Sui Jianguo's bound rocks, bondage has similar signification. It is interesting to note that in recent years this artist has started to make metal sculptures of "Mao" jackets, but without the man inside. In spite of the absence of the figure, the stiff metal jacket exudes material presence (hence power), sitting like a coat of armor. Sui's reason for selecting this jacket was that he wanted to find an image that represented modern China. The absent figure, like the broken Venus de Milo, gains eminence as it invites fantasy, the icon of power reborn. In comparison, clothes as the metaphoric outer skin are also obvious in the plastic opera costumes of Wang Jin. Like a looming ghost of the past, the absent body lacks the monumental power of Sui's "Mao" jacket. Clinically artificial, the plastic skin tempts one to read it as China's old ghost.

An obsession with skin diseases and questionable body surfaces started to become popular among younger artists in the mid 1990s. Usually bright and cheerfully colored, these disgusting, rotting details are turned into neon-glazed visions of humanity. The development of painter Liu Wei makes an interesting illustration: he started with caricatures of relatives and friends in the early 1990s, and went in for explicitly erotic women painted with a mischievous naughtiness, as though it was all tongue-in-cheek. Then his paintings became overrun with body parts gone wild with corpuscles and growths, suggesting internal diseases, which at the same time froth with liquid that suggests both sex and illness. The video artist Zhang Peili in 1996 also made a video work showing close-ups of hands scratching indeterminate body parts.

Alienated into isolated sensory experiences, the physical body has obviously gone wrong and become problematic. Localized diseased patches replace bodily wholeness in the works of many young artists. On a more cerebral level, Qiu Zhijie's work questions the uniqueness of the individual as he blends into the social and physical world

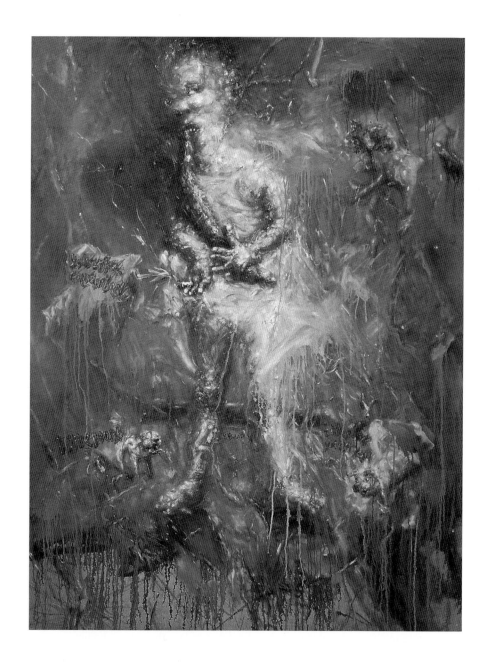

Liu Wei, *Standing Baby Boy,* 1995, oil
on canvas, 100 × 50 cm. Courtesy of
the artist.

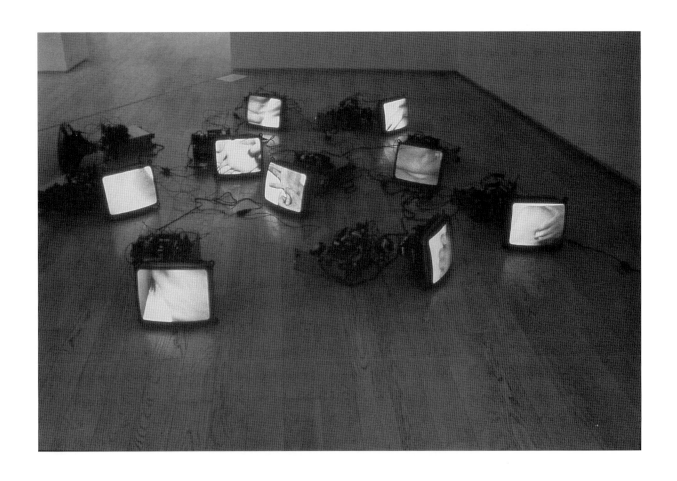

Zhang Peili, *Uncertain Pleasure*,
1996, video installation. Courtesy of
the artist.

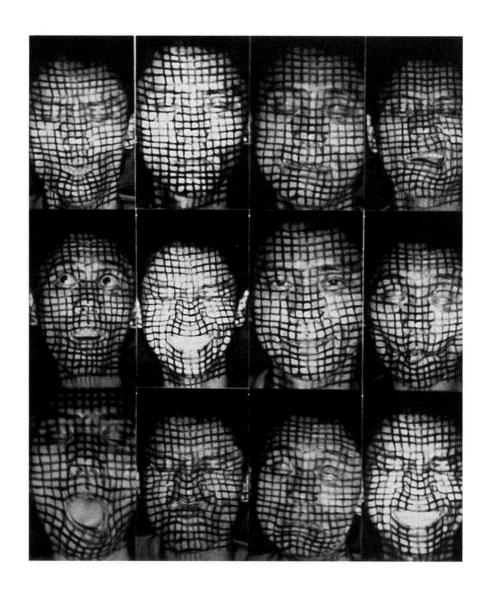

Qiu Zhijie, *Washroom,* 1997, video
installation. Courtesy of the artist.

around him. The undaunted glare at disgusting aspects of the biological has gone so far that a Beijing exhibition in December 1998 even included an installation showing a baby's and a man's face touching intimately, lying on a large bed of ice; it was lyrical except for the fact that the two were actual corpses taken from the mortuary. At the end of the century the human figure, which conquered China's visual culture, has started to disintegrate, no doubt spurred on by increasingly more frequent exposure to the international art scene since the mid 1990s.

When the theme of words appears in Chinese art since 1989, what is most interesting is how writing is used to explicate power. The best-known artists using the Chinese written word are Xu Bing, Wu Shanzhuan, and Gu Wenda. While Wu parodies public political language with everyday proclamations, in Gu's and Xu's works power is realized through the removal of textual meaning. The materiality of words is explored for its sense of power, either as otherworldly apparition (Gu) or as the enigmatic materiality of history and knowledge (Xu). The power of the written word, removed from its role as a signifier, can also be read as blind power without meaning: that is, power alienated from its historical and cultural roots. It is useful here to compare work by Gu and Xu with that by two "outsider" artists. Hung Tung's paintings are related to magic writing, in which the objective world is translated into wordlike pictures. The other "outsider," King of Kowloon, has been writing graffiti texts on the street for forty years, claiming areas of the city as his territory, pronouncing at every corner his imperial genealogy. Coming from the fringe of society, these texts illustrate an instinctive use of Chinese writing as an instrument of power, either for territorial claim or for connection to the supernatural. Conversely, we should also read in all these four artists a message of loss and disenfranchisement, because the claim to power is empty, pointing to a void.

In this respect the 1997 work by Xu Bing, *Square Word Calligraphy,* seems to be a curious and ingenious reply to the displacement of China's word culture. His famous *Book from the Sky* showed seemingly readable books when they were in fact unreadable. This recent work reverses the perspective. Here the seemingly unreadable is in fact in the English language "sinicized" into "Chinese" script. Xu is now in the process of developing this writing into a computer font, to be available for commercial consumption. This humorous gesture of reaching out to the "real" world, of playing the subversive, completes the message. The gesture is a tacit acknowledgment of the subordinate position of China's "square word" culture, and yet in knowing its position it has found a way to transcend its subordination and become radical.

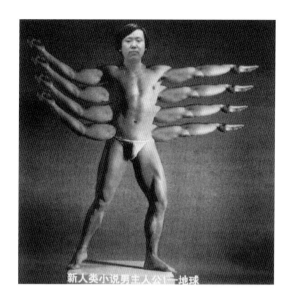

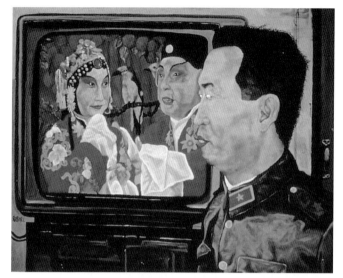

Huang Yan, *New Human Being,*
photograph. Courtesy of the artist.

Liu Wei, *Spring Dream in a Garden,
Dad in Front of the TV,* 1992, oil on
canvas, 80 × 100 cm. Courtesy of
the artist.

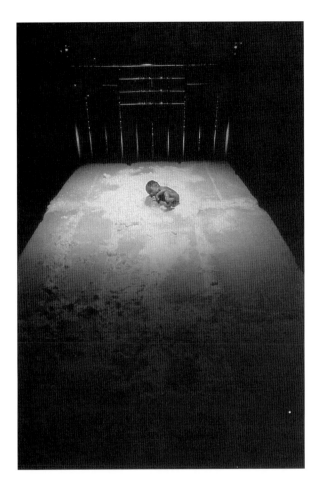

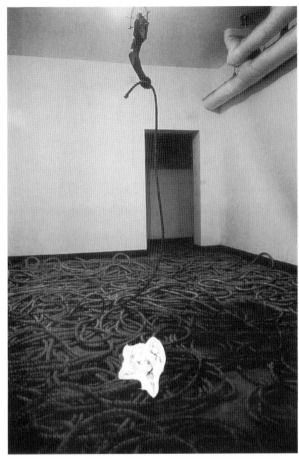

Sun Yuan, *Honey*, 1999, installation,
150 × 300 cm. Courtesy of the artist.

Zhu Yu, *Theologie Portative*, 1999,
installation. Courtesy of the artist.

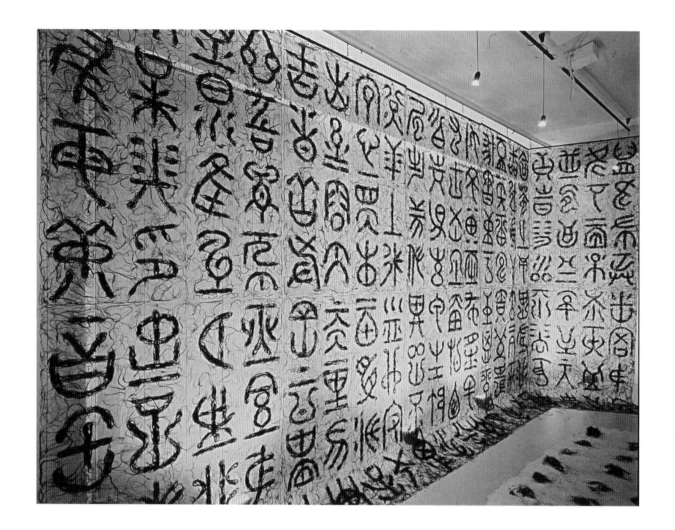

Gu Wenda, *United Nations—
Vancouver Monument: The World
Praying Wall,* 1998, site-specific
installation, Belkin Art Gallery,
Vancouver, Canada, wall of pseudo
English, Chinese, Hindi, and
Arabic, and world ethnical maps
made of human hair, 12.2 × 13.4 m.
Courtesy of the artist.

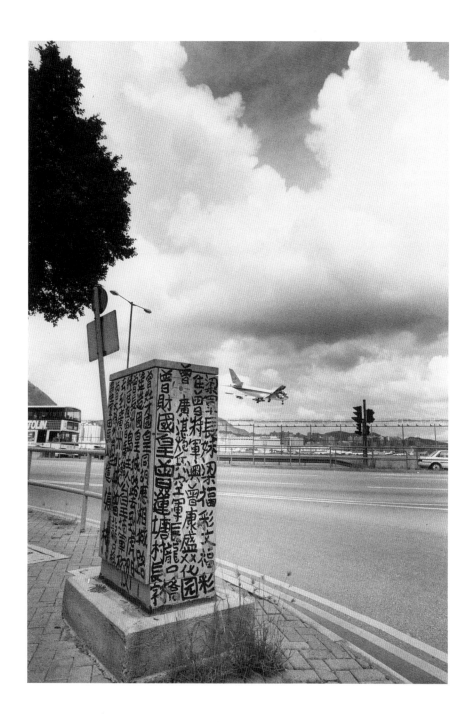

King of Kowloon, *In Situ*, ink on metal, photograph by Eric Wear. Courtesy of the artist.

Qui Zhijie, *April 8th,* 1996,
installation. Courtesy of the artist.

In using the written word in art, artists cannot avoid the issue of historical models. The coordination of the Chinese world of word culture is ordained by paradigms. Traditionally, masters in distant history set the model and acted as pointers to the future. In modern times Mao Zedong has become such a model. Ask any young Chinese artist from the People's Republic of China whom he or she deems the best modern calligrapher, and most likely the answer is Mao. This answer is partly a tacit recognition of the role of calligraphy as a barometer of Chinese statecraft, but importantly it also illustrates the orientation of history. The great paradigm today is not historical, but is here and now, in modern times. Works by Qiu Zhijie, *Copying the Orchid Pavilion Preface a Thousand Times* and *April 8th*, bring us to these questions. The *Orchid Pavilion Preface* by Wang Xizi (year 353) is arguably the most famous piece of historical calligraphy, and *April 8th* is simply the *People's Daily* from that day. Qiu uses both works as calligraphic models to question issues of authority and legitimacy. It is perhaps useful to reconsider Qiu's works about the body in light of the culture of the written "word." By treating the body and the psyche as objective materials, Qiu Zhijie has, in effect, turned the body into a metaphoric "figure" of writing.

After the vanguards of the progressive 1980s, China, by the end of the century, arrived at a new impasse. Current sensibilities depicted in art of the figurative body and the written word point to a subtle revaluation of the ideology of modernity. Today's artworks are vanguards caught midway, not just in the sense that they are not sufficiently "radical," but that they need to negotiate two opposing ideologies, with divergent views on history and time, each claiming a different purpose for art.

Minneapolis, 2000

Note

This text was first delivered as a public lecture at the University of Chicago, 1999.

The Millennial Intake of Humans as Opposed to Nonhumans, or Who Wins the Lotto and the Role of the Arts in the Process

Pam Johnston

A sibyl, questioned about Marozia's fate, said, "I see two cities, one of the rat and one of the swallow."

This was the interpretation of the oracle: today Marozia is a city where all run through leaden passages like packs of rats who tear from one another's teeth the leftovers which fall from the teeth of the most voracious one; but a new century is about to begin in which all the inhabitants of Marozia will fly like swallows, calling one another as in a game, showing off, their wings still, as they swoop, clearing the air of mosquitoes and gnats.

Italo Calvino, *Invisible Cities*

As we approach the millennium, Calvino's two cities seem to approximate ever more closely to the split between the real and the ideal. There is the public nightmare of environmental pollution, traffic gridlock and urban dereliction and the privatised dream of urban flight encoded in domestic interiors, back gardens, and home pages of the Internet. Even the most pedestrian line of desire, from home to work, is overlaid by trajectories belonging to other, invisible cities of hope, rage, despair and escape. At the end of the century, we are still struggling to come to terms with the fact that the heroic attempt of the modernists to

design a city of light and air, fit for swallows, resulted in the creation of so many urban rat runs.

Phil Cohen, "In Visible Cities"

As I ponder the vicissitudes of where I live, I casually pick up a newspaper article and read it. Somehow it seems immensely appropriate. The headline reads: "Black faces lure tourists? Never, never," and the column refers to a glossy four-page brochure released by the Northern Territory's tourist arm. The brochure in question speaks of swimming rock pools, crocodile farms, markets and beaches, food and sunsets, helicopter rides, and casinos. The article notes that there is not one mention of Aboriginal culture or of Aborigines in the brochure, and observes that of eight photographs in this brochure "not one black face is in sight: not even serving a white boss man a cold beer." As the commentary concludes, "As they say up north, you'll never never know there are Aborigines up there if you never never mention them."[1]

The first issue of *Art Monthly,* in June 1987, contains an article by Donald Horne titled "Constructing a National Past," in which he examines the artistic signifiers of a past (albeit a fluid one) that indicate a structure of nationhood. Focusing on Sydney, Horne asks, "In public art, art museums, relics, replicas, and buildings, what has been the rhetoric in stone and paint, in wood and metal, of five ideas? Ideas of national liberation? Of national cultural awakening? Of memories of a golden past? Of definition of the nation in painting?" Interesting questions, I suppose, if they hadn't become so repetitive over the years. And Horne is somewhat passé these days. Well, perhaps, except for this little paragraph tucked away in the middle of the article: "The long shot in golden ages might yet be found in the archaeology of early Aboriginal settlements, with their appeals of scientific dating and references to 'Early Man.' These sites have now become a feature of some atlases. But the rich clusters of relics in parts of the Hawkesbury district north of Sydney, which suggest at least 11,000 years of continuous occupation, don't as yet rate highly in the tourist itineraries."[2]

Just like the authors of the aforementioned brochure, Horne scarcely touches on the Aboriginal past that informs existing Aboriginality—a past that incorporates history and memory into the present. Tony Bond, director of the Biennale of Sydney, says in the catalogue for *TRACE,* "The theme TRACE suggests materials or objects that allow us to reconstruct histories through our personal memories and associations."[3] On the

surface, these articles might seem quite disparate. However, one way or another, they each acknowledge the importance of art to the construction of history and memory, and the impact that has on people.

We want art to be a reflection of the complex world in which we live. The development of critical theories of postculturalism and postcolonialism, which embrace problematic issues of cultural identity and representations of difference and hybridity, gives the art world a greater theoretical framework for discourse and content. But within this structured complexity, dominant Euro-American practices and forms remain virtually unchallenged. "The skeletal cage is merely rattled."[4] The "other" *still* exists in art through both visibility and invisibility despite an ongoing analysis of colonialism and postcolonialism.

I would like to address in some detail how art, particularly public art and community art, has an impact on the memory and history of place as well as how artists are becoming complicit in a process of dispossession of communities. I will use my own community, Woolloomooloo, as an example.

Is art holistic? Is it the sum of the parts of humanity, or a separate act to dehumanize? I've had this fanciful notion for some time that art is a tool for healing and empowerment, that its processes lead one on an internal road to self and spirit and on an external road to humanity and compassion. Art gives the lost a reason to live and the dispossessed a voice. This romantic notion allowed me to believe that art did not represent institutions, but was in fact the enemy of institutions—institutions represented by gray suits and gray buildings and coldness and cruelty.

Within this vision, I gave artists a tremendous role, not an elitist one, but nevertheless a very particular one. I saw them in the old way, as healers and magicians, as witch doctors. I saw artists as people among people with special tools and special visions that they expressed and shared. In this early part of the new millennium, I have a fear that artists have become the very institutions and corporations that I once saw as the enemy. My fear is that, without thinking, we might become the tools of the dispossessors, the heartless, and the inhumane.

A few years ago I saw a performance by local artist Fletcher Jetspree at the Green Park in Darlinghurst, New South Wales, called *The Darlinghurst Syndrome.*[5] He moved around the park accompanied by his own words and a damn good sound system. He stopped and he stalked and he yelled and he talked. He named and owned every inch of that park and the surroundings with his words. They told his story, his life. According to the *Journal of Geography in Higher Education:* "The geographical imagination is always rooted, in part at least, in a sense of the difference between places, the recognition that

other parts of the world differ in significant ways from those places and regions that we know, where we are 'insiders.' " [6]

The audience that night was the typical Darlo mix, along with a fair selection of my ex-students from Mulawa and Norma Parker Centre and people from Woolloomooloo.[7] The performer, in naming his life, was also naming their lives. Fletcher Jetspree spoke of the underbelly—of drugs and addiction, of hospitalization and AIDS, of the hangings in the old gaol that is now East Sydney Technical College. He spoke of his prostitution experiences at the Wall and of coming straight out of the emergency room, with an IV drip still in his arm, to score.[8] There were a lot of memories, a lot of history, woven around that particular bit of geography.

Everyone knows about the prostitutes, about AIDS, about the street kids, about addiction. We read about it in the papers or hear about it from social workers or criminologists. And we have experienced artists' and writers' interpretations of it. These interpretations, though made with the best intentions, dehumanize by their romanticisms, by their value judgments, by their expectations. This dehumanizing process ensures that the definer is the "human," and the defined, the "other."

That performance in the park was the first time, apart from Aboriginal ceremonies, that I heard a human memory weave itself into the landscape in which we were surrounded. It was the first time that I had seen my ex-students and my neighbors nod their heads in recognition at such a performance because the territory that was being marked was "theirs." For a minute, they were no longer the poor, the dispossessed, the powerless, the voiceless, the "not as human as the humans." For a minute, they were surrounded by their innate right as human beings to exist in their own human skin.

In that performance there was an owning of a place, of an identity—a naming of the often invisible that is usually only interpreted by an authoritative observer. This authoritative interpretation involves a process of disempowerment, of victimization, of dehumanization, because how can it be otherwise?

Let me tell you, Fletcher Jetspree was no victim; and the ex-prisoners, the Kooris, the Islanders, my neighbors—they were not victims as they listened to his words. I was pleased to see that no one was "owning" this performance as directly as the artist, although many were clearly "belonging" to it. Until then, the existing art, both public and private, had not been reflective of the memory and history of that geography. Without that performance, how long would it have remained invisible? Perhaps it would have just vanished like some endangered species, as many areas of Sydney have.

The identity of many indigenous Australian communities is deeply embedded in the country they belong to through the mnemonics of place. It is an essential way of

being reminded, "This is me and I exist." When a group of people (a community) has similar memories woven into the landscape, every single part of their life becomes a confirming signpost. The *mnemonics,* that practice of imposing memory on landscape, speaks.

English community artist David Engwicht has written: "Everything we build—from our individual house to large cities—contains a 'body language' that tells us about our beliefs, values, and mythologies. And because beliefs, values, and mythologies also shape social relationships—the environments we create will reinforce these patterns of social relationship."[9] When one is denied the signposts, the "body language," one becomes spiritually/psychically/psychologically/physically sick, as has been observed repeatedly in many indigenous communities in Australia and around the world. Nalo Hopkinson, on winning the Non-Warrior Aspect New Writer contest with her first novel *Brown Girl in the Ring,* wrote: "Science fiction . . . is traditionally a literature of colonising . . . a literature that does not really include US, except as a window-dressing. The overall impression you get from the book covers is that the humans are the white people, the aliens are people of colour."[10] It is vital to see a reflection that clearly says: THIS IS WHO I AM. Both community art and public art define communities spiritually/psychically/psychologically/physically through their practices and processes.

Art becomes an essential element of the mnemonics of place. For indigenous and nonindigenous people alike, the role of art is one of the fundamentals in defining both the internal and the external worlds in which we live. I saw this in practice among a disparate group of people with *The Darlinghurst Syndrome.* It was an empowering moment. More so because, in my opinion, despite consultative processes, despite structural processes, despite stated politics and objectives, community art contains within it the messages of the institutions that serve to make communities and individuals powerless. Juliet Peers, in her article "The Public Interest: Is There Any?" says, "The exercise (of community arts) celebrates not self-expression and the value of the individual but organisation and a governing narrative set by someone else."[11]

After the performance, I walked back down the hill to Woolloomooloo, observing the latest pieces of graffiti on the way, as I have done so many times before and since. Woolloomooloo is a community made up mainly of public housing that came about as a result of a tripartite agreement between the Commonwealth, the state, and local government. It is a unique area in many ways, and after living in the area for more than twenty years, my observations are very different from those of an outsider. My take on the local graffiti is perhaps one example of this.

At a recent conference on public art, I spoke about the significance of graffiti art to the people who inscribe it and its significance to communities such as mine.[12] I used visual examples as well as a video. Most of the people giving me feedback on that presentation insisted that graffiti art was an abomination. I went away from that conference thinking I had room to improve in the communications department. You see, I was talking at that time about how little the poor and the dispossessed—the Kooris, Samoans, Maoris, Islanders, Tongans, Asians, Middle Easterners—are surrounded by their own perceptions of who they are. I was saying that they are surrounded by community art, by every sort of art, but none of it is a signpost to their identity. The graffiti art, however, is.

Graffiti is a significant form of expression. It is alive and well more than twenty years after the original graffiti style, which is closely linked to the still thriving hip-hop culture, showed itself in the subways of New York, long before Keith Haring's work appeared. I was not talking then of *fine art* and those aesthetics that are rooted in the European tradition. I was talking about belonging and healing in an alien world. I was also describing a method for reclaiming power. I called that talk "Seize the Walls," as the graffiti artists did, and I meant it. Without "seizing the walls" a whole generation would truly have remained voiceless. It is not as if there is anything that can be called truly public property in this real-estate world. Ownership, even if not direct, is defined by the very institutions that graffiti alienates: the very institutions that deny graffiti's identity and voice.

In Woolloomooloo, graffiti became, and remains, a way for dispossessed young men and women—those thirteen to eighteen years old, who seem to be eternally demonized—to assert their existence and their power. Outside of their own families or their own "group," they have no positive affirmation of existence. This is the case, of course, all over Sydney, all over the world for that matter. It is particularly true in Woolloomooloo. In Newtown, several years ago, some walls were designated for use by young people, and the resultant images became a source of pride and identity for those involved.

Referring to the throngs of people traveling to Sydney for the 2000 Olympics, Peter Sellars, the American opera and theater director, is quoted as saying:

> Graffiti is the most important thing for any Olympic visitor to read when they come to Sydney. The graffiti tells you what is going on in a real neighbourhood in a way that no newspaper ever will. If you know how to read it, it is actually the language of a generation. . . . Graffiti is working in really profound ways to

actually say that certain people don't want their identity erased, even though every effort has been made to remove them from the public sector. They do not have access to a microphone, their opinion is not being considered. They are trying to say, "We are here."[13]

Bondi Pavilion Gallery has attempted from time to time to show graffiti in a gallery setting. The selections and the relationships were art-institutionally based and defined, which showed a certain lack of understanding about the nature of the world that was lived in; so-called fine art does have a way of appropriating lives and meanings. There have been other projects along similar lines. In Woolloomooloo, we have had some community art projects that attempted to develop graffiti art in the area. The history is as follows. Money was granted to hire a community artist to assist with a project for youth in the area. The artist noted that the imagery that was most significant to young people was graffiti art, and so the artist defined the project around graffiti art and presented it to the youth of the area, who took it up with enthusiasm, of course. When other residents of the area heard about this project, they protested. Their objections were along the following lines: graffiti art is derivative in that it comes from America and does not reflect "Australian" aspirations; it is "ugly"; it encourages a rebellious attitude among the young people. (Duh!!!) The upshot was that yet another community art project bit the dust. The artist, understandably, was both furious and upset, and there were some divisions within the community over the whole episode. The area youth were offered no illuminations about the world in which they lived. Within the community they were even more alienated from the adults than before.

Yet the process itself ensured the end result. The funding bodies as well as the artist had imported a particular "culture" that predefined both imagery and interest; worst of all, the project had already defined a community as "needing help" in some way. For all its good intentions, it was institutionalized before it had even started. What could that artist have done to make things different? Well, nothing really. That was the problem. Rachel Fensham, in an article on community arts, quotes Tim Rowse: "Surely . . . in the current appraisal of 'actually existing socialism' we must acknowledge the class interest of the intellectually qualified and urge them to question any aspiration they might have to generalise, however sympathetically about the interest of 'ordinary people.' "[14]

Woolloomooloo already has great graffiti artists. Unfortunately they get arrested for it. Why do they do it? Because otherwise they have no voice. Why do they have no voice? Now come on! We all know the answer to that. The fact that people are living in public housing, the majority on welfare, indicates a number of truths having to

do with choice. It does not, however, make these people less human, more stupid, or innately in need of help in some way. It does not give anyone the right to make assumptions about them or stereotype them or dehumanize them.

I have been checking my statistics and discovered that in 1998 there were almost 11,000 single mums under the age of twenty in Australia.[15] There are mums under twenty in Woolloomooloo. A community artist was employed to work with these young single mothers. The welfare groups that were involved in the project decided that it should help these young mothers define who they were and where they would like to be, as well as where they would be if they had not had their children. There was an immediate expectation that their self-esteem and career expectations would be boosted. And that would be a "good thing," because look at them! Surely they don't want to be where they are and if they do, they need to be snapped out of it (helped). Not one young mother

A visual memorial by Woolloomooloo residents to Edison Berrio, who was murdered by Sydney police during the Sydney Olympics. Photo: Pam Johnston.

came to that project. They already believed that they were being judged, and they were right, of course. They were as proud to be mothers as any of us are. They were proud of their children, proud of their lives. How long will that last, I wonder? I ask the question because there is *nothing* around them that affirms this pride—in fact, quite the opposite. Everything around them tells them they are losers.

Woolloomooloo kids used to play up at the Domain until the playground was removed to put up a police memorial on that spot. I wonder sometimes what the poor weekend- and holiday-access mums and dads do now that the playground is gone. Woolloomooloo kids used to play at Phillip Park until it was moved and became inaccessible through placement and price. Woolloomooloo kids used to yahoo around the Boy Charlton Pool until they turned it into a laps-only pool. Residents of Woolloomooloo have a habit in the hot months of dragging chairs out into the street and all sitting around for a yarn while the kids ride their bikes up and down. We can't do that so easily any more because of the slippery mosaic that appeared about two years ago, and because of the people in the new apartment buildings complaining about this street life. I notice, however, that when the Housing Department residents complain, their complaints are rarely acted upon. In her article, Fensham quotes artist and critic Jude Adams as saying, "We have permitted the growth of a separate sphere of art activity called community art, which, rather than extending, challenging and broadening traditional notions of art, leaves intact the definition and place of 'real art.'"[16]

The Art Gallery of New South Wales is just up the hill, and yet most people in Woolloomooloo have never been there. Artspace is down on the corner, but most people in Woolloomooloo have never been there either. Why? My opinion is that those places represent the institutions that conspire to make them powerless, to dehumanize them. How are they represented in the art galleries and the art world, except as objects to be observed, defined, and helped? There *is* a voice, a culture in Woolloomooloo. Woolloomooloo is not neat and tidy and aesthetically pleasing. It is chaotic. It is challenging. It is frightening. Despite the current multimillion-dollar developments, the incredible public art that costs a fortune, Woolloomooloo is messy. And sadly, its own wonderful diversity and gutsiness, its own voice, its own understanding of itself is nowhere visible.

In 2002 the tripartite agreement I mentioned earlier comes up for review. Woolloomooloo is in fear of losing the roof over its head. Worse, Woolloomooloo is starting to believe that it has no hope, that it has no right to its place in Sydney. At one time we believed otherwise. In 1983 a few of us mothers with infants got together and through a series of discussions, and as a result of one mother murdering her child, we were able to get funding for a community worker. Out of that initiative, the Juanita

Neilsen Centre was developed and we hired a community artist, Jo Darbyshire. By "we," I mean the community, not just a few individuals. None of the existing public artworks acknowledged the people or the history of the area. We believed we were unique, that Woolloomooloo history was unique. It was in the library, in the buildings, in the fact that we could look at that old Ginger Meggs movie and see our old community, and note the changes, even though it has always been peopled by the same sort of residents.

We saw it in the fact that artists wanted to come down and work in the old Gunnery building and make friends with us. We saw it in the unions who really cared about the development of the area. We saw it in the young left-wing people who came down to offer support on any local issue that came up. Jo Darbyshire was part of that attitude. She taught us stuff we wanted to know, not what she or anyone else thought we should know. We were humans among the humans then.

Now no one asks Woolloomooloo what it has to offer, no one delights in Woolloomooloo's existence. The public art that surrounds us does not tell Woolloomooloo anything, much as it would like to think that it does. In 1986 British community artist and writer Owen Kelly said of community artists, "We have become foot soldiers in our own movement, answerable to officers in funding agencies and local government recreation departments."[17]

The history and diversity of Woolloomooloo will be lost to Sydney because the very thing that art has to offer, the chance of a voice, the chance of surrounding ourselves with ourselves through our own eyes, is not being offered. This could be one of a number of communities around Sydney. The nature of Woolloomooloo *does* challenge. It also makes for a more tolerant and more compassionate Sydney. It cannot be made into what it is not; however, it can be made invisible—it can be vanished/vanquished.

The very thing that could have made us stronger, art in all its diversity, has dehumanized our community by asserting the very institutional cultures that Woolloomooloo has been fighting against for so long. It will be a truly terrible loss to Sydney if the people of Woolloomooloo are forced to move on. Many people in Woolloomooloo, like so many others in inner Sydney, have already been "moved on." Look at Woolloomooloo with an artist's eye, and look at what surrounds it. What is Sydney telling us?

Community art has an intrinsic value to both the community and the individual. It stitches together the spirit that gives humanity to what could otherwise be easily dispossessed. Community art has the potential to heal. However, it has to be aware of its tendency toward judgment. Currently, it is considered a disease not to be white, not to be educated, not to be clean, not to be employed, not to have your children in bed by 7 p.m., bathed and fed, not to refrain from parenthood until one's early thirties, not to

Mural completed by Danny
Eastwood of the Dharug nation
and residents of Woolloomooloo.
Photo: Pam Johnston.

refrain from loud music, yelling, fighting, or drinking at any hour of the day, not to be fat, not to wear trackies, and on it goes.

Neither the institutions nor the artists (and others) they fund recognize any intrinsic culture or value in Woolloomooloo. Woolloomooloo is seen as a problem, and everything that surrounds the people of Woolloomooloo says that they are a problem: that others are the humans and they are the hopeless.

In 2002 there is a real risk that our homes, our place, will be taken and that the center of Sydney will be filled with nice people who appreciate nice art and have nice clean clothes and cause no trouble because they are educated and cultured and administer the institutions and DO NOT NEED HELP. They will also own the nice apartments while those who lived in Woolloomooloo before will live on the fringes of the city, believing that is all they deserve because, as the humans have told them, they are the hopeless. They might write or paint or draw their own stories. They might fight for a voice, but IT WILL NOT BE CONSIDERED ART. Humans do art and the hopeless are helped.

Community artist Marla Guppy, at a conference in Newcastle, New South Wales, articulated a common problem among artists.[18] She wanted to know what role an artist could take in this argument when it was the very institutions, usually represented by councils, that defined the brief and paid the money. Guppy explained that there were very real issues of limited work, low pay, and lack of power, which left artists in a poor bargaining position in terms of following through on a less colonizing ideology in art practice. Professor Anne Graham explained at the same conference that she has chosen to work within institutions, and that despite many difficulties, she feels very effective in this area.[19]

I have sought here to explain a process of dispossession, a form of colonization, in which artists are complicit. I am not seeking in this article, despite its many observations, to vilify community artists. I, too, am in the middle of this dilemma as a practicing artist. Much of the public art in the inner city has great value in the art world. It works according to the brief; it is stunning. However, to weave the humans into it, I have had to adopt particular strategies. I have "given" children, including my own granddaughter, Janet Lawrence's trees on the way to Mrs. Macquarie's Chair, a central Sydney landmark. I pick the trees that are the exact height of the children—I haven't given them all away yet, there are lots left—and as the child grows, so grows the tree. The child has the possibility of an intimate link with that tree, as do friends and family members. Perhaps when the child is an adult, he or she will "give" that tree to a child as yet unborn. Certainly throughout childhood in Woolloomooloo, the particular tree will be looked after, loved, "possessed."

In such ways lives can be woven into the art, and memory and history play a confirming role in this type of public art. If I didn't do these sorts of things, the art would continue to represent not the artist, but the institutions that commission it—the institution "owns" the work and in the process psychologically dispossesses the community. It is a continuation of colonialization however you look at it. Sound familiar? The description fits, and I must say that colonialization has not stopped just because we now have "reconciliation."

I have a fearful vision of the Sydney of the future, in which anyone who is different from a mainstream, white, educated, professional group of people is condemned to live desperately on the outskirts of the city in appalling conditions, with death and despair as constant companions. These dispossessed look inward to a city and a people that they understand are beautiful. Art has told them, on the other hand, that they are ugly and unworthy. They have become the fringe dwellers and, having been dispossessed, can never regain access. Slowly they vanish from view. Sometimes the city says, "Remember . . ." until someone says, "No." Order and profit continue, and the fringe-dwellers are no longer even a memory.

My nightmare vision of Sydney is already happening, and art, sadly, is at the forefront of defining the lucky—and those who are not going to survive. Artists have a significant role to play in defining not only the city's structures but also who is going to live in them and, more important, *how* they are going to live. Artists, more than others, have a choice when it comes to a vision of this city's future and their role in it, and also a choice of political strategies for achieving that vision.

Seoul, 1997

Sources of epigraphs: Italo Calvino, *Invisible Cities*, trans. William Weaver (London: Harcourt Brace Jovanovich, 1974), p. 154. Phil Cohen, "In Visible Cities: Urban Regeneration and Place-Building in the Era of Multicultural Capitalism," *Communal/ Plural* 7, no. 1 (1999), p. 9.

1. "Stay in Touch" column, *Sydney Morning Herald*, 18 February 2000.

2. Donald Horne, "Constructing a National Past," *Art Monthly* (Australia), no. 1 (June 1987), p. 1.

3. Anthony Bond, introduction to *TRACE: The International Exhibition*, exh. cat. (Liverpool: The Liverpool Biennial of Contemporary Art, in association with Tate Gallery, Liverpool, 1999), p. 11.

4. Pamela Zeplin, "Connections and Enlargements or Swollen Joints?," *Art Monthly* (Australia), no. 123 (September 1999), p. 25.

5. *The Darlinghurst Syndrome,* performed by Fletcher Jetspree, with organizing artist Kathy Triffitt, March 1995.

6. A. Cosgrove and S. Daniels, "Fieldwork in Theatre," *Journal of Geography in Higher Education* 13, no. 2 (1989), pp. 171–72; quoted in Ian Henderson, "The Awareness of Place in Visual Landscape," *Periphery,* no. 11 (May 1992), p. 8.

7. "Darlo" is a colloquial reference to Darlinghurst, an inner suburb of Sydney, which also houses a number of unique communities. Mulawa Women's Detention Centre is the maximum security prison for women in the Sydney area, and the Norma Parker Centre (now defunct) was the former Parramatta Girls Home in Sydney.

8. The Wall is a section of wall along Victoria Street, in Darlinghurst, currently enclosing East Sydney Technical College and the National Art School. It was formerly the main Sydney gaol, and behind the section referred to was the hanging yard. This section of the wall is known for its male prostitutes, drug dealers, and so on.

9. David Engwicht, "How the 'Art of Public Places' Debate Shackles Creative Genius," *Artlink* (Australia) 18, no. 2 (June–August 1998), pp. 8–10.

10. Nalo Hopkinson, "Many Perspectives," *Locus: The Newspaper of the Science Fiction World,* issue 456, vol. 42, no. 1 (January 1999).

11. Juliet Peers, "The Public Interest: Is There Any?" *Artlink* (Australia) 18, no. 2 (June–August 1998), p. 11.

12. Pam Johnston, "Seize the Walls," paper given at "Watch This Space: Conference on Public Art," organized by *Australian Journal of Art* and School of Fine Art, University of Newcastle, Newcastle, New South Wales, September 1999.

13. Peter Sellars, quoted in Peter Cochrane, "Graffiti: Power for the Voiceless," *Sydney Morning Herald,* 17 April 2000, p. 7.

14. Rachel Fensham, "Why Do Angels Fly Anti-Clockwise?," *Artlink* 10, no. 3 (Spring 1990), p. 12, quoting Tim Rowse, "Doing Away with Ordinary People," *Meanjin* 42 (September 1983).

15. *Australian Bureau of Statistics Year Book, 1998,* Government Printer, Sydney, New South Wales.

16. Fensham, "Why Do Angels," p. 12, quoting Jude Adams, "Community Arts: Time to Come out of the Corner," *Community Arts National,* 1987.

17. Owen Kelly, "Storming the Citadels," *Community Art and the State* (London: Comedia Publishing Group, 1984), p. 5.

18. Marla Guppy, "Negotiating Locality in the Global City," paper given at "An Art of Interruption" conference, School of Fine Art, University of Newcastle, Newcastle, New South Wales, 20 May 2000.

19. Anne Graham, "Smooth Transitions: Between Fiction and Reality, Memories Are Made of This," paper given at "An Art of Interruption" conference, School of Fine Art, University of Newcastle, Newcastle, New South Wales, 20 May 2000.

TRANSCULTURAL CIRCUITS

Beyond the Box: Problematizing the "New Asian Museum"

Rustom Bharucha

In this intervention, I will throw out a series of questions and provocations on global cultural politics, out of which—and against which—the desire for and modalities of the "new Asian museum" can be problematized. I will begin by questioning the very category of "the new Asian museum": How exactly is "Asia" being invoked here? Which Asia do we have in mind—South Asia, Southeast Asia, or East Asia? If Asia is not being reduced to an ahistorical cultural essence or to a mere geographical expanse, then how exactly is it being conceived? To what extent are the upholders of the "new Asian museum" aware of the economic disparities that divide Asia, perhaps more so than in any other continent? Do these disparities matter in First World cultural contexts where it is possible to metaphorize "Asia"? To what extent does this "Asia" continue to be part of a residual orient that refuses to die even as it is in the process of being deconstructed? How does one negotiate the hierarchies of cultural hegemony that operate within Asia? And to what extent do they matter in determining the criteria and standards upheld in the curatorial policies of the "new Asian museum"?

From the politics of my own location, I would acknowledge that while we have a vibrant cultural discourse in India on a plethora of identities—regional identity, caste identity, communal identity, national identity—there is almost no inscription of an "Asian" identity in the emergent field of Indian cultural studies. It is not that Asia doesn't matter, or that we don't feel part of it; it is simply not our priority.[1] This is not the case in countries like Malaysia and Singapore where the discourse around "Asian values," for instance, has been upheld for a long time in political and intellectual circles, despite

the recent discrediting of these dubious "values" through their now acknowledged associations with cronyism, authoritarianism, pseudo-Confucianism, paternalism, and corruption.[2]

Significantly, even while "Asian values" get discredited, they are being replaced, if not reinforced, by a new affirmation of the "Asian Renaissance"[3]—a renaissance that is being manufactured not only by the agencies of the state in Singapore and Malaysia, but tacitly by a great many intellectuals, architects, and cultural practitioners as well, who are riding piggyback on its rhetoric. Simultaneously, in the field of intercultural theater practice, we are witnessing the projection of an "inter-Asian" aesthetic, which is gaining new clout through the substantial funding received for exclusively Asian work provided by the Japan Foundation Asia Center and the ubiquitous Ford Foundation. Out of these funding initiatives are emerging new infrastructures of exchange centered for the most part in Singapore, Hong Kong, and Tokyo—the metropolitan centers of an increasingly consolidated "East Asian" configuration in which the "other Asias" would seem to be on the margins.

From a South Asian perspective, I would acknowledge that the opportunity to work in Asia with other Asian colleagues offers a positive alternative in reversing the predominantly East-West trajectories of earlier modes of intercultural exchange. But a more critical perspective on these developments would reveal that, yet again, the funding is being controlled and framed precisely in those centers of global capital where a critique of global capitalism is politically unacceptable by the cultural agencies of the state. More problematically, the values of the market would seem to be thoroughly integrated within the ethos of corporate yuppiedom in which Asian (and more specifically, ASEAN) artists are increasingly implicated.

The "Asia," therefore, that is being celebrated in recent inter-Asian collaboration has less to do with the propagation of democracy through people's movements or emergent struggles in civil society, than with the creation of spectacles and events in which "Asia" becomes a new manifestation of cultural capital itself.[4] The very diverse resources of Asian cultures, particularly in the ritualistic, folk, and traditional sectors of performance, supplemented by a spectrum of visual traditions, contribute to the lure of this capital. With appropriate adaptation, these resources can be ingeniously reinvented in the form of new narratives, contributing lucratively to the global cultural industry and the spate of mega art shows, biennales, triennales, and blockbusters.

In presenting this synoptic view on some of the cultural developments being manufactured in the name of "Asia," my point is simply to emphasize that the "new Asian museum" cannot be separated from its larger implications in global culture. The

museum offers a particularly embattled site to study the tensions between the global and the local, the intercultural and the multicultural, "Asia" in Asia and the "Asia" supported by the increasingly privileged hegemonies of the diaspora. Since I cannot claim to be a critical insider to the intensely charged contradictions of the "local" Canadian art scene—I was a witness to its extremely articulate and strategic positioning at the symposium in Vancouver[5]—I will continue for the rest of this essay to focus on the larger global implications of the "new Asian museum," drawing on my own discomfort with museums in general, specifically within my cultural context in India.

"The Old Asian Museum": An Indian Predicament

We have already questioned the inscription of "Asia" within the construction of the "new Asian museum." Hopefully, in clarifying the raison d'être of this museum, we will not fall back on any attempt to authenticate "Asia" in the diaspora by drawing on the legacies of "old Asian museums," which are, for the most part, colonial relics, if not bureaucratic nightmares. Certainly this would seem to be an accurate description for museums in India, where, arguably, the very idea of the museum remains somewhat alien to millions of people in the absence of a vibrant museum culture.

Even as intellectual production in India on postcolonial theory, subaltern history, and popular culture has been internationalized in recent years, museum studies in India (particularly in the contemporary domain of public culture) remains woefully neglected. Even the most basic facts and data relating to collections and subsidies are not available for public scrutiny. Annual reports are not published. Despite their almost total absence of transparency and accountability, museums get away with their improprieties. In this context, would it be false to assume that they don't really matter to intellectuals in India or to the public at large? Quite unlike the enormously popular cinema halls, theaters, football stadiums, parks, amusement centers, *melas* (fairs), all-night musical soirees, and book exhibitions, museums cannot be said to contribute with any resonance to the cultures of "time-pass" in contemporary India. Museums are boring, and most of all, they don't make sense.

This view is not shared by Arjun Appadurai and Carol Breckenridge in their influential essay "Museums Are Good to Think: Heritage on View in India," wherein they subsume their empirically thin perspective on Indian museums within a transnational framework of public culture.[6] In this overly valorized theoretical terrain, it is not the actual state of Indian museums that matters but their "interocular" possibilities of spatialization through their alleged linkages with travel, tourism, pilgrimages, leisure, the

mass media, department stores, exhibition-cum-sales, and ethnic national festivals, among other manifestations of public culture in India.

Without denying the mobilizing power of these cultural phenomena, one needs to question how exactly they impact on the phenomenon of the museum itself. Take department stores, for instance, which are an extremely new up-market phenomenon that are to be found almost exclusively in more prosperous metropolitan cities like Bangalore: How can this consumerist site, arguably a "glocal" phenomenon, be related to the economic desuetude of Indian museums, which survive for the most part on meager state subsidies? Can they be assumed to share the same public sphere, regardless of their divergent accessibilities to communities discriminated on the basis of class and education? So seemingly rapturous is Appadurai and Breckenridge's apparent faith in the democratization of public culture that they highlight Indian museums as repositories of "informal learning." While this is a dubious compliment for a country with widespread illiteracy, it would be worth reflecting on if the authors could analyze visual literacy through an actual study of museum reception in India. This does not materialize because such a comprehensive study does not exist for the contemporary state of museums in India. The question arises whether the construct of "informal learning" remains at the level of theoretical desire, rather than being an actual fact.

Even while acknowledging the colonial heritage of Indian museums and the lingering premodern modes of perception internalized by the Indian public, Appadurai and Breckenridge fail to confront the disjunction that exists between this "heritage" and its postcolonial residue. At one level, this oversight can be ascribed to their "nondialectics of seeing" (to reverse Susan Buck-Morss's valuable category), which prevents them despite their own recommendation from intersecting the reception theory informing "the *contexts* of current museum viewing [in India]" with an "analysis of the colonial modes of knowledge and classification" pertaining to the *texts* contained in the museums.[7] Instead of acknowledging the extraordinarily intricate back-and-forth temporalities of seeing Indian artifacts, both within and beyond the boundaries of the museum, the authors settle for an evolutionary perspective of cultural spectacle, whereby "older Indian modes of seeing and viewing are being gradually transformed and spectacularized."[8] Once again, the globalizing process of capital is being assumed unequivocally without being interrogated within the disparate economic contexts of India, where one would need to take into account the "despectacularizing" tendencies of urban cultures in India, which are facing the breakdown of basic civic amenities and public services.

Museums in India, I would argue, are merely symptomatic of the larger indifference on the part of the government—and the public—toward the maintenance of cultural institutions. No longer can they be affectionately evoked with colonial nostalgia as *Ajaib Khana* (translated by Kipling as "Wonder House"), or as *Jadu Ghar* (Magic House), which is how the Indian Museum instituted in 1814 in my home city of Calcutta has been memorialized. There is nothing "magical" about this museum today—although it continues to attract crowds of people on a daily basis, it should be kept in mind that drawing an audience almost anywhere in India, with its population of one billion people, does not pose a challenge. At the risk of sounding elitist, I would urge some discrimination between a "crowd" and a "public," drawing on the very fine emphasis made by Appadurai and Breckenridge themselves that "in India, museums need not worry so much about finding their publics as about making them."[9]

Sadly, in the absence of any real confrontation of this difference between "finding" and "making," they land up *assuming* a public, which could be the most problematic factor in the thinking of Indian museums today. As Tapati Guha-Thakurta has demonstrated convincingly in what remains one of the very few scholarly assessments of "the museumized relic" in India, "the public" has almost always remained an "illusory entity" in the discourse around Indian museums; the disjunction between its "actuality" and its "absence" has never been fully confronted.[10] Playing into deeply entrenched colonial prejudices by which "appropriate" and "inappropriate" subjects are implicitly differentiated, the nebulous notion of the public is fractured further through the "vast gap" that exists between modes of "seeing" and "knowing." The Indian museum remains caught between an obligatory need to generate "mass recreation" through visual stimuli and the advocacy of "specialized knowledge" perpetuated through an unconsciously grotesque parody of orientalism. To this day the *Jadu Ghar* of Calcutta displays inscrutable handwritten Latin inscriptions attached to thousands of indistinguishable rocks, stones, and fossils. There's a time warp in this colonial spectacle that could be the subject of a postmodern fiction were it not so depressingly evocative of the ruins of a (post)colonial present.

With the rise of the Indian bureaucrat masquerading as a museum director, "specialized knowledge" has given way to an anachronistic adherence to the "living traditions" of "ancient India," now almost fossilized beyond recognition. The failure to extend the popularity of museums has been even more abysmal in the absence of new interactive technologies or the most basic user-friendly conveniences and attractions—a tearoom or a gift shop, for instance, would be hard to find within the precincts of any

Indian museum. Unable to do its job, the bureaucracy has "fumbled, floundered, turned increasingly inwards."[11] Insular rather than introspective, it has "failed," as Guha-Thakurta has put it candidly, within the parameters of its own national preoccupations to disseminate knowledge to its citizens. At the heart of the failure remains the unresolved "problem of the public," which refuses to be homogenized within "a natural community of citizen-viewers," but which has yet to be "pitched centrally within the particular trajectories of . . . modernity and democracy [in contemporary India]."[12]

In the context of this predicament, the attempts on the part of diasporic global intellectuals like Appadurai and Breckenridge to subsume the Indian museum within the larger dynamics of public culture are somewhat misleading. Today it is not simply a matter of whether "[Indian] museums are good to think." *How* do we think about them when their very survival is at stake? Excluding the "islands" of success like the Crafts Museum, sequestered in the arid wasteland of Pragati Maidan in New Delhi, or the even more exclusive Calico Museum in Ahmedabad, most of the museums that exist in India today do not function as museums: they have no shows, no exhibitions, no publications, almost no media representation whatsoever; their exhibits are layered in dust; the rooms are not always lit; there is almost no security; and the buildings themselves are often in a state of disrepair (on my last trip to Bharat Bhavan in Bhopal, designed by the internationally acclaimed Charles Correa, the roof was leaking in the gallery itself).

Under these circumstances, are museums good to *think*? What needs to be *done* about them? How can they be dismantled—and reinvented—to contribute more substantially to the public culture in India itself? While this question lies beyond the boundaries of this particular essay, which is concerned with the hypothesis of the "new Asian museum," it precipitates the discussion that follows on how to deal with the "Indian past" (and pasts elsewhere) through the principle of erasure, which I would now like to submit to critical scrutiny.

The Politics of Erasure

Risking an amateur reflection on what could be described as deeply internalized common sense, I would argue: if museums are repositories of the past, they risk being redundant in countries like India, where the past is alive in any number of unprecedented ways. Mutating, hybridizing, and getting juxtaposed with modern and postmodern incursions in our public sphere, the past is less a repository of seemingly eternal resources than a dynamic, even interruptive element in the shaping of new narratives. The "premodern"

can catalyze conflicting modernities, as indeed, the "folk" can defy the nomenclature of "folklore" by assuming, if not asserting, a contemporary significance.

The "Indian past," I would argue, challenges the very grammatology of the Euro-American museum structure (and its non-Western derivations), which continue to rely on the periodization, classification, and categorization of its artifacts. Indeed, the ironies deepen as one encounters this "past" in specially designed crafts museums, which inevitably ethnicize cultural difference and thereby reduce the folk to the cottage industries. What is worse is the live participation of traditional craftsmen and artisans, who are made to "informally" demonstrate their skills within the precincts of the museum. Such dehumanizing instances of manufactured "contemporary relevance" merely enhance the divisions between the "real" folk and their urban clientele, while appearing to ameliorate the conditions of the rural poor.

The "new Asian museum," it seems to me, will need to dismantle this projection of a factitious "past" by exploring new imaginaries, in which multiple times—indeed, multiple pasts—can be staggered rather than juxtaposed through discrete combinations. New principles of visualizing "Asia" could also be explored by drawing on the ecological principles that are embedded in traditional forms—principles relating to erasure, renewal, and impermanence, as can be discerned in the rich gamut of ritual and cultural practices like *kolams* (traditional floor drawings). Here the entire point of the artwork lies in the *erasure* of the floor drawing after it has been completed, following hours of meticulous work. In such practices, which have a continuing significance in the cultures of everyday life, the resistance to conservation and commodification provides a useful provocation in structuring new ways of "visualizing" Asian pasts.

Let me deepen the provocation further: How does one translate the principle of erasure embedded in premodern practices by intersecting it with, say, postmodern Derridean readings of erasure? Here I am not just thinking of the possibility of creating "biodegradable" installations, which could play with the possibilities of self-destruction. I would like to push the provocation even further: To what extent can the principle of erasure challenge the very ethos and structure of the museum itself? Can a museum erase itself?

The seemingly anarchist subtext of this question clearly needs some unpacking. A few qualifications would be in order: while articulating the possibilities of erasure, I am aware that it can be essentialized as a primary principle on the basis of which the "integrity" of an art practice can be guaranteed. There is also a suggestion in my earlier comments that erasures are endowed with a premodern sanctity and that there may be

no other options for the existing practitioners of premodern cultural practice than to hold on to the "authenticity" of their ritual processes. By preempting such possibilities of misunderstanding, I must necessarily elaborate on the sources inspiring my understanding of "erasure."

Apart from the practice of *kolam*-drawing, I have in mind the traditional clay modeling of Hindu deities like Durga, Kali, and Lakshmi during the Pujas (religious festivals) in Calcutta. These exquisite figures of the goddess are meticulously designed and shaped by the traditional artisans of Kumartuli, following which they are transported to roadside *pandals* (pavilions) on the streets of Calcutta, where they are worshiped with celebratory fervor and the active involvement of entire neighborhoods of people. It would be hard to think of a more "public" form of worship almost anywhere else in the world. Following the three-to-five-day worship of the goddess, the deities are transported once again on open trucks to the Hooghly River, where they are unceremoniously tossed into its muddy waters. This immersion of the goddess can be read as another kind of erasure, where the very "object" of the "art" produced by the Kumartuli artisans is ultimately cast into the waters, leaving no trace beyond its accessories.

To complicate the narrative, it is significant that the Kumartuli artisans are now reinventing their skills for other purposes. During the lean season of the year, when they are out of business, they have taken to sculpting contemporary figures relating to vignettes from everyday life. Street scenes incorporating life-size naturalistic clay models of vendors and pedestrians, juxtaposed with the interiors of shops, vehicles, and implements, were prominently featured in their first public exhibition in Calcutta (April to May 2000). Here within a makeshift "art gallery" in Kumartuli itself, it was clear that the artisans wanted to be recognized *as artists*, not least because they wanted to display and sell their "artworks," which necessarily had to be permanent.

At this point, at least two hypothetical interventions could be made by the representatives of the "new Asian museum." One possibility would be to extend the visibility of the new artworks of the Kumartuli artisans through diasporic representations in global art forums. Given the growing interest among alternative, multicultural curators in featuring subaltern art from Third World countries, the possibility of transporting "Kumartuli art" to Western art centers does not seem to be unduly bleak. Offbeat, yet "neotraditional," the Kumartuli art show could attract public attention on the lines of Satish Sharma's rich collection of snapshots from the roadside photographic studios of Indian cities and small towns—highly choreographed and fantasized images, with working-class men and small-town families posing alongside luridly painted film

stars, gods, luxury goods, sports cars, fountains, the Himalayas, the Taj Mahal, among other icons of *Street Dreams* (the catchy icon which provided the curatorial framework for Sharma's collection in its tour through numerous towns in Britain).[13]

I will let pass for the moment the risks involved in exoticizing the "real" through the blowups of anonymous snapshots and the close-ups of "significant" details guaranteed to titillate the insatiable First World voyeuristic interest in *desi* (indigenous)/brown sexualities. What I would emphasize instead is that it is one kind of challenge to transport the subaltern art of the Third World into the "new Asian museum," it is quite another matter for metropolitan artists affiliated with this museum to engage creatively and critically with those principles embedded in premodern practices that challenge the very norms of commodification embedded in the structure of the museum itself.

At least two possible caveats could be raised at this point. One relates to the implicit separation between "them" (the Kumartuli artisans) and "us" (the cosmopolitan interlocutors of the "new Asian museum"). Such a separation would seem to deny a "cosmopolitical"[14] status to the artisans themselves, apart from undermining the metropolitan possibilities of negotiating the "premodern." Neither of these positions, I should qualify, is absolute; indeed, both are capable of being implicated in each other's scenarios with the appropriate mediations and dialogue.

The second caveat is more pertinent to the immediate challenge presented to the "new Asian museum" by local Asian-Canadian artists questioning the global hegemony of "Asia": Why should minorities think of erasing their artworks when their very identities have been so ruthlessly marginalized by the art establishment over the years? Why not claim the most prestigious museum space in order to "display" one's work with all the trappings of social and artistic recognition?

To this response, I would qualify that erasure, as a creative principle, need not deny either the significance of an artwork or the recognition of an artist. In erasing our work, we do not necessarily erase ourselves. Besides, even as erasures get materialized in practice, they inevitably leave traces, if not faint signatures. Second, I would add that there are many different kinds of erasure that are open to being *imagined* within the specific materials and constructions of different modes of art practice. The principle of erasure needs to push the boundaries of the imagination, not lend itself to being neutralized in the process. Finally, I would add that when I posit the erasure of the museum, I don't mean it literally—in other words, I am not saying that museums shouldn't exist, even though metaphorically that would seem to be my intent. Metaphors are not meant to be taken literally; they are valuable not so much in indicating *what* to think, but *how* to think. It is in this context that I would suggest that the metaphor of

erasure should be constantly translated—and retranslated—within the mutations of specific practices.

Against Museumization

In problematizing my own reflections on erasure, I have focused primarily on the transforming roles of the artist/artisan and the work of art produced. But the larger question remains the erasure of the museum itself as a structure, *as an institution.* Moving beyond the safe hypothesis of a "museum without walls," we need to confront the basic power relations that sustain "new Asian museums" in an age of globalization. If there is an agenda hidden in the possibility of erasing museums, it is surely tied up with a critique of capital whose stability in the museum context is ensured through the investment in a building (more extravagantly termed, "the site") and a permanent art collection—the primary "assets" of a museum, which invariably determine its structure, public relations, and marketing profile.

This brings us to the crucial issue of money: Who's paying for the "new Asian museum"? How will it sustain itself financially? Is the initial capital investment likely to come from private foundations, the State, or donations made by rich Asian families, who are a new force to reckon with in the propagation of global culture? To what extent is the "long-distance absentee national feeling" of these families, to borrow Benedict Anderson's construction, a stimulus in reterritorializing the "imagined communities" of their erstwhile homelands within their new locations? How does this "feeling" get translated politically not only within multicultural scenarios but in relation to the endorsement of communal and fundamentalist movements "back home"? To what extent can rich Asian families—the potential sponsors of the "new Asian museum"—be regarded as adequate spokespersons for their own communities? And indeed, how do they relate to one another *across* communities?

One is calling attention here to the inter-Asian tensions that exist in almost all diasporic immigrant contexts. How can the "new Asian museum" assuage these tensions rather than highlight them through the prioritization of one "Asia" over another? If, for example, the chief donor of the museum happens to be an arts foundation based in Hong Kong with its clearly stated prioritization of contemporary Chinese art, then how is this representation likely to exclude (or marginalize) contemporary artworks from other Asian nations? And what is the likely fallout of this seeming equation of "Asia" with "China" (the new superpower of our times) in the reception to the museum across non-Chinese Asian communities?

If we suspend the problematic of "Asia" in the "new Asian museum" by accentuating its "newness," then what makes it "new"? Simply the addition of a new body of work from Asian countries that can compete with "the best in the West"—is this "new Asia" not another exoticization of the contemporary? How else can the "new" be problematized? Perhaps we can begin by deconstructing the colonial and imperial legacies of "old museums," which remain disturbingly uncontested in actual practice, despite the increasing evidence of the loot which is synonymous with the display of Asian artifacts and artworks in almost all the leading museums in Europe and the Americas. There is also the increasingly shady mediation of auction houses, which have succeeded in "laundering" loot, at times by selling it back to its rightful owners. So how does the "new Asian museum" position itself in relation to this history of loot?

Here there can be no coyness through the elision of responsibility: "The loot is not of our times, so what can we do about it? How can we be held responsible for the peripheral activities of colonial agencies? It's all in the past anyway. And besides, that past is our global multicultural present." Is "contemporary Asian art" then a new camouflage for the diffidence in dealing with loot? Or is it a compensation for the wrongdoings of the past? If this idea seems unduly cynical, we should keep in mind the devious and hypocritical strategies by which loot can be—and indeed, has been—transformed into intellectual property. Loot can also be legitimized on multicultural grounds: first you loot a country of its treasures, you display what appeals to you on the walls of your most established museums, you bury the rest in the warehouses, and then, when the time is ripe for a bit of museum expansion, the buried treasures can be exhumed for the edification of Asian immigrants in order to reconnect them to their lost cultural heritages. Such multicultural logic is vicious in its self-righteous duplicities and should no longer be endorsed through silence, indifference, or worse still, a resurgence of lapsed patriotism for one's country of origins.

The "new Asian museum," it seems to me, could benefit from radicalizing its agenda beyond the display of artworks from Asia. Here it would be useful to reinscribe the tensions between the "civil" and "political" dimensions of society in order to enhance the oppositional potentiality to the new institutionalization of culture in our times. While museums are traditionally located within the domain of civil society, they are increasingly more insulated from the emergent cultures of struggle in political society, cutting across nations, languages, and constituencies, which are succeeding in bringing together unprecedented alliances of activists, environmentalists, and cultural workers, who are substantially redefining the very grounds of intercultural meeting, dialogue, and practice.

At the start of the new millennium, it would be useful to widen the boundaries of civil society beyond the contestatory claims of its acknowledged participants; we need to recognize the challenge posed to the bastions of "high culture" in civil society, notably museums, by the new incursions and configurations of public culture in national and global forums. Museums need to confront the insularity of their implicit "no trespassing" zones, which have in effect denied vast sections of the population, particularly from the minority and immigrant sectors, not merely access to the museum, but the right to interrogate its assumed privileges and reading of history.

It is my plea that, instead of shutting ourselves up in the box—whether it is the "black box" of theater, or the ultrawhite, air-conditioned, dust-free box of the museum— we should open ourselves to those seemingly disruptive energies "beyond the box" that can enable us to forge new links between the public and the private, the civil and the political. Only then will it be possible to "twist" the box, if not to collapse its sides altogether, thereby preventing the "new Asian museum" from becoming yet another front for the promotion of the contemporary Asian market. What we need is not a new museumization of museums, but a new socialization of its radical possibilities.

Mexico, DF, 1995

Notes

This intervention is a revised version of my talk at the international symposium "The New Asian Museum—Twisting the Box," organized by The Vancouver Centre for Contemporary Asian Art, 5–6 May 2000.

Many thanks to Hank Bull for sparking my interest in museums by inviting me to attend the symposium in Vancouver, and to the Prince Claus Fund for Culture and Development for facilitating my travel.

1. To retrieve an earlier history of pan-Asianism in India, we need to recall Rabindranath Tagore's seminal contributions on the subject, enhanced by his close friendships with other advocates of "one Asia," notably Okakura Tenshin (whose name is synonymous with the Japanese collection of the Museum of Fine Arts, Boston). Unfortunately, this history has been marginalized in studies of early modernism in the Indian subcontinent. When Tagore's universal humanism is invoked in the discourse of the social sciences, it is generally inscribed in the context of anti-imperialism and "the illegitimacy of nationalism," as Ashis Nandy (New Delhi: Oxford University Press, 1994) has conceptualized the poet's attitude without

sufficiently acknowledging his embrace of modernity. In the process, Tagore's inter-Asian *cosmopolitanism* remains insufficiently inflected, if not undermined.

2. For a critical overview of this Foucauldian discourse, which shows no signs of disappearing, read the special issue on "Asian Ways: Asian Values Revisited," *Sojourn* 14, no. 2 (October 1999), specifically Clive Kessler's lead article on "The Abdication of Intellectuals" (ironically subtitled "What Everybody Needed to Know about 'Asian Values' That Social Scientists Failed to Point Out").

3. Addressing the Renaissance City Report on 9 September 2000, the Singapore Minister for Information and the Arts, Lee Yock Suan, clarified that the use of the term "Renaissance" was not meant to "hark back to the post-medieval days of [the] European Renaissance;" rather, it was aimed primarily at establishing "Singapore as a global city of the arts," while "providing cultural ballast in our nation-building efforts." "Go international" is one of the key strategies of this cultural resurgence, which demands nothing less than "an arts and cultural 'renaissance' economy."

4. For an elaboration of inter-Asian theater practice in the context of global capitalism, read my monograph *Consumed in Singapore: The Intercultural Spectacle of "Lear,"* Centre for Advanced Studies Research Paper Series (Singapore: CAS and Pagesetters, 2000).

5. The multicultural polemic on "boxing the local" can be read in the animated and reflexive exchanges between the representatives of the Asian-Canadian artist community and the organizers of the symposium in Vancouver.

6. Arjun Appadurai and Carol Breckenridge's essay "Museums Are Good to Think: Heritage on View in India" was presented at a conference organized by the Rockefeller Foundation and the Smithsonian Institute. The essay is included in Ivan Karp, Christine Mullen Kreamer, and Steven D. Lavine, eds., *Museums and Communities: The Politics of Public Culture* (Washington, D.C., and London: Smithsonian Institution Press, 1992).

7. Ibid., p. 51.

8. Ibid.

9. Ibid., p. 36.

10. Tapati Guha-Thakurta, "The Museumised Relic: Archaeology and the First Museum of Colonial India," *The Indian Economic and Social History Review* 34, no. 1 (1997). All references to Guha-Thakurta in this paragraph are drawn from her essay, pp. 47–51.

11. Ibid., p. 51.

12. Tapati Guha-Thakurta, "Instituting the Nation in Art," in Partha Chatterjee, ed., *Wages of Freedom* (New Delhi: Oxford University Press, 1998), p. 122.

13. Val Williams and Anna Fox, eds., *Street Dreams: Contemporary Indian Studio Photographs from the Satish Sharma Collection* (London: Booth-Clibborn Editions and the Shoreditch Biennale, 1997).

14. Countering the implicit moral condemnation of cosmopolitanism as "uncommitted bourgeois detachment," Peng Cheah and Bruce Robbins have invented the term "cosmopolitical" to focus on "the mutating global field of political, economic, and cultural forces" in which the discourses of nationalism and cosmopolitanism intersect. See their edition of *Cosmopolitics: Thinking and Feeling beyond the Nation* (Minneapolis: University of Minnesota Press, 1998).

Encounters and Disencounters: A Personal Journey through Many Latin American and U.S. Latino Art Worlds

Carolina Ponce de León

"The four cardinal directions are three: north and south."

Ticio Escobar over drinks in Guadalajara

My complex position in relation to art comes from a lifelong journey of displacement, discontinuity, extreme contrasts, and cultural clashes—a trajectory through zones of perpetual difference and ever-evolving cultural paradigms. Along the way, art has revealed itself in many forms and has shaped my many-sided identities.

To explain, I will start from the beginning.

1

I was born in Bogotá, Colombia, in 1955 and immigrated with my mother and four siblings to New York City when I was barely six months old. I lived there throughout my childhood as a foreigner, an imaginary Colombian, a condition that has been at the core of my identity ever since.

I grew up in two languages. At home, we spoke a natural fusion of English and Spanish, each language filtering into the fissures of the other. I enjoyed the cultural advantage of being bilingual and inhabiting, at will, such different cosmologies as an

insider/outsider. Very early on, language became a form of escape and an instrument for cultural survival.

My other form of escape was art. With my mother, I discovered the Museum of Modern Art in New York, my favorite place in the world at that time. I felt secure there. Its architecture bewildered me; I was moved by its solemnity and the quiet admiration with which it protected, exhibited, and sacralized what seemed to me playful and childlike artworks. I was mesmerized by the whimsical art of Miró, Calder, Matisse, and Pollock. The "patriarchal," Eurocentric universe of modern art became my playground. I was completely taken by a photograph of Picasso painting in his underwear. I recognized myself as a member of his tribe. I was determined to become an artist and began to draw compulsively. I was six or eight years old.

My brother and sisters soon became radical teenagers, always ready to explore unlimited universes. Gradually, I was tempted by the taste of rebellion. I was still too much of a little girl, but I became a voyeur, watching their experimentation with awe. Behind my mother's back, Jim Morrison and the Doors, the Velvet Underground, Procol Harum, Bob Dylan, Jefferson Airplane, Andy Warhol, water pipes, drugs, and enthusiastic sexuality came into our home, in keeping with the effervescence of the times. Through my siblings' sense of adventure, I acquired a thirst to push the limits. Art: my maximum expression of desire.

In 1966 I moved to Paris with my family. I was eleven years old. Having been raised with the American eagerness for modernity and the future—with images of the first man on the moon—I was in a state of culture shock. Compared with New York, Paris seemed provincial and old-fashioned, sensual yet weighed down with an excess of historical vanity. My classroom, my teacher, and my schoolmates all seemed trapped in a black-and-white postwar movie. Nevertheless, my "Third Worlder" status turned out to be the perfect excuse for my teacher, with her dead-dragon breath, to harp on how privileged I was to be exposed to French culture. During those years, I felt treated as an inferior cultural Other in desperate need of colonization. As an unconscious act of resistance, I learned to *parler français* with a perfectionist's obsession. Language, once again, became the ideal medium for the art of cultural camouflage. However, I, who considered myself a daughter of the New York pop world, had become a cultural orphan: I still wasn't a Colombian, and I certainly wasn't a European. I had become a cultural transient.

With my mother, I often visited the Louvre, which appeared to me as the epitome of cultural arrogance. Art had been transformed into an imperialistic device of

nationalistic narcissism, the unscrupulous display of French colonialism. Unknowingly, I was becoming aware of the tacit power structures endemic to the world of art.

Meanwhile, the 1967 Palestinian-Israeli war, the student uprising of May 1968 in Paris, and the media images of the civil rights struggles in the United States opened even wider my voyeuristic child's eyes. The world frightened me. To overcome the vertigo, I began to write and illustrate poems in which I proclaimed my romantic desire to flee toward the haven of freedom.

When I was fourteen, my family moved again, this time to Belgrade, Yugoslavia. My already multifaceted identity was about to explode into a thousand pieces, so I dismissed the opportunity to learn Serbo-Croatian. My sense of cultural loss became acute; my longings were filled with nostalgia for American pop culture and for my imaginary Colombia. I was yearning for an impossible home and sense of belonging. I was a teenager trapped in a tunnel. Colombia became ever more distant, ever more mythical, like a photograph of laughing, loving relatives at a garden party that was fading away, little by little. My drawings poured out, one after another, compulsively. Only art protected and saved me.

One fine day, I announced to my mother that I wanted to live in Colombia. I "immigrated" there at fifteen, without my immediate family, to reclaim what were, technically, "my cultural roots." Contrary to my expectations, reclaiming my roots was neither immediate, nor natural, nor even possible. My wild look, with long, unruly hair, embroidered peasant blouses, and a guitar over my shoulder, automatically turned me into a threat to the conservative family environment to which I had come "home." My cousins insisted on taming my hair, my ideas, my clothes. My new friends called me *gringa.* I was not fluent in Spanish, and I had an accent; French and English betrayed my desire to be a pure Colombian.

In my own country, I had to negotiate my "difference." I had become a multicultural phenomenon, viewed with suspicion. The imaginary basis of my "Colombian" identity, which had sustained me throughout all those years abroad, was shattered forever. The United States and Europe had condemned me to perpetual cultural exile. My salvation was to declare myself a citizen of my other country, art. I enrolled at the Universidad Nacional in Bogotá. I was going to be an artist.

But no. I was not able to reconcile myself entirely with "painting," which, at that time in Colombia, seemed to be the only route for an artist. Despite my teachers' auspicious predictions, I decided to end my artistic career at the birth of my son Sebastián, the light at the end of all my doubts. From that moment on, my relationship

with Colombia began to stabilize. I lived there for the next twenty-five years. It was there that I was formed in practice as a curator and an art critic.

2

Like most Latin American countries, Colombia lacked a structured art system of cultural institutions, galleries, and collectors. Yet, however precarious, its artistic infrastructure resolutely supported modernist values. The majority of emerging artists were mostly ignored by the institutions and by the public; hence, contemporary and conceptual art practices were barely tended to. Consequently, one of my first objectives as a curator was to provide a public space for young artists and experimental art practices. In spite of the uncertain economy—an endemic problem for all Colombian cultural enterprises—I bolstered the deep conviction that I would fulfill my professional destiny by training, challenging, subverting, and revitalizing the Colombian art world. As curator of the Biblioteca Luis Ángel Arango of Bogotá, a position I held for ten years, I established a national program for emerging artists, and became an accomplice of the young generation of experimental and critical artists working at the margins of recognition, traditional mediums, and art institutions.

By the mid 1980s, the whole country began to witness the merciless crumbling of all institutional and symbolic moral structures due to the corruption of the political class, the judicial system, and the military. Terrorism and the assassination of journalists, politicians, *campesinos,* indigenous peoples, and left-wing activists were at the heart of the obscure and changing alliances between the drug cartels and the guerrilla forces, and between the military and extreme right-wing paramilitary groups. An increasing number of deaths surpassed the official count of 30,000 victims per year. Everyday life in Colombia became a bloodbath, to the point of genocide, filled with murder, torture, mutilation, disappearances, massive displacement, kidnappings—in sum, every kind of social, political, psychological, and economic violence imaginable, or even unimaginable. Violence had deeply infiltrated the Colombian psyche.

Extremely moved by all of this, I devoted myself to working with artists who defied the reigning atmosphere of trauma, rage, and confusion by taking on a conscious responsibility toward what it meant, in Colombian society, to make art and be an artist. I worked with artists such as Beatriz González, whose emblematic paintings evoked a mythic dimension of violence; Doris Salcedo, who created a poetics of mourning objects; and Miguel Ángel Rojas, whose work brightly revealed a radical autobiography that exposed the dark side of Colombia's pyramidal, conservative, and homophobic society.

However modestly, artists became increasingly committed to constructing a different way of seeing and representing the experience of violence. Since the end of the 1980s, a large number of Colombian artists have created a visual forum that gives symbolic structure to a historical experience that is simultaneously private and collective, real and mythic. This collective body of work put into perspective the significance of violence in the construction of the country's political and cultural thought. As a collection of diverse narratives, it provided agency to confront and subvert historical amnesia, indifference, and horror—a means for bold resistance that poignantly confirms the words of Colombian writer Rafael Moreno-Durán: "If it weren't for death, Colombia would have no vital signs."

This experience changed, forever, my relationship with art and with its unique ability to link the politics and the poetics of personal and collective experience, of culture and society.

3

Perhaps because of my sense of belonging to multiple worlds, I valued the need to examine art in Colombia within the larger framework of Latin America. Determined to establish strategic connections with other cultural processes that were parallel to our own, I began organizing a series of exhibitions of Latin American art.

It was the beginning of the 1990s, the peak of the so-called multicultural years. The postmodern notion of cultural relativity encouraged adventurous U.S. and European curators to decentralize their practice and travel to Latin America, Africa, and Asia just as the United States was preparing for—and debating—the quincentennial anniversary of the "New World." All throughout 1990 and 1991, less than a handful of curators came to Bogotá for quick visits. They were seeking an "authenticity" beyond folk art, one that would "translate" if transported to neutral cultural grounds, meet their standards of taste and spectacle, and survive the sophisticated demands of art theory. Many Anglo and European curators never made it to Colombia, however, mainly because the dangers associated with Colombia didn't seem to inspire the same thrills of fantasy, desire, and prohibition associated with, for example, Mexico City, São Paulo, or Havana.

Meanwhile, back at *el rancho* . . . several of my Latin American and U.S. Latino and Latina colleagues began organizing a series of survey exhibitions on Latin American art throughout the United States. These exhibitions asserted alternative art-historical frameworks to the dominant Eurocentric paradigms and established the grounds for a two-way art circuit between North and South.[1]

My attention began shifting toward the evolving discourse of intercultural politics advanced through the work of this new generation of Latin American critics and curators, which involved art and cultural theorists such as Gustavo Buntinx, Ivo Mesquita, Gerardo Mosquera, Mari Carmen Ramírez, and Nelly Richard, among others. From the Havana Biennial to academic encounters in São Paulo, Bogotá, Caracas, and Santiago, new critical perspectives were being proposed to contextualize both Latin American art and the paradoxical relationships between dominant cultures and the Other.

This focus led, in 1992, to *Ante América*, an exhibition I organized at the Biblioteca Luis Ángel Arango in Bogotá, along with Cuban curator Gerardo Mosquera and Rachel Weiss from the United States. *Ante América* arose as a ground-breaking counter-1992 exhibition aimed at remapping the landscape of "American" art by presenting a highly politicized vision of a hemispheric, multiethnic America. Besides Colombia, Venezuela, and Costa Rica, the exhibition also traveled to, among other venues, the Queens Museum of Art in New York, the Centro Cultural de la Raza in San Diego, and the Yerba Buena Center for the Arts in San Francisco. *Ante América* was a unique case of an exhibition moving from South to North, and thus crossing a highly guarded cultural border. As Mosquera stated at the time, *Ante América* was organized with the boldness of "Pancho Villa invading the North."[2]

Precisely because I was raised in zones of tension between the First and Third Worlds, I felt the need to further understand and participate in the evolving processes of cultural negotiation. Hence in 1995, after twenty-nine years, I decided to return to New York.

4

As a Latin American immigrant, I was suddenly conscious of the radical transformation of the city's populace—a "mosaic" of decolonized nationals, "hyphenated" Americans, and "newcomers" from Latin America, Asia, Africa, and the former Soviet bloc. Twenty-four percent of the population was of Latin American descent. I recognized my condition of cultural displacement in the experience of these many immigrants, and could lay to rest my uprootedness, for good. I was discovering a new sociocultural context and became a "born-again Latina," one among many immigrant "aliens" from the postcolonial world.

The New York art world and its power structures overwhelmed me. I was troubled, to say the least, by the angst of New York networking and the traffic in business cards, by the unspoken class system that isolated different sectors of the art world. Since I am an "ethnic white," I was able to cross over easily from one sector to another;

nonetheless, my identity became contextual—a discrete condition of the cultural Other. I was perceived either as a "Latin American expert" or as a "*barrio* curator." Cultural romanticism and demonization—the evil twins—were fully intertwined. However distressing this experience was, it allowed me to get an insider's view of the self-proclaimed international art world. Simultaneously, I reorganized my sense of purpose in my new professional and political territory.

I was in the center of the center, in the heart of the Big Apple and the northern extreme of the South: the other Latin Americas, the ones rooted in the American imaginary and in the multilayered experience of U.S. Latinos. The many worlds of Latin American art began to split apart before my very eyes.

Not only were my colleagues and I faced with the misrepresentations of Latin American art in the dominant art world, but we were also confronted with the self-exoticizing strategies promoted from our own countries. In the early 1990s, the economic downturn in the United States and the epidemic of neoliberal economies in Latin America contributed to the blossoming New York–based Latin American art market. Largely sustained by Mexican and South American collectors, works by the much-touted "masters" (Rufino Tamayo, Fernando Botero, Diego Rivera, Frida Kahlo, and Wifredo Lam, for instance) and by the young members of the *neo-mexicanista* movement, such as Julio Galán, Alejandro Colunga, and Nahum Zenil, reached unprecedented sales records. Latin American art became a luxury commodity for cultural export. Annual sales at Christies increased from 2.5 million dollars in 1981, when they founded their Latin American Art Department, to more than 27 million dollars in 1999. North and South became blurred by the outpouring of capital.

The combination of hype and speculation, and the flow of capital, favored the rise of an "alternative mainstream," which began to be featured in U.S. museums and galleries. It comprised a generation of contemporary artists—mainly from Cuba, Brazil, and Mexico—who had already been established since the 1970s and 1980s in their native countries, yet had received limited acknowledgment in the United States and Europe.[3]

With headquarters in New York, São Paulo, Buenos Aires, and Mexico City, two distinct art circuits emerged. One was the state-sponsored "art for export" model, with nationalistic undertones and modernist ideals, sustained by Latin American capital invested in the global economy. The second was the "contemporary global art scene," to which most Latin American artists aspire access, without ethnic or national labels, as members of the international avant-garde. This exchange between North and South is but one example of the subordinated networks linked to the global art scene. Both

circuits led to upward mobility—the transnational art world—supported by a multinational clique of dealers, collectors, and galleries. Consequently, the prestige and market opportunities that come with them easily lure Latin American artists (and artists coming from parallel cultural realities) into biting the juicy apple of New York–instituted artistic paradigms.

However, not everything was about glamour and money. Continuing to pursue intercultural alliances, I made the choice to work with Latino institutions: first as a curator at El Museo del Barrio in New York, and then as director of Galería de la Raza, a not-for-profit Chicano art space in San Francisco.

At El Museo del Barrio, I found myself "at home" again on the border between two worlds. El Museo's very location is a metaphor of the ambiguous position that "ethnic-specific" arts organizations have within the city's cultural landscape. Located on Fifth Avenue, at the top of the Museum Mile (which begins at the Metropolitan Museum of Art), it is also part of *el barrio,* the Latino neighborhood of East Harlem. El Museo is literally on the rim of the world-class museum establishment while at the same time directly rooted in an unresolved history of migration and neocolonization. I experienced the other side of the Latino artist community, one that is divided and subdivided by ethnicities, nationalities, class, art practices, and dissimilar degrees of immigration.

My first direct experiences involved, on one hand, the apprehension many Latin American colleagues and artists expressed to me for El Museo's Latino-specific mission and, on the other, the never-ending complaints U.S. Latino and Latina artists had about the privileged attention given to their Latin American peers.

One symptomatic episode took place in October 1997. El Museo inaugurated a show on the Taínos, the Caribbean's native inhabitants before the Spanish conquest. Since the New York Latino population is largely of Caribbean origin (from Puerto Rico, the Dominican Republic, and Cuba), the show was received with a great deal of nationalist fervor.

At the opening ceremony, as one of the museum's curators, I was wearing a name tag with my family name prominently displayed. Suddenly, an artist began to proudly proclaim that "the Taíno heritage lives on, five hundred years later, in spite of the attempt at annihilation by the Spaniard Ponce de León during the conquest." He belonged to a group called "The Neo-Taínos of New Jersey," his ceremonial bare feet on the Fifth Avenue sidewalk an involuntary metaphor of the perplexing fusion of ethnic essentialism and contemporary transculturalization. His speech was greeted with shouts of approval and enthusiastic applause. I, on the other hand, felt the vertigo of different

moments of colonial history colliding: indigenous Americans versus European colonizers; Latinos versus Latin Americans; disenfranchised communities versus privileged ones. All of these conflicts were signified instantly by my nametag, at a Taíno ceremony, on a New York Sunday morning in *el barrio*. I discreetly hid it in my pocket.

This anecdote mirrors the conflictive nature of Latino and Latin American relations. Being hired by El Museo to carry out its newly established Latin American mission, I had to wonder about the ethical and political implications of interjecting Latin American art into an organization founded by a historically marginalized community. I asked my friends; several warned me that my challenge involved reconciling incompatible differences. My own bifocal position, as a Latin American curator and "born-again" U.S. Latina intellectual, encouraged me to look for productive ways to intersect these separate art worlds.

5

Latin America stands on fractured territory. It inevitably includes the virtual continent of deterritorialized, neocolonized, and decolonized Latin American expatriates, migrants, exiles, and cultural orphans—the 35 million people of Latin American descent who represent 12.5 percent of the U.S. population, a tally that is expected to reach 42 million by the year 2010. As great capitals from Latin America are being invested into the global economy (as free-trade partners), new "peripheries" composed of U.S. Latino and immigrant communities are being reconfigured within the United States.

U.S. Latino and Latina artists are often deprived of the romantic undertones awarded to artists born south of the U.S.-Mexico border. The U.S. economy of poverty applied to U.S. Latinos and immigrant communities does not quite resemble the atmosphere of partnership that surrounds U.S. trade with neoliberal economies in Latin America. By extension, many Latin American curators—and artists—seem suspicious of U.S. Latino art and of the organizations that support it. They argue that identity politics (which are often used to frame U.S. Latino art) unsuccessfully contain the complexities of Latin American art and ultimately exclude it from contemporary art discourse. In conclusion, they fear being marginalized by the undeclared "class system" of the broader art world.

In the late 1990s, with the backdrop of nouveau chic otherness and the economic cushion of free-trade markets, Latin American curators developed a new approach to secure artistic legitimacy: simulating the colorblind mainstream. This postethnic strategy liberated them from the rhetoric of minority politics. Contrary to the

explicit issues of race, gender, and class, many Latin American curators infused their theoretical discourse with Oswald de Andrade's 1928 concept of *antropofagia*—the cultural cannibalization of European avant-garde art, an improved version of mestizo tactics where anticolonial critique is subtly at play.

In very general and simplified terms, art in Latin America is more likely fashioned by the neoconceptual postminimal practices of the "international avant-garde." U.S. Latino art, inversely, tends to be informed not only by contemporary art practices but also by U.S. pop and Latino street culture. Often gravitating around the intersection of North and South, of the vernacular and "high" art, U.S. Latino art is also frequently both inside and outside of the art world's borders.

Contextualizing U.S. Latino and Latin American art has entailed taking in divergent forms of cultural negotiation, depending on which side of the U.S. border they are conceptually on. The notion of "border" becomes extremely complicated within the specific binational, bicultural experience of Nuyoricans and Chicanos/Chicanas. As "nationless" residents who carry a U.S. passport, Nuyoricans inhabit "the enchanted island" of Manhattan as postcolonial citizens of a hybrid America. On the other hand, Chicanos and Chicanas, as indigenous inhabitants of the Southwest, reside in the conceptual "nation" of Aztlán, the "Original Land" lost to the United States in 1848.[4] As double outsiders, U.S. Latino and Latina artists live in a cultural limbo. They are often unwelcome in the "global" art world because of their alleged "folk" aesthetics and politics. They are also frequently excluded from the art worlds of their original homelands. U.S. Latino and Latina artists are constantly challenged to turn this exclusion into a valuable asset for their multifocal understanding of cultural politics and of the politics of art.

6

How do all of these contradictions fit into the homogenizing perspectives of global art circuits? This impending question has made me ever more suspicious of "global art world" cheerleading. Over the last twenty years, multiculturalism, identity politics, and postcolonial discourse have infused the discussion with the rich ethnic and gender diversity of the subjects they address. Curators, dealers, collectors, and art professionals from New York to Los Angeles, London, Berlin, Madrid, and Tokyo eagerly travel to the new centers of Third World biennials. There, they join forces with their amiable colleagues from the "outer mainstream" while aspiring to create a decolonized territory beyond the central art system. The positive outcome is a more inclusive art world; the

negative is that, within those confines, cultural difference is homogenized and commodified, a mere mainstream prop without specificities and definitely without the points of tension of its critical practices.

The postmodern displacement of the center is yet another postmodern simulation: the center has not been displaced, it has just gotten bigger. Globalization has led to the recolonization of the art world. It has mostly achieved what Gerardo Mosquera describes as "a tolerance based on paternalism and *political correctness.*"[5] As a result, the cults of postcolonial otherness and of globalization have become strangely interchangeable. The global art world is a colonizer captivated by the strategies of decolonization.

7

As a deterritorialized, post-Colombian, trans-Latina/Latin American curator, I have crossed from one side to the other of national, ethnic, class, and cultural borders. I have experienced the North from the South, the South from the North, the South in the east and west coasts of the United States, and the First World in the Third World and vice versa so often referred to by postcolonial theorists.

In 1998, following my heart, I migrated yet again to San Francisco, a city where 41 percent of the population is foreign-born. The "South" is omnipresent across California by virtue of the high demographics of Chicanos and Mexican and Central American immigrants, as well as the vestiges of its historical past found in the architecture, city landmarks, and street names. It is also present in the pervasive infiltration of Latino street culture, Spanglish, and Latin American cuisine into the mainstream. California is the paradoxical land of World Beat culture and of the sinister Propositions 187 (abolishing medical care for illegal immigrants) and 227 (ending bilingual education). Settling among these tensions, I realized that I had also migrated to Aztlán, the conceptual refuge for many non-Chicano Latinos and Latinas such as myself, who live here as bicultural citizens.

The art world I encountered in San Francisco was very different from the one I had found in New York City. First, the oppositions between U.S. Latino/Latina and Latin American artists are absent. Whether in exile or living in their native countries, "international" Latin American artists are concentrated in New York and have a very sporadic presence on the West Coast. Also, contrary to the neonationalist positions of certain sectors of the Caribbean artist community that I witnessed at El Museo, Chicano

institutions in San Francisco seemed to embrace broader understandings of community, nationality, ethnicity, and gender.

Operating outside of the formalities of a museum setting and within the open structures of a grassroots organization has allowed me to work in a collaborative, interdisciplinary environment with artists concerned with going beyond conventional cultural boundaries and with exploring experimental forms of activism through digital media, performance, and installation art. My role as a curator has extended beyond the visual arts. I consider myself more of a cultural DJ, attempting to "sample" a more dynamic understanding of "diversity" and of Latino/Latina cultural production. By constantly shifting between the *high art* of museums and Latino pop culture, between fringe cultures and the so-called mainstream, between visual arts, performance, and spoken word, we have been aiming at community-building across all borders, seeking a balance between grassroots efforts and true internationalism, where difference thrives.

This effort seems ever more urgent since September 11, 2001, with the resurgence of a right-wing fury fueled by the rhetoric of "evil." In view of this newly enforced cultural era, promoting Latino and Latin American art per se has become a dispensable purpose. Working within a U.S. context, it does however enable a vantage point, one among others, one in connection to others, from which to examine the myriad voices and visions that, through art and difference, can shed light on the shared and disparate conflicts of the global crisis.

8

If I could appropriate just one image to illustrate this personal journey, I would choose *Verde por fuera, rojo por dentro (El closet de mis padres) [Green on the Outside, Red on the Inside (My Parents' Closet)]*, created in 1996 by Meyer Vaisman. It is a landscape consisting of a Third World rancho (a shanty like those that haunt the outskirts of any major Latin American metropolis) that has been "transplanted" to a quaint eighteenth-century French garden in Portugal. In the interior of the shack, Vaisman has reconstructed a fragment of his childhood upbringing, the sober and untainted 1960s middle-class sanctuary of his Romanian and Ukrainian parents' bedroom closet in Caracas, Venezuela. Outside, black bean plants flourish gently amid the restricted geometrical patches of the garden. Originally from Brazil, these plants are the fruit of successive harvests in different countries. They are live examples of the imperceptible negotiations between economics, memory, and displacement that nomad cultures must constantly make. This image, filled

8.1
Meyer Vaisman, *Verde por fuera,
rojo por dentro (El closet de mis
padres) [Green on the Outside, Red
on the Inside (My Parents' Closet)]*,
1996, installation. Photo courtesy of
the artist.

with contradictions and unexpected harmonies, evokes in me a peculiar kind of hope. It is, perhaps, the perfect metaphor for the conceptual home I long to inhabit. A place of resistance, in a constant process of reinvention, where the politics and the poetics of art—whether subtle, lyrical, spiritual, critical, or transgressive—can go beyond the exotization of cultural difference and play a significant part in the collective articulation of a truly diverse and democratic forum.

San Francisco, 2002

La Habana, 2000

Notes

1. Some of the most significant exhibitions of Latin American art organized throughout the decade include *America: Bride of the Sun,* Royal Museum of Art, Antwerp, Belgium (1992), curated by Catherine de Zegher; *Ante América,* Biblioteca Luis Ángel Arango, Bogotá, Colombia (1992), and other venues in Latin America and the United States, curated by Gerardo Mosquera, Carolina Ponce de León, and Rachel Weiss; *Cartographies,* Winnipeg Art Gallery, Canada (1993), curated by Ivo Mesquita; *The School of the South: El Taller Torres-García and Its Legacy,* Archer M. Huntington Art Gallery, Austin, Texas (1994), curated by Mari Carmen Ramírez; *The Spirit of Latin American Art,* Bronx Museum, New York (1994), curated by Luis Cancel; *Re-Aligning Vision: Alternative Currents in South American Drawing,* Archer M. Huntington Art Gallery, Austin, Texas (1997), curated by Edith Gibson and Mari Carmen Ramírez; and *The Experimental Exercise of Freedom,* Museum of Contemporary Art, Los Angeles, California (1999), curated by Rina Carvajal.

2. Gerardo Mosquera, *Ante América,* exh. cat. (Bogotá: Biblioteca Luis Ángel Arango, 1992), p. 12.

3. In the late 1990s, for the first time in mainstream institutions, U.S. audiences were able to view solo shows by artists such as Hélio Oiticica, Cildo Meireles, Gabriel Orozco, Eugenio Dittborn, Tunga, Kcho, and Doris Salcedo.

4. The "Original Land" consists of California, Arizona, New Mexico, southern Colorado, and parts of Nevada and Utah, which were acquired from Mexico in 1848 in the aftermath of the Mexican-U.S. war. Texas was separated from Mexico a decade earlier.

5. Gerardo Mosquera, "Infinite Islands: Regarding Art, Globalization, and Cultures, Part I," *Art Nexus* (Bogotá), no. 29 (1998), p. 67.

Forms of Resistance, Corridors of Power:
Public Art on the Mexico-U.S. Border

José Manuel Valenzuela Arce

dedicated to Tomás Ybarra and Amelia Malagamba

Current cultural debate places special emphasis on the processes of creating and re-creating cultural frontiers, visualizing these zones not as barriers but as points of crossing and contrast, of intersection and interstice, of appropriation and resistance. Borders are spheres of changing social relations, and single-faceted interpretations can contribute little to our understanding of them. Mexico's northern border, for example, comprises interstitial and rooted spheres subject to intense processes of transculturation, reinvention, resistance, and cultural frictions. It encompasses specific conflicts, such as deep-seated hostilities over the shifting of the international frontier following the defeat of Mexico by the United States in the Mexican-American War in 1848. Under the redrawn border, Mexico lost half of this territory to the United States, and thousands of Mexicans were suddenly transformed into residents of an alien land. Along with the new borderline came new origin myths, new identities, new languages. Also emerging on the scene were new mythical figures of social resistance, such as the *bandoleros,* who appeared in the second half of the nineteenth century.

Another quality that defines the border is its heterogeneity. The border region encompasses (a) dozens of indigenous groups whose territories were split by the 1848

Treaty of Guadalupe Hidalgo and whose members now live on both sides of the frontier; (b) strong regional differences along the length of the border; (c) a diversity of ethnic groups; (d) important differences in gender balance; (e) a range of identity markers adopted by the region's youth (pachucos, cholos, hippies, rebels, surfers, punks, rockers, Goths, and ravers); (f) sociocultural "disencounters" triggered by escalating racism, stereotyping, and prejudice; and (g) an interweaving of cultures as people from many regions converge on the border as participants in the intense migratory flows that populate this region.

And on top of all these defining elements of border relations are sociocultural processes rooted deeply in national contexts and symbolic allegiances to an imagined nation that led each domain to mark out and defend its areas of authority. One result is that some two thousand people have perished trying to cross the border into the United States, a virtual funeral procession. Another element is the percentage of Mexicans who reside outside of their nation's territory. These individuals are equal to one-fifth of Mexico's population, and their remitted earnings represent Mexico's third-largest source of foreign income. The existence of these groups also carries foreseeable implications regarding double citizenship and the right to cast ballots from abroad in Mexican elections.

This essay will examine the various experiences of inSITE97[1] from the perspective of these transborder cultural arenas (understood as foundational and interstitial). It will also give special consideration to the circular processes of cultural feedback and exchange through which influences flow in multiple directions.

The influence of Mexican art on Chicano artists has been widely documented, but little research has been directed toward demonstrating the reverse: that is, that Chicano art has influenced Mexican artists. We know very little about the circular, almost osmotic processes of artistic exchange that cross and recross the border, or about their repercussions on the development and self-identification of groups who have reclaimed important elements from the production and symbology of Chicano murals. This type of exchange is especially visible in poor neighborhoods on Mexico's northern border, where one finds murals created by cholos[2] and the more rare but important artworks that have come about through transborder collaborations.

My aim is to place inSITE within this complex scenario of the transborder artistic experience in order to identify its unique contribution to the interpretation of border-zone cultural processes.

Chicano Art

Chicano art is an art of symbiosis, defined by layers of transborder interaction. It develops out of a collision between U.S. society and Mexican society. It is logical, then, that Chicanos would embrace Mexican symbols and Mexican mural art when shaping their referents of social and political resistance and redefining their place in U.S. society. The Chicano movement and Mexican mural art coincide in the belief that art is a powerful resource for social change, a positive channel, not for mourning the past, but for portraying potential realities, alternative paths leading toward coexistence. But Chicano mural art is not an afterthought to a fully developed Mexican mural art. Instead, it marks a new beginning. Mexican and Chicano mural art converged in an imagined metaphor, in an original and mythical re-creation.

The spark of Mexican mural art was fed by the winds of revolution early in the twentieth century. Although the genre was later integrated into the political project of Mexico's postrevolutionary governments, it retained its critical voice. The muralists proposed a more just, less racist society, one with a strong socialist vein, and one in which the oppressed played a noble role as protagonists of a civilizing project.

Mural art's impact was consolidated in the 1930s when Mexico's "three masters"—José Clemente Orozco, Diego Rivera, and David Alfaro Siqueiros—painted numerous works in the United States. These murals brought them recognition among U.S. artists and intellectuals. Besides the legacy that these artists bestowed through their work, the three also sparked the so-called Mexican invasion of the 1920s and 1930s, which established new foundations upon which to form cross-border connections through art. These connections included U.S. artists' survey trips to Mexico, to experience firsthand the tremendous power that was expressed in the murals. Rivera's exhibition at the Museum of Modern Art in New York in 1931 broke all prior attendance records. It attracted an audience of 56,575, twenty thousand more than had attended any prior show of a single artist. Also without precedent was the inauguration of Rivera's mural in the Art Institute in Detroit, which was attended by more than 86,000 people.[3]

These three artists created artworks that resonate deeply in the daily lives and hopes of the Chicano community. In the 1960s, the community made them an integral part of the decade's ongoing debates about a suffering people, indigenousness, ancient and modern-day migrations, and the devastation of millenarian cultures.

Chicano mural and graphic art from the 1960s and 1970s is interlaced with the anticolonialist and antiracist movements of those decades. This art asserts the presence—and the cultural dignity—of the Mexican population in the United States. More than a

century after the Mexican-American War, which marked the beginning of a continuing process of social subordination and ethnic discrimination, a sociocultural system was still firmly in place in which ethnicity played the determining role in defining a person's options and opportunities. Nearly 100,000 Mexicans were denied their nation when the U.S.-Mexican border was redrawn in 1848. They were later joined by many more. Some arrived in the waves of Mexicans fleeing their country in moments of national upheaval. Others were drawn by the demand for labor in the United States, where the agricultural and service sectors had a nearly insatiable need for workers.

In the mid 1960s the Chicano community, following a path already traced by African Americans, developed an important political discourse in opposition to racism and inequality. The core of the Chicano response revolved around protests against colonialism, racism, discrimination, U.S. military interventionism, and the Vietnam War (in which minorities, especially Chicanos, were dying in disproportionately high numbers). These were also the years of the counterculture. The other major movement of this period was the women's movement, which was broadly critical of a society anchored in patriarchal discourse and which placed biopolitics at the heart of sociocultural change.

Chicano art re-created central aspects of this popular culture. Tomás Ybarra-Frausto offers an interpretation of this sequence in his examination of Chicano art through related or parallel artistic developments, such as the saint-makers (*santeros*) of New Mexico. Between 1821 and 1860 the *santeros* developed a visual iconography in missals, prayer books, and paintings. Their art constituted an embryonic translation of Mexican popular art for a population that had been bisected by the redrawn boundary of the Treaty of Guadalupe Hidalgo. The saint-makers carved statues of saints and altars with Christian saints, but they also made images that incorporated older motifs of ancient customs, idealized landscapes, and a dreamed-of homeland. They introduced sacred images, especially the Virgin of Guadalupe, into calendars that would hang in the kitchens, parlors, and bedrooms of the Mexican population.[4] The images were thus fused with the cultural practices of everyday life—the life of the barrio, the pulque stands, altars, tattoos, cholos, offerings, and small artistic renderings in thanks for miracles performed. The waves of migration carried many Mexican artists to the United States. Some worked as illustrators for Spanish-language newspapers such as *La Prensa* in San Antonio and *La Opinión* in Los Angeles. Others did illustrations or painted murals in shops, bars, and restaurants. They filled their neighborhoods with images of popular culture and pre-Columbian symbols, of Mexican heroes and religious effigies.[5]

Over and above the clear influences of popular Mexican art that came from the resident populations of territories appropriated by the United States after the Mexican-American War and from later-arriving Mexican migrants, Chicano art also drew sustenance from Mexican mural art and the relationships that developed between Mexican and Chicano artists. Chicano artists took up many of the themes that addressed shared historical and cultural experiences—pre-Hispanic symbols, images of the Conquest and of a prior idealized rural existence, class struggle, and a people at the nucleus of history.

If we look at the recurring themes in the first period of Chicano art, we find that the key concepts in the graphic art and murals of this movement reflect the artists' immersion in the struggle to open new spaces for freedom and self-determination. These influences include (a) the impacts of the Civil Rights movement of the 1950s; (b) the Cuban Revolution and its resonance among young people throughout the world; (c) the farmworkers' movement led by César Chávez and Dolores Huerta, which culminated in the founding of the United Farm Workers and which engaged the political-symbolic dimension of the Virgin of Guadalupe as well as the engravings of José Guadalupe Posada and the Taller de la Gráfica Popular in the pages of *El Malcriado;* (d) the mark of the 1968 student movement and its violent, often bloody engagements with the system; (e) antiwar protests during the Vietnam conflict through the Chicano Moratorium Committee, which organized multiple demonstrations, the last of which was a national-level protest held on August 29, 1970, in Los Angeles; (f) the reawakening of the American Indian movement and Chicano neo-indigenousness; (g) the women's liberation movement and the involvement of Chicana artists who introduced issues of gender into the movement and resurrected images of pre-Hispanic women or prominent women of post-Conquest Mexico, women such as Frida Kahlo who became the archetypal figures of Chicana feminism; and (h) the life of barrio youths, whose original cultural codes combined in a rich sociocultural expression in the barrios, in the jails, and in the households of Mexican and Chicano families.[6]

Simultaneous with the Chicano movement was the appearance of art in public spaces. These murals shaped new contexts in which residents of Chicano barrios posed new sets of questions, and community members worked alongside artists in painting the murals on fences and walls, catalyzing intense social processes of coparticipation. While the Mexican muralists of the 1920s and 1930s decorated interior walls of public buildings, the Chicano artists' "canvas" was the barrio, and their interlocutors the barrio residents. The Mexican muralists were highly trained and specialized artists; Chicano artists were self-trained members of the community.

The linking of Chicano art with the community's interests, demands, and cultural resistance came about through the artists' own experiences. They originated from within these communities, and most were members of the working class. They turned to public space as an arena for artistic expression and also as a battleground upon which to wage political war using murals and graphic art, which also served to document Chicano history.[7]

The Wide-Ranging Legacy of Border Mural Art

In border cities, inequalities collide and converge, are reinvented, and become complementary. Public art contributes to the assignment of new meanings to spaces and borders. It embodies elements that redefine borders' meanings and cognitive aspects, but it also partakes in laying claim to symbols. This was true of the great murals of Mexico's postrevolutionary period, which spoke to an audience that was illiterate yet fully versed in the basic codes with which the artists expressed their vision. Chicano artists' critical appropriation of elements from Mexican mural art opened up new ways to link members of their community. With this act, Chicano artists were duplicating the efforts of a cadre of African American artists who used mural art to present their political alternatives for a more just multicultural society. The African American artists, however, were not addressing an illiterate population but groups who spoke different languages and practiced different cultural traditions.

Graffiti is another form of expression that has contributed an important thread to the urban fabric, especially through cholos' spontaneous inscriptions, with their angular calligraphy and letters that allude to cholo power and to the barrio. Urban graffiti is also the medium of choice among "taggers," a group whose bold blitzes first appeared in New York in 1972 as an offshoot of hip-hop, along with rap and breakdancing.

The key defining feature of urban space in Mexico is social inequality. In the United States, social inequality is compounded by differentiation and segregation along ethnic lines. The linkages between these themes in Chicano art and the daily lives of the Chicano community supported the development of a close relationship between Chicano art and Chicano society. Public art permeated intimate space, traced territorial boundaries, and constituted symbolic landmarks illustrating forms of cultural resistance. These influences rippled throughout the population and helped define barrio residents' forms of expression. This happened, for example, beginning in the mid 1970s, when cholos appropriated building walls, along with the symbols that define the threshold for membership in La Raza[8] vis-à-vis the global society and the dominant symbolic universe.

Because *cholismo* extends across a transborder environment, it has catalyzed vigorous processes of cultural exchange and led to the rediscovery of shared elements endemic to a common cultural matrix. In this context, the Mexican tradition of mural art that had influenced so many Chicano artists in past decades suddenly reappeared. It spread widely, but not in a search for artistic recognition or as a way to intervene in civic spaces. Instead, it surged up from the barrio with no greater ambition than to mark the barrio's boundaries, its symbolically identified territory.

Murals were transformed into symbols of identity and neighborhood pride. But this role was also the source of their vulnerability, their susceptibility to attack by members of other barrios. In destroying a mural, one could humiliate the people who had created it. Even adults and children of Mexican ancestry who did not self-identify as cholos took part in the campaign against the murals, seeing this as a way to stamp out *cholismo.* They succeeded in destroying a huge number of murals, but new ones took their places and in a few cases some of the damaged murals were restored or re-created.

The retaking of public space through murals and graffiti re-created symbols of identity. Religious elements proliferate in this art, especially representations of the Virgin of Guadalupe (though more as a cultural identity marker than as a sacred image) and the crucified Christ, whose anguish was seen as paralleling the sorrows of the barrio. Tricolor mestizo angels are also common in this new art. Cholo murals also incorporate national icons such as Pancho Villa and Emiliano Zapata. Alongside these national heroes stand pre-Hispanic figures illustrative of the people's dignified heritage. And dominating over all of these many elements are indigenous women and warriors, the founding figures of victimized, but undefeated, united identity.

The third array of symbols includes idealized images of homeland, nostalgic evocations in frank juxtaposition to new and modern urbanized spaces. A return to intimate space appears as an escape from the modern contexts of danger and violence. Another element in the series is the life of the barrio, defined from the perspective of the *vida loca,* a vision that fuses violence, drugs, jail, and death.

The cholo and the chola are both motif and image on these walls. These spaces set up an interplay of images where, sometimes, the mural is transformed into flesh and blood. By re-creating and expressing the sociocultural relations that exist within the barrio, the murals reproduce the cognitive maps and markers that have been defined by the barrio, by the *clikas.* They portray machismo, misogyny, loyalty, sentiment, power symbols, hatreds, and enemies. The murals constitute urban altars and aggregated epitaphs to purified identities.

Border Art

One of the most important events for the creation of a transborder arts environment was the 1984 International Festival of La Raza, or FIR (later called the Border Festival). Amelia Malagamba and Gilberto Cárdenas served as the creative spark and key promoters of the plastic arts portion of this pioneering event, which brought together artists and intellectuals from both sides of the border and enabled artists (especially Mexicans and Chicanos) to come together on the basis of shared cultural themes. The FIR constructed bridges across the border, allowing artists on one side to reach a better understanding of the concerns and the work of artists on the other side, creating a place for reflecting on the nature of cultural boundaries.[9]

In addition to the International Festival of La Raza, a number of other events have been very significant for border art. One is the Border Art Workshop (Taller de Arte Fronterizo, or TAF), established in 1983, whose participating artists include Guillermo Gómez Peña, Richard H. Lou, Roberto Sánchez, Michael Schnorr, David Dávalos, and María Eraña, among others. The special problems of the border are at the center of all projects done by the Border Art Workshop, which is strongly committed to the border community and particularly to its marginalized and forgotten members.

The most complete recounting of the experiences of the Border Art Workshop and the artwork of other border groups such as Las Comadres appears in the exhibition catalogue *La Frontera/The Border: Art about the Mexico/United States Border Experience*, coordinated by Kathryn Kanjo. Madeleine Grynsztejn noted that the works in this exhibition were defined by a "formal and intellectual hybridism" and that collage was their formal language.[10] *La Frontera/The Border* constitutes one of the most noteworthy examples of cross-border artistic expression, with thirty-seven artists taking up the challenge—to cross borders. The line separating Mexico and the United States provided a shared repertoire from which the artists created representations of their own experiences and re-created the thresholds of ethnicity, class, race, and gender. The circularity that was intrinsic to this exhibition made it possible to reinvent the border according to the multiplicity of cultures that comprise it—or, as Patricio Chávez has suggested, to consider the border "as the link within a cultural zone hybridized by migration."[11]

Any discussion of transborder art would be incomplete if it failed to mention the mural created by Malaquías Montoya in Tijuana. Montoya, a highly acclaimed Chicano artist, defines his art in opposition to traditional, "domesticated" forms. For him, in today's capitalist world, art must be protest: it must be liberationist, political, and popular.

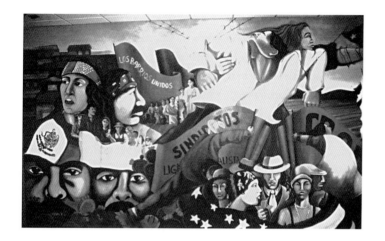

Malaquías Montoya, *La otra historia de Tijuana,* 1987, mural painting, Tijuana. Courtesy of the artist.

In 1987, as part of the International Festival of La Raza, Montoya created *La otra historia de Tijuana (Tijuana's Other History),* one of the first murals painted by a Chicano artist in Mexico. Located in the offices of the Consejo Nacional de Recursos para la Atención de la Juventud, Montoya's mural presents the historical and cultural symbiosis between Mexicans and Chicanos. The mural depicts a border history, complete with national heroes, patriotic symbols, idealized rural landscapes, renditions of the people's efforts to defend themselves through peasant and labor organizations, and images of the youths of the barrio. Women also hold a central place in Montoya's mural. His women are strong and determined, in stark contrast to the traditional portrayal of women as weak and indecisive. Montoya also paints broad aspects of social struggle that go beyond the Mexican or the U.S. context.

This artwork's liberating premise contains a layering of multiple references, including one to runaway slave Frederick Douglass, who sent letters to those still held in slavery admonishing them to fight for their freedom. Montoya's mural also depicts youths of the barrio, but it avoids the stereotypical portrayal that reduces them to violence-prone delinquents. Their features are markedly indigenous, a single referent that both confronts racism and dignifies their heritage. Chicanos laid claim to Mayan, Aztec, and other indigenous images, and used them to reinvent themselves as a people, to give dignity to what heretofore had been elements that engendered only social exclusion and cultural shame.

Montoya's mural also alludes to the border as it existed in the 1920s and 1930s. Those were the years of the Volstead Act and Prohibition in the United States and of the

proliferation of bars, casinos, gaming houses, and brothels in Mexico, places to satisfy the needs of the North Americans who traveled in droves to the border cities of northern Mexico. During this period, Mexico's northern regions gained importance as cross-border "service centers," giving rise to the "black legends" that still circulate. This was also the era of a strengthening labor union movement focused on workers' demands for jobs. Montoya's mural shows us a universe where people still hold the power to pursue economic models that contrast with those of neoliberalism.

Painting Tía Juana

Tijuana is a young city. Less than one hundred years have passed since it first gained visibility. With time, it has managed to shed the judgments that formerly identified border cities as "cultural deserts," encapsulated them in black legends, and stereotyped them as frozen images of violence, prostitution, and drug-running. The image of Tijuana in the first decades of the twentieth century was defined by bars, casinos, horse and dog racing, and prostitution, but also by its culinary offerings and artisan crafts. But this border is not so unidimensional. For much of the population of Mexican origin in the United States, Tijuana also signifies a place to be reunited with family, friends, and elements of their cultural heritage for which they can find no substitutes.

Several factors—including Tijuana's isolation, the complex processes involved in a city with such a large fraction of immigrants (even today, half of Tijuana's residents were born elsewhere), and the development of a business and political class that has amassed great wealth but has little social veneer—help to explain the general lack of interest in developing the city's cultural infrastructure and creating a wide range of cultural products. Even so, the resources for Baja California's cultural development were taking shape. The Autonomous University of Baja California (UABC) was established in 1957. In 1955 the José Clemente Orozco School of Arts was founded in Mexicali, and the Art and Culture Circle was begun in Tijuana. A few exhibitions were held, all somewhat precarious, but sufficient to awake an interest in the arts. This spark led to the Intercultural Exhibition (Mexico-U.S.) in 1963. Successive exhibitions, such as MEXPO 72, featured etchings, paintings, and sculptures, but the conditions were not generally encouraging.[12]

The 1970s saw the construction of Casas de la Cultura in Mexicali, in 1973, and in Tijuana in 1977. This last was also the year in which the First Biennial of Fine Arts of Baja California took place. Yet it was not until the 1980s that one began to see in Tijuana the infrastructure and cultural arenas that would allow this city to participate on the national, and sometimes the international, art stage. The Centro Cultural Tijuana was a

particularly relevant player in bringing about this transition. It provided a permanent facility for exhibitions of artworks by national and foreign artists, and it offered an appropriate showcase for the presentation of work by Baja California artists. Also of utmost importance in this regard was the founding of the Centro de Estudios Fronterizos del Norte de México (now the Colegio de la Frontera Norte) in 1982. This institution gave crucial support to research on sociocultural phenomena on the Mexico-U.S. border. It was also during the 1980s that an arts community took shape, complete with infrastructure, ongoing production, new opportunities for dissemination (galleries, exhibitions, and workshops), and a more attuned public.

Against this background, artists constructed new spaces for interaction and established some cross-border arts venues. Chicano artists and Mexican artists met face to face and discovered their common interests, although some "disencounters" were inevitable. For example, unlike Chicano artists, Mexican artists have had little experience with collective, community-based art. For Chicanos, the border is a political-military construct, an engine of sociocultural colonialism and a trap that captures thousands of victims. For Mexican artists, the border is a social landscape, an urban stage, although this perception is beginning to give way among artists who are re-creating the inherent tragedy of the border. Such portrayals, outlined here in the most general terms, constitute important exceptions on both sides of the border.

One artist influenced by the rise of public art and the political fervor of the 1960s was Álvaro Blancarte, who began his career making clay figures in his native Sinaloa. Blancarte joined other young people to cover walls with murals that depicted political causes and figures: "At the time, there was not much public art. All of us were a little bit Siqueiros, a bit Orozco, a bit Rivera. What they proclaimed as the only truth— 'the only way is our way'—was what we accepted. And the worst part is that we believed it."[13] Blancarte has created public art in Sinaloa and Mexico City, as well as in Panama, Palestine, and the United States. He participated in inSITE94 with *The Tomb/Magical Ritual,* in which he combined huge wooden posts and boulders to present his personal reconstruction of the rituals of death among the native peoples.

Tijuana resident Marcos Ramírez (ERRE), a border interlocutor who grew up in Colonia Libertad, folded the experience he gained from building houses into his installation *Century 21* in the 1994 version of inSITE. ERRE constructed a ramshackle dwelling in the Zona del Río in Tijuana, a most expensive real estate area. It was once home to junkyards and garbage, as well as to a large population of the city's poor, new arrivals to Tijuana from other areas of Mexico, who settled in a huge shantytown called "Cartolandia" (Cardboardland). ERRE erected a house like those belonging to the

original squatter-settlers, a type of structure that has come to define the urban profile of the Zona del Río. His installation was an immovable symbol of resistance to machines, to the flood rushing down from the reservoir, to the greed of all those who had grown rich through land speculation. The cardboard houses of all of Latin America's Cartolandias, invoked in the songs of Alí Primera, sprouted in a modern space built upon the history and the lives of the squatters.

ERRE's art is intermeshed with the social reality of the border. One piece challenges California's Proposition 187, which would legalize the denial of health care and education on the basis of a "reasonable doubt" about a person's immigration status:

> I felt that by using this number, 187, I could photograph people and their jobs. I could show that Mexicans and Latinos are contributing their labor across all economic sectors. I determined to photograph hands, in images stripped of any identifying face. I focused at the level of hands at work. One hundred eighty-seven black-and-white photographs mounted on metal plates, laid out on the ground. There were 187 different kinds of work, 187 different individuals, men and women. I approached them with the same discriminatory criteria that the Border Patrol uses; that is, I chose them according to their appearance. The names of the 187 people were listed in a book placed on a desk. By consulting the book, a viewer could identify whose hands these were. We constructed a place around a metal box that had several openings through which one could see the interior, supposedly the workplace. For me, the metal box was the border, and the interior was California. Following Andy Warhol, I placed boxes one on top of another, to represent Mexican labor's contribution to the accumulation of these consumer goods. At the other end of the walkway were all the photos on the floor. I was documenting that there are professionals in this workforce, politicians, lawyers, doctors, but presenting only their hands. This served to make it more universal, the hands could be those of Arabs, Asians, Palestinians in Israel, Tunisians in Germany, or Algerians in France. I didn't want hands that said, "This is a Mexican"; they had to have a more universal flavor.[14]

Tijuana native Armando Muñoz created *Tijuana, Third Millennium*, known among local residents as La Mona. This is "residential sculpture," a work of "anatomical engineering." It rises up from among humble houses, an enormous female figure, her body a home, complete with kitchen and narrow rooms, a home that allows an oedipal

return to the maternal breast: "The original concept was to create a woman to represent Tijuana, a female sculpture, a woman who bears children, like the city. But then I realized that, given the technical allowances of the construction method, I could build a hollow structure made of cement, except for the head and arm, which are made of fiberglass. Then I said, 'hollow space, like a house.'"[15]

Anchored in a canyon in Tijuana's Aeropuerto neighborhood, La Mona measures over seventeen meters in height, weighs nearly eighteen tons, and encompasses about twenty-six cubic meters of space. The sculpture has become a city landmark, an obligatory stop for anyone interested in Tijuana's urban profile. But it has not sated Muñoz's creative drive; he is finding new challenges, including building an inhabitable sculpture 100 meters tall: a sculpture-hotel, envisioned by the artist as the largest sculpture in the world. While he looks for project sponsors, Muñoz is completing another livable sculpture, a mermaid figure titled *Eva Marina*. This work, now almost complete, is located in Puerto Nuevo, the fishing village that developed the menu of lobster, beans, rice, and flour tortillas that has become a major tourist attraction in the town.

One noteworthy example of border art is *La Frontera*, a collaborative effort by the Tijuana-based group Bajo el Mismo Sol. Its members include Roberto Rosique, Álvaro Blancarte, José Lobo, Juan Zúñiga, and Margie Shrike, as well as Los Angeles artists Luis Ituarte (originally from Tijuana), Carola Nan Roach, Anny Buckley, and Ned Baughmann. Part of this work involved tracing a white line across the floor through a series of rooms on the second story of the Dada building in Los Angeles. Along this deranged border, the words "Mexico" and "United States" were written over and over again, as if laying claim to their respective sides of the line. A few meters later, a sign reversed the territories, and the anarchical game of chance continued, confirming the certainty that borders serve no function but to annoy. The line suggested other readings and invaded other spaces. Without consulting the artists, viewers erased the lines of this capricious border, leaving it redefined by others who saw this game of borders as an attack on other power spaces—nicely underscoring the artists' original conceptualization of "border."

InSITE97

InSITE97 brought together more than forty artists from throughout the world to produce installations in Tijuana and San Diego. According to Felipe Ehrenberg, it was "perhaps the most successful joint cultural event ever celebrated in a border area joining two countries." Emphasizing both inSITE's achievements and potential, Ehrenberg added: "It

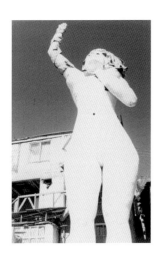

Armando Muñoz, *Tijuana, Third Millennium,* 1990, house in the shape of a woman, Tijuana. Courtesy of the artist.

seems undeniable that inSITE, as a binational event, is on its way to becoming firmly institutionalized, and it is doing outreach to the community. These effects are harder to measure; they are not so spectacular, but they are creating an impact that will be felt three or four years down the road. . . . This event legitimates a series of contemporary art forms that audiences generally have distrusted and seen as ambiguous, uncertain whether they are art, whether they are important."[16]

InSITE has gained a pivotal position in the area of cross-border and international art, and it has won widespread recognition for its relevance. Nevertheless, this view is not universal. For example, some Chicano artists have dubbed the exhibition "oversite," because they were not included, and some people in Tijuana have called it "outsite."

Despite some obvious unevenness in their conceptualizations, most of the participating artists offered very direct representations of border life. In offering my point of view on inSITE, I emphasize the spaces that interweave between the artwork and the border—the border as space that participates in the work's definition, as space absorbed into the work, that is, as space within and commingled with the work. However, some artists, such as Tony Capellán of the Dominican Republic, avoided open spaces and chose instead to address and define the dimensions of space by having their object articulate the space. In Capellán's work *The Good Neighbor,* created in the ballroom of the Casa de la Cultura in Tijuana, the border is a permanent wound that cuts across both countries, the laceration (traced by an electric saw) is inflicted by the governments of the two nations. Capellán's space is colored red and smells of dried chiles. The metallic wound is surrounded by darker shades, like the congealed blood that permeates the cold embankments edging the border. Capellán displays a keen insight into the social problems that arise on the border because of the asymmetrical relations of power between these two countries. He creates a tragic, devastating, never-healing wound, a modern, mechanized Prometheus, cut open over and over again by an indefatigable blade that splits people and territories in a repeating cycle driven by disconnected authorities. The cutting blade obsessively retraces the border division, leaving its bloody wake over the divided territories.

For Capellán, the element that is common to both sides of the border is an officialdom that obstinately insists on delineating territorial divisions. In contrast, Tijuana artist ERRE emphasizes the implicit interrelationship that forms the substrate of border relations. His monumental two-headed wooden horse, installed on the borderline between Mexico and the United States, is thirty meters high. The two halves of its body are mirror images of each other, with one head facing north, the other south. It has two

Tony Capellán, *El buen vecino (The Good Neighbor),* 1997, mixed-media installation, Casa de la Cultura, Tijuana. Courtesy of the artist.

opposing views, but it can never move in opposing directions. The horse's hollow interior and translucence tell us that, unlike the horse at Troy, here there are no troops hidden within the belly. ERRE's project seems to suggest that only through transparency in cross-border relations can we avoid destroying the horse that dwells in both territories. ERRE underscores some of the concerns reflected in this work, where two-headedness emphasizes a dual perspective, a dual identity, and, as a result, ambiguity. Who is the invader, who is being invaded? Who is dependent, who is being depended upon? Does this border separate us or unite us? Duality also provides the answer. The border neither separates nor unites. We remain linked like Siamese twins, and the other is a part of ourselves. Escaping impermanence, ERRE's work remained in place for nearly eleven months and was seen by millions. It also became an integral part of daily television after being incorporated into the stage set of a morning program.

ERRE does not offer us a clear-cut dichotomy in black and white. Instead, he gives us counterpoised and complementary spaces of light and shadow. Border relations are highly nuanced; they cannot be reduced to simple binomial expressions of light and dark. Border relations are complex and contradictory, as Brazilian photographer Miguel Rio Branco's *Between the Eyes, the Desert* suggests. It captures us in a fascinating but

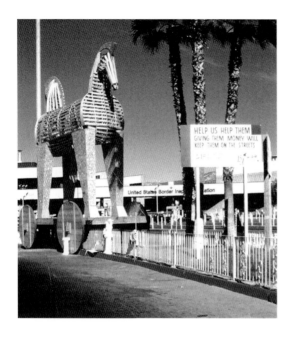

Marcos Ramírez (ERRE), *Toy-an Horse*, 2000, wooden sculpture at the Mexico-U.S. border in Tijuana. Courtesy of the artist and Iturralde Gallery, Los Angeles.

sorrowful game of images and dissolving images, with many-layered shades, contrasts, arid contradictions.

Borders are frameworks that transect people and territories. If national borders can be crossed, fracturing the boundaries between inside and outside can also play a role in overstepping external delimiters. This was done by Colombian artist Fernando Arias in *The Line and the Mule,* in which Arias mounted a section of fencing like that used to construct the border fence, blocking the view of the other side, breaking the visual connection. Suspended from the fence hangs a metallic surface, so highly polished that we see our reflection. And we watch the aggressive trajectory of this guillotine, falling nearly to the floor. Below lies a line of white powder, a line of cocaine, visible from both sides of the border. It leads back to the mule, with the persona of Arias substituting for the traffickers. Using an endoscope, we peer within his body, to his most intimate self. The viewer becomes voyeur, scrutinizing the exposed interior of the artist. And he, in turn, challenges us to look within ourselves, to confront the borders that exist within us, that give us form.

Two projects shown at InSITE97 adopt the car as their identifying icon. The car has been an important player in redefining the shape of cities in the twentieth century.

Automobiles are a means of transport, a mark of distinction, a status symbol, an identity-giver. From the famous roadsters of the 1920s and 1930s to the hotrods of following decades to the low-riders of today, the car has framed young people's fantasies and their group affiliations. In *Alien Toy UCO* (a hybrid between a car and a television set), Rubén Ortiz draws on the youthful tradition of souping up an old junk car and exhibiting it at car shows, where low-riders, those mobile murals, carry cholos' dreams in their hydraulic shocks, gleaming exteriors, and altarlike interiors.

Ortiz projects the automobile into a cosmic future permeated with the cultural patterns of homeboys and low-riders. Betsabée Romero, in contrast, carries the car in the opposite direction. By carefully hand-covering her car with flower-printed cloth and filling the interior with dried flowers, she retraces the steps that led from craft production to industrial manufacturing. At the same time, she underscores a characteristic common to cars in Mexico: their juxtaposition of the sacred and the profane. Rosaries and crucifixes dangle from rearview mirrors, and interiors are decorated with religious images and statues of the Virgin of Guadalupe. Romero broadens the range of possibilities with her car-offering, the *Ayate Car,* in Colonia Libertad. "La Liber," one of Tijuana's oldest neighborhoods, grew with the influx of deportees from the United States during the Depression years of the late 1920s and early 1930s. Its name expresses the orientation of its founders. Some had fought in the Mexican Revolution; others were on the front lines of Mexico's first labor uprisings to protest the shortage of jobs for Mexican workers. Romero installed her car just meters from the border fence. She converts her car into a statement of disdain for both the internal combustion engine and a car's potential to convey distinction and status. Embedded on the crest of a hill, *Ayate Car* is a postmodern epiphany that nullifies all the measures of modernity: mobility, visibility, status.

According to Romero, this installation was constructed with a 1950s Ford that had traveled 2,841 kilometers, from Mexico City to Tijuana. It crossed undocumented into the United States, but it was deported and abandoned next to the metal fence, coming to rest in Colonia Libertad, where it remained encrusted in the broken topography, like one more of the city's many junkyards. *Ayate Car*'s cold, metallic structure adopts a new texture, ultimately transforming itself into an offering—to the deported, the exiled, the fallen—existing in a permanent tension between industrial goods and artisan craft, masculine and feminine, mobility and sedentariness, space-installation and habitat opportunity. Art empowers the local residents to ascribe new meanings to the car as well as to experience an alteration in their daily space, within which locals appraise the presence and demeanor of the people who eagerly come to view the installation.

Against the insistent portrayals that reduce border cities to spaces of transit, sites of crossing, or an extension of the nonplaces defined by Marc Augé, Brazilian artist Rosángela Rennó portrays Tijuana as something more. She re-creates the heterogeneity of the national experiences that give form to the border, the multitudinous traits that converge here from all states of the nation. She presents the many ways of being a Tijuanan without severing one's cultural and affective ties to one's place of origin. Rennó's work, comprising photographs by wedding photographer Eduardo Zepeda, cultivates images of "unknown" people. She has chosen photographs of people who live and work in Tijuana, not migrants or others determined to cross the border. Her eye frames a complex city whose residents come from every point in Mexico, rendering null and void the superficial interpretations that stress a supposed lack of identity in border cities. Rennó seeks and finds the plural identity of the city; she constructs her vision from within the city, not from the border gates.

In counterbalance to eternal flight or evanescence as an inherent condition, works by other artists reflect on permanence, continuity, existentialist representations, or anchored identifications. *El Niño,* a pyramid created by Jamex and Einar de la Torre, expresses nervous, entrenched identities—bloody, defensive, on the knife-edge. It was built with an amalgam of flattened, broken bottles and worn-out images of re-created identifiers with jeering markers, jury-rigged like covers on worn car seats. The pyramid is a site of sacrifice but also a volcano: a reality about to explode. The border is collision, confrontation, syncretism, duality. At the apex is the child, sacred and profane, angelic and diabolic, blessed and doomed. A heart of goodness and sacrifice. This duality alienates and seduces, fractures and fortifies. It offers no straight paths. Its definition lies in the daily struggle for meaning and identity, as in *Our Daily Rounds* by Tijuana artist Manolo Escutia. Patterned on a popular toy, this work presents a boxing match between four gigantic wooden figures inside a circular boxing ring. The current runs along a grid whose dividers point to the four cardinal points. The image demonstrates the scars that mark life's "contenders," and it proclaims that this is a "match" being fought in all corners of the world.

In his *City of Greens,* Thomas Glassford employs a humorous but sharp-edged tool. His San Diego is the golf center of the United States, with artificial greens whose holes are marked by nationalistic emblems. Glassford gives us an irony-tinged image of a neo–James Bond in a city whose spaces are defined by a fanaticism for golf. Golf permeates these spaces on different scales and appears in every conceivable place and on every conceivable surface: airports, umbrellas, cell phones, bicycles, hats, coins, car trunks, stairs, urinals, cars, cemeteries (the crypt is a huge golf ball), elevators, martini

glasses, skyscrapers, oceans, bedrooms, erotica, the moon landing, a briefcase carrying the requisite identity markers—the U.S. flag and a miniature golf course. If this image were extended southward, might not the holes be replaced with potholes?

Like Glassford, Melanie Smith uses irony and the juxtaposition of contrasting scenes in her *San Diego Informatica* to highlight the inconsistencies between our societies—the inequalities expressed, for example, in a McDonald's built on top of a rubbish heap, and in areas where children are peripheral, almost dispensable. Her work amalgamates a heterogeneity of tattoos—Indians, angels, death, fearsome figures, Nordic warriors, satanic perversions. The human skin is her canvas, her tapestry, presenting the possibility for constructing mobile graffiti and walking murals. The city's visual discourse can be conducted through voices imprinted on the skin—or by purchasing a minisculpture by feeding some coins into a machine. The machine dispenses one of several works in miniature created by Eduardo Abaroa as part of his inSITE installation *Border Capsule Ritual (Black Star)*. Smith's *San Diego Informatica* aims to colonize other parts of the world, to extend its project, to reveal images that substitute for real people. But one can also procure a ticket and travel around the world, moving from country to country without crossing a single border. In *The Loop*, Francis Alÿs departed from Tijuana and flew to San Diego by going around the world in order to avoid passing over the border that divides Mexico and the United States.

In addition to presenting projects, inSITE integrated the artistic process within the communities. The *Proyecto Comunitario Popotla* was done by the residents of this coastal village, where fishing is the dominant economic activity and lives are linked to the sea. Popotla is the site of the film studios that Twentieth Century Fox constructed for the filming of James Cameron's *Titanic*. Tania Candiani, a member of Revolucionarte, described the project's goals:

> This was a very beautiful place, the people were happy, until Twentieth Century Fox arrived on the scene and built a hideous cement-block wall. Instead of seeing the sea, all we could see was this barricade. We went to talk with them about what could be done. The townspeople had a list of needs—paved streets, park benches, sculptures—but what they disliked more than anything was to turn around and see this concrete barrier. That's where the idea of working with them came from. It was Popotla's children who come up with the designs, a heap of drawings, with some help from the adults. We made a selection of the drawings and sketched out how they could be integrated. The constructions made with pieces of plastic, shell, etc., are all based on the children's drawings.

What we did in effect was to create a new panorama so that we do not see the wall anymore.[17]

Twin Plants: Forms of Resistance, Corridors of Power, a project by Michael Schnorr and Manuel Mancillas ("Zopilote") of the Border Art Workshop, was more than an artistic intervention in a public space.[18] It represents a strategy of participatory art/action that involves an intensive involvement with community groups in long-term projects. Art/action projects develop out of both the personal interests of the artist and the needs and concerns of the members of the community. Carried out in Maclovio Rojas, a working-class neighborhood, this project of art in the community implies a multiyear involvement. It proposes to remain active for six years, generating self-initiated, community-based art projects. According to Schnorr:

> Here they have the same problems you find between the barrios in Tijuana. This particular area is called Barrio Ampliación; it's new. There's also Old Maclovio, and the tracks and the slaughterhouse. At night, you get some fighting. That's why, when we paint the murals and hold the workshops, we do two or three in Old Maclovio. . . . That gets the people together to create cultural centers. We have a committee that serves as "community facilitators." The people tell us, "Michael, we don't want photography classes, we want classes about prenatal care." "Perfect," I say. We have a grant to support people who want to do other things in the community. The Aguascalientes Community Center is a revolutionary idea in Mexico, and in the world. Here we have a place for art. We have community involvement. After six months in operation, we're holding some art classes, some English classes, but the classes aren't really the most important thing for the community. Their primary concerns are food, health. . . . We have classes for children and for adults. We have a medical center and a free clinic.
>
> InSITE didn't play such a large role here, because they have their own idea about creating art in the community. For them, community art is something very controversial, with a lot of conceptual restrictions. Where does the community fit in all this? Is this a work that derives from the community? I think that in the twenty-first century, public art, installation art, will be a powerful force for change. But as David Harding observed, context is at least 50 percent of the work.[19]

The Forgetfulness Cloud

Alfredo Jaar's work *The Cloud* was formed by one thousand white balloons inflated with helium and carrying the names of the identified victims among those who died attempting to cross the border. The cloud rose up about one thousand feet above El Valle del Matador at the Tijuana–San Diego border. It hovered above the borderline mural, sustained by cords from both sides of the border and enclosed in a fine net that allowed the balloons to remain undulant, propelled by the wind and crossing the line with pendulant movements, not noticing passports, documents, or police vigilance. The balloons were kept united by the fine net, much like the multiple clusters of migrants who cross under the order of the *coyote,* their guide. Finally, the cloud opened up and the balloons went their own way, advancing like the groups of migrants who immediately disperse after they have crossed the border, heading to their destiny. This ephemeral monument to the memory of the victims was an effort to prevent them from falling into the abyss of forgetfulness.

The ceremony brought together artists, the families of those who had died trying to cross the border, and members of migrant support organizations, as well as curious bystanders who watched the movement of the cloud from the hills close by. During the ceremony there was a poetry reading, while some musicians dressed in mourning on both sides of the border interpreted adagios, sarabandas, and the second movement of a Brandenburg Concerto. After a moment of silence, the cloud opened up, letting the balloons escape with difficulty. Slowly they disappeared in the sky.

Projection in Tijuana

In early 2000, I met Krzysztof Wodiczko, who was preparing his project for inSITE. His first question was: Who are the heroes of Tijuana? Then: Who is represented in the city's monuments? He was not thinking of the "magnificent men," the heroes with revered names, but of the everyday actors of the city who do not participate in the official history represented in public spaces. Wodiczko resignified those public spaces with his *Projection in Tijuana*, which projected the testimonies of working women onto the Tijuana Cultural Center ("The Ball"). In doing so, a space of cultural production in the city was used to give amplified expression to other stories—stories of abuse, exploitation, vexations, fear, poverty, and impunity. The projection of the faces and the testimonies of these women gave a monumental tone to the stories. The close-ups, the tilt of their faces, emphasized the strength of their words, while the exposure of lips and nasal cavities denoted internal exploration, scrutinizing the most protected secrets.

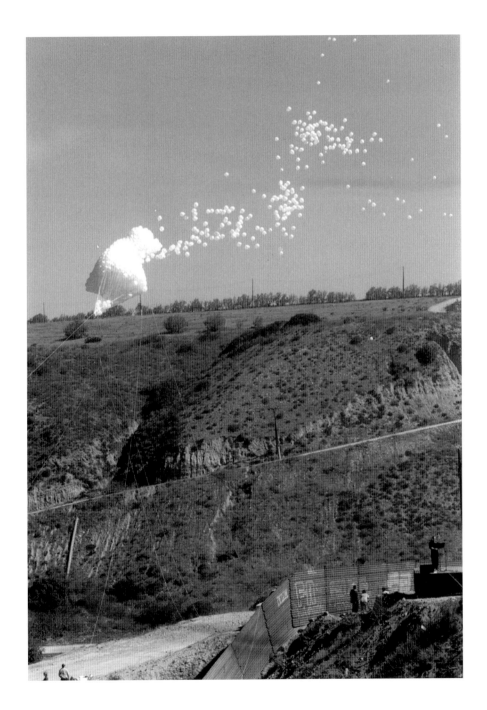

Alfredo Jaar, *The Cloud,* 2000, 1,000 white balloons with the names of the identified victims that died in the attempt to cross the Mexico-U.S. border, Tijuana. Courtesy of the artist and Galerie Lelong.

Through this projection we were able to see and listen to testimonies of women who are otherwise absent from the urban Tijuana discourse—working women from the *maquiladora* (assembly industry), raped women, beaten women. The circumference of the Cultural Center was converted into an exterior projection screen, with the faces of the women covering the entire surface. With this representation, the artist transgressed the threshold between public and private; he touched the boundaries of the city and questioned the perspectives of those who consider their depository as privileged.

Coda: Art as a Builder of Bridges and Disseminator of Culture

Public art takes shape in the juncture between what is real and what is imagined,[20] between the arenas of daily meaning and those of representation, between imputed meaning and symbolic re-creation. Public art requires deciphering, but the reconstruction of meanings is not the exclusive property of the specialist. This produces something more than an artistic code, which Bourdieu defined as a historically constructed classification system— and therefore changeable in time and space.[21] We are thus able to name and perceive differences, to talk about a system of codes to the degree that art, especially public art, puts into play a diverse set of cultural matrixes producing differentiated "decipherings." This is especially the case in border contexts, which tend to be defined by their economic, social, and cultural heterogeneity.

The geographic proximity of Tijuana and San Diego immerses them in the social relations of two large national systems, with their different norms, languages, and cultures, as well as in the marked inequality of power between the two cities. And yet borders also form interstitial environments. In addition to the geographic line that marks the international boundary between Mexico and the United States, and despite these two nations' strong economic ties, the border also envelops and shapes heterogeneous cultural thresholds across which the populations of these two countries construct a relationship. The prevailing image of this border is constructed with stereotypes, like the black legends that grew up during the Prohibition era, but it also includes painful, inescapable truths that implicate both countries, such as narco-trafficking, violations of migrants' human rights, an absence of public safety, and racism.

Drawing on their important ties across the border, phenomena such as the International Festival of La Raza and the Border Art Workshop have repostulated some important aspects of Chicano iconography. The wellsprings of Chicano art are social memory and the struggle against enduring U.S. sociocultural colonialism; and Chicano artists' incorporation of a reality from south of the border is expressed through origin myths and the portrayal of the border as a region of social inequality. But for the artists

in the International Festival of La Raza and the Border Art Workshop, the border does not mark the beginning of an experience, but rather is a watershed dividing the life trajectories of the two countries. Many of their works promote joint participation by artists from both sides of the border, and they support exchanges.

Among Chicano artists and the artists associated with the International Festival and the Border Art Workshop, we find that public art creates an intense relationship as it mediates collective experiences. In the same way, the works created by Mexican border artists incorporate a negotiation between the piece and individual experiences. They incorporate the region's imprint and its reevaluation of native cultures, as evidenced in the work of Blancarte, who re-creates elements inscribed in the cultures of the indigenous populations of northern Mexico. On the border, the division that separates these two national territories is an indelible presence that inspires many of the artists' works. Increasingly, we are witnessing the critical incorporation of border themes and problems into art, but from new dialectical camps among Chicano artists, Anglo artists, and perhaps even African American artists. This widespread interest in border themes makes possible new cultural experiences and artistic creations that present a more complex re-creation of the border and a better understanding among people. These artists are re-creating a broad range of cross-border experiences along national lines, but also along social lines and on the dividing line between high culture and popular culture.

Undoubtedly, inSITE enriches the art experience on the border. Although not all of the included artworks adopt the border as their axis, inSITE contributes to an important repositioning of border art primarily because the event sustains a more intense dialogue with international-level debates and proposals. It cultivates a convergence of multiple perspectives on artistic production and the portrayal of the border as one more shared element, and it advances the definition of metanarratives about the problems inherent in the complex and diffuse negotiation of art and society. Additionally, inSITE empowers us to rethink our own ideas and images of the border.

InSITE allows for reflection on the diversity of frontiers: (a) "without" versus "within"; this dichotomy was illustrated in very important ways in the elements that defined the priorities and meanings of works in public space or interior space, the rejection of museums and galleries as legitimizing venues, the selection of open spaces integrated into popular life, and the transformation of outlaw spaces into legitimate settings, or in the reoccupation and assignment of new meanings to places that had been factories, milk companies, gymnasiums, etc.; (b) legality versus illegality, symbolized by narco-trafficking; (c) the border defined as "disencounter," breach, or rupture; (d) the hybrid or syncretistic border, visible in works that incorporated different elements of

time, space, and cultural arenas, or that made it possible to redefine daily space or that corresponded to different matrices of meaning; (e) borders as narrative context; and (f) borders as multidirected violence.

The artistic creations that achieved the greatest power were the works done in open spaces at the crossroads of diverse social experiences. In a break with the commandments of installation art's theoretical definition—which focus on the duration of the work, the materials used in its construction, and the open or enclosed space in which it is located—the elements that are the most powerful in terms of intervention art's agency are its social context and its capacity to shape fields for assigning new meanings into the collective environment. Two basic mechanisms are in operation here: the work's participation as a code of collective new meaning for the features that define the sociocultural construction of space, and the work as a framework that signals proximate fields. The urban skin displays contrasts in economy, society, and power. These relations are also inscribed in objectivized spaces, and they contribute to the symbolic shaping of public milieus whose signs allude to shared—but also differentiated and unequal—elements.

translated from the Spanish by Sandra del Castillo

Mexico, DF, 1996

This is a revised and edited version of an essay previously published in Néstor García Canclini and José Manuel Valenzuela Arce, eds., *Intromisiones compartidas: Arte y sociedad en la frontera México/Estados Unidos* (San Diego and Tijuana: Fondo Nacional para la Cultura y las Artes and InSITE97, 2000).

1. InSITE97, the third in a series of binational contemporary arts projects based in San Diego and Tijuana, was co-directed by Carmen Cuenca and Michael Krichman.

2. *Cholo* is a word referring to youth gangs. Cholos appropriate Mexican symbols such as the Virgin of Guadalupe, pre-Hispanic images, and traditional images. Although *cholismo* began as a transborder juvenile phenomenon (in the north of Mexico and the south of the United States), cholos are found today throughout the Mexican territory.

3. Laurance P. Hurlburt, *The Mexican Muralist in the United States* (Albuquerque: University of New Mexico Press, 1989), p. 157.

4. See Tomás Ybarra-Frausto, "Introducción a la historia del arte mexicano-norteamericano," in *A través de la frontera,* Centro de Estudios Económicos y Sociales del 3er Mundo (Mexico City: A.C./Instituto de Investigaciones Estéticas, UNAM, 1983), pp. 53–64. See also Ybarra-Frausto, "Arte Chicano: Images of a Community," in *Signs from the Heart: California Chicano Murals* (Venice, Calif.: Social and Public Art Resource Center, 1990); and "Rasquachismo: A Chicano Sensibility," in *Chicano Art: Resistance and Affirmation, 1965–1985,* exh. cat. (Los Angeles: Wight Art Gallery, University of California, 1991).

5. David Maciel and María Herrera-Sobek, *Culture across Borders: Mexican Immigration and Popular Culture* (Tucson: University of Arizona Press, 1998).

6. Shifra M. Goldman and Tomás Ybarra-Frausto, "The Political and Social Contexts of Chicano Art," in *Chicano Art,* pp. 83–96.

7. Rupert García, "Arte mural del Movimiento Chicano," in *A través de la frontera,* pp. 107–18.

8. La Raza literally means "The Race," a concept dating from the second half of the nineteenth century and used by the Chicano population to proclaim their Mexican ancestry. The concept expressed an ethnic and nationalist recovery. Later, its meaning was expanded to refer to "our people," "our friends," and "poor people" in general.

9. Gilberto Cárdenas, "Cultura fronteriza, cultura sin frontera: Muestra de arte chicano," in Amelia Malagamba, ed., *Encuentros: Los Festivales Internacionales de la Raza* (Tijuana: CREA/Secretaría de Educación Pública/El Colegio de la Frontera Norte, 1988), pp. 91–104.

10. Madeleine Grynsztejn, "La frontera/The Border: Art about the Mexico/United States Experience," in *La Frontera/The Border: Art about the Mexico/United States Experience,* exh. cat. (San Diego: Centro Cultural de la Raza and San Diego Museum of Contemporary Art, 1993), pp. 23–58.

11. Patricio Chávez, "Políticamente cultural multi-correcta," in *La Frontera/The Border.*

12. Roberto Rosique, ed., *30 artistas plásticos de Baja California* (Tijuana: Consejo Nacional para la Cultura y las Artes/Centro Cultural Tijuana, 1998).

13. Álvaro Blancarte, interview by the author, Tijuana, 9 February 1999.

14. Marcos Ramírez (ERRE), interview by the author, Tijuana, February 1999.

15. Armando Muñoz, interview by the author, Tijuana, February 1999.

16. Felipe Ehrenberg, interview by the author, San Diego, September 1997.

17. Tania Candiani, interview by the author, Tijuana, September 1997.

18. Berenice Badillo also participated in the project.

19. Michael Schnorr, interview with the author, 13 February 1999, in the Aguascalientes Community Center in Colonia Maclovio Rojas.

20. Fredric Jameson and Slavoj Žižek, *Estudios culturales: Reflexiones sobre el multiculturalismo* (Buenos Aires: Paidós, 1998).

21. Pierre Bourdieu, *Las reglas del arte: Génesis y estructura del campo literario* (Barcelona: Anagrama, 1995).

Desperately Diasporic

Apinan Poshyananda

In January 1999, driving from Los Angeles to the San Diego zoo with the cultural anthropologist Soo Young Chin, in whose house my family and I were staying after being introduced by artist and professor Yong Soon Min, I noticed some unfamiliar road signs: silhouette figures of what seemed to be a man, a woman, and a child running. My curiosity aroused, I asked my companion what these signs signified. Where and why were these people running? The answer was that many illegal migrants escaped or were smuggled across the border from Mexico to the United States, and so motorists are asked to beware.

But the answer did not satisfy my curiosity. What did these signs actually signify? Motorists should be cautious of these illegal people? What should motorists do when they encountered them? Should they report them to border patrol guards who could have let them through in the first place? Accelerate and speed away from them? Run them over, steal their belongings, then drive away? Stop and pick them up to take them to their destination? Give them some food, money, and a place to hide? Another thought crossed my mind. These illegal travelers might escape the authorities to become sojourners and then settlers in communities where their status would change to that of housemaids, waiters, teachers, laborers, bartenders, masseurs, chauffeurs, security guards, robbers, and so on. Their status one day might be that of American citizen, later driving on that same LA–San Diego motorway to see the signs of their past.

Yet another thought also crossed my mind: Soo Young Chin's acceptance into her house of a Thai family about whom she knew nothing was a typical Asian response to

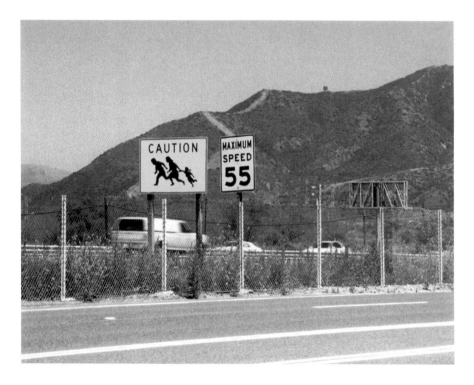

Beware of Diasporans. Courtesy of Buck Burns, CPA.

Traffic sign on Interstate 5, near the Mexican border, California. Photo: Center for Land Use Interpretation Archive.

strangers in need. My family slept in her bed and she slept on the floor. Soon my son called her Auntie Soo.

The story did not end there. In fact, it was just the beginning. It did not take long for Soo Young Chin and my wife to discover a shared past. Soo Young Chin had spent most of her youth and adolescence in Bangkok with her family, where her father had a thriving shipping business. Her father and my wife's father had been close friends and played golf together. Soo Young Chin and my wife had met in Bangkok during embassy gatherings and meetings at a school for Korean children. They parted ways more than twenty years ago, only to be unexpectedly reunited in LA at her house.

My wife's father, Im Jin-Dong, the longest and oldest Korean resident in Thailand, owned import-export companies and was the president of the Korean Society in Thailand. In fact, he came to settle in Thailand long before Mr. Chin and the Korean embassy's existence in Bangkok. Mr. Im was born in Kaesong on the thirty-eighth parallel. He had studied in Japan for two years before returning to Korea, then occupied by Japan. He became a soldier in the Korean unit of the Imperial Japanese Army during the Second World War, when he was posted to Bandung, Java, and then to Siam, later to be named Thailand. He was assigned to guard European prisoners of war in Kanchanburi province where the Japanese were building the famous bridge over the River Kway. After the Japanese surrender, many of them were arrested and imprisoned. Mr. Im was hospitalized with his friend Mr. Omura. After their release they remained in Thailand as illegal citizens posing as Chinese workers. Altogether, there were about sixteen Koreans who stayed in Siam as illegal aliens. Mr. Im married a Thai, had three daughters and eight grandchildren, and has lived in Thailand for more than fifty-five years. Of his Korean family, his grandmother and sister were executed for resisting communism.

Im Jin-Dong's career is a rare case study of the Korean-Thai relationship and diaspora. His life allows us to see different kinds of diasporic experience. I should define the term "diaspora" as the renaming of various communities of dispersion formerly known as ethnic and racial minorities, refugee and exile groups, and overseas communities. Lucie Cheng and Marian Katz have defined the core concept of diaspora as the involuntary scattering of people to many locations away from their homeland. Loss of homeland and a yearning to return create a desire to reproduce intergenerationally a sense of identification and to find some aspects of common culture in the new environment. Diaspora suggests a sense of roots that lie outside the country of residence. Recently, the term has been used to highlight the emergence of political formations excluded from nation-state systems and to redefine cultural identities in modern multiethnic societies.

Migration and diasporan communities have shown that global economic restructuring and changing relations among nation-states have led to expansion and acceleration of the movement of peoples in the Asia-Pacific region. There has been intensification of migration creating conditions for the emergence of new patterns. Briefly, I will mention five types of diaspora noted by Cheng and Katz.

1. Imperial expansion: migration from a place of origin to a place of destination, for example, imperial Japan's settlement in Manchuria, Korea, and Taiwan.
2. Forced expulsion and exile: this is a consequence of colonization, war, and prosecution. A high percentage of migrants may desire to return home but face barriers and difficulties. One-way diaspora can be seen in Korea, Vietnam, Cambodia, and Laos.
3. Large-scale migrations to Europe and the United States: these include early Chinese and Japanese labor diasporas to the United States; Filipino workers to the United States, Japan, Korea, and Hong Kong.
4. Trading/entrepreneurial, middlemen diaspora: those who occupy positions as traders or financiers working in overseas companies. Many settle and marry locals while others continuously move across national borders depending on job opportunities.
5. Professional and intellectual diaspora: the mobility of highly educated people resulting in multidirectional movements.

We note that migration patterns, types of diaspora, and diasporic identities vary from places of origin and destination. This predicament of place exposes the moral dimension of contemporary migration. What happens when people are forced out of their traditional homelands but whose resettlement is not welcomed anywhere, as has happened with Vietnamese and Indonesian boat people, Cambodians on the Thai-Cambodian border, or Afghan asylum seekers? There is also the case of North Koreans in China trying to sneak their way into Japanese and Spanish consulates, which I shall return to later.

Early Asian diasporas occurred during a regional land-sea trading system that linked routes and the traffic of migrants in Asia. Through colonization and the expansion of European-American hegemony, the flow of Asian labor and migrants expanded into the West, where historically Asian diasporas have had to face all kinds of misconceptions that often cause frustration and disillusionment. One might cite, for instance, the treatment of Chinese immigrants who went to the United States as railroad workers; or

the Japanese Americans who, during World War II, were forced to leave their homes and to be incarcerated in internment camps. Or one might think of how Western assumptions about orientalness circulate around physiognomy or stereotypical and reductive notions of culture—Zen, yin-yang, and so on.

Dino De Laurentis's film *Year of the Dragon* is one of the best depictions of Chinese American contradictions in Chinatown, New York, where generations of business, family feuds, extortion rackets, sweatshops, and youth gangs jostle with racial frictions between Chinese, Italians, Poles, Vietnamese, African Americans, and Puerto Ricans. Mickey Rourke plays a New York cop with Polish ancestry who falls in love with an Asian American journalist. They team up to break the Triad networks that, with help from corrupt police, control the drug trade in Chinatown. John Loan plays a cool, tricky gangster who migrated from Hong Kong to find his fortune in New York City. He epitomizes young Chinese immigrants willing to reject family traditions and venture into new global drug worlds. Peeling away layers of stereotypes, the film challenges how Americans perceive Chinese settlers as aberrant in American society.

Traditional American migration studies tend to focus on a single view and preconception exemplified by Oscar Handlin's 1951 study, *The Uprooted*:

> The sojourn of immigrants entails a radical, and in many cases a singular, break from the old country to the new nation; migration is international across well-defined national territories and boundaries. In the process of unidirectional crossing, migrants are "uprooted" and shorn of pre-immigration networks, cultures and belongings. At the shores of the new land, migrants enter the caldron of a new society. The melting pot "assimilates" migrants; the huddled masses become Americans.

New studies on migration patterns of different periods show how variables of race, ethnicity, language, and gender affect the construction of those seen as diasporan, even within a single country. For instance, the neighborhoods of Chinatowns, Japan towns, Korea towns, Thai towns, and so on, show generations of settlers and how they have transformed through ethnic resistance and commerce. Assimilation by each group has been variable; for instance, studies on Filipinos have shown that they have adapted to the American way of life far more smoothly than their Asian counterparts.

Discrimination and racism resulting in anti-Asian sentiments were seen clearly during the LA riots in 1992. For many Asian Americans the riots represented an assault

on their faith in the United States as the Promised Land or Golden Mountain. Their success in the United States has singled them out for resentment. Studies have revealed that anti-Asian violence has been on the rise in black communities for years. In *Confessions of a Chinatown Cowboy,* Chinese American author Frank Chin writes that, as far as blacks are concerned, Asians are "the Uncle Toms of nonwhite people . . . we're hated by the blacks because the whites love us for being everything the blacks are not. Blacks are a problem: badass. Chinese-Americans are not: kissass."

In some cases violence and hatred have focused on Koreans, who have therefore felt besieged by blacks and abandoned by whites. Why has this happened? Before 1965 there were only about 70,000 Koreans in the United States. By 1980 the Korean population had risen to 357,000. In 1992 there were more than 800,000 legal residents. Many of the 250,000 Koreans in greater LA have been involved in small businesses, restaurants, and convenience stores. During the riots, Korean losses were estimated at $350 million, almost half the damage done to the city. Koreans knew they were vulnerable. In the May 1992 issue of *Newsweek,* two blacks were interviewed near the ruins of Korean-owned shops. They admitted that they were among the looters. "We despise the Koreans with passion," said Albert, unemployed. "They operate all the business in our community and it's obvious they're racist because they don't employ a single one of us. Every black that walks into the store they think is a criminal."

What Is Asia or Asian? Problems with Discrimination

The predicament of place and of rootless cultures has been the focus of Asian American studies, in particular, in the writings of Rey Chow, William Wei, and John Kuo Wei Tchen, as well as journals such as *Asia/Diasporic Literature and Culture.* I should like to quote a section from Karen Tei Yamashita's essay, "Benefits—Koreatown from Tropic of Orange," in *Muae 2:*

> That's Bobby. If you know your Asians you look at Bobby. You say, that's Vietnamese. That's what you say. Color's pallid. Kinda blue just beneath the skin. Little underweight. Korean's got a rounder face. Chinese's taller, Japanese's dressed better. If you know your Asians. Turns out you'll be wrong. And you gonna be confused. Dude speaks Spanish. Comprende? So you figure it's one of those Japanese from Peru. Or maybe Korean from Brazil? Or Chinamex. Turns out Bobby's from Singapore. You say, okay, Indonesian. Malaysian. Wrong again. You say, look at his name. That's gotta be Vietnam. Ngu. Bobby Ngu.

They all got Ngu names. Hey, it's not his real name. Real name's Lee Kuan Yu. But don't tell nobody. Go figure. Bobby's Chinese. Chinese from Singapore with a Vietnam name speaking like a Mexican living in Koreatown. That's it.

In comparison, Todd Kwapisz writes in *Voices from Another Place,* a collection of works from a generation born in Korea and adopted in other countries,

You perceive me as Chinese, Japanese, Vietnamese (never mention Korean . . . why?) You perceive me as the one who started WW II or the Vietnam War . . . the Korean War, what was that? You perceive me as the straight-A student, destroyer of the bell curve. You perceive me as the model minority myth, the rich person. You perceive me as the exchange student with my host family. You perceive me as the Bruce Lees and Jackie Chans . . . martial art experts. You perceive me as a foreigner, until I speak and even then you say I speak wonderful English . . . how long have I studied? You perceive me with an identity crisis because my last name doesn't match the face. Your perception is wrong! I am Korean American . . . part land of the Morning Calm and part Red, White and Blue. I am the product of the Korean War which happened between 1950–53 ravaging a beautiful country.

As Russell Ferguson points out in the book *Out There: Marginalization and Contemporary Cultures,* when talking about marginal, we must ask, marginal to what? The place from which power is exercised is often hidden. When we try to pin it down, the center always seems to be somewhere else.

There have been several exhibitions on diaspora that attempt to pinpoint the center(s).

1. The exhibition *Asia/America: Identities in Contemporary Asian American Art,* organized by the Asia Society, New York, 1995. Curated by Margo Machida, third-generation Japanese American, the show was a courageous attempt to grasp the extremely complex presentation of interpretations of Asian Americans through contemporary art. Subjects related to disconnection, dislocation, and diasporic journeys reflected the intricate nature of contemporary Asian diaspora and transcultural experience. By attempting to negotiate Asian identities in the United States, the show allowed in-between space for creative invention to be discussed or debated. Perceived as not being sufficiently authentic or not meeting the preconceived notion of orientalness,

these artists have been overlooked as either not original or not exotic enough. In my review of this exhibition in the *Art Asia Pacific,* I was impressed by several artists, including Sung Ho Choi, Long Nguyen, David Chung, Yong Soon Min, Hanh Thi Pham, and Manuel Ocampo.

2. The exhibition *Across the Pacific: Contemporary Korean and Korean American Art,* organized by the Queens Museum of Art, New York, 1993, was a major show that linked Koreans at home and abroad. Several works focused on the Korean diapora, including Sung Ho Choi's *Choi's Market,* Jin Me Yoon's *Screens,* Yong Soon Min's *Ritual Labor of a Mechanical Bride,* Mo Bahc's *Learning American,* and Jae Soh's *Mama Blues.*

3. The largest immigration population in the United States is Filipino. Oversea contract workers are the most successful export from the Philippines, providing as much as $6 billion a year. With ability in English, these OCWs have been sojourners as maids, laborers, and entertainers. A number of Filipina migrant women have entered the United States, Europe, and Australia as mail-order brides. Illegal trafficking has led to large proliferation of Filipinas in illegal sex industries. These overseas Filipinas occupy ambiguous positions; neither inside nor wholly outside the nation-state, they hover on the edges of its consciousness.

The exhibition *At Home and Abroad: 20 Filipino Contemporary Artists,* organized by the Asian Art Museum, San Francisco, 1998, contrasted works by overseas and local artists. Artists who made works related directly to diaspora included Pacita Abad, Elmer Borlangan, Santiago Bose, Alfredo Esquillo, Brenda Fajardo, and Reamillo & Juliet.

4. The traveling exhibition *Who Owns Women's Bodies?,* organized by The Creative Collective Center and supported by the Ford Foundation, focused on the theme of the female body as a space of colonization and diaspora. Norberto Roldan's *Around the World* depicted Filipinas dressed in kimonos for the Broadway musical *Miss Saigon* that traveled to the Philippines. The work raised the issue of women entertainers performing various roles in Saigon, Manila, and other places in Asia.

5. The exhibition *There* at the Gwangju Biennale 2002 offered new research on the Korean diaspora with insights on selected nodal points such as Almaty (Kazakhstan), Los Angeles, Yanbian (China), São Paulo, and Osaka. For instance, in the catalog essay the curator writes, "Nowhere in the Korean diaspora is this entangled condition more intent or poignant than in Japan, in the belly of the former colonizing beast, so to speak." In her research the curator noted that many saw themselves as Korean, except in Japan where many tried to pass as Japanese.

There was a seminal art project on diaspora that will be an example for future projects and research in contemporary art and anthropology. It would have been most interesting if this exhibition had included samples of works from or experience in North Korea. As a space of diaspora, the other half of Korea is one of the most curious and fascinating in the context of Koreanness.

In 2001 the world witnessed on the news the image of the Kil Su family storming the Japanese consulate at Shenyang in China seeking political asylum. It was a desperately diasporic sight. Chinese police entered the consulate and dragged the family back from the front gate. The incident sparked tensions in relations among Japan, China, and North Korea. Tokyo demanded that North Korean asylum seekers be returned to the consulate. On the contrary, the Chinese government claimed, it was the Japanese ambassador's request that North Korean asylum seekers should be removed from the Japanese consulate. Consequently, the Japanese have been attacked by the South Korean media as conducting a two-faced policy by using North Korean diasporans as a political tool. The Kil Su family is an example of the Korean diaspora that has spilled from North Korea into China. News of suppression, poverty, and starvation in North Korea has surfaced more than ever; even cannibalism has been reported. Brainwashing and human degradation have been exposed by writers such as Helie Lee in her books *Still Life with Rice* and *In the Absence of Sun*. The latter records her seven-month journey into China, Mongolia, and North Korea looking for her uncle whom she wanted to unite with her grandmother after forty-seven years' separation.

Panama, 2002

Online Communities: Experimental Communication in the Virtual Diaspora

José Luis Brea

To these central systems, the authors counter-propose a-centric systems, networks of finite automata in which communication flows from one neighbor to the other, in which all individuals are interchangeable and are defined only by a state in a particular moment, in such a way that local operations can be coordinated and the final result can be synchronized independently of a central body.

Gilles Deleuze and Félix Guattari, *Rhizome: Introduction*

These pure singularities communicate only in the empty spaces of the example, without being tied by any common property, by any identity. They are expropriated of all identity, so as to appropriate belonging itself, the sign ε. Tricksters or fakes, assistants or "toons," they are the exemplars of the coming community.

Giorgio Agamben, *The Coming Community*

Identity, Community, and Technology

When discussing identity and its construction in new media, one has at least two main areas to consider. The first is the biotechnological sphere, which concerns genetic

engineering, the impact of technology on the construction of the body, and even the impact of virtual technologies on the production of a certain rearticulated *machine technology* of desire. There are many significant changes taking place within all these fields which need to be considered as we analyze the transformative processes of the construction of self due to new technologies.

A second approach focuses more on the way in which new technologies are creating new working conditions within the field of communication, and how through them we can think of a transformation in the way we articulate the common, the collective, and new forms of community. If we understand (according to the thesis defended by the communitarians) that a subject exists only if he or she can enjoy a *position* in the heart of a community, then we must accept that this second approach is especially relevant. Although I do not wish to adopt an exclusionary position, I will analyze how new communicative technologies are affecting the production of sociability and processes of construction of subjectivity that are themselves inscribed within concomitant processes of socialization.

The questioning of the existence of identities within virtual space will therefore pass through an ellipsis that I consider necessary: we will discuss the modes of producing community made possible by new technologies. Only in the response to this question about modes of online community will a certain emphasis emerge around the transformations of modes of production of the self and the construction of identity, inasmuch as they are affected by the impact of new technologies.

I will refer above all to those modes of producing community online that have been approached explicitly or implicitly as artistic or (post)artistic practices. In other words, although I will consider cases of communal production, I will give special emphasis to those practices that have emerged in the artistic sphere and its characteristic audience.

If it is possible to limit oneself to a discussion of the modes of producing community online that have been proposed from within the artistic sphere, it is undoubtedly because artistic practices have themselves recently undergone a series of transformations, within which the aim of producing community has become a major trend. Many contemporary artistic practices have centered precisely on the production of community and relational structures rather than on aesthetic objects or formulations.

From this perspective, one may consider that Net art descends primarily from the activist forms of media art characteristic of a general expansion of public art in the late twentieth century. This very suggestive proposal provides a useful key for identifying the most interesting manifestations in the fuzzy world of online art. It means that we can see the opportunity for communicative action provided by being online in the

same problematic context within which the above-mentioned artistic practices are renegotiating their contemporary meanings and functions. In other words, we can examine both in terms of their ability to develop mediations, systems of relations, and mechanisms of communicative action that can produce community.

Virtual Heterotopias: A Critique of the Mediations and Productions of the Public Sphere

> For all these reasons, this use value, this product that is the public sphere, is the most fundamental product that exists. In terms of community, of what I share in common with others, this is the basis of all processes of social change. This means that I can forget about any kind of politics if I reject the *production of a social sphere.*
>
> Alexander Kluge, "On Film and the Public Sphere"

> What action is possible in the public sphere?
>
> Knowbotics Research, *IO_Lavoro_inmateriale*

In art of the second half of the twentieth century, the avant-garde's immanent self-criticism has taken on the form of a critique of mediations. If the historical avant-garde concentrated its deconstructionist efforts on a critique of the "work of art" itself and its languages, in the second half of the twentieth century the critical emphasis was directed primarily at unraveling the web of social mechanisms that produce artistic value. Risking generalization, one may suggest that this deconstructionist project was realized at its most refined as a systematic exercise of dismantled displaying of mediations. In other words, emphasis was placed on the incorporation of a self-reflexive system that allows cultural practice simultaneously to become an effective social practice and to exhibit and question the set of conditions that make this possible. Inasmuch as this critical practice also aspires to transform these conditions in a meaningful way, its most important action as a cultural practice has necessarily involved a midterm strategic objective: that of "producing a public sphere," producing the mechanisms that will allow a critical reorganization of the conditions of dissemination and social inscription of these practices. Jürgen Habermas's famous theory states that the production of a public

domain is a "pending task" in contemporary society given its debased or weakened condition.[1] If we take this idea a step further, we can develop a proposition. The art of the twentieth century has left a *message,* a heritage or challenge for art of the twenty-first century: to create a practice that can produce the conditions for a reconstructed and recovered public sphere. The historical significance of Net art and online artistic practices may be defined, on the cusp of the twenty-first century, by their ability to take on this challenge and to produce an *autonomous* public sphere.

In the contemporary historical context, this task brings together the best "urbanizing" aspirations raised by recent critics of public art and media activism (as producers of citizenship). These aspirations are no longer merely to produce objects and contents with which to uncritically populate the public space or the media sphere as they exist now, but rather, to actively and directly produce communicative and social mediation in themselves. Within this field, the challenge is to produce the systems, the agencies, the abstract machines that will make possible civil encounters and public dialogue on the issues shared by different social agents. Once again, the intention is to *produce a public sphere.* As Kluge has pointed out, only by producing a public sphere is any critical action or communal project possible that could represent a concrete and profound reflection on democratic forms upon the reconstructed stage of the political.[2]

My intention is not to attribute to the Internet per se salvational or messianic (or demonic) qualities. I propose that we think of its potential within the context of the transformation of contemporary society, cultural practices, and social actions within them, which will require a revision of its mechanisms, structures, and order. The Internet is obviously not an empty field—alien to the rest of social activity—into which we can project absolute promissory fantasies. It is a territory with a complex set of transversal dynamics that allows for cuts and acts. Therefore, it is not so much a utopia as a mechanism whose promise lies in its relationship to social space itself, and thus it is open to an investigation of its potential, its qualities, and its possible uses. What is really at play is the possibility of developing an *antagonistic* use of mediations, an acknowledgment of the enormous tactical potential contained within technological mediation, and the exploitation of this quality from the perspective of a renewed interest in equality and emancipation.

The challenge now is to evaluate the tactical usage of the Internet as a tool that *is here,* changing the character of our world and our possibilities for action in that world. On either side of the contemporary political-cultural arena, new media are no more than transmitters and, perhaps, potential producers of heterotopias. As such, it is a mistake

and a mystification to attribute redemptive, utopian, or demonic and apocalyptic qualities to new media.

The futility of applying utopian fantasies to the Internet has been explicitly critiqued by Critical Art Ensemble, the same authors who theorized the concept of electronic disturbance.[3] However, it is clear that no defense strategy associated with a specific differential act—be it a local culture or a system of symbolic production associated with any identity—can afford to renounce the use of one of the tools that can best serve the interests of differential communication. Therefore, considering that the Internet has this quality of being a medium, and simultaneously recognizing that no mediation is neutral (but rather polyvocal and multiple), the issue now is to *politicize* its use. Through this use, social politics and cultural politics can come together, no longer just in terms of the ends but also the modes of practice.

Pioneering Modes of the Online Community: The Utopia of a "Community of Media Producers"

Through the emergence of digital cities, the spirit of media activism developed by independent and community television stations has been exported to new technology. The solidity of activist groups linked to "old media"[4] favored the rapid emergence of politics claiming a radical democratization of access to new media. Launched as an experiment in direct electronic democracy, intended initially to last ten weeks, the digital city of Amsterdam, DDS, tested an unprecedented system of participation in civil society in the municipal decision-making process.[5] This direct electronic democracy that allowed for civil participation was quickly abandoned in favor of more traditional—and less worrying for the political establishment—modes of "civic representation." However, the experiment did produce valuable gains, including the demand for free access and support for broadband and freeware. Two fundamental trends evolved from this experience and would come to characterize the future development of online communities. The first trend is the desire to relate directly to a civic space, to a real social fabric, rejecting the idea of an imaginary virtual "autonomous" limbo. The second trend is to assign an ideal of radical participatory communities to the constitution of online communities, considering them as future experimental realizations of the Brechtian ideal of "communities of media producers." Here we are speaking of communication communities as open systems of users in which all the participants can act at the same level, with similar rights to the transmission and public reception of opinion, discourse, or communicative action. Obviously this suggests heuristic conditions that in reality will

be hard to achieve, and we can imagine that the historical development of online communities may be read as an optimistic sequence of attempts to constitute real approximations to this ideal model. This is far from Habermas's idea of the ideal community of communication; instead, it is an eccentric and nonhierarchical map of small interconnected cells that follows, if anything, the model of "islands on the Net" characterized by Hakim Bey in his conceptualization of the Internet as a Temporary Autonomous Zone (TAZ).[6]

Within the Internet, this "community of media producers" is often characterized fundamentally as a model of participation, attempting to replace the traditional unidirectional and vertical scheme of emitter-receptor with that of a disseminated rhizome of users. This is the spirit behind the initial constitution of BBSs (Bulletin Board Systems, the precursor to Web sites and online forums). Within the artistic community, The Thing was a pioneer that developed as an instrument of emitter participation. For the original BBSs, such as The Thing, the difficulty in becoming true communities of emitters/participants became clear as soon as multimedia browsers appeared and the communicative potential of the medium far exceeded the limitations of a mere notice board.

With the Internet we have the ability to develop communities of participants/emitters or communities of media producers. However, the BBS structure was too limited to carry this out. The new unit of information is no longer the message or announcement, but the Web site. The issue is no longer how to create alternative, democratic, and participatory "emitters," but rather to allow anyone who wants it the ability to create their own autonomous and independent emitter. The challenge for the BBSs is to become open Internet-service-providers of Web site hosting, becoming meta-editors. The Thing developed quickly into this new condition, becoming a service not only for Web hosting but also for access. Therefore, the user becomes not merely an active receiver—in the sense that this pull technology allows for the active selection of content—but also an independent and autonomous transmitter. The dream of a community of media producers seems to be closer than ever. However, major communication industries and mega corporations are now trying to undo this development.

The End of Utopia: Drowning in Noise

The mass arrival of industrial corporations on the Internet has not created an immediate negative effect on either the costs of access or those of "emission." The work carried out

by those early hosting services (which were encouraging the creation of "communities of media producers") becomes futile in the face of the generalized cheapening of access and emission (the possibility of personal Web pages) led by large corporations. In many cases, these corporations fund their "generosity" by charging the customer another way, be it through the use and monopoly of software or through increased use of telephone lines. But above all they do so through a surreptitious appropriation of the mechanisms of mediation. The results are the dissolution of the dream of the Internet as a community of participants/emitters, the creation of a mass medium and its subsequent portalization, the saturation of the communicative space of the new medium, and its drowning in noise. Thus, the emerging communities of media producers rapidly became mere communities of media users. These communities no longer produce their own instruments of emission, given that hosting and access are freely available through portals fighting for "audience" share, nor do they control their own distribution mechanisms. This is now in the hands of the portals, which from this point on will administer the circulation of information in the new communicational space, or at least its main channels.

Whereas the macroindustry emergent around the Internet generalizes the conditions of emission and reception, it appropriates and monopolizes those of distribution—abandoning any pretension of independence. The immediate effect has been the neutralization of any political quality that was structurally maintained by the early Internet. The emitter no longer owns the channels of emission, and the general effect is one of drowning in noise. We can conclude that we are still dealing with a communicational technology that potentially allows for free and independent emission, but for which the mechanisms that grant visibility have been moved to specific nodes focused on mass circulation. Everything else gradually gets lost, segregated to the peripheries. The great strategy of advanced capitalism with regard to the Internet has not been censorship or control of the medium but rather its *megalization* in order to force it into the implacable logic of mass media. The old attempts to construct a "community of media producers" are now facing the question posed by the title of a work by Heath Bunting: "Own, be owned . . . or remain invisible."[7] The issue now is how to instrumentalize independent mediations that make "visibility" possible for those projects that refuse to succumb to the mass-media demands of portals, the realm of the dot-coms. The idea is to intervene in the generation of relational mechanisms of coalition that can guarantee that "any emitter" can effectively reach "any receiver." To make it so, one must play with operators of visibility. Working on mechanisms of coalition therefore becomes the central challenge so that the ruthless progress of portals, search engines, and other

operators of the new economy do not sideline the objective of constructing communities of communication.

Operators of Visibility/Mechanisms of Coalition (Revised Modes of the Online Community)

The first of these "mechanisms of coalition" is the collective Web site which, as environment and as unit of production/dissemination/presentation, allows a group of emitters with common expressive or ideological aims to come together and share resources and strategies. Most of these collective Web sites were developed as small mechanisms of resource-sharing among directly implicated emitters—usually artists or Net artists—and were self-promoted and self-maintained. The structures of function are initially minimal, and operate through a strategy of "minority" (as promoted by Deleuze and Guattari), always maintaining the ideals of DIY media. This independent model lives on in the structure of Bey's TAZ, proposing very light and versatile mechanisms that can displace and transform with ease. Nonetheless, the logic of institutional absorption was finally imposed, as the incorporation of äda'web into the Walker Art Center showed.[8] For others, strategies of survival involve the expansion of coalitions in ever-increasing circles, passing from the "molecular" (to use Deleuze's term) to the molar. Thus we see the emergence of different ways to construct constellations between different spaces and Web sites, creating circular structures, or rings. Of these, we should mention PLEXUS as a successful example within the artistic field.[9] Within the Spanish–Latin American realm, we have Doble_vínculo: Una constelación de comunidades web (Double_link: A constellation of Web communities).[10] A similar approach can be found in an earlier project developed as an e-show in February 1998, with the title *The Postmedia Age.*[11]

 This type of ring-constellation collaboration, based above all on "reciprocal links," soon lost its effectiveness with the rise of link maps and bookmark lists, through which each user can make his or her own Web logs and lists of favorites. Collaborative links then required additional "framing"—in the sense that Derrida speaks of *parergon*[12]—through the addition of interpretive mechanisms and guides to reading the groups of links. To a large extent this appeared through the large e-shows that, like traditional temporary exhibitions, were characteristic of Net art during its golden age from 1997 to 2000. Of these ephemeral exhibitions and "instant museums,"[13] we should highlight *Digital / Studies,* organized by Alex Galloway and Rachel Greene for Rhizome; Steve Deitz's *Beyond Interface,* for the Walker Art Center; and *net.condition,* organized by ZKM in Karlsruhe. If the e-show could once be considered just another collaborative

mechanism through which groups of artists could raise "visibility" for their work, then the large exhibition organized by ZKM represents the complete absorption of these mechanisms into conventional structures of art exhibition and legitimation, and therefore the disappearance of any communal principle. The e-show is no longer a collaborative strategy, a producer of community, but rather simply one more device through which art institutions and advanced cultural industries can reproduce the structures and complex problems of the *offline* art world.

However, the most important means for the creation of online communities is the e-mail forum: the mailing list. We could say that it marks the true emergence of the online community. The mailing list is the main—if not the only—mechanism of dialogic interaction, participation, and communication among the members of an online community. We can even say that it has a generative effect: wherever a mailing list emerges, a community can be born. We can list a number of online communities limited to artistic practices conceived and developed for the Web: nettime and syndicate in Europe; Rhizome in the United States; and ::eco:: in the Spanish-speaking world.

As direct descendants of the original BBSs, these critical forums are based on the free exchange of news and opinions among members. Although these forums began as spaces for communal interaction free of any kind of "censorship," it soon became clear that they required some form of filtering. For technical reasons, and also for practical and objective communications issues, it became impossible to maintain open forums. In some cases, such as Rhizome, there was an attempt to maintain some totally unmoderated lists, but the need to block spammers and hackers and to deal with error messages, returns, etc., soon took their toll. As a result, two types of activity emerged: first, the establishment of different types of lists; and second, the delimitation of editorial control. In nettime, for example, different lists were established essentially according to language use, each of which had a fairly stable team of editors whose function was to filter out messages that did not follow the rules.

The second main issue around which mailing-list forums have developed is the selection of subject matter. To take the example of nettime again, the subject matter was determined by the self-reflexive aim that had spawned the group: the creation of a mechanism to enable a real-time critique of the development of new media in contemporary society. Therefore, debates on isolated issues of art and aesthetics were excluded, and the inclusion of the political was a natural demand within a group that from the outset accepted the political and social issues implicit in working with communication media.

With Rhizome, the very diversification of its lists favored an increasing distribution and specialization of content. Messages that focused on art with particular reference to online art went to the net.art.news list, while those dealing with theory, debate, and politics went to the rhizome_rare list. General or undefined messages went to rhizome_raw, which remained unmoderated, while those messages deemed to be more important editorially were distributed through the weekly digest list. Within this structure, the limits of the mailing-list model can clearly be seen. On the one hand, we have total free expression, generating an incredible amount of noise, while on the other hand we have an editorial model more akin to that of a magazine and increasingly removed from the participatory and nonhierarchical forum that defines a community of media producers.

Rhizoid Authorship: Collaborative Communities and Copy-Left

> We have written the Anti-Oedipus between the two of us. Given that each of us is multiple, it was already too many people.
>
> Gilles Deleuze and Félix Guattari, *Rhizome: Introduction*

One of the most interesting cases of forums by mailing list leads us directly into the final issue to be considered here, namely, communities of authorship. I am referring to 7-11, a participatory mailing list in which the desire to collaborate overcame in practice any intention to "inform." In this list, circulating messages adopted the form of illegible concrete poetry, in a form of resuscitated neodada that transferred the achievements of mail art into the territory of e-mail, playing above all with ASCII drawings and experimentation with a universal language drawn from the world of programming.[14] The majority of messages were practically illegible, placing all of their relational value in the circulation and exchange of pure signifiers in which writing recovered its status as pure grapheme and prelinguistic sign. At the same time, a complex system of pseudonyms and continual rotation meant that the list had no fixed moderator, and even the identifiers could be modified by the participants. Therefore the identifiers of the list were effectively limited to "nonformat" message formats and the widespread use of green monospace fonts on black backgrounds on their Web archive. Clearly this group had little interest in dialogue or rational debate, so the forum gradually became a kind of collective macrowork of Net art. The intention was to participate in a communicative game of

creating a community that did not exist beyond its constitutive acts of communication. It was not only a community of communication but also, simultaneously, a collective body promoting an expressive, participatory, nonhierarchical, and eccentric *authorship*.

It is quite possible that the second great political potentiality of the Web lies in its ability to create collectivized modes of authorship: in practice, eccentric modes of collective identity diffused through a nondelimited dispersion of enunciative operators. This quality constitutes a new political potential, this time in terms of radical experimentation with contemporary modes of constructing identity, far removed from any pretension of essentializing its figures, and basing its articulation only on modes of praxis and action—appealing precisely to the *materializing* conditions of discourse, of performative acts of speaking and communication.[15]

One of the territories in which this experimentation has been carried out with great success—aside from the development of open and free software, which perhaps constitutes one of the most interesting examples of collaborative experience in the production of knowledge—is *online* artistic production, a field in which many collectives develop their symbolic work, avoiding traditional notions of the "artist-genius." There is an obvious technical reason for the formation of groups and the "division of labor" within these groups (the case of *jodi* is paradigmatic: artist-designer + IT technician), but beyond this technical need, there is an ideological and political intent that explains why so many Internet projects result in collective, communitarian, and open practices. In fact, the most interesting work on the Internet almost always arises from this kind of molecular structure, which represents the connection of many individual efforts. These efforts run through many different fields of activity, from theoretical debate to technological experimentation. Some projects have even dealt intelligently with the communal issue by exploring and questioning its critique of preestablished notions of individual authorship. This process of resistance aims at the effective transformation of the economics of art and practices of symbolic production in contemporary society, as well as the transformation of authorship to modes of production and labor in information societies. In this regard, the foundational manifesto of La Société Anonyme is explicit: "Any notion of authorship has been overtaken by the logic of circulation of ideas in contemporary society."[16]

The process of questioning authorship—applied in the best cases to the very "collectives" that propose it—refers equally to the profound transformation currently affecting the economies of art in the information society. The logic of distribution of symbolic goods, affected by the potentialities of new technologies of dissemination and

articulation of cultural consumption, determines not only the obsolescence of an art market based on traditional notions of presence and originality but also the displacement of the function of artistic practices away from the mystical-magical surplus attributed to it by an anthropological demand, as though the artist were still a tribal shaman. In information societies in which *immaterial production* tends to become one of the main generators of wealth, artistic production—or more generally, all symbolic production— begins to occupy explicit areas with regard to the articulation of new forms of knowledge management. In this sense, Walter Benjamin's formula of the "artist as producer" can be revised into new and rich interpretations, now that the aim of transforming the conditions of production of one's own medium implies specific positions with regard to one's specific economy.

At the point where artistic practice is no longer connected in a hegemonic manner—or at least not exclusively—to the mercantilism of trade in unique objects (and certain modes of public heritage building that cut through the mechanics of collecting and physical exhibitions through a spatial acquiescence), works produced on the Internet by collectives involve an experimental exercise that doubly questions these regimes. Such experiments test, on the one hand, established modes and conditions of production, each time they attack the principle of authorship, and the legalities of intellectual property, of copyright. On the other hand, they question modes of distribution, consumption, and public reception, which are no longer limited to trade in the singular or exhibition of the original, but incorporate new economies of production, multiplication, and postmedia distribution in which what is regulated tends not to be property (increasingly irrelevant with regard to artistic experience) but rather access to information.

The Coming Community: On the Production of Identity in a Postidentity Context

Because if instead of continuing to search for a proper identity in the already improper and senseless form of individuality, humans were to succeed in belonging to this impropriety as such, in making of the proper being-thus not an identity and an individual property but a singularity without identity, a common and absolutely exposed singularity—if humans could, that is, not be-thus in this or that particular biography, but be only *the* thus, their singular exteriority and their face, then they would for the first time enter into a community

without presuppositions and without subjects, into a communication without the incommunicable.

Selecting in the new planetary humanity those characteristics that allow for its survival, removing the thin diaphragm that separates bad mediatized advertising from the perfect exteriority that communicates only itself—this is the political task of our generation.

Giorgio Agamben, *The Coming Community*

And class happens when some men, as a result of common experiences (inherited or shared), feel and articulate the identity of their interests as between themselves, and against other men whose interests are different from (and usually opposed to) theirs.

Edward Thompson, *Making of the English Working Class*

The new economies characteristic of Web societies are affecting not only the modes of production and consumption of the *objects* generated and distributed by cultural practices but also the *subjects* themselves—the ways in which effects of subjectivity or subjection are generated in them. A profound crisis is affecting the traditional Great Mechanisms that produce identity, such as family, ethnicity, school, fatherland, or tradition, and making them increasingly irrelevant. Without doubt, the spectacular increase in social mobility—geographical and physical but also affective, cultural, gender- and identity-based—determines the decline of these essentially territorial machines. But the most decisive factor is the general absorption of the institutional function by contemporary industries of collective imagination. We can speak of an expanded "constellation of industries" that brings together the industries of communication, spectacle, leisure, and cultural entertainment, and in more general terms all those related to the experience and representation of life itself, and that takes charge of producing the subject in as much as it can recognize itself as *itself* among peers, and can administer its differences and similarities within this relationship.[17]

Faced with this incredible potential, acquired in contemporary societies by this mega-industry of subjectivity, symbolic production practices are being charged with an

irrevocably political dimension. As immaterial production and knowledge occupy such a central role in the new economy, their impact, according to Toni Negri, "deeply affects the very reorganization of production on a global scale." Negri states that increasingly those elements "that are connected to the circulation of merchandise and immaterial services, to the problems of reproduction of life, are effectively becoming central."[18]

This is how the domain of the virtual, the online interstice on which the Web is formed, defines a territory of experimentation of singular value to test some of the most interesting challenges of our age. One area of attention is without doubt the new economy of the consumption of objects and cultural production, altered by new systems of distribution created by new communications technologies. More significant, however, is the challenge to the universe of identity, the horizon of processes that constitute the social and the subjective. In a world in which the need for an authentic "life of one's own"[19] becomes more and more threatening—and therefore more urgent—the activation of these self-reflexive mechanisms of criticality being sought through artistic and cultural practices allow one to develop effective processes of resistance in the face of the homologating and deauthenticating effectiveness of the new powerful industries of the collective imaginary associated with mass media.

In this context, and like other territories and mechanisms of relational work, the Web will reinforce our ability to articulate versatile and community-generating forms. Constellations of molar units will themselves express moments of community and the tensions of shared experience. Specific vectors of the community of interests, experiences, beliefs, or desires, stretching momentary and unstable lines of code, will be established in the free flows of difference. We are not vindicating a community that can be essentialized under homological notions of identity, but rather inducing fluctuating communal contingents regulated only by the instant and ephemeral expression of effects of difference: transidentical, mixed, multiform, and pluricultural from their origins. Eccentric and nonhierarchical constellations of small units disseminated in a capillary fabric of connected vials.

In this new *relational space,* perforated and constituted not so much through its nodes but through the interstices between them, the Web appears as the perfect (non)space for the renewed appearance of what Georges Bataille called "the impossible community": the ever-returning "community of those who have no community."[20] In this community there will probably be no more "subjects" or individuals but instead a mere circulation of transitive effects of identity inscribed in the shared experience of their own *incompleteness.* On the strength of this, the Web may well become the announcement, if

not the actual habitat, of the "coming community." By forcing us to awaken from the despotic delirium of an ancient system, it can become its greatest nightmare. And therefore, for us, the sweetest dream.

translated from the Spanish by Gabriel Pérez-Barreiro

Montreal, 1999

Notes

1. See Jürgen Habermas, *Strukturwandel der Öffentlichkeit* (Darmstadt: Hermann Luchterhand Verlag, 1990).

2. Alexander Kluge, conversation with Klaus Eder, "On Film and the Public Sphere," *New German Critique,* no. 24 (Fall 1981), pp. 211–14.

3. Critical Art Ensemble, "Utopian promises, net.realities," <www.critical-art.net>.

4. I take this ironic allusion to TV from the denomination adopted by the Association for Old and New Media, WAAG, <www.waag.org>.

5. On the Digital City of Amsterdam, see <www.dds.nl>.

6. Hakim Bey, *Temporary Autonomous Zone* (Brooklyn: Autonomedia, 1985).

7. See <www.irational.org/heath/_readme.html>.

8. äda'web is an online art site or gallery on the Internet. Following its opening in May 1995, it presented (and in many cases produced) more than two dozen artworks and projects designed for Internet viewing. Founded by curator Benjamin Weil, äda'web was headquartered in New York. By the time it closed in February 1998, äda'web was regarded by many commentators as the premier showcase for online art. See <http://adaweb.walkerart.org>.

9. See <www.plexus.org>.

10. Doble_vínculo: Una constelación de comunidades web, <aleph-arts.org/doble_vinculo/>.

11. *La era post-media* was originally an e-show I curated and presented on Aleph (aleph-arts.org/epm/). Since then, I have developed these ideas in *La era post-media: Acción comunicativa, prácticas post-artísticas y dispositivos neomediales* (Salamanca, Spain: Centro de Arte de Salamanca, 2002).

12. See Jacques Derrida, *The Truth in Painting* (Chicago: University of Chicago Press, 1987).

13. I am using Francis Haskell's terminology; see *The Ephemeral Museum: Old Master Paintings and the Rise of the Art Exhibition* (New Haven: Yale University Press, 2000).

14. ASCII is the international character set, and ASCII drawings are made through alphanumeric characters. There are Web sites dedicated to ASCII art, which have influenced many pioneering Net artists, particularly Vuk Cosic.

15. This materializing characteristic of discourse and discursive practices directly affects the production of identity, as Judith Butler argues in *Gender Trouble: Feminism and the Subversion of Identity* (New York: Routledge, 1999).

16. La Société Anonyme, "A Redefinition of Artistic Practices (LSA47)," *Parachute* (Canada), no. 109 (February 2003).

17. In this regard, one should consider the interesting statements of Pierre Bourdieu on "cultural capital" in relation to the processes of production of *distinction*. See Pierre Bourdieu, *La distinction* (Paris: Les Éditions de Minuit, 1979).

18. Toni Negri, "El G-8 es una caricatura; la globalización exige una participación de todos," interview by Gabriel Albiac on the publication of *Empire*, in *El Mundo* (Madrid), 21 July 2001.

19. See Ulrich Beck, "Living Your Own Life in a Runaway World: Individualism, Globalization, and Politics," in Anthony Giddens and Will Hutton, eds., *On the Edge: Living with Global Capitalism* (New York: Jonathan Cape, 2000), pp. 164–74.

20. On Bataille's notion of "the impossible community," see Maurice Blanchot's exceptional essay *La communauté inavouable* (Paris: Les Éditions de Minuit, 1983).

Chinese Artists in France

John Clark

Periodization

The June 4, 1989, Beijing massacre marked yet another exodus of artists from China. It was, however, a qualitatively different situation from that in the early 1980s, which led to the departure of artists belonging to the Stars group, the first post–Cultural Revolution avant-gardist art group. The events in Beijing in 1989 had been preceded by the rise, over a period of five years or so, of an avant-garde in China, which was formalized in the *China Modern Art* exhibition at the China Art Gallery, Beijing, in February 1989. Direct contact between the French modern art world and that avant-garde had been established by the inclusion of Huang Yongping, Gu Dexing, and Yang Jiechang in *Magiciens de la terre* at the Centre Georges Pompidou in 1989. The exhibition's Chinese adviser was the young art historian and critic Fei Dawei, who had come to France on exchange in 1986 and subsequently became very closely linked to the French cultural and curatorial elite.

There were a number of important exhibitions of contemporary Chinese art in the early 1990s in France, England, Holland, and Germany, but these gave way to exhibitions in which the newer Chinese artists who had come to be based in France were increasingly articulated in an international context. Toward the end of the 1990s, some France-based Chinese critics, including Hou Hanru, put aside a China-centered concept of their own critical and curatorial activity and moved toward a broad international scale. Hou was co-curator of the 1997 *Cities on the Move* exhibition, which included Chinese artists but was not ostensibly built around a conception of their "Chineseness." One strategy for Chinese artists in France, such as Huang Yongping, was to place Chinese

culturally based meaning and experience in a dialectical relationship to Western European ideas, frequently conceived as a "China-West" binary. Another approach was to set this Chineseness aside altogether, or to include it merely as a technical or iconographic tool, as in the work of Yan Peiming or Wang Du.

Artists

Generalizations about the reception and promotion of Chinese artists in France need to be founded on an initial characterization of their experiences and works.[1] Since World War I, there has consistently been a relatively large number of Chinese artists who either live or sojourn in France. In the twentieth century, France was firmly part of the imaginary homeland of modern Chinese artists, and a site for legitimation.

Chinese artists who became prominent in France in the 1990s differed from their predecessors in the Stars group, such as Wang Keping and Ma Desheng, due in part to differences in age and background. Wang and Ma were both active during the Cultural Revolution and neither had attended one of the prestigious fine art academies in Beijing or Hangzhou, as did the artists in the 1990s. In addition, a certain directness in commenting on current events in China caused Wang and Ma to be characterized as "political" artists by some of the later arrivals. Certainly, both in their explicit attitudes and to some extent in their reception by the French elite, the post-Stars arrivals tend to regard themselves as truer artists and critics. They see the Stars artists, including their representatives in France, Wang and Ma, as a small group of experimenters who were thrown into the limelight by a short-term series of historical events, the Beijing Spring of 1979–81, but who are not necessarily serious artists worthy of consideration.

An intermediate figure is oil painter Jiang Dahai, who was born in Nanjing in 1949 and graduated from the Central Academy Oil Painting Department, Beijing, where he then remained as a teacher.[2] Jiang had already exhibited in China as part of the *Same Generation* exhibition in 1980, before coming to France in 1986, where he chose to study at the École Normale Supérieure des Beaux-Arts, Paris, and to master the technique of modernist oil painting. He builds dense, closely modulated fields of semitransparent dark colors in works that produce a deep sense of melancholy, if not despair. Jiang's work has no trace of political reference, but it profoundly implies all the personally experienced bitterness felt by his family toward their earlier Nationalist Party connections and toward the Cultural Revolution, which he endured.

Yan Peiming had done propaganda paintings as an adolescent, before arriving in France from Shanghai in 1980 directly after high school. He studied fine arts at the École des Beaux-Arts in Dijon, from which he graduated in 1986, but he had already

Wang Keping, *Sculpture,* 1988.
Courtesy of the artist.

Jiang Dahai, *Landscape—Green Mountain*, 1999, acrylic and oil on canvas, 130 × 97 cm. Courtesy of the artist.

begun to participate in group exhibitions as early as 1982. By 1987 he had started to revisit Mao icons in some large and distinctive paintings, and in 1989 his first solo exhibition at the Musée Greuze brought him critical attention.[3] An interpretation in terms of Soulages or Kline would be mistaken since there is no intended irony in his use of the Mao image, for which he still has affection and to which he reverts only when he has a creative blockage. His works' recognizable but deformed figurations seek monumentality, while his drippings allude to calligraphy.[4] But his own understanding of the choice of the portrait subject surely accounts for its wide popularity with French critics. Yan says: "The choice of a single motif seems to me to be the most meaningful choice. I see my work as a lifelong program: painting heads . . . when I do a face it is totally autonomous and does not represent a specific person. I work on antiportraits . . . I am interested in men in general, and my work can be seen as a kind of universal portrait. What I always paint is ultimately an idea of this humanity."[5]

For a while Yan backed off from his decision to paint only portraits,[6] but he also determined not to use any recognizable figures who are not Chinese. For example, to paint famous French politicians would be a denial of himself and of his search for an Other. He has restricted himself to painting images of Mao Zedong, his father, and, in a series from 2001, Bruce Lee. The attraction for French critics may be that such work is highly theorizable, but its distance and cultural traces carry with them the attraction of an unfathomable, uncanny Other, the exoticism of a romantic pathos. That is, it displays the Other without making the cost of absorbing it too high.[7]

Chen Zhen, also from Shanghai, died in France in 2000. He had studied painting at the Shanghai Arts and Crafts School in 1973 and graduated from the Shanghai Drama Institute in 1978. In China his artistic challenge had been how to engage in "re-reading Chinese culture from a Western context,"[8] but when he came to France in 1986 to study at the École Normale Supérieure des Beaux-Arts, Paris, the tables were turned. In 1989 he was one of very few foreign artists invited to study at the Institut des Hautes Études en Arts Plastiques, Paris. Chen saw his work as "a kind of open architecture," a wide field of research with assimilated references.[9] This position is evident in the work he created in 1990 at Pourrières, the site of a forest fire, where he hung up consumer goods from the town rubbish dump on the burnt-out trees. Chen wanted his art to be situated somewhere between therapy and meditation, and to serve as a metaphor "to critique the world." According to Chen, "Chinese thinking swings 'between' objects and elements. [It is] a kind of 'non-object' and 'non-place.' "[10] He saw himself as a "spiritual runaway" and coined the term *transexperience* "to describe the dynamic and dialectical process that

Yan Peiming, the artist standing in front of a work from the *Bruce Lee* series, 2001, oil on canvas. Photograph by John Clark in Yan's studio at Dijon, August 2001.

Chen Zhen, *Daily Incantations*, 1996, installation with Chinese chamber pots, wood, metal, electrical appliances, and sound system, 230 × 700 × 350 cm. The Dakis Joannou Collection, Athens.

occurs when an individual is displaced between cultures, societies and languages."[11] He might have further relativized his dialectic of "the Chinese" and "the Westerner" in his use of the phrase *rongzhao jingyan,* the experience of blending together and transcending experience: to penetrate into humanity to combine with others to make one whole.[12]

Of the three artists who exhibited at *Magiciens de la terre,* Huang Yongping has been especially visible through his residency at the Fondation Cartier in Jouy-en-Josas in 1990, and through his solo exhibition at the Fondation Cartier in Paris in 1997.[13] Huang was also selected to represent France at the 1999 Venice Biennale, but due to some political maneuverings in the art establishment, he eventually exhibited in the French pavilion alongside a French artist, since at that time Huang had not yet acquired French citizenship.[14] Having graduated from the Zhejiang [now China] Art Academy in Hangzhou in 1982, and independently creating his own dadaist installations at Xiamen in 1986, Huang was already one of the most active innovators of the post-1985 New Currents in Art Movement before he came to France. There, he seems to have deliberately decided to incorporate Chinese contents and references in his installation works to set up a dialectical relation with Western art discourse and its institutions.[15] Huang drew on the structure of the neoclassic French pavilion itself to critique the order of the national,

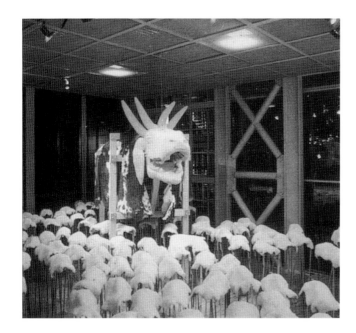

Huang Yongping, *Peril du mouton,* exhibition at Fondation Cartier, Paris, 1997.

disturbing the building's roof with images of Chinese magical animals. Huang is clearly attempting, from within a multicultural situation, to create a new space in his relativization of the West by applying Chinese folk symbols to Euro-American contexts— and more broadly, according to Hou Hanru, "to obviate the power of national cultural organizations."[16]

Yang Jiechang had been one of the major innovators of modern Chinese ink painting before he came to France from Guangdong. His abstract innovations in ink depend on Chinese technique and they reflect new sensibilities from a Chinese position, but they do not perform difference in the same manner as the works of Huang Yongping. Some of Yang's black-on-black works pose a relationship between supreme ideals and pictorial representation, yet make no display of a dialectical relation to either Western or Chinese painting. His work is neither Sinicizable as an Other nor theorizable as representing a trend, yet it is eminently understandable and sometimes deeply moving as a kind of pure painting.

In contrast, the work of Wang Du easily relates to his own Chinese history, prior to coming to France in 1992, where his work has attracted a wide range of important theorists and writers who champion its attributes. Wang takes two-dimensional mass-

Yang Jiechang, *Guillotine II*, 1995–
96, ink on xuan paper, 170 × 186 cm.
Detail. Courtesy of the artist.

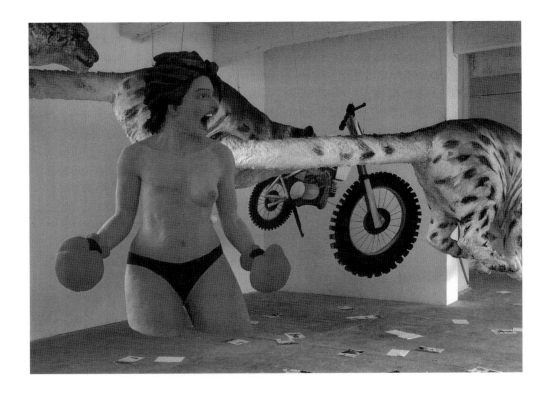

media images and turns them into three-dimensional sculptures, preserving the virtual framing of the original images and then cutting off parts of the image to emphasize this viewing position. He acknowledges the influence of the 1992 exhibition *Post Human,* organized by Jeffrey Deitch. But Wang brings to this work a historically contextualized Chinese awareness, for "during the Cultural Revolution there was a lack of understanding that images were being used for the purposes of propaganda alone since all the images produced at that time were propaganda in nature."[17] What concerns him is the inability to escape from the technological construction of our lived and imaginary worlds: "If *Post Human* was speculative, I thought I could then find a way of making it tangible, to depict the reality of certain contemporary ideologies."[18]

Wang's images make palpable the hidden principles of production and exchange in modern societies, which use reproduced images as the medium for and representation of exchange. Such an intellectual position may be feeding back through the artist's conception of his or her own practice. For Wang, art today is neither

Wang Du, *La boxeuse,* ca. 1999, sculpture and installation. Courtesy of the artist.

Shen Yuan, *Wasting One's Spittle,* 1994, installation with tongues sculpted in ice, knives, and spittoons, 650 × 400 × 100 cm. Courtesy of the artist.

"ideological nor linked to a concept or artistic movement, but rather a way of understanding reality. . . . I have chosen to act like a double in the reality of media."[19]

The notion of doubling is also relevant to the siting of an artist's self in a world where people move between different cultures and languages. Huang Yongping's wife, Shen Yuan, joined him in France in 1990. Her work exemplifies the shift from the immigrant's passive receptivity to the active engagement in the processes that made him or her emigrate. There is an antipathy to language in the foregrounding and relative scale of certain imagery in her work, or at the very least a recognition of the "limits of language to describe and translate lived experience in a new global economy,"[20] for "the speed and exchange of worldwide communication has not resulted in an equally fast exchange of cultural understanding."[21]

Engagement is only one of several possible relations to immigrant passage, for some artists also disengage and turn their imagery into absolute singularities, using

visual representation as a way to go beyond textual expression. Gao Xingjian, who prior to his recent celebrity as Nobel laureate for literature supported himself for many years in Germany and France through his ink paintings, still seems to be searching for phantasmic imagery beyond the significations of the written word. This places him in a kind of metaphysical isolation that, however traditional within the "inner emigration" of many premodern Chinese literati, now signifies in France a kind of separation from the search for or engagement with the Other, who cannot be transformed by this lack.

Cai Guoqiang is a sojourner, temporarily in residence in France to create site-specific work for a particular exhibition. He has lived for significant amounts of time in Japan and then New York; he has produced site-specific work at Pourrières (1990) and also worked at the Fondation Cartier studio in 1993. Fei Dawei thinks that Cai, in "convening diverse and fluctuating methods . . . looks for the profound disorder of the world, in the attempt to attain an organic, global vision of the universe that surpasses chaos."[22] Cai's work forms a fertile object onto which may be mapped a recurrent idea in some Chinese discourse on the modern: the conception proclaiming that Western and Eastern philosophies had once shared a single idea but then split off, and only now are they in the process of coming back together. Because of his systematic use of Chinese materials, art techniques, and art objects, Cai has always been concerned with a Chinese tradition facing the West under conditions of modernity: "The important question is to know how to appropriate this traditional model and how to fuse it with my own *Weltanschauung*. Neither forms nor concepts of art can be contained within a model forever . . . we need fundamental changes. It is the difference between artists and craftsmen."[23]

This fascinating overlap—of the need for the academy-trained artist, long a resident abroad, to distinguish his tradition from that of the Others, and his professional status from that of an artisan—speaks to a perception of artistic migration in terms of struggle or conflict with unabsorbed or unsynthesized Others. This comes out specifically in a conversation between Fei and Cai:

> **Fei:** When we arrived in the West in the nineties, we felt as though we were going off to war. What do you think of this now?
> **Cai:** In China, I was in the underground. In Japan I was in guerrilla warfare. Today, I have set off into regular war because in the United States you learn how to fight in a regulated manner.[24]

Critics

Of the small number of able Chinese curator-critics living abroad since the late 1980s—among them Fei Dawei, Gao Minglu, Hou Hanru, Zheng Shengtian, and Zhou Yan—two reside in France: Fei (since 1986) and Hou (since 1990). Because they adopted contrasting, and sometimes opposed, curatorial practices and critical perspectives, their activities and positions are worth examination.

Fei Dawei

Fei Dawei is known principally for his consulting to *Magiciens de la terre* and for his own exhibition *Art chinois: Chine demain pour hier,* presented in Aix-en-Provence in 1990. In the catalog for the latter, he explicitly states his intentions: "There is truly no dialogue between contemporaries. Above all it is this disequilibrium which led me to conceive of this exhibition. The second and more objective reason comes from the fact that for ten years there has existed a real cultural and intellectual movement in China which is absolutely unknown in the Occident."[25]

The selection of artists and the quality of the work they produced for this exhibition were clearly intended to overcome a general European disregard for the Chinese avant-garde, which was considered imitative or passé. Fei observed, "Perhaps the occidentals are not yet sufficiently ready to look at the others? This is of course valuable in the other direction, for if there is not enough contact and comprehension, the Chinese artists risk not understanding in their turn the points of view of the Occident."[26]

There are clearly contradictions inherent in Fei's position that contemporary art is a worldwide phenomenon but that the underlying mentalities are inalienably different: "There exists a universal and worldwide phenomenon of art. Maybe the differences could be a formal question or one of language. Even if apparently there exist formal resemblances, the mental state between China and the Occident remains radically different."[27]

At the heart of this critical stance lie feelings that Chinese art has been unfairly excluded and that the quality of Chinese avant-garde has been denied, due to institutional hostility toward the outsider. But at the end of the 1990s Fei also ties this empirical curatorial disdain back to art history:

> Following the total institutionalization of contemporary art, since the seventies, the logic of art history has degraded to the point of becoming nothing more than a system of trademarks. This system records the concept and language an artist invents. Then it suffices to simply reiterate the usage of these trademarks

in order to preserve one's status as an "artist." That is how art lost its capacity to bypass reality.[28]

This text shows an intensely felt ambivalence. It is trapped between admiration for the various freedoms from tradition brought by Western modernism, and the competitive exclusion of non-European modern artists whose work does not come with the appropriate genealogical marks attached. An ideational freedom in Western modernism has now been translated in practice into an ideological orthodoxy with its own institutional barriers to recognition of Others. One could infer from Fei's argument that Western modernism has reconstructed toward outsiders the very ideological barriers it had torn down toward its own pasts.

Fei later commented on why Chinese artists have achieved a certain prominence in France.[29] The reason stems from a chain of coincidences, and the situation would have been completely different had Fei not met Jean-Hubert Martin in 1986. At that particular juncture, and coinciding with a change in the French elite's perceptions of China, Fei was given very high-level access to members of the French political class, including even the Minister of Culture Jack Lang.[30] After 1989 the solidarity among Chinese artists, and their relative status in China, enabled them to achieve a prominence in France they might not otherwise have obtained. For Fei, France is a cultural melting-pot and a space of in-betweenness—a third space that may in fact replace the idea of identity as defined by national-cultural terms. But he sees that third space as an invention, as a nowhere, and one may suppose that he has a deep-seated resistance to moving beyond the Chinese-Western binary. Like so many others, he clings to culture as an authenticating boundary for the self rather than as contingent material brought to the surface of interpersonal negotiation, itself formed by historical conjuncture.

Although one could argue that the cultural milieu in France had long been prepared for Chinese artists—whether by eighteenth-century rococo, *chinoiserie*, or the late-nineteenth-century exoticism of a Victor Segalen—Jean-Hubert Martin felt that after *Magiciens de la terre* French culture exhibited symptoms of an opening-up that was partially formed by that exhibition.[31] Martin found that the Western art markets were opportunistically in search of the new and, following on the heels of the fashion for Russian modernism, the Chinese were increasingly in style in the 1990s. But Martin also noted France's backhanded admiration of Chinese culture, which holds that China is the only civilization to have attained a cultural level equivalent to that of occidental culture, which is, of course, synonymous with France.

Even though the French art market plays only a small part in the sales of works by Chinese artists living in France, it does have an important role in consecrating aesthetic tendencies on a European scale. The critic Domino observed that in terms of social appraisal it is considered a good thing for a French collector to "have his Chinese" at home. Domino also noted succinctly that "Chinese culture has always been important for the French culture, particularly because the French culture . . . recognizes in it another culture with its historicity and rich history. . . . Chinese culture is not dependant on a religious system, but is rather a system of arts, with an art for the court, and an art for the elite. Well, the French cultural arrogance accepts the Chinese culture as equal."[32]

One also finds a mutual accordance of space without self-imposed questioning, mixed sometimes with a kind of operational opportunism, in the forewords to the catalog for Fei's 1990 exhibition at Pourrières. The organizer Michèle Cohen neatly brings out this bifurcation: "The idea of a manifestation around immigrant Chinese artists immediately seduced us. It testifies to an interest we have in France for China and its creators. . . . In the era of cultural exchanges it appeared to us important to demonstrate once and for all to the public that contemporary Chinese works are not simple copies of the Western."[33]

It is not difficult to see how a conception of cultural interaction becomes conceptualized in France as an "exchange of exoticisms," allowing both sides to remain imperiously secure in their differentially constructed access to cultural authenticity, without any challenge or deconstruction being engaged at their points of contact.

Hou Hanru

In the first half of the 1990s, Hou Hanru curated a wide range of small exhibitions in Paris by artists of many backgrounds. Since then he engaged locally and internationally with Chinese artists before moving on to major international curatorial activities.[34]

Hou considers that Chinese artists overseas "not only provide information and other materials for other artists in China, but they stimulate their imaginative powers, and they themselves in Western society open up a space for a multiethnic site in truly globalizing artistic creation."[35]

While continuing to work with and for Chinese artists, Hou has realized the functions of Chinese artists in an increasingly multicultural world, particularly in the old imperial metropolises. This position sets him apart from those who continue to work with only bicultural binaries. Indeed he sometimes seems highly ambivalent about the opportunities this position affords him, considering that France had to be forced to admit to the quality of the Chinese artists who came there in the 1990s. The acceptance of Huang Yongping in the French pavilion at the 1999 Venice Biennale was, for Hou, a sign

of French opportunism. His recent and recurrent concern is that "there is no real interest in France in the postcolonial condition, in which the Chinese artists represent neither themselves nor France, but only their own self-awareness."[36]

These concerns were quite evident in a small but important exhibition that Hou curated in 1997, titled *Parisien(ne)s,* in which only three of the seven artists from Paris were Chinese. Hou notes that "the Paris that exists in our minds is the city of artists and the birthplace of modern art," but that Paris now had an "identity as a *modern* city . . . changing into a pluralist, multi-cultural and constantly changing *post-modernist* city."[37] He draws a line between multicultural art and folkloric or exoticized readings of the colonial "other," such as those in *Magiciens de la terre:* "The deconstruction of modernism and modernity should entail a form of progress from, rather than denial of, the impact of modernity on international culture." Hou accepts Homi Bhabha's concept of a third space between cultures that is replacing the mainstream dominant "national" culture, for "as immigrants are more central in society, society is increasingly defined by immigrants."[38] The French intellectual absence from the multicultural and other postcolonial debates was noted with scarcely concealed hostility by Evelyne Jouanno and Hou in their 2000 exhibition of artists from non-French backgrounds who are active in Paris, titled *Paris pour escale.*[39]

Two prefatory texts, by noncurators, give a good indication of the attitudes with which Jouanno and Hou have had to deal. There is an uncomfortable compromise struck between privileging Paris and attempting to grasp new kinds of artistic movement: "Many artists remain who continue to wait on Paris for the energy of a metropolis for which they recognize the true qualities of hospitality, especially at the level of intellectual offering . . . but the dynamic naturally created by these artists doubles in size with the force proper to the new modalities on the principle of nomadism, itself global."[40]

Jouanno and Hou, in their essay, suggest that there has been a change in the definition of immigration, which is no longer a simple implantation, and that many artists continue to travel for reasons of work or daily life. Paris is thus a "port-of-call."[41] The curators hold out quite a challenge to Parisian culture, proposing: "We must accept that the diverse points of view coming from different cultures are of equal value and coexistent, and accept, too, that the different understandings and practices of modernity should be privileged and developed."[42] Further, the intensity of negotiations between the local and the international "has oriented art toward new challenges aimed at overcoming the collapse of its established limits, as much aesthetic as geopolitical."[43]

Their debate presents straightforward views about multicultural societies that would be mundane in, say, London, Mexico City, or Sydney. The reaction to this exhibition clarifies that the challenge of multiculturalism is not simply one of presenting

art from outside; the exhibition posed something of a challenge to the French art-knowing intellectual and journalistic circles, whose legitimacy to interpret was challenged or eroded by the works.

This is nowhere clearer than in the reception of the exhibition. There was no review of the show in the leading art journal *Artpress,* which had earlier been the site of a critique of Huang Yongping's selection to represent France at Venice. In its review, *Le Monde* represented Paris as a cosmopolitan port-of-call for nomadic artists, and the twenty-seven foreign creators as refugees in France, presenting work marked by exile. The review mentioned known artists, including Chen Zhen, and then in a curiously circumlocutory mode continued: "One is inclined to doubt the tonic qualities of the air of Paris in the thread of these impediments which meanwhile provide some good things, notably on the part of the women artists."[44]

Meanwhile, *Inrockuptibles,* a popular if not "pop" culture weekly often read by students, wrote of Shen Yuan's work: "A memory of childhood? Nostalgic evocation of an ancestral and disappeared China? Or a true Chinese-style readymade? Of course. But it is a bit as if a French artist exhibited the front of a Normandy farmhouse at the Tokyo Art Center. Folklore is always the world of the other, and boils down to very little." This is simply a sneer, but the review goes even further to make the spurious comparison to a quite differently conceived exhibition, the Lyon Biennale: "And one perceives, beyond the similarities and differences of situation and context, that the problem of exhibitions such as the Lyon Biennale or *Paris pour escale* is that each artist comes not to develop his own aesthetic adventure but more often to testify to his exoticism, to his *foreignness.*"[45]

Anyone who is familiar with the cultural riches of multicultural Paris, apparent on almost every street corner, can only be appalled at the inability of the intellectual and journalistic class to accept, value, or theorize cultural difference and its exchanges with French culture. If they did, they would acknowledge foreignness as a site of practice, and not accuse the artists of parading it as a quality or a thematic for display. The left-wing daily *Libération* discussed only the work of Chen Zhen, and concluded: "How does one get out of a simple process of integration in order to be inspired by other cultures without shutting them up in a Chinatown?"[46] Spurious fashionability, irrelevance to genuine artistic practice, privilege: nothing in these critiques relates to what the original exhibition was intending.

Routes to Acceptance

To truly understand the position of Chinese artists in France would require outlining a very developed sociology of French taste and the way foreignness is articulated within it.

That is beyond the scope of this essay, but outlining a few generalizations about how and why Chinese art was accepted in France is possible.[47]

First, invitations may be made to artists in China who are unknown in France but gain recognition by French cultural bodies overseas. This may include artists with direct links to similar practitioners who are advisers to government bodies themselves, for example, Robert Cahen, who is involved in the Belfort video festival, but has direct links of his own with video artists in China. There is the Association Française d'Action Artistique (AFAA) program to promote French art abroad under the auspices of local French embassies, which also generate links with the local art communities. The AFAA is supposed to handle only outward flows, but can be involved in inward flows when there is an agreement to exchange a cultural program, or when there are *saisons étrangères* such as Saison Chine in France in 2003 and France en Chine in 2004 in China. After certain political events, such as the suppression of the Beijing Spring in 1981 or the Beijing massacre in 1989, changes in local circumstances in China meant that artists who wished to go to or remain in France needed French support. France also derived symbolic benefits from providing such assistance.

Second, artists coming to France are handled by a bourse system administered by the cultural section of the French Embassy and by the Département des Relations Internationales, Ministère de la Culture. Studios may also be awarded via the Ministry of Foreign Affairs, or through other processes of contact and appraisal by private enterprise foundations.

Third, even if there is increased interest by commercial galleries, the French art market itself is restricted largely to stylistically conventional and even clichéd types of work that have proven commercial viability in other markets.

Fourth, recognition of Chinese artists in France may come from French-based curators. Such curators may be Chinese themselves, or an interested French curator may get recommendations from a France-based Chinese artist.

Fifth, recognition may come from a literary or cultural interlocutor in France who is sympathetic to China, for example, poet Henri Michaux, who championed the work of Zhao Wuji in the 1950s. This may for a time lead to a unique relation with a single gallery.

Sixth, recognition may come more conventionally from within art circles by an established art critic. This form of recognition is perhaps the most desirable since it is necessary for commercial gallery exhibition and regular sales.

In general, artists who speak adequate French, usually having French wives and citizenship, are the ones who are best assimilated and accepted. Huang Yongping's

selection for the French pavilion was something of an anomaly, since he was not at that time a French citizen. And, as already discussed, the too-rapid favor toward a non-French artist resulted in some art world controversy and forced the authorities (AFAA) to accept Huang's being co-exhibited alongside a French artist.

The enormous effort currently being devoted to the forthcoming series of cultural exchanges with China in 2003–04 should result in special cultural centers being set up in both countries. France seems to be attempting to gear a number of its perceived cultural equalities with China to economic advantage. Some French entrepreneurs on the political right have had a long-standing interest in exploiting the resources of China.

The rearrangement of relations between culture and the French state following the events of May 1968[48] has also had a long-term impact on the reception of foreign, and particularly Chinese, artists.[49] Jack Lang, who was minister of culture in the early 1980s, inherited systems of state intervention in culture that were handed down from Gambetta to Malraux. Many policies had been set as a reaction to the May 1968 events, particularly the establishment of various intervention funds dispersed through the minister's cabinet. One can only presume that the scope and directedness of the post-1968 increases in cultural funds had a major and positive impact on the ability of the French state to intervene in cultural processes and to accept and support activities and artists that might otherwise have remained marginal to the system.

Zurich, 1999

This text is the result of research done in France during July and August 2001. The texts cited are in French, Chinese, and English, and I have generally translated from Chinese and French myself but have used an available English version of some French catalogs if the translation was reliable. I am grateful to Fei Dawei, Huang Yongping, Jiang Dahai, Martina Köppel-Yang, Wang Keping, and Yan Peiming for their help.

1. On the issue of how artists leave China and domicile elsewhere, see John Clark, "Dilemmas of [Dis-]attachment in the Chinese Diaspora," *Visual Arts + Culture* 1, no. 1 (1998). For a brief description of Chinese artists in France in the 1980s, see my article "Chinese Artists in Paris," *Far Eastern Economic Review*, 16 December 1986; Chinese translation in *Meishu Shichao,* no. 4 (1987), pp. 31–33.

2. Material on Jiang Dahai is based on the catalog *Jiang Dahai* (Taipei: Chengpin Hualang, 1999).

3. See remarks by the critic Dourroux, quoted in Christian Besson, *Yan Peiming* (Paris: Éditions Hazan, 1999), p. 73.

4. Yan made the following statement in 1996: "I paint violently or energetically in order to finish more quickly." See ibid., p. 103.

5. Ibid., pp. 74–75.

6. Yan made this statement in 1996, in ibid., p. 81.

7. Victor Segalen is invoked in the Besson catalog.

8. Chen Zhen (1993), quoted by Hou Hanru in Lisa G. Corrin et al., *Chen Zhen* (London: Serpentine Gallery, 2001), p. 15.

9. Jerôme Sans, in ibid., p. 6.

10. Quoted in ibid., p. 10.

11. Hou Hanru in ibid., p. 15.

12. Hou Hanru in *Dian Zang jin yishu,* no. 104 (May 2001), p. 40.

13. On Huang Yongping, see Hou Hanru, *Huang Yongping,* exh. cat. for the XLVIII Venice Biennale French Pavilion (Paris: Association Française d'Action Artistique–Ministère des Affaires Etrangères, 1999); and material in *La collection: Fondation Cartier pour l'art contemporain* (Paris: Fondation Cartier pour l'art contemporain, 1998).

14. For Hou Hanru, the curator of Huang's exhibition in Venice, "this selection serves to emphasize the coexistence and dialogue between different cultures, individuals, as well as the diversity of concerns that are played out in the common spaces of creation"; see Hou, *Huang Yongping*, p. 21.

15. As reported by Hou Hanru, Huang said, "When I was in China I worked with more Western elements to handle Chinese realities. Today in the West I mainly use Chinese cultural influences to conceptualise my own works"; see Hou, *Dian Zang jin yishu,* no. 104 (May 2001), p. 41.

16. Quotation is from ibid, p. 41. Hou Hanru notes: "The task as it is seen by Huang Yongping is to create a new kind of space, a 'beyond space,' which breaks down the boundaries of this framework"; see ibid., p. 22.

17. *Wang Du Magazine: Je veux être un média* (Paris), no. 1 (Summer 2001), p. 38. Significantly, Wang does not discuss the earlier work, which uses similar images and techniques, created by Xu Tan in China around 1993.

18. Ibid., p. 37.

19. Ibid., sec. 4, p. 29.

20. Gilane Tawadros references Sarat Maharaj's concept of "leftover inexpressibles of translation" in Tawadros, et al., *Shen Yuan,* exh. cat. (London and Bristol: Institute of International Visual Arts and Arnolfini Centre and Chisenhale Gallery, 2001), p. 33.

21. Ibid., p. 40.

22. Fei Dawei, in Dawei et al., *Cai Guoqiang* (Paris: Fondation Cartier pour l'art contemporain; London: Thames and Hudson, 2000), p. 13. Material on Cai Guoqiang also came from Hirano Akihiko and Takeuchi Hiroko, eds., *Cai Guoqiang: From the Pan-Pacific,* trans. Margaret E. Dutz (Iwaki: Iwaki City Art Museum, 1994).

23. Cai Guoqiang, quoted in Dawei et al., *Cai Guoqiang,* p. 127.

24. Ibid., p. 133. This trope can also be found in the writings of Taiwanese ink painter Liu Guosong from the 1960s. See John Clark, "Liu Guosong: The Road of Chinese Painting," *Journal of the Oriental Society of Australia* 27–28 (1995–96), pp. 33–56.

25. Fei Dawei, ed., *Art chinois: Chine demain pour hier,* exh. cat. (Aix-en-Provence: Les Domaines de l'art and Éditions Carte Segrete, 1990), p. 14. Artists included in the exhibition were Cai Guoqiang, Chen Zhen, Gu Wenda, Huang Yongping, Yan Peiming, and Yang Jiechang.

26. Ibid., p. 16.

27. Ibid.

28. Fei, in Fei et al., *Cai Guoqiang,* p. 13.

29. Fei, interview by Martina Köppel-Yang, cited in her article "Zheng Shengtian: 'Youjian Bali, Youjian Bali,'" *Dian Zang jin yishu,* no. 104 (May 2001).

30. Fei, interviews with the author, August 2001.

31. Fei, quoted by Köppel-Yang in "Zheng Shengtian."

32. Ibid.

33. Michèle Cohen, foreword to Fei, *Art chinois: Chine demain pour hier,* p. 11.

34. A compendium of his selected writings has now appeared: Hou Hanru, *On the Mid-Ground,* ed. Yu Hsiao-Hwei (Hong Kong: Timezone 8, 2002).

35. Hou Hanru, quoted in Köppel-Yang, "Zheng Shengtian," p. 40.

36. Ibid.

37. See Hou Hanru, *Parisien(ne)s,* exh. cat. (London: Camden Arts Centre and inIVA, 1997), p. 4. The catalog has a foreword by Jenni Lomax, director of Camden Arts Centre, and Gilane Tawadros, of inIVA.

38. Ibid., p. 6.

39. Evelyne Jouanno and Hou Hanru, *Paris pour escale,* exh. cat. (Paris: ARC-Musée d'Art Moderne de la Ville de Paris, 2000).

40. Ibid., p. 8.

41. Ibid., p. 12.

42. Ibid., p. 13.

43. Ibid., p. 12.

44. *Le Monde,* January 20, 2001.

45. *Inrockuptibles,* December 19, 2000.

46. *Libération,* December 15, 2000.

47. I am grateful to Martina Köppel-Yang for some of her views in response to an early draft of this section.

48. This structure is outlined in Claude Mollard, *L'ingénierie culturelle* (Paris: Presses Universitaires de France, 1999).

49. Consideration of parallels in the repositioning of "Les arts premiers" has been relinquished here for lack of space.

Crystal Palace Exhibitions

Marian Pastor Roces

> Besides the spear-like gaze of relentless semiosis, the other weapon
> Columbus carried with him was Minerva's gorgon-bossed shield of
> mimesis. This, commonly imagined in the Renaissance as made of
> crystal and reflective like a mirror, was a device for stopping natives in
> their tracks and making them wonder who the actors were—themselves
> or the reflections.
>
> Paul Carter, *The Lie of the Land*

Specters in Mirrors

In the second half of the nineteenth century, a world at once overt and chimerical was
conjured at the universal expositions by their imperial inventors. Natives from everywhere
were stopped in their tracks, wonderstruck, for they were spectators but also, clearly
though phantasmically, actors. Minerva's crystal shield of mimesis is an astonishing
machine. In its reappearance as the Crystal Palace during the cusp of the industrial
revolution, the shield secured clarity of vision by bedazzlement. It is the same shield that
plays with our reflections in our turn-of-the-millennium international art events. It
plays with—and finally annuls—time and space as inherited from the Enlightenment.
Confoundingly, the Crystal Palace mirrors its future and its spatial dilation in today's

global art shows, which glint with endless spectral reflections of nineteenth-century imperialism.

Queen Victoria herself was bedazzled, and understood this magic experience, with its discrete layers of private anxiety and affection, as inherent to imperial purpose. She wrote effusively in her diary on the opening day of the very first universal exposition, in London in 1851, for which the original Crystal Palace was built:

> The Park presented a wonderful spectacle, crowds streaming through it—
> carriages and troops passing, quite like the Coronation and for me the same
> anxiety. . . . I never saw Hyde Park look as it did, being filled with crowds as far
> as the eye could reach. . . . [T]he sun shone and gleamed upon the gigantic
> edifice, upon which the flags of every nation were flying. . . . The sight as we
> came to the centre . . . facing the beautiful crystal fountain, was magic and
> impressive. . . . [M]y beloved husband, the creator of this peace festival "uniting
> the industry and art of all nations of the earth," all this was indeed moving, and
> a day to live for ever. God bless my dearest Albert, and my dear Country, which
> has shown itself so great today. . . . Albert left my side and at the head of the
> Commissioners . . . read the Report to me . . . and I read a short answer. . . .
> After this the Archbishop of Canterbury offered up a short and appropriate
> prayer, followed by the singing of Handel's Hallelujah chorus, during which
> time the Chinese Mandarin came forward and made his obeisance. This
> concluded, the Procession of great length began, which was beautifully
> arranged, the prescribed order being exactly adhered to.[1]

In addition to being reflective, Minerva's shield is the gorgon's face. Equally reflective are the monarch's words, which crystallize the power to stun. To produce unity globally, movement is curated, "the prescribed order . . . exactly adhered to," and accidents tabooed. "Peace" is in this manner a stillness, which is realized within a finely produced state of stupefaction. "The viewer's mystical sense of being carried to a higher realm is calculated; it means, in effect, experiencing the no-place of seeing all places in terms of a single formal key," writes spatial historian Paul Carter, who sees the reiteration of the colonizer's vision in the twentieth-century aesthetics of formal structure.[2] In both the imperial vision and high modernism, what is of value is "the composition as a whole rather than in its particulars . . . it still at bottom insists on grasping the object as a whole, in a single glance."[3]

That particular single glance, cast "as far as the eye could reach," projects toward the outer limits of what is possible to be perceived or known at all. Thus the success of the Crystal Palace as a sign of modern ambition: it materialized that glance as architecture. The transparent edifice produced the no-space of seeing all places, contrived to contain the uncontainable outside.

Perhaps it is the spatial turn in postmodernism that makes the crystal-palace form such grim (if not baleful) reading, as this essay does read it. Certainly the phantom links between the universal expositions and the current biennials and triennials are fleshed out, as it were, only thinly—caricature-like and emptied of fulsome menace—in temporal terms, as lineage. Not so, when they are regarded as similarly rarefied loci where an aristocratic few exercise the will to order plurality on a vast scale. Even if we grant the shift toward global art events as an attempt to outstare the colonizer's gaze, there are bedeviling risks of paralysis in spaces of contest that mirror the spaces created by the forces contested. Time, then, offers the assurance of safe distance and a guarantee of liberating epistemological change. That which is consigned to the past is rendered curiously unthreatening today.

It is with a bravura shaped by historical distance (which plots space diachronically as well) that, for instance, Rosa Martínez, curator of two of the newest biennials, in Santa Fe and Istanbul, avers that "We are reinventing the biennial today. New biennials have arisen on the periphery. Havana, Johannesburg, and Istanbul are introducing new approaches that question the nineteenth-century model of the Venice Biennale."[4] Articulating faith in historical progress, in this case tracked along an emancipatory trajectory, Martínez speaks of emergence: "new biennials have arisen from the will to exorcise political traumas, . . . to create new spaces for art in the Third World."[5] Such reversals can only be proposed within an obdurately linear history, which has a precise medial axis for folding. That median is verbalized off-hand as a "center" in the explanation provided by curator Germano Celant for his departure, in the XLVII Venice Biennale, from the thematic exhibition modality in favor of the flipping of time conveyed by the title of his effort, *Future Present Past:* "The past is my future and my future is my past; these two meet at the center, which is the present."[6] That privileged present is still the sphere of the modern subject (persisting atemporally in postmodernity), so given to inventive ways of coupling a receding past with a future that thrusts forward in search of a target.

Liberation from myriad griefs is one such target, the express aim of most of the current megashows. "The ideal biennial is a profoundly political and spiritual event. It

contemplates the present with a desire to transform it," concludes Martínez, who then cites Arthur Danto for his description of the biennial as "a glimpse of a transnational utopia."[7] Then again, because the Crystal Palace events were likewise glimpses of a kind of transnational utopia, one wonders if hope is an apparition. The universal expositions, too, were ideal events in a profoundly political and spiritual sense. Thus the suspicion and the worry arising from the synchronic view. The spaces produced in the nineteenth century for the global diffusion of capitalist power may have closed off the reinvention of those same spaces for social justice. As a single spatial form that reasserts its controlling power even as it is perpetually replicated, the world exposition, in its very dimensions, annuls any new spaces that are shaped transformatively.

Danto bracketed the young Johannesburg Biennale of 1993 with the concurrent edition of the oldest biennale, that of Venice. Taking up the title of the Venice event, *Punti dell'arte*, he briefly undertook a poetics of mapping: "the [Venice] exhibition was to serve precisely the purposes of a compass: it was to orient the viewer to the artistic geography of the Biennale, and then to that of the world itself—so a map within a map." He continued: "A compass does not define the center of the world, after all, it orients the user wherever the user stands." Then he observed: "So far as I can tell, Johannesburg was not one of the cardinal points on [Venice Biennale curator] Bonito Oliva's compass."[8] He spotted a lacuna in the biennale's liberal, humanist encompassing of the earth.

Danto's pithy observation may very well be the necessary provocation alerting the erstwhile native, who is drawn into international art events, to the mystifying force of mimesis. It is hard to avoid being transfixed; perhaps it can be done only by cultivating a wariness of the too-overt and overly celebrated democratized space, or by detecting equally telling lacunae. Such urgencies, of course, make for baffling wanderings. To head off into the politics of centers and margins leads into domains where time and space are each in turn imprisoned in binary formulae. To keep retracking art history with a gusto for politically valuable nuance leads paradoxically to the tight, long space of genealogy. The tightness leaves little room for any description of the blurring of every period idea in that sequence of radicalisms—in other words, for any description of a mess of ideas, differently chaotic in different places, that often cancel one another out.

The movement can be only into messy digressions. Nonetheless, this peripateia will at least be like prowling, or stalking. The Crystal Palace expositions were constructions of vastness, and so are their replications today. Vastness—the grand integrities that are the spatial form of dominance—is perhaps vulnerable only to the unruly minutiae encountered in stalking about the crystal palace of mimesis.

The Production of City

Rem Koolhaas writes:

> The inspiring example of London's International Exhibition, held in 1851 in the Crystal Palace, triggers Manhattan's ambition. Two years later, it has organized its own fair, staking a claim for its superiority, in almost every respect, over all other American cities. At this time, the city hardly extends north of 42nd Street—apart from the omnipresent Grid. Except near Wall Street it looks almost rural: single houses scattered on the grass-covered blocks. The fair, implanted on what will become Bryant Park, is marked by two colossal structures that completely overwhelm their surroundings, introducing a new scale into the island's skyline, which they dominate easily. The first is a version of London's Crystal Palace.[9]

Already a spatial discourse on the global in its prehistory and in its textual formulation as *universal,* the Crystal Palace expositions hothoused nothing less than the modern city, the spectacular space that materializes the power to command constructions of the global. The international art exhibitions of the last century have in large part performed the same imperative. Through the 2000 Shanghai Biennale, entitled *The Spirit of Shanghai,* for instance, the organizers set a course for this city to be the "Venice of the East." As in Shanghai, the international art events organized in Kwangju, Pontevedra, Lyon, and Rotterdam are understood as assertions of metropolitan wherewithal, aimed at having these cities emerge from secondary status within their respective countries.

In the case of the august Documenta, which does not articulate itself in terms of Kassel's economic and architectural growth, the exhibition is nonetheless framed by the city's historical and cultural position in German and European history.[10] Since 1959, Documenta has also been "organized by a limited liability company, the associates being the City of Kassel and the State of Hesse."[11] The regrettably short-lived Johannesburg Biennale succumbed to city politics. It was dependent for funding on a specific metropolitan cluster, and the issue was, ironically, about which of the four clusters birthed by the Biennale itself would foot the bill.[12]

City-centric hubris was evident in the mid nineteenth century, even though the political intent underpinning the expositions was typically articulated as national pride and imperial capacity—the power, that is to say, to orchestrate worldwide harmony. A placard at the first Crystal Palace exposition declared its statement of purpose: "The

Strengthening of the Bonds of Peace and Friendship Among All Nations of the Earth." It was, nonetheless, the resonant notion of "capital"—the capital idea, capitals of columns, capital letters, capitalism, and imperial and national capital cities—that focused the claims of superiority. The expositions, magniloquent celebrations of capitalism, were for and about the metaphysical dimensions of the capital, meaning the national and imperial realm at its control center. The materials on display were organized around the triumphalism of this city/realm, as when, for example, paintings and sculptures from twenty-eight nations were exhibited at the second universal exposition, in Paris in 1855, in what constituted the first international art exhibition.

All curatorial enterprise subsumes parts to the whole. The large-scale effort, of course, makes the distance dramatic between micro and macro. At the universal expositions, individual exhibits are indeed minutiae of the big picture. Because the titanic domain is the city itself, it is the spatial experience of urban renewal that was, and is, made to speak most extravagantly to the spectator. The direct impact of the first universal expositions on the built environments of their host cities, London and Paris, assured the persistence, throughout the last century and a half, of "exposition" as shorthand for urban modernization.

As was the case in London, the second Paris universal exposition was forthright about the relationships between architecture, urban design, art, industry, and money. Addressing lack of space as plans were being considered, Napoléon III suggested a grid "with national sections along one axis and exhibition categories along the other."[13] The prince's plans were realized in 1867 in Frédéric LePlay's great oval exhibition hall, built at the Champs-de-Mars. As it turned out, according to Patricia Mainardi, the centering of power of capital within the power of place was quite literally realized:

> Within, exhibitions were organized in concentric ovals, heavy industry being the outermost ring, the fine arts being near the center (and thus taking up less space). Paul Mantz wrote: "Material things occupy the first ring and, with each circle crossed, you approach the spiritual." This lovely symbolism was ruined however. Perhaps in a moment of supreme honesty, the Imperial Commission revealed its true spirit by placing in the innermost circle, at the heart of the Exposition, a display of money.[14]

So far as art is concerned, the decision to go with small private works rather than large public ones, and to hold retrospective exhibitions for major artists at the 1855 exposition,

served to uphold the romantic individual. The ideology "emphasizing individual self-referential development—the concept of progress defined in aesthetic terms—has proved to be the principal Modernist tool for understanding art apart from its social and political milieu,"[15] writes Mainardi, tuning up what has become the standard account of the birth of the modern. She contributes a significant refinement to that account by providing the direct link between the universal expositions and subsequent international art exhibitions.[16]

The literal diminution of the art object at that pivotal moment, as art itself compacted around the modern bourgeois subject, was at the same time the enlargement of the promise of social change vested in capitalism and expressed in urban renewal. Extraordinary social significance was vested in change; the more sweeping, the more passionately charged. This passion persists in contemporary art practice, and its register is turned up very high indeed during the biennials and triennials. It persists despite and because of the failure of capitalism and modern aesthetics to live up to their promise of social justice; because the bourgeois domestication of art to the task of maintaining critical pressure in relation to onerous power, cast as the onerous past, remains an enduring aspect of modern subjectivity. The mythos that the world exposition space holds radical possibilities continues to be compelling. It pertains to no less than the structural shape of the modern subject, particularly as this form of life is sustained and validated in city-building work that itself preserves and reiterates the heroic aspirations of its nineteenth-century precedent.

The kind of utopian agenda that provides strong reasons for the holding of international exhibitions today tends to be expressed in a vocabulary reminiscent of the romantic imagination. The references to reinvention, crossing over, discovery, looking beyond, and redefinition in Martínez's explanation of her curatorial approach to the Santa Fe Biennial may or may not accurately represent the collective political timbre of the works exhibited, but they do envelop them in a heroic light: "The title of the biennial is 'Looking for a Place,' because we have to reinvent the places occupied by art, beyond the limitations of disciplines, cross over the museum walls, discover the implications in the separation of public and private spaces, and redefine the politics of exploitation. . . . Art must contribute to make the world a more habitable place."[17] A more habitable place was similarly claimed at the 2000 Shanghai Biennale, expressed as a struggle with the ruling powers of the People's Republic of China:

> The third Shanghai Biennale . . . will go down in Chinese art history as marking
> a new chapter in the re-entry of contemporary Chinese art to its homeland. . . .
> Not only is it the first time that leading international contemporary artists have
> been invited to participate in an event initiated by Chinese organizers . . . but it
> is the first time for works by contemporary Chinese artists to be given official
> blessing to enter the hallowed halls of a national art museum.[18]

The city/realm of distinction, globally valid, is reproduced even where the project is to
deconstruct the romantic rhetoric of utopian dreaming. The Kwangju Visual Media
Academy, represented with works at the Kwangju Biennale, draws discursive power from
a specific moment of political violence, which allows the positive re-creation of this city
vis-à-vis a negative State.[19] Allan Smith, curator of the inaugural Auckland Triennial,
creates a seamless weave of the intent to place Auckland on the world art map and the
postmodern aspiration to reconsider the myths that determine the mapping of the world:
"The working thesis of *Bright Paradise* is that New Zealand is peculiarly well suited as a
place from which to speculate on the disturbing beauty of artificial paradises and the
fateful allure of utopian desire." Smith rests faith in how "such speculations uncover
metaphors of our contemporary world caught between an exhilarating desire for
experience, information, on one hand, and a powerful sense of our having corrupted
history and destroyed any oceanic sublime or paradise, on the other."[20]

Utopia appears no more endlessly malleable than in these events—but not
necessarily as the postmodern strategy that Fredric Jameson urges, which requires
incessant modification to address the quicksilver manipulations wreaked by power in
the age of transnational capitalism;[21] nor in the way Hal Foster argues the possible
recuperation of the political force of an insistently transmuting and returning avant-
garde. For Foster, "There is this fundamental stake in art and academy: the preservation,
in an administered, affirmative culture, of spaces of critical debate and alternative
vision."[22] It is in this way that there is cause for doggedness. Indeed, the prowler's
alertness—to the operations of utopian imaginings that are too comfortably assimilable
to what remains a nineteenth-century technology of representation—is indispensable.
The universal exposition, the ur-form of capitalist cultural infrastructure, conceived to be
an alternative space in the first place, may be expected to literally corner the market on
alternatives. And utopia, institutionalized in the city as produced in the nineteenth
century, may be expected to dazzle as it shields the powers that be.

The Havana Biennial was the first instance in which an alternative vision of the biennial was institutionalized. Taking up a locus of resistance to the spatial politics of the world exposition, it was also the one biennial that projected a parallel world (the Third) rather than the city/realm. (It did not, and could not, have the ambition to renew Havana architecturally, or economically, or politically.) Curator and critic Gerardo Mosquera sketches the difficult terrain of its intent:

> The idea behind the Biennial was always to introduce artists who work outside of the main centers. It was meant to facilitate horizontal relations, which doesn't exclude North-South relations. However, this wasn't supposed to come as an attempt at legitimization by the mainstream, but rather to facilitate an equal relationship upon the inclusion in the mainstream mechanisms, which is something completely different. There's a difference between trying to be an active presence in these circles and letting oneself be subordinated. It's important how the Biennial deals with this problem, so that it doesn't end up a shop window for critics and curators from the centers—a kind of "scouting for Third World talent."[23]

That it has become such a window, however, is not necessarily its undoing. Since it formed itself as an alternative biennial, the idea of an alternative art market does present itself. Nonetheless, it presents itself with an instructively oxymoronic charge. For there is no alternative to market; the market is a unified field. Which leads to the principal difficulty: is there really, in tautological and practical terms, an alternative biennial?

Regrets have been expressed about the softening of the Havana Biennial's rhetoric as it engages art world realpolitik. For Rachel Weiss, the Havana "organizers have proved that a convincing global position can be developed from outside the usual circles of power; their task now, one fears, is to defend their achievement from its own success well enough to preserve its voice and distinctness—a problem of middle age."[24] But if this biennial were to be considered only in terms of a career path to security, that is to say, as a temporal track, the spatial dimensions of its politics of contestation recede from view.

The synchronic repetition of the crystal-palace exposition form locates the essentially historical question the Havana Biennial experience begs. A point of departure may be a refreshed appreciation for the originality of Havana's political location in the world of world expositions—but not only in that it is a site/sign of the domains of the

Other. More important, Havana was outside a planetary network of cities re-created during the second half of the nineteenth and first half of the twentieth centuries, specifically in relation to the architectural, artistic, and technological efforts given expression during the expositions. Realizing the organic and machinistic metaphoric conventions that framed modernity, the universal expositions were the factories—the hothouses—of this network of cities; but they were *merely* the factories and hothouses. It was, and is, the network itself that shaped and styled itself as international. The unconnected place, Havana, connected itself to this network even as it thought to oppose it. But the world exposition form is a production and supply node, and it maintains linkage more than it contradicts. The opposition constructed by the Havana Biennial is not that of without/within; the network rearranged itself to accommodate a productive bilateral symmetry. The Havana Biennial can hence properly claim to be an alternative biennial, and that indeed there is such a thing, but one which provides symmetrical beauty, and fresh creative labor (from without), *within* the network.

Havana remains outside the realm of physically altering cityscapes (though it may be destined for scenographic delight in the global scheme of things). In this location, at the present time, there remains hope in rupture, because the city itself obliges art making to fall into and widen the cracks, instead of elevating it in the service of visions of global ascendancy. (It is for this reason that the demise of the Johannesburg Biennale occasions regret.) That this is not similarly the case with Kwangju, Taipei, Shanghai, Fukuoka, Yokohama, and the host of other newly crystal-palaced cities is due to their surfaces, which are metaplinths for art, capital, histories of monolithic power, and global ambition. Given that East/West is a coarse and bankrupt scenographic divide, which has obscured the labyrinthine lines of difference in the world, the victim side of the politics of alterity is only claimed implausibly in the arena of competition of cities. A response is begged by, for instance, Rene Block:

> Charged with the task of selecting 20 artists from Africa and Europe for the 3rd Biennale in Kwangju, I recall the embittered remarks of the South African artist, curator and critic, Kendell Geers, which he wrote for the catalogue of the Fellbach Triennial in 1998: "Traditionally, the exhibitions are staged in a 'white cube,' somewhere in a major European or American art centre, and typically with the 'exchange' flowing in just the one direction: into the 'white cube' gallery, which—as we all know—can house anything imaginable. . . . Placing non-Western work into this setting has nothing to do with dialogue or

exchange, but rather a restoration of the colonial power structure. The non-Western work is expected to behave as the guest it is and respect the rules of its hosts regardless of how condescending or racist they are." Yet already at this stage we can conclude that this gathering of 20 artists from Northern Europe, South Africa and the Orient at the Kwangju Biennale will have fulfilled at least one of Kendell Geers' aspirations. All the submitted works will be exhibited in a non-Western context. They all will respect the rules of their Asian hosts. And perhaps it will be possible, by virtue of the equidistance to Europe, Africa and the Orient, to view these works from diverse perspectives. The presentation on "neutral" Asian ground will serve to highlight the common cultural roots but also the substantive differences in the artists' works.[25]

But the rules of their Asian hosts may have more in common with those of the Western hosts of international art events than can be comfortably acknowledged. The key players at the hothouses share a common culture, and transit and live together in abstract modern space. It is for this reason that any spatialized account of modern art, architecture, and city planning reads like an album of friends. Though industrial capitalism was realized differently in England and France, Richard Sennett points out that, nonetheless, "from capital to capital, such differences were not as extreme as differences from nation to nation."[26]

Today's international elite is distinguished, more than anything else, by the speed of their travel to absorb the world. It exists in the same rapid-transit space as that which was home to the nineteenth-century cosmopolitans. In both cases their elite status and transnational resources are assured by a savoir-faire with communication technology. It is disingenuous for this elite to appeal to geography-based cultural difference, without reflecting on the hostility to difference ordering their aesthetics of mobility and speed; to profit from the gains of radical art and activism; and to displace attention from themselves in the critique of power. It is precisely their culture and interests that maintain the modern construction of the global. A strong contrary position is called for whenever blind spots are offered that may occlude the operations of power, including the power of organizing international art events. Hence, one takes exception to a suggestion offered by Okwui Enwezor, artistic director of Documenta 11, in connection with his earlier effort at the Johannesburg Biennale, when he said that such work "should ultimately lead to a focus on the art works themselves, and not on the trials and problems

of the people trying to organize these events."[27] For to point out that the trials and problems of the organizers are precisely the site to be watched most stringently and engaged by progressive critics is to press the progressive curators, Enwezor among them, to lay aside Minerva's shield.

Foster gives a valuable glimpse of the power infrastructure vis-à-vis which critical effort must persist, in citing both Mandel, to whom "the postindustrial signals not the supercession of industrialization so much as its extension," and Jameson, to whom "the postmodern announces not the end of modernization so much as its apogee."[28] The postindustrial and the postmodern invoked in recent international exhibitions are then the object, not the subject, of critical engagement. This is not lost on most commentators, for instance, Hazel Friedman, who writes of *Africus* in Johannesburg: "Biennales . . . constitute a microcosm of power relations in the real world. They have their centralized cores of high visibility and their undeveloped, neglected cultural peripheries; their skyscrapers and squatter shacks, city councilors and serfs."[29] Given this space, artists respond by resisting or performing to expectations, often simultaneously. The activity of hothousing ideas for cities has often been taken up literally, and with compelling subtlety, by many artists.

How artists maintain subtlety, let alone reflexivity, in the hothouse requires another extended discussion. However, participants in today's crystal-palace events do understand, or sense, that a grave disjunction exists between the minutely layered, minutely differentiated spaces of radical contestation where it really hurts, and the colossal spaces celebrating the radical, where it really effervesces. The effervescence raises the temperature in the crystal palace, but one finds that the temperature must be so well calibrated that the experience is curiously pleasant, and the exotica on display so useful to the status quo. As proof of that invigorating heat, perhaps the most riveting example is the online introductory text for *Cities on the Move,* curated by Hans Ulrich Obrist and Hou Hanru. The following section is verily Victorian:

> Asian cities are becoming new key points in the "network" of global cities which are the very central forces influencing, controlling and even dictating the new world order. In the meantime, the urban spaces are being fast expanded. The political, economic and cultural authorities also share a long-term vision of modernization. In spite of the search for typically modernist symbols such as the tallest skyscrapers, they also conceive projects and strategies to develop the future industry represented by new technologies. In many cities, new areas are

planned and developed to become "Asian Silicon Valleys." The Malaysian Multimedia Super Corridor (planned by Kisho Kurokawa), among others, is the most mediated example, while most of the computers in the global market are produced in Taiwan, Malaysia, Korea, Singapore and China. What is also remarkable is that the most advanced telecommunication technologies have become a natural aspect of everyday life in Asian urban societies. Mobil [*sic*] phone, Internet and video games are not only trendy gadgets for young people to show off, but indispensable "survival kits" for the urban inhabitants. . . . As a natural part of the "success story," the pressure of the growth of international travels makes all cities invest in new commuting infrastructures.[30]

History, modern to postmodern, lies. It converts its readers to the arousals of change where stasis is everywhere. It has, among other confidence tricks, promoted the construction of the last century and a half as a *long* time, time in which change in the structures of domination is supposedly well under way. What *is* well under way is the work of radicalizing the understanding that things are not all right in the world. Such work benefits from any realization that the nineteenth century is not such a long time ago. The Crystal Palace exposition is inherent in a spatial order that, because it is architecturally imposed on the earth, does not disappear quickly; certainly not to make room for dissent beyond the confines of clearly marked hothouses.

Hong Kong, 1997

1. Among other sources of the quotation, see Christopher Hibbert, *Queen Victoria in Her Letters and Journals* (Gloucestershire: Sutton Publishing, 2000), pp. 84–85.

2. Paul Carter, *The Lie of the Land* (London: Faber and Faber, 1996), p. 133.

3. Ibid., p. 132.

4. Rosa Martínez, interview by Carlos Basualdo, "Launching Site," *Artforum,* (summer 1999); available online at <http://www.findarticles.com/cf_0/m0268/10_37/55015163/p1/article.jhtml>.

5. Ibid.

6. Germano Celant, <http://dialnsa.edu/iat97/Venice/FPP/index.html>.

7. Martínez, interview by Carlos Basualdo.

8. Arthur Danto, "Mapping the Art World," originally published in the "Essays" link of the Official Internet Archive of *Africus '95,* Johannesburg Biennale, <http://sunsite.wits.ac.za/biennale/essays/danto.htm>.

9. Rem Koolhaas, *Delirious New York* (Rotterdam: 010 Publishers, 1994), p. 23.

10. See Catherine David, paper presented at the "Art and Theory" conference, Mumbai, convened by the Mohile-Parikh Art Centre, 1998.

11. According to information provided on the Documenta Web site, "The documenta and Museum Fridericianum Veranstaltungs-GmbH is a non-profit organization that is owned and financed by the city of Kassel and the State of Hesse"; see <http://www.documenta.de/d12_engl.html>.

12. See Brenda Atkinson, "Behind the Biennale Blues," in *Electronic Mail and Guardian,* 11 December 1997, <http://www.chico.mweb.co.za/mg/art/reviews/97dec/11dec-biennale.html>.

13. Patricia Mainardi, *Art and Politics of the Second Empire: The Universal Expositions of 1855 and 1867* (New Haven: Yale University Press, 1987), p. 131.

14. Ibid.

15. Ibid., p. 196.

16. Ibid., p. 197.

17. Martínez, interview by Carlos Basualdo.

18. Introduction to the Shanghai Biennale catalog, available online at <http://www.sh-artmuseum.org.cn/double/msg2000/e-jihua.htm>.

19. See references to "Kwangju of May" and "the life of the martyr, Yoon Sang-won" in the Arts and Human Rights section of the Kwangju Biennale Web site, <http://www.gwangju-biennale.org/last-biennale/2000/english/sspeci-artartist34.htm>. See

also Frank Hoffmann, "Monoculture and Its Discontents," *Art in America* (November 2000), available online at <http://www.findarticles.com/cf_01/m1248/11_88/66888245/p1/article.jhtml>.

20. Allan Smith, introduction to *Bright Paradise*, the First Auckland Triennial, exh. cat. (Auckland: Auckland Art Gallery, 2001), p. 5.

21. Fredric Jameson, *The Cultural Turn: Selected Writings on the Postmodern, 1983–1998* (London and New York: Verso, 1998).

22. Hal Foster, *The Return of the Real: The Avant-Garde at the End of the Century* (Cambridge, Mass.: MIT Press, 1996), p. xvii.

23. Gerardo Mosquera, interview by Gerhard Haupt, "Sixth Biennial of Havana," available online at <http://www.universes-in-universe.de/car/havanna/opinion/e_mosqu.htm>.

24. Rachel Weiss, "The Sixth Havana Biennial," *Art Nexus,* no. 26 (October-December 1997), available on-line at <http://www.universes-in-universe.de/artnexus/no26/weiss_eng2.htm>.

25. Rene Block, "Commissioner's Concept," Kwangju Biennale, 2000, available online at <http://www.gwangju-biennale.org/last-biennale/2000/english/mainex-concept-eu.htm>.

26. Richard Sennett, *The Fall of Public Man* (New York: Alfred Knopf, 1977), p. 138.

27. Okwui Enwezor, quoted in Brenda Atkinson, "The Art Show of the Year," Johannesburg Biennale update, in *Electronic Mail and Guardian,* August 14, 1997, <http://www.chico.mweb.co.za/mg/art/reviews/97aug/14aug-biennale.html>.

28. Foster, *The Return of the Real,* p. 218.

29. Hazel Friedman, "The Curator as God," in *Electronic Mail and Guardian,* October 9, 1997, <http://server.mg.co.za/mg/art/reviews/97oct/9oc-biennale2.html>.

30. Hou Hanru and Hans Ulrich Obrist, introduction to the exhibition *Cities on the Move* (Bangkok), available online at <http://www.art4d.com/bangkokonthemove/2542/city/index_1.html>.

DIS-POSITIONS

For Opacity

Édouard Glissant

Several years back, if I made the statement, "We demand the right to opacity," or argued in favor of this, whoever I was speaking to would exclaim indignantly: "Now it's back to barbarism! How can you communicate with what you don't understand?" But in 1989, and before very diverse audiences, when the same demand was formulated, it aroused new interest. Who knows? Maybe, in the meanwhile, the topicality of the question of differences (the right to difference) had been exhausted.

The theory of difference is invaluable. It has allowed us to struggle against the reductive thought produced, in genetics for example, by the presumption of racial excellence or superiority. Albert Jacquard dismantled the mechanisms of this barbaric notion and demonstrated how ridiculous it was to claim a "scientific" basis for them.[1] (I call the reversal and exasperation of self barbaric and just as inconceivable as the cruel results of these mechanisms.) This theory has also made it possible to take in, perhaps, not their existence but at least the rightful entitlement to recognition of the minorities swarming throughout the world and the defense of their status. (I call "rightful" the escape far from any legitimacy anchored silently or resolutely in possession and conquest.)

But difference itself can still contrive to reduce things to the Transparent.

If we examine the process of "understanding" people and ideas from the perspective of Western thought, we discover that its basis is this requirement for transparency. In order to understand and thus accept you, I have to measure your solidity

with the ideal scale providing me with grounds to make comparisons and, perhaps, judgments. I have to reduce.[2]

Accepting differences does, of course, upset the hierarchy of this scale. I understand your difference, or in other words, without creating a hierarchy, I relate it to my norm. I admit you to existence, within my system. I create you afresh. —But perhaps we need to bring an end to the very notion of a scale. Displace all reduction.

Agree not merely to the right to difference but, carrying this further, agree also to the right to opacity that is not enclosure within an impenetrable autarchy but subsistence within an irreducible singularity. Opacities can coexist and converge, weaving fabrics. To understand these truly, one must focus on the texture of the weave and not on the nature of its components. For the time being, perhaps, give up this old obsession with discovering what lies at the bottom of natures. There would be something great and noble about initiating such a movement, referring not to Humanity but to the exultant divergence of humanities. Thought of self and thought of Other here become obsolete in their duality. Every Other is a citizen and no longer a barbarian. What is here is open, as much as this there. I would be incapable of projecting from one to the other. This here is the weave, and it weaves no boundaries. The right to opacity would not establish autism; it would be the real foundation of Relation, in freedoms.

And now what they tell me is, "You calmly pack your poetics into these craters of opacity and claim to rise so serenely beyond the prodigiously elucidating work that the West has accomplished, but there you go talking nonstop about this West." —"And what would you rather I talk about at the beginning, if not this transparency whose aim was to reduce us? Because, if I don't begin there, you will see me consumed with the sullen jabber of childish refusal, convulsive and powerless. This is where I start. As for my identity, I'll take care of that myself." There has to be dialogue with the West, which moreover is contradictory in itself (usually this is the argument raised when I talk about cultures of the One); the complementary discourse of whoever wants to give-on-and-with must be added to the West. And can't you see that we are implicated in its evolution?

Merely consider the hypothesis of a Christian Europe, convinced of its legitimacy, rallied together in its reconstituted universality, having once again, therefore, transformed its forces into a "universal" value—triangulated with the technological strength of the United States and the financial sovereignty of Japan—and you will have some notion of the silence and indifference that for the next fifty years (if it is possible thus to estimate) surround the problems, the dependencies and the chaotic sufferings of the countries of the south with nothingness.

And also consider that the West itself has produced the variables to contradict its impressive trajectory every time. This is the way in which the West is not monolithic, and this is why it is surely necessary that it move toward entanglement. The real question is whether it will do so in a participatory manner or if its entanglement will be based on old impositions. And even if we should have no illusions about the realities, their facts already begin to change simply by asking this question.

The opaque is not the obscure, though it is possible for it to be so and be accepted as such. It is that which cannot be reduced, which is the most perennial guarantee of participation and confluence. We are far from the opacities of myth or tragedy, whose obscurity was accompanied by exclusion and whose transparency aimed at "grasping." In this version of understanding the verb "to grasp" contains the movement of hands that grab their surroundings and bring them back to themselves—a gesture of enclosure, if not appropriation. Let our understanding prefer the gesture of giving-on-and-with that opens finally on totality.

At this point I need to explain what I mean by this totality I have made so much noise about. It is the idea itself of totality, as expressed so superbly in Western thought, that is threatened with immobility. We have suggested that Relation is an open totality evolving upon itself. That means that, thought of in this manner, it is the principle of unity that we subtract from this idea. In Relation the whole is not the finality of its parts: for multiplicity in totality is total diversity. Let us say this again, opaquely: the idea of totality alone is an obstacle to totality.

We have already articulated the poetic force. We see it as radiant—replacing the absorbing concept of unity; it is the opacity of the diverse animating the imagined transparency of Relation. The imaginary does not bear with it the coercive requirements of idea. It prefigures reality, without determining it a priori.

The thought of opacity distracts me from absolute truths whose guardian I might believe myself to be. Far from cornering me within futility and inactivity, by making me sensitive to the limits of every method, it relativizes every possibility of every action within me. Whether this consists of spreading overarching general ideas or hanging on to the concrete, the law of facts, the precision of details, or sacrificing some apparently less important thing in the name of efficacy, the thought of opacity saves me from unequivocal courses and irreversible choices.

As far as my identity is concerned, I will take care of it myself. That is, I shall not allow it to become cornered in any essence; I shall also pay attention to not mixing it into any amalgam. Rather, it does not disturb me to accept that there are places where my identity is obscure to me, and the fact that it amazes me does not mean I relinquish

it. Human behaviors are fractal in nature. If we become conscious of this and give up trying to reduce such behaviors to the obviousness of a transparency, this will, perhaps, contribute to lightening their load, as every individual begins not grasping his own motivations, taking himself apart in this manner. The rule of action (what is called ethics or else the ideal or just logical relation) would gain ground—as an obvious fact—by not being mixed into the preconceived transparency of universal models. The rule of every action, individual or community, would gain ground by perfecting itself through the experience of Relation. It is the network that expresses the ethics. Every moral doctrine is a utopia. But this morality would only become a utopia if Relation itself had sunk into an absolute excessiveness of Chaos. The wager is that Chaos is order and disorder, excessiveness with no absolute, fate and evolution.

I thus am able to conceive of the opacity of the other for me, without reproach for my opacity for him. To feel in solidarity with him or to build with him or to like what he does, it is not necessary for me to grasp him. It is not necessary to try to become the other (to become other) nor to "make" him in my image. These projects of transmutation—without metempsychosis—have resulted from the worst pretensions and the greatest of magnanimities on the part of West. They describe the fate of Victor Segalen.

The death of Segalen is not just a physiological outcome. We recall his confiding, in the last days of his life, about the slovenliness of his body, whose illness he was unable to diagnose and whose decline he was unable to control. No doubt it will be known, with a list of his symptoms and the help of medical progress, what he died of. And no doubt the people around him could say he died of some sort of generalized consumption. But I believe that he died of the opacity of the Other, of coming face to face with the impossibility of accomplishing the transmutation that he dreamed of.

Like every European of his day, he was marked with a substantial, even if unconscious, dose of ethnocentrism. But he was also possessed, more than any of his contemporaries, by this absolute and incomplete generosity that drove him to realize himself elsewhere. He suffered from this accursed contradiction. Unable to know that a transfer into transparency ran counter to his project and that, on the contrary, respect for mutual forms of opacity would have accomplished it, he was heroically consumed in the impossibility of being Other. Death is the outcome of the opacities, and this is why the idea of death never leaves us.

On the other hand, if an opacity is the basis for a Legitimacy, this would be the sign of its having entered into a political dimension. A formidable prospect, less dangerous perhaps than the erring ways to which so many certainties and so many clear,

so-called lucid truths have led. The excesses of these political assurances would fortunately be contained by the sense not that everything is futile but that there are limits to absolute truth. How can one point out these limits without lapsing into skepticism or paralysis? How can one reconcile the hard line inherent in any politics and the questioning essential to any relation? Only by understanding that it is impossible to reduce anyone, no matter who, to a truth he would not have generated on his own, that is, within the opacity of his time and place. Plato's city is for Plato, Hegel's vision is for Hegel, the griot's town is for the griot. Nothing prohibits our seeing them in confluence, without confusing them in some magma or reducing them to each other. This same opacity is also the force that drives every community: the thing that would bring us together forever and make us permanently distinctive. Widespread consent to specific opacities is the most straightforward equivalent of nonbarbarism.

We clamor for the right to opacity for everyone.

translated from the French by Betsy Wing

Vilnius, 2002

For Opacity

Notes

1. Albert Jacquard, *Éloge de la différence* (Paris: Éditions du Seuil, 1978).

2. Translator's note: *Compréhension* could, of course, be translated as "comprehension" to point out the root connection with the French word *comprendre,* which I have earlier rendered as "to grasp" or, where the sense is mechanical, as "to comprehend" (and once at Glissant's behest, as "to integrate"). In American English, however, the controlling attitude implied in this particular instance, vis-à-vis other people of cultures, is more apparent in *understanding* than in *comprehension.*

Modernity as a Mad Dog: On Art and Trauma

Everlyn Nicodemus

Critical thinkers have been speaking with ever-increasing frequency of the twentieth century as an era of trauma. And recently, this psychiatric term has cropped up in the most diverse contexts. It has been applied to both individuals and collectives as a way of trying to understand crises and their aftermath in a less rigid manner than most social and political thinking offers today.

This tendency has a specific source. A branch of psychiatric research originally initiated in the 1890s by Freud and Breuer's studies on what was at that time labeled "women's hysteria," it has been subsequently fueled by clinical findings in connection with historical catastrophes and the aftermaths of two world wars, Shoah, Hiroshima, the Vietnam War, and the AIDS epidemic. On one side, the research has focused on extreme situations and symptoms such as those of posttraumatic stress disorder (a diagnosis officially recognized as late as 1980), experienced for instance by soldiers who after intense stress in battle suddenly lose it and often die for no apparent physical reason. On the other side, it has been widened, not least by feminist psychiatrists, to apply to more socially widespread suffering, especially rape and child abuse.

The step-by-step development throughout the decades of this research and school of thinking had to overcome a lot of resistance. Repugnance was manifest at an early stage: from a dominant macho and military perspective, a diagnosis that had been labeled "hysteria" and typically applied to women could not possibly be applied to soldiers, to men! But in recent decades, increased professional research in the field and greater public awareness of traumatic suffering in, for instance, the conflicts in Bosnia

and Kosovo—as well as the opening up of the research into new fields, including literary and cultural studies—have called forth a broad response beyond psychiatric circles. This was probably the moment when the terminology began to penetrate everyday language and media.

Traumatic Tragedies, Visible and Invisible

This focus on psychic trauma has clearly followed us into the twenty-first century. As I write this text, only a few weeks after September 11, 2001, it would be premature to venture a judgment about the long waves of consequences of what happened in Manhattan that day. But we have had an opportunity to watch, in a unique way, a catastrophic event and its immediate aftermath: how trauma affects individuals, society, and a nation with countless interacting repercussions. And we have also witnessed how this huge traumatization almost immediately began to change the world. Exactly how, no one yet knows. "It has blown a hole in the world as we knew it," writes Arundhati Roy.[1]

Whereas September 11 was an extraordinarily visual event, which we were able to watch in real time on the television screen and to follow through massive media coverage, the catastrophe that once took place within the Nazi extermination camps was utterly invisible. It was first blacked out while it was happening, by the perpetrators and their colluders, and then by a postwar Western world reluctant to deal seriously with its wounds and with the full range of responsibility involved. "In order to escape accountability for his crimes, the perpetrator does everything in his power to promote forgetting. Secrecy and silence are the perpetrator's first line of defence," writes Judith Lewis Herman.[2] Finally, the Holocaust was put in a black hole by the fact that most survivors from the death camps, especially the Jewish, were too deeply traumatized to talk about their sufferings, even to their children. As literary historian Cathy Caruth has written, "In trauma the greatest confrontation with reality may also occur as an absolute numbing to it."[3] For many survivors it took more than forty years to overcome this muteness, which is one of the gravest symptoms of posttraumatic stress disorder.

The terrorist attack on New York introduced the sudden insight that civilian airlines can be turned into weapons of mass destruction. It spread fear all over the world, and in this respect it may be more appropriate to draw a parallel with Hiroshima than with the attack on Pearl Harbor. The atomic bomb threw the world into its biggest trauma, and the world is still dealing with its threats to human survival.

For the victims of the bombings of Hiroshima and Nagasaki, it took some time and many turns before their voices reached the public in the country that launched the bombs. Despite groundbreaking research on survivor experience by New York professor

Robert Jay Lifton,[4] and the appearance in the press soon after the war of John Hersey's reports on the issue, the victims' voices didn't really reach the American public until Hersey's collection of Japanese testimonies was published in book form in 1985.[5]

This kind of tardiness of and repugnance toward knowledge brings up the question of "othering" and of center/periphery relations. It has been noted that the terrorist attack of September 11 targeted the center of the center of the white Western world, throwing light upon America's *unsuspecting* sense of security and its self-centeredness. It should be noted that psychiatric research on trauma has developed mainly within this introverted Western sphere. It would be easy to make a long list of catastrophes and human tragedies that have taken place beyond the horizons of the immediate attention of this sphere and that have been "forgotten" when it comes to psychiatric investigations of their impact on both individuals and the collective psyche. Pain is not a Western prerogative, nor are deep psychological wounds, despair, confusion, mourning of loved ones, traumatization. They have been the aftermath of each of those human catastrophes that in most cases were left—or kept—more or less invisible to a self-centered and self-righteous Western world. I leave it to the reader to fill in the list.

Psychology and Blacks

Only recently did I delve into the literature on psychic trauma, for reasons I will explain shortly. I studied psychology in the early 1980s, in the context of environmental engineering. My studies included stress but not traumatic stress disorder. I left the field in favor of other ways of thinking that could make better sense of my situation as a black African woman and as an artist. My experience of how psychology was theorized and practiced was akin to being in a hall of mirrors where I could watch white people's neuroses reflected like phantom images. Something lingered of the atmosphere of depraved individualism in Freud's Vienna.

It is impossible for any serious thinker in psychiatry or psychology not to be influenced in one form or another by Freud's writings; he is, after all, the great founding father of the whole science. But from my perspective, Freud makes more sense when one reads the writings of Frantz Fanon, because they show that it is not Freud's revolutionary thought itself that is fenced in but, rather, certain common Western applications of it.

Fanon brings Freud's thinking on trauma into the daylight of a wider cultural and political field in order to build an understanding of postslavery and postcolonial black existence and of the necessity for a decolonization of the human mind. He illustrates how the forces that produced the deeply deranged black self-consciousness

caused by slavery, racism, and colonial oppression were inscribed as a racist pattern in European popular culture and spread around the world, transmitting by *cultural imposition the black trauma* to every new generation, even to individuals who were never exposed to the physical and psychological violence of the original scenes of trauma (a term Fanon borrows from Freud). Thus, Fanon concludes, a normal black child will become abnormal on the slightest contact with the white world.[6] In the chapter "The Negro and Psychopathology" of his groundbreaking work *Black Skin, White Masks,* Fanon notes that "Freud and Adler and even the cosmic Jung did not think of the Negro in all their investigations."[7]

Only when I began writing an autobiographical testimony of my own experiences as a black African woman artist in the European diaspora did I examine the recent psychiatric literature on trauma. Part of my experience is common ground: the kind of marginalization and exclusion from exhibition forums, museums, and art historical documentation that most nonwhite, non-Western artists have been exposed to in Europe, and which in themselves are deeply traumatizing to an artist. Problems arose as I tried to write down my story while giving an account of organized systemic persecutions, which, for more than fifteen years, had made an already unbearable situation even worse and had severely affected my psyche. I had difficulty finding the words to give these experiences a language.

When I began reading about psychic trauma, I understood that I had been lacking a knowledge that would enable me to better understand my own distorted behavior. My difficulties were not exceptional: I shared them with many. I was not crazy! Psychic trauma not only means personal suffering but also involves an unknown world of distortions in thinking and responses, creating personality disorders.

Realities Most of Us Have Not Begun to Face

The title of this section is taken from the preface to *Trauma: Explorations of Memory.*[8] In order to explain the immensely intricate dialectics of traumatic disorders and understand how humans exposed to severe stress function, the authors took their clinical examples from very different cases, sometimes from the aftermath of genocidal events and sometimes from everyday harassment. Traumatic disorders can be about distorted memory. And because all trust is taken away from the traumatized individual, it can mean disconnection from almost all human relationships—a loss of trust in oneself, in other people, in justice. It can even mean a shattering of the whole construction of the Self. Traumatized people often fixate on the trauma, thinking of nothing else. This

emotional imprisonment means an erasure of their individual history outside the trauma. And when history is abolished, identity also ceases to exist. There can be countless psychosomatic symptoms, such as premature aging, insomnia, pain, and disease, or, even more critical, severe personality disorders, including seclusionism, paranoia, or sudden outbursts of psychotic rage.

I recognized painfully many of these and other symptoms described in the book. And every moment of recognition was a revelation and a relief. From the moment I began to understand myself, and what had been inflicted upon me, in the light of this new knowledge, I had no choice but to assume a doubled and complicated role both as a critical commentator and as a witness giving testimony. I am aware that this is a highly sensitive double role; the demand for objectivity is folded into subjective experience. But as I will show, it corresponds to a certain intertwining of the roles of narrator and listener, which is necessary to every situation of traumatic testimony.

My symptoms began with difficulties in finding words. And I found that psychiatric researchers have focused more and more on the problems sufferers encounter in narrating their traumatic life experiences. The insight has emerged that the difficulties of testifying about severely traumatic experiences come from the fact that in the act of witnessing, memory, thought processes, and the implementation of language are themselves heavily traumatized. Similar to a therapeutic dialogue, listening to or reading a testimony has to include elements of solidarity and identification with the individual who testifies, which goes beyond critical understanding and general empathy.

A New School

During the 1990s there emerged within the psychiatric research on trauma a new school of thought around the problems of testimony and language. Literary and other cultural theorists joined psychiatrists in investigating the genre of testimony. *Testimony: Crises of Witnessing in Literature, Psychoanalysis, and History,* by psychoanalyst Dori Laub and literary theorist Shoshana Felman, is a typical example, containing analyses of works by Fyodor Dostoyevsky, Stéphane Mallarmé, Paul Célan, Albert Camus, and Paul de Man.[9] Another key work is Caruth's *Trauma: Explorations in Memory,* which collects essays by a wide range of psychiatric and cultural writers, among them director Claude Lanzman, whose film *Shoah* holds a central place in both books. Lanzman's essay, "The Obscenity of Understanding," points to a crucial problem: the most painful traumatic experiences cannot be narrated and explained by any outsider. Such "understanding" becomes obscene.

Along with some rather thought-provoking literary analyses, the new literature on trauma contains interesting theories about the genesis of modernity in literature and art. I am now drawing close, on this long preamble, to the proper subject of my essay: the relationship between visual art and trauma in light of a traumatized modernity. The literature represents a new and speculative area of thought emerging from the crossroads between psychoanalysis, psychiatry, and literary writing. It should come as no surprise that it touches upon visual art as testimony only occasionally and in rather vague and general terms. But the issue provoked and fascinated me, and I could not avoid making comparisons with the field of visual art or testing the theories on my own disturbed situation as an artist with traumatizing experiences of racism, exclusion, and persecution. What can be said about works of art and artists within twentieth-century modernism from the point of view of testifying to trauma, collective or individual?

Art as Testimony: A Random Inventory

Let me start by venturing a loosely founded theory that, in this context, there are two kinds of artworks and artists: those that narrate or symbolically represent experienced historical events and catastrophes of a traumatizing nature, and those that testify to the impossibility of narration and representation of such experiences. The extreme of the latter position is marked by Adorno's assertion that no one can write poetry after Auschwitz. Shoshana Felman elaborates on this further by noting that "all of thinking, all of writing . . . has now to think, to write against itself," and that "it is only art that can henceforth be equal to its historical impossibility, that art alone can live up to the task of contemporary thinking."[10] What this should mean, I believe, is that works of art containing a dimension of testimony to trauma can be expected in most cases to show signs of a breakdown of narrative language.

In order to get an overview of possible examples of an art-historical "writing against itself," I bought the catalog to the exhibition *Facing History, 1933–1996: The Modern Artist before the Historical Event* (Centre Georges Pompidou, Paris, 1996), which had been organized in commemoration of André Malraux. For Malraux, facing history had meant, among other things, dealing with the general strikes in Hong Kong and Canton, the uprising in Shanghai, the concentration camps, the Spanish Civil War, and the fight against fascism and anti-Semitism; this background already hinted at a certain interpretation of "historical events" as catastrophes. Despite contributions to the catalog by authors from the category of non-European so-called Others, including Gerardo Mosquera, Ery Camara, and Luis Camnitzer, the exhibition itself had been extremely

Eurocentric. Not one single work by an African artist had been included, evoking yet again the specter of a continent allegedly lacking both history and modern art. As if colonization, slavery, and apartheid had not been historical events! As if Gerard Sekoto's painting about convicts in one of South African's labor camps, or Ezrom Legae's enigmatic images of mutilation were not modern works facing contemporary history! Despite holding these reservations about the show, I would like, as a prelude to further theoretical commentary, to select a number of works from the catalog that illustrate art connected to traumatizing events.

The catalog narrative begins in 1933, the year of the Nazi takeover. Illustrated from that year is Paul Klee's broken and subversive drawing of a couple of émigrés, together with his bewildering *Angelus Novus* from 1920. Walter Benjamin owned the latter work and wrote of it, "This is how one pictures the angel of history. . . . Where we perceive a chain of events, he sees one single catastrophe which keeps piling wreckage upon wreckage and hurling it in front of his feet."[11] The premonition of gathering storms symbolized in Richard Oelze's painting *Waiting* (1935–36) joins Salvador Dalí's *Premonition of the Civil War* (1936), followed by Pablo Picasso's *Weeping Woman* and Jacques Lipchitz's *Prometheus Strangling the Vulture*, both from the crucial year of 1937, the year of *Guernica*. All of these works are torn apart and shaken by anguish.

If artists reflect catastrophes by foretelling them, then the visual art of the first decades of the twentieth century can probably be said to be full of premonitions. During World War I, dada staged a theater of furious madness against a bourgeois society and culture responsible for the conflict; Duchamp went a step further by questioning the whole notion of art. Freud was not the only one whose work was informed by the nightmares and the disconnected associations of traumatized soldiers from Europe's trenches; so was that of André Breton. He confessed that much of what surrealism would build upon emanated from his experiences as a military doctor stationed at a neuropsychiatric center.[12] Whereas the dadaists performed cultural insanity, the surrealists used the symptoms of posttraumatic stress disorder to portray the deranged subconscious of the time. And few succeeded as provocatively as Dalí, in paintings such as *Premonition of the Civil War*.

Two artists excelled at making visible the impossible depiction of people deprived of their human identity and reduced by brutal arbitrariness to flesh and matter, to the status of insects, during what is sometimes referred to as our concentration-camp era: Wols, with his spider's web images of camps and his helmeted heads; and Jean Fautrier, with his heads of hostages. They both expressed a painful yet sensual

disintegration of visual language. Aside from their works, which date from the Second World War, visual wartime testimonies are rather exceptional. In the decade after the war, on the contrary, works in which visual language is shaken and violated by feelings of destruction and tremendous aggression become more abundant. This trend seems to confirm the observation by Predrag Finci, about the work of art in times of war, that "it is only when the event fades, when it becomes recollection . . . that the artist can say what really happened, if it is indeed at all possible to express what has shaken being to the core."[13]

As overshadowing historical events, the Holocaust and Hiroshima are documented in photographs taken by Lee Miller in Dachau (April 1945) and by Yosuke Yamahato in Nagasaki (August 1945). Some forty-five years later, artistic interpretations of these catastrophes can be found in the catalog *Facing History*. They testify to the complete impossibility of narrating such events. Kosho Ito's installation *A Work in Red and Chestnut for Hiroshima* (1988) is a terrifying, void space above soil covered with carbonized clay and shells from Hiroshima. Bracha Lichtenberg-Ettinger's transparent images referring to memories of the Holocaust, *Matrixial Borderline* (1990–91), are marked by an autistic repression of legibility. Totalitarian repression around the world provoked many desperate artistic responses, such as Antoni Tàpies's *Murderers* (1974) and Luis Camnitzer's series *From the Uruguayan Torture* (1983). And in 1995, Oleg Kulik staged a performance as a mad dog doing away with the last taboo of Cerberus, which forbade him to bite.

Several of these works could easily be analyzed in the same manner that Camus's *The Plague*, Célan's poetry, de Man's *Exercise of Silence*, and Lanzman's *Shoah* have been analyzed in the literature on testimony, that is, in terms of historical and personal trauma as well as the kinds of formal strategies employed. What literary analyses teach us, among other things, is that the testifying expression and message are often hidden in the formal structuring of the work. The painters and sculptors mentioned above could also be regarded as acting within a traumatized modernism.

Art as Testimony: The Dog and the Hostages

As I am writing this, and by coincidence, Oleg Kulik is passing through Brussels and a mutual friend happens to bring him to my place for an improvised dinner and chat. We have never met. I read to him what I have written on trauma and art and on testifying to the private unspeakable. And I mention that for me, his performance as a mad dog has to do with giving testimony. He agrees completely. For him the piece is about a deep cultural

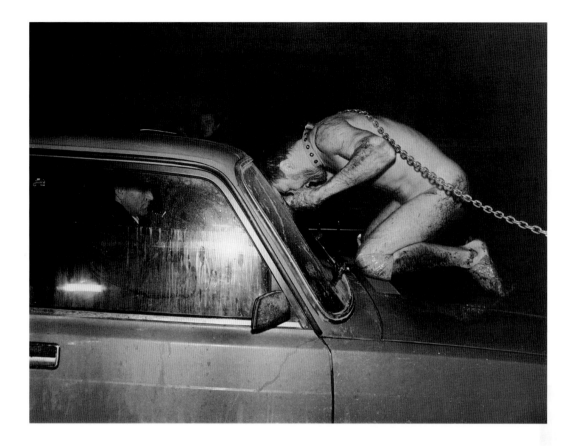

Oleg Kulik (with Alexander Brener),
*Mad Dog or Last Taboo Guarded by
Alone Cerber,* 23 November 1994,
performance at the Guelman
Gallery, Moscow. Courtesy of
Oleg Kulik.

trauma. It is about the fact that all cultural contexts have collapsed, that the bonds which should unite humans and hold them upright are ruined, leaving us down on our knees. He is thinking specifically of the enormous trauma produced by the sudden collapse of the former Soviet Union. Within weeks, an imposed Soviet way of thinking was rendered obsolete. The speed of events left people without words. It left them trying to hold their lives together merely with their senses, and sick feelings. How does an artist narrate a trauma like that? From down on his knees playing a mad dog that bites.

Let me use another example from the historical works above. What is behind Fautrier's *Hostages* series, which, I would guess, are among the most typical paintings of twentieth-century art bearing the stamp of both personal and historical trauma? The rather small paintings that comprise the series were exhibited in Paris in late 1945. A clue to the historical context—if clues were even needed at that time—was provided by some

larger canvases, one of them called *Oradour*. It referred to the summary execution by the German SS of 642 men, women, and children, which had taken place in Oradour-sur-Glane the previous year.

Fautrier, who seems to have been programmatically apolitical in the years before the war, became involved in the French resistance movement. He was arrested by the Gestapo, but subsequently released thanks to the intervention of the German pro-Nazi sculptor Arno Breker, and he went into hiding in an asylum for the mentally ill.[14] His exhibition met with a divided response. It was criticized severely by those who expected a rhetoric of heroism, martyrdom, and outrage. It was hailed, but in the purely formal terms of artistic innovation, by those who would become the advocates of art informel. Only later was it acknowledged that the radicality of Fautrier's *Hostages* was due as much to their complete breakdown of the rhetoric of narration as to their new form of abstraction. They paradoxically combined a sense of violence, defenselessness, and death with a rosy, sweet smell of fleshy sensualism. The insistent materiality of the paint sometimes looks like large bird droppings. I believe the series tells us something crucial about how a visual artist may handle the traumatic unspeakable by displacing the catastrophe into highly loaded substance and color.

My Own Testimony

I was lying on the floor in a pool of blood. I had vomited blood and soiled and wet my pants. When I regained consciousness, I didn't know what had happened. I must have burst, exploded. Confusion and fear reigned. I have dim memories of threats and hostility closing in on me. I felt weak and helpless and realized that I was going to die. I knew there was no one around to help me. My husband had gone to Copenhagen to sign a contract for a book. He had been reluctant to leave me alone in the house we rented in a village in Alsace because he knew that I was in a very bad psychological state. Years of persecution in Sweden had followed me to France, where my neighborhood had recently turned hostile. I had found the carcass of a decapitated black cat on my doorstep. Some youngsters had come by on a cart with drums and trumpets, their faces painted black, to stage a hellish racist manifestation outside our house. This was the part of France where the Nazis had once had a death camp.

I was possessed by a fixed idea that I needed to get a message through to my family in Tanzania that I didn't want to be brought back to Kilimanjaro to be buried at home, according to our custom, but that I wanted to be buried in the diaspora where Kristian, my husband, could care for my grave. When I finally managed to reach him by

phone, this is what I said to him. He got the underlying message, rushed back home, and managed to save my life.

When I had recovered some strength, I reached for my drawing block. I needed to cling to my craft as an artist to avoid going insane. Day after day, from morning to evening, I sat at a table drawing the same subject over and over again: a cramped woman sitting on a chair that could overturn at any moment; in front of her a black floor seems to open upon an abyss. It wasn't a picture of what had happened to me; rather, it was about a total loss of foothold. Ten years later, on the occasion of an exhibition of my work in Spain, which broke a long-standing exclusion, Jean Fisher wrote about these drawings in the catalog, and I recognized my feelings in the following lines: "Above all, the figure's sensory, motor, and conceptualizing faculties—hands, feet, and head—are all but withdrawn into the swollen bulk of its body. We might say that this self has taken leave of its senses."[15] Professor Shinkichi Tajiri, who had invited me in 1988 as his guest student at the Hochschule der Künste in West Berlin, expressed it more bluntly when Kristian showed him the same drawings: "Don't you see she is going mad!"

I can now assess in psychiatric terms what happened to me after the trajectory from Sweden to Alsace. The breakdown was a typical case of catastrophic posttraumatic stress disorder of the kind that often leads to psychogenic death. And as Lawrence Kolb observes, "those threatened over long periods of time . . . suffer long-standing personality disorganization."[16] In Sweden I had known my persecutors by name and had been able to fight back, but in Alsace, they had been invisible and anonymous. Threat arouses the sympathetic nervous system and makes the threatened person go into a state of alert. But when action is of no avail, writes Judith Lewis Herman, the adrenaline rush goes astray and produces disorder.[17] Psychically disorganized by this psychological warfare, I have occasionally acted like a mad dog myself.

Testing the Theories

The series of drawings entitled *The Object*, which I made immediately following my breakdown, were part of a highly traumatic situation. Taking into account that testimonies to traumatizing catastrophes seldom or never consist of orderly narratives but are often evasive translations characterized by monomaniac repetitions, *The Object* can be said to bear witness to my posttraumatic stress disorder. This doesn't mean that the drawings functioned as spontaneous outlets, as when, for instance, children are encouraged to draw in order therapeutically to relieve traumas. The drawings were completely within my artistic control. I executed them in a complicated, time-consuming, black mixed-media technique, which I had first developed in some fictive portraits of

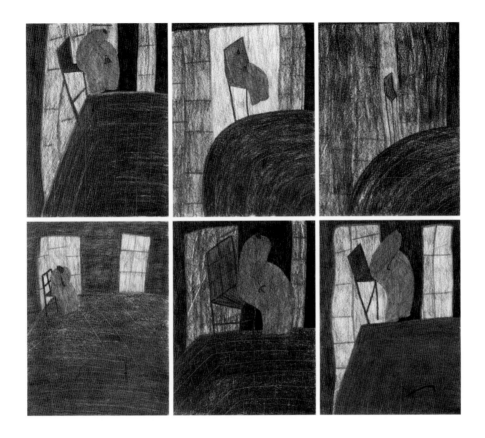

Everlyn Nicodemus, *The Object*,
1988, suite of six drawings, graphite
and ink on paper, 37.5 × 29.8 cm.
each. Courtesy of the artist.

Antonin Artaud with a brain tumor. Even the repetitiveness of the series was an aesthetic project and complicated by the smallest of variations.

Two years later, now in Antwerp, the persecutions having followed me into yet another exile, I felt hounded by nightmares of the breakdown in Alsace. I found myself embarking on a series of paintings about death, without first realizing where the urge to paint them came from. I soon found out that it was about my meeting death in Alsace, about my wrestling with death, and about my return to the space of life and to what I hoped was a restored Self. I was making the paintings for myself without any thought of ever showing them publicly. The series took me three years and amounted to eighty-four paintings. I externalized my memories and thoughts, and transformed them into a kind of painted ballad. The series was given the camouflage title *The Wedding*.

When I now look back at *The Wedding,* I hesitate to categorize the series as a testimony to trauma, at least not in the sense of providing evidence to the world about what happened to me. There was a dimension of autotherapy. It was a witnessing to myself, driven by the need to give shape and language to confusion and chaos. In most of my visual production I have been processing life experiences. Life and death were realities, not abstractions, in my African childhood. I believe *The Wedding* can be read as a visual narrative about the traumatizing moment in Alsace when I came so close to death that it changed much of my outlook on life. It meant a fight in self-defense, a conquering of the will to live and continue, a desperate fight that was heightened by my conviction at the time that the goal of the continuing persecutions was to crush me, was death in one form or another. The more the series proceeded toward the return to life, the more it became a sensual song of praise to life. Luxurious greeneries testified to life's vital force.

The conclusion I draw from my attempts to test the theories against my own experiences as an artist is that probably no sharp boundaries can be drawn around what in visual art might be defined as testimony to trauma. I will return instead to the question of whether we are acting within a traumatized modernism.

A Traumatized Modernity

In the writings on trauma, testimony, and literature, the theme of a traumatized modernity—in the sense of an interrupted and shattered consciousness—has been taken up mainly in connection with Walter Benjamin's commentary on Charles Baudelaire and Baudelaire's own essay on laughter and shock. This is how Kevin Newmark, in his study "Traumatic Poetry: Charles Baudelaire and the Shock of Laughter," sums it up:

> It is now clear why Walter Benjamin singles out Baudelaire as the exemplary poet, the star that lights up the sky of our modernity. The laughter that shakes his texts as well as our attempts to understand it emanate from the shock that modernity dissociates once and for all the traditional cohesion of experience and cognition. For Benjamin, the writings of Baudelaire offer us a privileged access to the bumps and jolts the continuity of individual and collective consciousness sustains in the industrial age of the big city.[18]

Baudelaire called progress a grotesque idea. He made it clear that he didn't identify the modern spirit with the vulgar obsession with technical novelties. In his critical commentaries on the World Expo in Paris in 1855, he noted that to the common

man progress means steam, electricity, and gaslight, and he added: "The poor man is so americanized by his zoocratic and industrial philosophers that he has lost the notion of the difference characterizing the phenomena of the physical world and those of the mind, of the natural and the supernatural."[19]

When Benjamin wrote his essay "On Some Motifs in Baudelaire," first published in 1939, he focused on a much more complex relationship between the writings of the poet and ongoing large-scale industrialization.[20] In his analysis he invokes Bergson and Freud and goes into how memory is decisive for the pattern of experience understood as a matter of tradition. He hints at the collapse of traditional forms of experience, cognition, and narratives to which Baudelaire as a modern poet was witness, a collapse caused by the shock of the excessive new impressions of industrialization, of stimuli that could no longer be integrated into an inherited collective experience. It meant a loss of a conventional consciousness and of a traditional language.

According to Benjamin, as a poet Baudelaire could only meet shock with shock. Shock became for Baudelaire the crucial element in his modern poetry and also the main condition of art. In Baudelaire's view, the creative process may be compared to a duel in which, just before being beaten, the artist screams with fright. Benjamin calls the metaphor a self-portrait of the poet.[21] And in his text "On the Essence of Laughter," Baudelaire explains that the shock consists of the insoluble contradiction between man's grandeur and man's misery, and that it is this that produces laughter.[22] In Baudelaire we see the dawn of a modernism with absurdism rather than progress as its criterion. For Baudelaire, as for Stéphane Mallarmé, another pioneering French poet, the loss of language and of a traditional form of narration in itself represented a traumatizing accident.[23]

Black Slaves, the First Modern People

In order to encounter the daring thought of modern humanity united by a traumatized consciousness, one need only turn to Toni Morrison, who builds on both Benjamin and Fanon. I refer here to the chapter "Living Memory: A Meeting with Toni Morrison" in Paul Gilroy's book *Small Acts*, in which he quotes both from an interview with Morrison and from her writings, including her great novel *Beloved*. He stresses that "Morrison sees the intensity of the slave experience as something that marks out blacks as the first truly modern people."[24] She is aware of Benjamin's perspective on how, as she writes, "the so-called modernist writers of the nineteenth century registered the impact of industrialization in literature—the great transformation from the old world to the new."

And she points to how "the people that we call the true modernists in painting" had abandoned direct representation. Referring to the transition to the unknown, which is a traumatic crossing, she insists that Africa was feeling the same thing.

The passage that follows has, for me, a deep and far-reaching significance. It does away with those Eurocentric notions of modernism and modernity to which so many degrading prejudices against non-Western modern artists have been linked: the notions that the white Western world "owns" modernity and that Others should stick to their original cultural traditions; that only white Western artists have license to break with tradition, to problematize language, and to engage in artistic innovation. Morrison reminds us implicitly that we all make the journey to the new and that we all own modernity, or postmodernity—she doesn't seem to consider the distinction important. We all are condemned by the traumatic nature of modernity.

> It's not simply that human life originated in Africa in anthropological terms, but that modern life begins with slavery. . . . From a woman's point of view, in terms of confronting the problems of where the world is now, black women had to deal with "post-modern" problems in the nineteenth century and earlier. These things had to be addressed by black people a long time ago. Certain kinds of dissolution, the loss of and need to reconstruct certain kinds of stability. Certain kinds of madness, deliberately going mad . . . "in order not to lose your mind." These strategies for survival made the truly modern person.

And Morrison continues about the grounds of the strategies:

> They're a response to predatory Western phenomena. You can call it an ideology and an economy; what it is is a pathology. Slavery broke the world in half, it broke it in every way. It broke Europe. It made them into something else, it made them slave masters, it made them crazy. You can't do that for hundreds of years and it not take a toll. They had to dehumanize, not just the slaves but themselves. They have had to reconstruct everything in order to make the system appear true. It made everything in World War II possible. It made World War I necessary. Racism is the word that we use to encompass all this. The idea of scientific racism suggests some serious pathology.

There are echoes of Fanon's deep insights here!

Words and Our Visual Brain

Toni Morrison had language very much in mind during her conversation with Gilroy. As an artist, it is interesting for me that, in order to remind us how radical was modernity's split from traditional narratives, she invokes the modernist painters who, she points out, were more aware of the "pitfalls of representation" than "the so-called modernist writers of the nineteenth century."[25] This idea occasions thoughts about the differences between literature and visual art. As a basic element, is the word in itself already a representation, a construct? Does visual art build more directly on the activity of our visual brain, which modern neurophysiologists such as Semir Zeki have shown is involved in an active process of searching for knowledge, not just in receiving impressions?[26] Does our visual self-expression react more directly and intimately to traumatic intrusions into our mind? While, paradoxically perhaps, maintaining a certain integrity granted to the process of seeing, to our visual intelligence, even in the middle of the disarray brought on by the trauma?

These very elementary questions must be answered, I believe, before we can with any certainty transcribe findings on literature and trauma to trauma and visual art. And until then, I prefer to see the problems in more general terms of a traumatized modern era. Which is, I guess, what Felman is hinting at when she concludes that the cryptic forms of modern narratives and modern art, consciously or not, partake of the historical conditions that for Adorno made poetry impossible.[27]

New York City, 2002

Notes

1. Arundhati Roy, "The Algebra of Infinite Justice," *Guardian,* 29 September 2001.

2. Judith Lewis Herman, *Trauma and Recovery: From Domestic Abuse to Political Terror* (London: Pandora, 1994), p. 8.

3. Cathy Caruth, ed., *Trauma: Explorations in Memory* (Baltimore: Johns Hopkins University Press, 1995), p. 6.

4. Robert Jay Lifton, *Death in Life: Survivors of Hiroshima* (Chapel Hill: University of North Carolina Press, 1991).

5. John Hersey, *Hiroshima* (New York: Bantam, 1985). Hersey's reports were originally published in *The New Yorker* in 1946, and in newspapers of that time.

6. Frantz Fanon, *Black Skin, White Masks* (London: Pluto Press, 1986), pp. 143–46.

7. Ibid., p. 151.

8. Caruth, *Trauma*, p. vii.

9. Shoshana Felman and Dori Laub, *Testimony: Crises of Witnessing in Literature, Psychoanalysis, and History* (New York: Routledge, 1992).

10. Felman and Laub, *Testimony*, p. 34.

11. Walter Benjamin, *Illuminations*, trans. Harry Zohn (London: Fontana Press, 1992), p. 249.

12. *André Breton, La beauté convulsive*, exh. cat. (Paris: Musée nationale d'art moderne, Centre Geroges Pompidou, 1991), p. 89.

13. Predrag Finci, "The Work of Art in the Time of War Destruction," *Third Text*, no. 24 (1993), p. 11.

14. Biographical information on Jean Fautrier is from Patrick le Nouëne, "Jean Fautrier, des otages aux Partisans 1945–57," in *Face à l'histoire 1933–1996, L'artiste moderne devant l'événement historique*, exh. cat. (Paris: Centre Georges Pompidou, 1996).

15. Jean Fisher, "Everlyn Nicodemus, between Silence and Laughter," in *Everlyn Nicodemus, Displacements*, exh. cat. (Alicante: Sala de Exposiciones de la Universidad de Alicante, 1997), reprinted in *Third Text*, no. 40 (1997), pp. 41–53.

16. Quoted in Herman, *Trauma and Recovery*, p. 119.

17. Ibid., p. 34.

18. Kevin Newmark, "Traumatic Poetry: Charles Baudelaire and the Shock of Laughter," in Caruth, *Trauma*, p. 253.

19. Charles Baudelaire, "Exposition Universelle de 1855: Méthode de critique," in *Baudelaire II critique*, ed. Pierre-Jean Jouve (Fribourg: Egloff University, 1944), p. 55.

20. Benjamin's essay "On Some Motifs in Baudelaire" was originally published in *Zeitschrift für Sozialforschung* (1939), and subsequently in English translation in the volume of writings *Illuminations*. Quotations here are from the Fontana Press edition (1992).

21. Ibid., p. 159.

22. Charles Baudelaire, "De l'essence du rire," in *Baudelaire II critique*, p. 77.

23. See Shoshana Felman, "Poetry and Testimony: Stéphane Mallarmé, or an Accident to Verse," in Felman and Laub, *Testimony*, pp. 18–24; and Kevin Newmark, "Traumatic Poetry: Charles Baudelaire and the Shock of Laughter," in Caruth, *Trauma*, p. 238.

24. Paul Gilroy, *Small Acts: Thoughts on the Politics of Black Cultures* (London: Serpent's Tail, 1993), p. 178. All further citations in the text refer to this page of this edition.

25. Ibid.

26. Semir Zeki, *Inner Vision: An Exploration of Art and the Brain* (Oxford: Oxford University Press, 1999), p. 21.

27. Shoshana Felman, "Camus' *The Fall*," in Felman and Laub, *Testimony*, p. 201.

Keeping It Real

Kathryn Smith

About eight months ago, I was driving on the M4 north bound towards Umhlanga. . . . Somewhere near Kings Park swimming pool I encountered something that inadvertently became the inspiration for this first project. Walking along the low concrete barrier that divides the two freeways was this tall black woman—clearly inebriated—weaving her way deliberately like a tightrope walker. She was barefoot and dressed in black plastic, contrived as a wedding dress, with long train trailing behind her. In her hands she clasped a posy of white plastic flowers. . . . Later that evening on my way back into the city center, I saw her again, this time emerging out of the bushes some seven or eight kilometres from where I had originally seen her. Wedding dress now a little tattered, posy now replaced by a neat bundle of dry wooden branches balanced perfectly on her head, moving back into the city. There is a plethora of what I call urban shamans, attaching bits of detritus to themselves. . . . They are possibly examples of the hybrids that emerge from the interface of rural with the urban. I became absorbed by these sorts of collisions or fusions.

Greg Streak, 27 October 2000

The first South African initiative of the RAIN [Rijksakademie International Network] network took place in Durban, South Africa. Entitled *Pulse: Open Circuit* (2000), it was followed by the second exchange-based project, *Violence/Silence* (2002), both curated by local artist Greg Streak. In speaking about localized differences in South Africa, there's a neat saying that goes: "Cape Town's on rewind, Durban's on play and Johannesburg's on fast-forward." While generally taken to refer to lifestyle idiosyncrasies in each of South Africa's major cities, on closer inspection the triteness reveals many of the subtexts of each zone's cultural and political affiliations, where although detail has changed, the fundamentals have remained pretty much the same both before and after apartheid.

Durban is often touted as a point of reflection and respect in debates about cultural "hybridity." Where Johannesburg's grab mentality, harking back to gold-rush days, is rapidly replacing serious culture with a *laager*[1] of European-themed casino-mall developments enveloping its periphery, Durban's quiet efficiency has seen its dedicated artistic community single-handedly save the Durban Art Gallery's fated acquisitions budget through a series of "art party" events.

Although one of South Africa's three major cities (Johannesburg and Cape Town complete the triad), Durban is often excluded from the loop of major local art world activity. The significance of *Pulse: Open Circuit* not only raised the profile of this heady and complex city, but also created a rare intimacy between local artists and our international contemporaries. *Pulse* exposed and coaxed the cultural growing pains of a country having to mature in the public eye. The double bind of integrity versus the need to please informs the locations and biases of South African contemporary visual art on every level.

The climate leading up to and from the first democratic election in 1994 saw an unprecedented interest in "art from South Africa," almost as if the visual culture produced in South Africa would offer some sublime understanding of the schizophrenic state of the nation(s). As a result, any number of group exhibitions have been hosted by Euro-American institutions, many of which received critical acclaim in their host country, but were panned "back home" as simplistic, retrograde, or fundamentally misinformed.[2]

While not exclusively symptomatic of the South African status quo, financial and other more abstract factors translate into a lack of "imported" exhibitions to South Africa. Events predicated on "cultural dialogue and exchange" often end up as desperately one-sided, frustrating, and limited in terms of productivity. As such, young local artists without the means to travel abroad often feel as if they are producing in a

vacuum. The details of the whys and wherefores are predictable and boring, resulting in circuitous debates around postcolonial politics that more often than not end up parodying the seminal issues at hand (and by extension, making caricatures of the critics themselves).

Two tumultuous biennales later and no promise of a third, we aren't any closer to understanding ourselves, apparently still doomed to being constructed rather than constructive. Groundbreaking as they were, neither biennale appears to have wrought any real change on the cultural topography of this country.[3]

Pulse: Open Circuit took up this challenge, with its telescopic crosshairs strategically focused on bringing local differences into view through real (lived) interaction with international contemporaries. Intersections between First World (high-tech) and Third World (low-tech), their mutant art/craft spawn, and the increasing "absent presence" of technology in the information age were all on the agenda.

Low-tech Needs and High-tech Wants

South African contemporary visual artists are exquisitely aware of our potential to become curiosities. It is something that we guard ourselves against, or strategically embrace for better or for worse. In less than sensitive hands, forays into identity and place (along with history and memory) can so easily become oversubscribed and tired. *Pulse: Open Circuit* was a true reflection of the potential of the "glocal," as unappealing a word as it is, or as Andreas Broeckmann would have it, the "translocal."

Artists from "Africa" are time and again confronted with strange preconceptions from international "centers" that are not so much about whether the possibilities of working in high-tech media exist this far south as much as they are about what we are expected to produce. This is generally two-pronged. In the first scenario, any technologically dependent work is celebrated regardless (any video is a good video). In the worst scenario, international audiences often seem to want a kind of production that corroborates with some sort of anachronistic "primitive exotica," an attitude that is often informed by an ignorance of cultural nuance between one African country and another.

Needless to say, it is most often (but not exclusively) black artists who encounter this attitude, which prompts the question: Are all artists from Africa created equal? Are their creations then equal too, on a global scale? Technology, if we assume it to hold the potential to better serve the cause of human development, is inherently modernist. As such, how do we reconcile postmodern everything-is-representation and postcolonial identities-in-crisis, which seem to underpin every contemporary creative

act, with the historicity of technology? And in the writing of history in the information age, where space and time are compressed, extended, nonlinear, and abstract, is linear chronology still a defining trope of development? At the risk of sounding completely off-base, I wonder whether the sometime subconscious reluctance to acknowledge high-tech in African contemporary art has to do with some traditionalist desire to retain the "pleasure of the primitive," as it were—the mark of the hand. Does picking up the same tools that preserve the First/Third World gap perform a fundamental threat to the construction of Western art history and cultural production?

As Olu Oguibe has pointed out, for a country where the gap between the haves and the have-nots is still so large, the cyberspeak acronym PONA (People of No Account, that is, those not "connected") accounts for the majority of the population.[4] In the politics of inclusion/exclusion, PONA takes on a more sinister inflection. The rhetoric of posthumanism will celebrate the perceived ability to transcend the biological body, but we have not yet solved the problems of hunger, thirst, and disease, let alone electricity, basic telecommunication, and literacy.

From where I sit, First and Third World debates aside, the true potential of digital technologies lies in the shared communities of highly specific interest groups that, while creating some sort of converged economy (I hesitate to use the definitive term "global"), intensify their own niche zones. I celebrate the Web for facilitating easier and cheaper publication opportunities, I revel in its hype about democratizing access to art and design, and I take advantage of transcontinental discussion forums and information trading. But what interests me above all are the assumptions some make as to the apparent "cleanness" of the digital medium, and the spaces where its perceived seamlessness is ruptured by the organic and biological.

In her curatorial essay for Transversions (Second Johannesburg Biennale), Yu Yeon Kim adopts computer virus rhetoric to describe the trade in international mega-exhibitions as "a system of mutually ensured infection", and asks the question: "How are we translated, modified and re-embodied in these crossings?"[5]

Production and existence, for those with access, now occur at the interstices of informational systems. But what of an understanding of low-tech that is crucial to position oneself in the world of high-tech that moves so fast between "new" and "old" that it almost disallows a transitional state? Low-tech as media may be sentimentalized or nostalgic, but what about seeking out the instances that we describe as low-tech (and in so doing, as "other" to the digital) in order to better focus the critique of high-tech? Doing so allows us to ask questions of necessity, seduction, desire, and self-reflexivity.

Mutant Grafts—or Flawless Copies?

If we exist in the spaces that Yu Yeon Kim envisages—treading water in globalized and digital seas without cultural anchors to hold us in place—we run the risk of sacrificing heritage for The Empire of the Sign. If this is the case, does the global marketing of "culture," she trenchantly asks, "effect a dilution of the original culture, or is it just a feature of its evolution?"[6]

As digital technologies increasingly (and invisibly) change the way we perceive ourselves and others, more boundaries between the acceptable and the unacceptable present themselves to be policed, albeit in a strangely paradoxical "democratized" space.

The weeklong experience in Durban, which included a walking tour through the Central Business District that covered the cultural gamut from traditional African *muti* (traditional medicine) markets to mosques, Catholic churches, and bunny chows at the famous Patel's eatery,[7] got me thinking once again of the valuable notion of cultural "grafting" as proposed by Colin Richards.[8]

A "graft" is not simply a boundary or an edge, but a traumatic cut that may or may not be regenerative or reparative. Possessing both surgical and botanical applications, grafting inescapably involves contact and exchange across "difference." It requires cultivation and time, the "work" of culture. It extends and opposes clichéd, organic metaphors of "cultural hybridity" or "cross-pollination" to highlight ever-present but unspoken tensions between nature and culture. As such, it is about aesthetic contamination, "the sometimes violent aesthetic of the imperfect fit, the parasitic in the symbiotic."[9] It is most successful even in its failure, reminding us "how things can be made to turn out differently."

So, in the cultural context of South Africa, is the digital edge seamless or scarred? Are works produced by digital means a new kind of "entangled object" as described by Nicholas Thomas?[10] I would agree with Richards that the space between the cut edges is symbolically dense, as space and spatiality have come to dominate our understanding of visual culture as well as our interaction across geographical borders.

By Way of a Conclusion

The subtext and significance of such a venture like RAIN comes down to access. Money and international networks provide the valuable means by which we can begin to tackle these issues discussed in ways that are productive and even controversial. It is deplorable that we should need to rely on help from our international friends to carry out the work of local culture, but as such, it becomes contractual with mutual responsibilities.

When it comes to project funding, *les mots du jour* are "contained" and "sustainable." The developing countries in which events like *Pulse* take place have their own particular conditions of production, for which Eurocentric or Western institutional systems and methods may not be appropriate. That is, future events like this must be consciously considered such that they do not simply perpetuate old-guard attitudes and formulas. Participants and facilitators too, in their complicity, need to enter the contract self-consciously, with clearly articulated and informed programs that not only go some way toward creating spaces for genuine and lived "translocal" exchanges that have life after the party, as it were, but that also expose their working mechanisms and agendas, their systems and prejudices, to critique these initiatives "from the inside." These things need saying, because to dance around the fundamentals is not unlike creative lobotomy.

The provider cannot assume the role of "parent," as this risks regurgitating colonial legacies. The same can be said for "reaching out," the flipside of which is maintaining our own begging-bowl mentality. Nor can the funding agency renege with the excuse "but it's not about the money." Because it so clearly is, which then makes it possible to extend the field of production, and in so doing, enables a clearer idea of our position within this field.

Porto, 2000

Notes

1. Traditionally, a *laager* is a ring of ox wagons creating a protective enclosure as practiced during the Great Trek and similar settlement exercises.

2. The "survey show" debate has been taken up in various print and Web-based media, including *De Arte* (Kathryn Smith), the *Mail and Guardian* newspaper (Brenda Atkinson), and *Contemporary Art from South Africa* <www.artthrob.co.za> (Kathryn Smith, Sue Williamson, and others).

3. See Colin Richards, "Retaining This Fire," *Atlántica International: Revista de las Artes Centro Atlántico de Arte Moderno* (1995), pp. 132–44.

4. Olu Oguibe, "Forsaken Geographies: Cyberspace and the New World Order," in Okwui Enwezor, ed., *Trade Routes: History and Geography,* exh. cat., Second Johannesburg Biennale (South Africa and the Netherlands: GJMC and the Prince Claus Fund, 1997).

5. Yu Yeon Kim, "Tranversions," in Enwezor, *Trade Routes.*

6. Ibid., p. 347.

7. A bunny chow is a street fast food made from half a loaf of (usually) white bread, hollowed out and filled with a curry. The provenance of this food, which is synonymous with Durban culture, is the stuff of urban legends.

8. For further debate on the question of the digital "cut edge," see Colin Richards, "Bobbit's Feast: Violence and Representation in South African Art," in B. Atkinson, B. and C. Breitz, eds., *Grey Areas: Representation, Identity and Politics in Contemporary South African Art* (Johannesburg: Chalkham Hill Press, 1999), pp. 165–209.

9. Colin Richards, "Graft," in Enwezor, *Trade Routes*, p. 235.

10. Quoted by Richards, ibid., p. 234.

Transit Visa to Postwar Lebanon!

Jalal Toufic

Transit Visa?[1] Doesn't postwar Lebanon have anything labyrinthine about it? If it does, does it make sense to have a transit visa to it? Does it make sense to have a transit visa to a labyrinth? Isn't it de jure impossible to leave the labyrinth? Doesn't the whole notion of having a transit visa to Lebanon imply that notwithstanding its war-damaged, ruined buildings it is not a labyrinth? Will the title of my coming, first feature film be *Transit Visa to the Labyrinth*? The film's three protagonists have to do with problematic vision: the filmmaker of *Phantom Beirut,* Ghassân Salhab, since his tracking shots from a moving car are not followed by reverse subjective shots, and therefore do not indicate vision but the condition of possibility of recollection in Beirut; the video artist and producer Walîd Raʿd, whose doctoral dissertation was "(À la Folie): A Cultural Analysis of the Abduction of Westerners in Lebanon in the 1980's," who has come from New York to Beirut to produce a video on hostages, and who on his visits to Hamra Street has himself blindfolded so as not to witness the unsightly urban fabric; and a vampire, who was intrigued enough by the video images of both war-damaged and reconstructed buildings sent to him by a Lebanese real estate agent to come to Lebanon, and who, dead, has no vision. When, soon after arriving in Beirut, the vampire was asked: "Why did you come to Lebanon?" he answered bluntly: "For ruins and blood . . ." "I can understand that one would come to Lebanon for its war ruins; but why would anyone come to Lebanon in 2002 for blood? The war and civil war have ended a decage ago!" "Like most Lebanese, you are overlooking the yearly ten-day commemorative event ʿÂshûrâ. In a letter a writer sent me from Lebanon, he wrote: 'During ʿÂshûrâ, one again feels that one's body is a *jasad* (in Arabic *jasad* means "the body, with the limbs or members, [or

whole person,] of a human being, and of a jinnee [or genie], and of an angel . . .”; and *jasida* [aor.; *jasad,* inf. n.] means “It [blood] stuck, or adhered, *bihi* [to him, or it]; and it [blood] became dry”).² Moreover, and as I was saying before you rudely interrupted me, I came to Lebanon also because 31.7% of the population in this country is under the age of 15 according to the latest United Nations Human Development Report.” The vampire tries to find his territory in this foreign city—while knowing that the dead are in a labyrinth, therefore unsettled, in permanent exile. During his initiation, the vampire’s latest victim soon felt the need to find a dancer, one who can be in a place and simultaneously not in it but elsewhere. He visited several dance companies, but was dissatisfied with them. Did he, in the absence of real dancers in Lebanon, try to recreate the impression they induce of being superimposed on a different backdrop than the one where they ostensibly are by going out with a weathercaster, given that the background against which the latter provides her forecast is keyed in? Yes. He managed to lure her to the reconstructed building that was given to him by the vampire, and which gave onto the gutted and shrapnel-poked Grand Theater. Standing with her at the window, he wondered aloud: “How many more bombs will it take to produce in Lebanon not just holes in buildings, but a hole, however small, in reality, a tear in reality itself, so that it would no longer be seamless and so that there would be a crack in it à la that in Bergman’s *Persona*?” (As he finishes saying this, the camera would pan to the mirror, where the vampire does not appear, is a hole in it.) When she came back to consciousness, she felt famished. She headed to a restaurant. She felt relieved that it was not as crowded as usual, for she was presently feeling hypersensitive to sounds. She stood in front of the counter to order. She felt nauseated by the smell of the food—a smell that she would have found exquisite before. One Lebanese man, then two others, then a fourth came and stood before her to order. Notwithstanding the presence of three seated customers, one of the two men standing in front of her looked back and said: “It’s empty tonight!” His friend agreed. She felt anxious that they were not seeing her, and that that was because she no longer existed. She rushed to the bathroom and looked apprehensively at the mirror there: she appeared in it! She was relieved that the disregarding behavior of the four customers at the counter was to be attributed merely to the Lebanese’s common uncivilness. She spent the next few nights “with” the vampire. When her fiancé met her next, she was so anemic she had to be rushed to the hospital. He waited in the hall outside the emergency room. He could see from one of the windows a man outside pacing back and forth. Every time he would pass a certain spot in front of the facing house, the automatic light would come on, then be off again once he had moved away from that spot. After a while, that man headed for the emergency room to check the condition of the father he had brought in shortly before. When the fiancé looked from the window

again, he saw another man pacing back and forth. He was unsettled by the phenomenon he next saw: the light did not turn on when that man passed the same spot in front of the house. He thought with jealous admiration how unselfconscious, how withdrawn that man must be for even light not to detect him. In the coming days, the fiancé was to discover that that man was a vampire. A few nights after her discharge from the hospital, the weathercaster was back at the vampire's house. He said to her: "Do your weather forecast." "Here? With no blue screen or maps?" "Yes." She began moving her right hand across the air, stopping it momentarily and pointing at certain invisible marks: "In Beirut, it is 82°F (high: 82; low: 63); in Tehran: 84°F (high: 84; low: 72); in Esfahan: 84°F (high: 84; low: 52); in Paris: 57°F (high: 70; low: 57); in Berlin: 57°F (high: 59; low: 52); in London: 61°F (high: 63; low: 61); in Bremen: 61°F (high: 66; low: 54). . . ." She looked in the mirror and was hypnotized by the absence of the vampire in it. His response was: "They have eyes, but do not see." Then he, who continued not to appear in the mirror, asked her: "Where are you now? In London? Bremen? Transylvania? Lebanon?" He bit her on the neck and began sucking her blood. At this point the latter's fiancé rushed in: "At long last I found you!" The vampire's mocking response was: "Where?" The lover ran toward her body, touched it, waved his right hand in front of her eyes to ascertain whether she was dead, then shrieked: "You've killed her!" Given his hypersensitivity to the micromovements that announce a gesture, the vampire not only followed with his eyes, but also predicted all macrogestures—except one: the movement of the hand in front of the eyes of someone to check if he does not see. The moment the fiancé stopped waving his hand, the vampire regained his seeming vision, tunneling just next to him. Instinctively, the fiancé repeated the same waving gesture but now in the direction of the vampire. The latter's eyes suddenly became glazed, and once more his eyes no longer saw. Regaining his composure, the lover said to the vampire: "After all, as you must know, the dead cannot see." Unseeing, the vampire responded: "Insensitive that you are, I cannot reciprocally tell you: you have seen nothing in Beirut, the site of a surpassing disaster, nothing." While continuing to wave his left hand in front of the vampire's eyes, the fiancé reached for a dagger with his right hand and stretched it toward the vampire's back and stabbed him deep inside the region of the heart. *We stab the dead,* those subject to overturns, *in the back.*

Transit Visa? Can one have a transit visa to a radical closure?[3] Doesn't the very notion of having a transit visa to Lebanon imply that notwithstanding the siege of West Beirut by Israel during the latter's invasion of Lebanon in 1982, it is not a radical closure?

In addition to so much Lebanese photography that remained at the level of artistic documentation—for instance the work of Sâmir Muʿdad (*Les Enfants de la*

Guerre: Liban 1985–1992; and *Mes Arabies* [Éditions Dâr an-Nahâr, 1999]) and Fuʾâd al-Khûrî, who have continued to treat the civil war and war as a disaster and the closure that affected Lebanon as relative, albeit extreme—we encounter two kinds of works that are symptomatic and emblematic of a Lebanon that was during part of the war years a radical closure and/or a surpassing disaster.

Where is the rest of the world? What is the world doing? How is the world allowing such atrocities not only to happen but also to go on being perpetuated for months and years? The incredible desertion of the world is the leitmotiv of the indignant exclamations one hears in zones under siege: the Palestinians and the Lebanese in West Beirut during the Israeli siege of that city in 1982; the Palestinians in the West Bank and the Gaza Strip since the start of their closures then sieges by the Israelis; the inhabitants of Sarajevo during its siege by Bosnian Serbs; the Tutsi minority during the Rwandan genocide of 1994; the Iraqis since the start of the ongoing sanctions in 1990. Is it strange that some feel, or make artworks that imply that these places became radical closures? Can we detect in such places one of the consequences of radical closures: unworldly, fully formed ahistorical irruptions? As usual, it is most appropriate to look for that in artworks. The "document" attributed by Walîd Raʿd to Kahlil Gibran and projected as a slide for the duration of Raʿd's talk "Miraculous Beginnings" at Musée Sursock in Beirut,[4] and the eight small black-and-white photographs of group portraits of men and women that were published in Raʿd's photo-essay "Miraculous Beginnings"[5] and that—the reader is told—are part of twenty-nine large photographic prints and fifty-two documents (handwritten notebook entries, letters, typed memoranda, and minutes) unearthed in 1991 during the demolition of Beirut's civil war-devastated Central District, processed by laboratories in France and the United States, and handed to the Arab Research Institute,[6] can legitimately be viewed as unworldly ahistorical irruptions in the radical closure that Beirut may have become at one point.[7]

We live in a block universe of space-time, where nothing physically passes and vanishes, but where occasionally things withdraw due to surpassing disasters. Palestinians, Kurds, and Bosnians have to deal not only with the concerted erasure by their enemies of much of their tradition—the erasure by the Israelis of hundreds of Palestinian villages in 1948 and their renaming with Jewish names,[8] and the erasure of hundreds of Kurdish villages during the *Anfâl* operation in Iraq, etc.—but also with the additional, more insidious withdrawal of what survived the physical destruction. The exhibition *Wonder Beirut* by Juwânnâ Hâjjî Tûmâ and Khalîl Jurayj (Janîne Rbayz Gallery, Beirut, July 1998) revolves around a photographer who, along with his father, was commissioned by the Lebanese State in 1969 to do postcards. Four years into the civil war and while shut up in

The Atlas Group/Gibran,
*AG_Gibran: Document 782.9-1S
BPL*, 1914–2000, paper. Courtesy of
the Atlas Group.

The Atlas Group/Anonymous,
AG_Secrets: Plate 1, 1975–2002, color
photographic prints. Courtesy of
the Atlas Group.

The Atlas Group/Anonymous,
detail (bottom frame) of
AG_Secrets: Plate 1, 1975–2002, color
photographic print. Courtesy of
the Atlas Group.

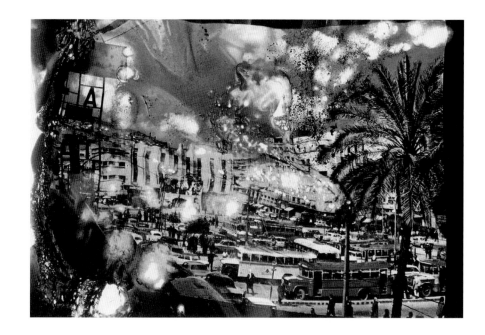

Juwânnâ Hâjjî Tûmâ and Khalîl Jurayj, *Postcard of War (No. 15)* from *Wonder Beirut: The Story of a Pyromaniac Photographer,* 2001, postcard. Courtesy of Khalîl Jurayj.

his studio, he takes down all these postcards, "which no longer referred to anything" since what they showed—Martyrs' Square, the souks, policemen on camels, etc.—either was destroyed or no longer existed, and "burns them patiently, aiming at them his proper bombs and his own shells . . . thus making them conform better to his reality. When all was burned, it was peace." Thus the following model sequence: photographs of burned buildings and scorched walls taken by him from the window of his studio a couple of years into the conflict; then, four years into the war, burned photographs that are later exhibited (this indicating that the war was then not yet a surpassing disaster, but just a localizable catastrophe); then in 1999, undeveloped photographs, a symptom of the withdrawal past the surpassing disaster that Beirut must have become:[9] "Today, this photographer no longer develops his photographs. It is enough for him to take them. At the end of the exhibition *[Wonder Beirut],* 6,452 rolls of film were laid on the floor: rolls containing photos taken by the photographer but left undeveloped."[10] Hâjjî Tûmâ and Jurayj are currently preparing a show titled *Latent Image* in which they will frame and mount on the gallery's walls textual descriptions of photographs taken but left unprocessed. Here are six examples from film roll no. PE 136 GPH 160:

Juwânnâ Hâjjî Tûmâ and Khalîl Jurayj, *Latent Image*, 2002, installation with three drawers and film rolls. Each drawer 7 cm × 31 cm × 39 cm. Detail. Courtesy of Khalîl Jurayj.

1. Master shot of the dead end from the window of the room. It is raining.
2. Close shot of the seepage under the living room's windows.
3. The water enters into the kitchen.
4. Close shot of the floorcloth in front of the living room's windows.
5. The rain on the room's pane, with the camera focus being on the drops.
6. Close shot of the spots of humidity on the wall and the ceiling.

Their work in *Wonder Beirut* and their forthcoming *Latent Image* bring to my mind two parts of Hollis Frampton's *Hapax Legomena, Nostalgia* (1971) and *Poetic Justice* (1972). In the first, Frampton placed photographs one at a time on a hotplate, the latter's coil shortly tracing its shape on the photograph before the photograph fully burned. In the second, Frampton placed on a table, in between a small cactus and a cup of coffee, a stack of papers with descriptions of 240 different shots, which descriptions we read one at a time for the span of the film (for instance "#4. [close-up] A small table below a window. A potted cactus, a coffee cup"). Despite this resemblance, I am aware that the burning of the photographs in *Wonder Beirut* has to do not only with matters relating to the medium as such, as in Frampton's *Nostalgia* (Hâjjî Tûmâ and Jurayj said, "We wanted to return to

an ontological definition of these images: the inscription of light by burning"),[11] but is also a reaction to the incendiary wars that were going on in Lebanon; and that the substitution of textual descriptions for the photographs is related not only to the problematic relation of words to images in audiovisual works, but also to the withdrawal of many images past a surpassing disaster. I had not expected the intermediary step of *Latent Image* between exhibiting rolls of undeveloped films in *Wonder Beirut* and a possible future exhibition of developed photographs. This intermediary step can be considered a contribution to the resurrection of what has been withdrawn by the surpassing disaster. The intended effect of the work of the one trying to resurrect tradition past a surpassing disaster is fundamentally not on the audience, except indirectly; it is on the work of art—to resurrect it. Such resurrecting works are thus referential. It is interesting to see when—if at all—Hâjjî Tûmâ and Jurayj will feel the impulse to develop those photographs, this signaling the resurrection of tradition.

Felicitous photographs of Lebanon many years into the war and then many years following it: photographs taken by nobody—unworldly irruptions in a radical closure—but developed (*Miraculous Beginnings*); and photographs taken by someone but left undeveloped because of the withdrawal due to the surpassing disaster that was Beirut (*Wonder Beirut*, 1999).[12]

It is one thing for an academic scholar like the Palestinian Walîd al-Khâlidî to do archival work (he is the editor of *Kay lâ nansâ: qurâ Filastîn al-latî dammarathâ Isrâʾîl sanat 1948 wa-asmâʾ shuhadâʾihâ* [All That Remains: The Palestinian Villages Occupied and Depopulated by Israel in 1948]); it is, or at least it should be, another matter were Walîd Raʿd and Juwânnâ Hâjjî Tûmâ and Khalîl Jurayj to do so. Walîd Raʿd is already a member of the Arab Image Foundation (AIF), and Juwânnâ Hâjjî Tûmâ and Khalîl Jurayj would, in my opinion, be fine candidates for membership in the same foundation, which was established in Lebanon in 1996, and whose aim is "to promote photography in the Middle East and North Africa by locating, collecting, and preserving the region's photographic heritage. . . . Material in the collections will date from the early-nineteenth century to the present." Raʿd is also implicated through his artistic practice in both the Arab Research Institute's archival collection *Miraculous Beginnings: The Complete Archive* (which as of 1994 comprised, we are told, forty-six hundred documents) and the Atlas Group's growing collection. While for now the artistic practices and issues at stake in these latter two archives have not affected or interfered with the collection of the AIF, it is quite conceivable that they will, through Raʿd, do so, problematizing the historical authenticity of its photographs, with the probable consequence that we will learn about

new Muhammad ʿAbdallâh, Kamîl al-Qârih, or Alban photographs. I envision, as a first stage, the archival collections of both the Arab Research Institute and the Atlas Group ending up equaling the collection of the AIF, presently around thirty thousand photographs; then at a later stage, the AIF archive becoming just an appendage of Raʿd's (largely virtual) archive, the latter occasionally referring to the former as holding a small number of photographs that it does not have: "For an additional twenty-three photographs of the work of Kamîl al-Qârih, as well as for an additional twenty photographs by Muhammad ʿAbdallâh, we refer you to the Arab Image Foundation's collection." What would happen to the AIF's "long-term goal of . . . the creation of a center in Beirut for the preservation and exhibition of its photographic collections . . . ," were Juwânnâ Hâjjî Tûmâ and Khalîl Jurayj to end up becoming members of the foundation? How would the AIF's goal of preservation be affected by the presence of two artists who have burnt some of their photographs, then exhibited them? How would the Foundation's goal of exhibition be affected by the presence of two artists who have included in one of their exhibitions myriad rolls of unprocessed photographs, therefore of unexhibited photographs? How would the Foundation's goal of archiving and therefore also dating be affected by the presence of two artists who assigned two different dates to what seems to be the same postcard of pre-civil-war Beirut's Central District, and who wrote through the mouth of their fictional interviewer, the twentieth-century Pierre Menard of Borges's "Pierre Menard, Author of *Don Quixote*": "I have here two images, one taken by the photographer in 1969, the other a 1998 photograph of this same preexisting postcard. . . . By simply photographing these images you invent a new path, that of the deliberate anachronism and the erroneous attribution"?

Transit Visa? Does the ghost, who does not stay in a place but haunts it and who is thus the in-transit being *par excellence,* need a transit visa?[13] It does not seem to be the case: while, on their respective arrivals on the platform before the Elsinore castle in Act I, Scene I of *Hamlet,* first Bernardo is told by Francisco at his post: "Stand, and unfold yourself" (to which Bernardo responds: "Long live the king"); then Horatio and Marcellus are ordered by Francisco: "Stand, ho! Who's there?" (to which Horatio responds: "Friends to this ground," and Marcellus elaborates: "And liegemen to the Dane"), the ghost is not asked to "stand, and unfold" himself when he appears on the platform. The dead is not with us in the same space, nor for that matter in the same country: while the vampire ostensibly standing with his future victim is revealed not to be in his or her company through not appearing with him or her in the mirror, the ghost

is shown not to be with us through troubles in communication, which is thus revealed to be not a local, in-person one but actually a telecommunication with the beyond, indeed a telepresence (of what no longer has a presence):

> *Two remote audiovisual conferencing set-ups are linked across continents (Elsinore, Europe, and Beirut, Asia) through the Internet. Bernardo, Marcellus, and Horatio await the arrival of the signal. "We have tried this set-up twice already, most recently yesterday. We got a signal only for a short period: the second time for the span during which 'one with moderate haste might tell a hundred'; the first time for somewhat longer. Then it broke off." After a few minutes' wait, a signal appears.*
>
> *Enter Ghost*
>
> **MARCELLUS**
>
> Peace, break thee off; look, where it comes again!
>
> **BERNARDO**
>
> In the same figure, like the king that's dead.
>
> **MARCELLUS**
>
> Thou art a scholar; speak to it, Horatio.
>
> **BERNARDO**
>
> Looks it not like the king? mark it, Horatio.
>
> **HORATIO**
>
> Most like: it harrows me with fear and wonder.
>
> **BERNARDO**
>
> It would be spoke to.
>
> **MARCELLUS**
>
> Question it, Horatio.
>
> **HORATIO**
>
> What art thou that usurp'st this time of night,
> Together with that fair and warlike form
> In which the majesty of buried Denmark
> Did sometimes march? by heaven I charge thee, speak!
> *The signal becomes gradually weaker.*
>
> . . .
>
> **HORATIO**
>
> Stay! speak, speak! I charge thee, speak!
> *By this point, the signal has become too jumbled and weak, drowned in noise.*

MARCELLUS

'Tis gone, and will not answer.

They tinker with the computer and soon enough the connection is reestablished and the signal is clear again.

Re-enter Ghost

BERNARDO

'Tis here!

HORATIO

'Tis here!

The signal again becomes too weak and blurred and then is off.

MARCELLUS

'Tis gone!

When Horatio asks the ghost of the late king to speak but the latter doesn't talk, the scene looks very much like one of the initial experiments in using the Internet to establish a live audiovisual communication between individuals in various countries or continents, the sound signal failing to reach Horatio although the image does (to Hamlet's "Did you not speak to it?" Horatio answers: "My lord, I did; / But answer made it none: yet once methought / It lifted up its head and did address / Itself to motion, like as it would speak. . . ."). Yet even if the ghost fails to articulate properly his linguistic message; or moves his lips but his voice is not heard at all by his interlocutor; or his words are drowned in some eerie rumble so that his interlocutor does not get what he says; or the connection is off frequently, his mere appearance conveys all by itself an important part of his message: namely that there is something wrong, indeed rotten in the family, or the village, or the country, or the world (commenting on the ghost's appearance, Marcellus says: "Something is rotten in the state of Denmark"). Isn't Lebanon, a country that underwent fifteen years of civil war as well as foreign invasions and numerous massacres, haunted? How can the Lebanese live normally when their government's debt is one of the highest among all rated sovereigns according to the international credit rating agency Standard & Poor's, and is expected to increase from the estimated 163% in 2001 to at least 170% of GDP in 2002; when according to the 24 August 2001 Middle East edition of *Le Monde* (p. 3) around 150,000 Lebanese emigrated in 2000 from their country, whose total population is a mere 3 million; when Israel, the country at Lebanon's southern border, has a warmonger, Ariel Sharon, as premier; when Iraq, a fellow Arab country, is still under barbaric sanctions; when Elie Hobeika, who was the head of the Phalangists' intelligence division in 1982 and who was blamed by Israel's Kahan Commission for

personally directing the slaughter of hundreds, possibly thousands of Palestinians in the Sabrâ and Shâtîlâ refugee camps between 16 and 18 September 1982, served three times as a minister in various postwar Lebanese governments, and was for a number of years the member of parliament for B'abdâ; when religious sectarianism is still entrenched in the population even after fifteen years of civil war; when wiretapping is legalized and the use of car pollutants is condoned; when there is a flagrant remissness in enforcing a livable urban plan . . . ? According to Deleuze, one of the characteristics of "the crisis which has shaken the action-image [and which] has depended on many factors which only had their full effect after the [Second World] war" are "events which never truly concern the person who provokes them or is subject to them, even when they strike him in his flesh: events whose bearer, a man internally dead, as Lumet says, is in a hurry to extricate himself."[14] This is the price that the Lebanese are paying for giving up the ghost, for this repression of the revenant now a decade after the war. When the ghost is banished or repressed, people turn into zombies, act insouciant in the weirdest and most alarming of situations. Henry Miller: "Once you have given up the ghost, everything follows with dead certainty, even in the midst of chaos" (the opening line of *Tropic of Capricorn*). After vast catastrophes, we need the ghost to keep implying to us by his mere haunting how rotten is the country where we live (when Hamlet returns from his encounter with the specter, Horatio asks him: "There's no offence, my lord." Hamlet answers: "Yes, by Saint Patrick, but there is, Horatio, / And much offence too"), and thus prevent us from turning into zombies. In postwar Lebanon, Rwanda, Cambodia, Bosnia, and Herzegovina, etc., the survivors are faced with the following choice: either they tolerate the ghost, resist the temptation of repressing or banishing him, or else they gradually turn into zombies (in the Haitian sense). With its unjust death of King Hamlet, Shakespeare's *Hamlet* deals with this alternative. Prince Hamlet's words to his mother in her closet characterize her as a zombie:

> **HAMLET** (*to his mother*)
> Ha! have you eyes?
> . . .
> . . . Sense, sure, you have,
> Else could you not have motion; but sure, that sense
> Is apoplex'd; for madness would not err,
> Nor sense to ecstasy was ne'er so thrall'd
> But it reserved some quantity of choice,

To serve in such a difference. What devil was't
That thus hath cozen'd you at hoodman-blind?
Eyes without feeling, feeling without sight,
Ears without hands or eyes, smelling sans all,
Or but a sickly part of one true sense
Could not so mope.

As Hamlet finishes describing his mother as a zombie,[15] the ghost of his late father appears. We are thus provided with an occasion to witness the cause of her state as zombie: she has repressed the ghost (and hence does not see him).

> *Enter Ghost*
> **HAMLET**
> Save me, and hover o'er me with your wings,
> You heavenly guards! What would your gracious figure?
> **QUEEN GERTRUDE**
> Alas, he's mad!
>
> . . .
>
> **HAMLET**
> How is it with you, lady?
> **QUEEN GERTRUDE**
> Alas, how is't with you,
> That you do bend your eye on vacancy
> And with the incorporal air do hold discourse?

Paris, 2000

Notes

Sections of this essay were published in Akram Zaatari and Mahmoud Hojeij, eds., *Transit Visa: On Video and Cities* (Beirut, 2001), and *DisORIENTation* (Berlin: House of World Cultures, 2003). It is itself composed of two texts that appear respectively in the second editions of Jalal Toufic's *Distracted* (Berkeley: Tuumba, 2003) and *(Vampires): An Uneasy Essay on the Undead in Film* (Sausalito: Post-Apollo, 2003).

1. The title of a May 2001 workshop organized by Lebanese videomakers Mahmûd Hujayj and Akram Za'tarî. They invited seven persons from four Middle Eastern countries and from various fields (cinema, video, graphic design, etc.) to come to Lebanon, join two Lebanese, and each make, along with these latter, a one-minute video by the end of the workshop.

2. Edward William Lane, *An Arabic-English Lexicon*, 8 vols. (Beirut, Lebanon: Librairie du Liban, 1980), entry *jîm sîn dâl*.

3. I put forward the concept of radical closure in my book *Over-Sensitivity* (Los Angeles: Sun & Moon Press, 1996), pp. 175–250; I further elaborated on the concept in the

sections "First Aid, Second Growth, Third Degree, Fourth World, Fifth Amendment, Sixth Sense," "Radical Closure Artist with Bandaged Sense Organ," and "*Seen Anew,*" in my book *Forthcoming* (Berkeley: Atelos, 2000).

4. Walîd Ra'd, "Bidâyât 'ajâ'ibiyya—miswadda" (Miraculous Beginnings—A Draft), trans. Tûnî Shakar, *Al-Âdâb,* January-February 2001, Beirut, Lebanon, pp. 64–67. The document in question appears on page 65.

5. Walîd Ra'd, "Miraculous Beginnings," *Public* (Toronto) 16 (1998), pp. 44–53.

6. Is the role of art to reestablish the search for truth in the aftermath of wars, with their many falsifications and distortions? Is it, on the contrary, to insinuate and extend the suspicion to reality itself? Would the aforementioned Ra'd works be ones that extend the problematization and suspicion not only to the discourses and behavior of politicians but also to reality?

7. The video *Hostage: The Bachar Tapes (English Version),* 2000, produced by Walîd Ra'd can also be seen in this way. Its purported director is the hostage Bachar Souheil, notwithstanding that historically there was no hostage by that name.

 Is it at all strange that the director of the radical closure film *The Birds* (1963) should conceive the following scene for *North by Northwest* (1959)? "Hitchcock: 'Have you ever seen an assembly line?' Truffaut: 'No, I never have.' 'They're absolutely fantastic. Anyway, I wanted to have a long dialogue scene between Cary Grant and one of the factory workers as they walk along the assembly line. They might, for instance, be talking about one of the foremen. Behind them a car is being assembled, piece by piece. Finally, the car they've seen being put together from a simple nut and bolt is complete, with gas and oil, and all ready to drive off the assembly line. The two men look at it and say, "Isn't it wonderful!" Then they open the door to the car and out drops a corpse!' 'That's a great idea!' 'Where has the body come from? Not from the car, obviously, since they've seen it start at zero! The corpse falls out of nowhere, you see! . . .' 'That's a perfect example of absolute nothingness! Why did you drop the idea? . . .' '. . . We couldn't integrate the idea into the story.' " (François Truffaut with Helen G. Scott, *Hitchcock,* rev. ed. [New York: Simon and Schuster, 1984], pp. 256–57.)

8. See Walîd al-Khâlidî, *Kay lâ nansâ: Qurâ Filastîn al-latî dammarathâ Isrâ'îl sanat 1948 wa-asmâ' shuhadâ'ihâ* (*All That Remains: The Palestinian Villages Occupied and Depopulated by Israel in 1948*), 2d ed. (Beirut: Institute for Palestine Studies, 1998).

9. I put forward the concept of withdrawal of tradition past a surpassing disaster in the section "Credits Included" of my book *Over-Sensitivity;* I further elaborated on the concept in the section "Forthcoming" in my book *Forthcoming.*

10. Juwânnâ Hâjjî Tûmâ and Khalîl Jurayj, "Tayyib rah farjîk shighlî" ("OK, I'll show you my work"), *Al-Âdâb* (Beirut; January-February 2001).

11. Ibid., p. 37.

12. Alongside the irruption of ahistorical, fully formed unworldly entities in the radical closure that the 1982 besieged West Beirut may have become (Walîd Ra'd's *Miraculous Beginnings,* 1998 and 2001; *The Dead Weight of a Quarrel Hangs,* 1996–99; and *Hostage: The Bachar Tapes [English Version],* 2000); the withdrawal of tradition past the surpassing disaster that Lebanon may have become during and even after the 1975–90 war (my *Credits Included: A Video in Red and Green,* 1995; Juwânnâ Hâjjî Tûmâ and Khalîl Jurayj's *Wonder Beirut,* 1999; and their forthcoming *Latent Image*); tracking shots from a moving car that are not followed by reverse subjective shots and therefore do not indicate vision but the condition of possibility of recollection in Beirut (Ghassân Salhab's *Phantom Beirut,* 1998); the fourth most important aesthetic issue and strategy in relation to Lebanon is that of the archaeological image. This subject has already been addressed by Gilles Deleuze regarding Straub-Huillet's work; Deleuze writes that, with the break in the sensory-motor link, "the visual image becomes *archaeological, stratigraphic, tectonic.* Not that we are taken back to prehistory (there is an archaeology of the present), but to the deserted layers of our time which bury our own phantoms . . . they are again essentially the empty and lacunary stratigraphic landscapes of Straub, where the . . . earth stands for what is buried in it: the cave in *Othon* where the resistance fighters had their weapons, the marble quarries and the Italian countryside where civil populations were massacred in *Fortini Cani . . .*" (Gilles Deleuze, *Cinema 2: The Time-Image,* trans. Hugh Tomlinson and Robert Galeta [Minneapolis: University of Minnesota Press, 1989], p. 244). Serge Daney also discussed the archaeological image in relation to Palestine:

"As for the missing image, it is, still in *L'Olivier,* when Marius Schattner explains in a very soft voice that beneath the Israeli colony (which we see) there is, buried, covered over, a Palestinian village (which we don't see). I also remember this because we are among the few, at *Cahiers du cinéma,* to have always known that the love of cinema is also to know what to do with images that *are really missing*" (Serge Daney, "Before and After the Image," trans. Melissa McMahon, *Discourse,* no. 21.1 [Winter 1999], p. 190). I also discuss it, mainly in *Over-Sensitivity*'s section "Voice-over-witness" in relation to the Shoah. Clearly, the issue and aesthetic of the archaeological image belongs to any of the zones that have suffered massacres and mass graves: Lebanon, Rwanda, Cambodia, Srebrenica, etc. Do we witness an archaeology of the image in those sections of Danielle ʿArbîd's *Alone with War* (2000) in which she goes to the Sabrâ and Shâtîlâ Palestinian refugee camps and to the Christian town ad-Dâmûr, the sites of massacres and mass graves in 1982 and 1976, respectively, asking playing Palestinian children whether they have come across anything arresting while digging in their makeshift playground? Regrettably, the possibility of an archaeological image is somewhat botched because what we hear in relation to these images is not a voice-over-witness, but journalist ʿArbîd's commenting voice-over. It is therefore better to look for this archaeology of the image in Paola Yaʿqûb and Michel Lasserre's *Al-Manâzir* (The Landscapes), 2001, where at the corner of some of the photographs of the green landscapes of south Lebanon one can read the inconspicuous terse factual information about Israel's invasion; and where one can hear the disincarnated voice of the stretcher-bearers ascend from this archaeological earth to relate work anecdotes and describe life during the long Israeli occupation. In this postwar period in Lebanon, those of us who have not become zombies are suspicious of classical cinema's depth (Deleuze: "You [Serge Daney], in the *periodization* you propose, define an initial function [of the image] expressed by the question: What is there to see behind the image? . . . This first period of cinema is characterized . . . by a depth ascribed to the image. . . . Now, you've pointed out that this form of cinema didn't die a natural death but was killed in the war. . . . You yourself remark that 'the great political *mises-en-scènes,* state propaganda turning into tableaux vivants, the first mass human detentions' realized cinema's dream, in circumstances where . . . 'behind' the image there was nothing to be seen but concentration camps After the [Second World] war, then, a second function of the image was expressed by an altogether new question: What is there to see on the surface of the image? 'No longer what there is to see behind it, but whether I can bring myself to look at what I can't

help seeing—which unfolds on a single plane.' . . . Depth was condemned as 'deceptive,' and the image took on the flatness of a 'surface without depth,' or a *slight depth* rather like the oceanographer's shallows. . . ." [*Negotiations*]). This suspicion may explain, no doubt along with financial reasons, why a substantial number of the most interesting Lebanese makers of audiovisual productions work in video, with its flat images, rather than cinema. Instead of believing in the depth of classical cinema, we believe in the depth of the earth where massacres have taken place, and where so many have been inhumed without proper burial and still await their unearthing, and then proper burial and mourning.

13. Indeed, *Hamlet* is punctuated by the abrupt stage cues *Enter Ghost* or *Re-enter Ghost* and *Exit Ghost.*

14. Gilles Deleuze, *Cinema 1: The Movement-Image,* trans. Hugh Tomlinson and Barbara Habberjam (Minneapolis: University of Minnesota Press, 1986), pp. 206–7.

15. For an additional allusion, among numerous others, to zombies in *Hamlet,* cf. Hamlet: "How long will a man lie i' the earth ere he rot?" First Clown: "I' faith, if he be not rotten before he die—"

The Return of the Sign: The Resymbolization of the Real in Carlos Leppe's Performance Work

Gustavo Buntinx

"The Hole of Desire"

Claudia Schiffer slides her frigid sensuality over an elegant catwalk in the capital of fashion and of France. The year is 1994 and her body is voluptuously fitted into a tight dress designed by Karl Lagerfeld for Chanel. Long translucent gloves and an enticingly open décolletage bring out the sinuous and insinuating silvery lettering vaguely recognizable as Arabic. Its sparkling presence covers and demarcates the black bodice and the body—white thus made even more sensuous and phallic—in almost the same way that the very same calligraphy covers the grand facade of the Taj Mahal, the monumental mausoleum built by a Mogul king in honor of his deceased wife. But the texts thus configured on the dress did not correspond to a love poem—as Lagerfeld would later allege that he believed—but to fragments of the Koran. Immediately after the publication of this photograph, Chanel was forced to apologize to the Muslim community and destroy all its dresses based on that design.

Such a displacement of a romantic and religious fetishism toward a sexual and mercantile one—as well as its drastic consequences—didactically exposes some of the renewed terms of the perennial struggle for symbolic power in our postmodern and globalized times. We live in an epoch in which the greater accessibility of all types of cultural capital from the world over has given rise to the growing embezzlement of its values, the draining away of its contents, the emptying out of its "original" meanings. Or

Claudia Schiffer modeling the
controversial dress designed by Karl
Lagerfeld for Chanel. Paris, 1994.
© CORBIS SYGMA

at least it is thus perceived by those in this power play who feel they are fulfilling the role of the defeated and the plundered.

As the Chanel affair and other similar situations make evident, the violent decontextualization and resignification of all codes has forced the perennial struggle for symbolic power to now become, more fundamentally, a struggle for the *power of the symbolic,* for the very power to signify.

This is an absolutely current political struggle. Hal Foster has suggestively interpreted certain First World artistic practices as manifestations of an epochal turn-of-events which he calls "the return of the Real." A category to be understood in Lacanian terms, the Real is that which cannot be symbolized because it precedes speech, and thus precludes meaning. The "Real" does not refer to history or to the social, but to the formless and precultural. It is the realm not of the object—much less of the subject—but of the *abject.*[1]

In much of Latin America, however, the relevant artistic tendency is not so much the return of the Real as *the return of the sign,* the return of the very act of signification, no matter how traumatic. This cultural development is closely linked to historical and political conditionings that are related to structural determinants in the sign itself. It should suffice here to evoke that linguistic theory (of Saussure and others) that perceives the sign as the encounter between the signifier (the image) and the signified (the concept). Although both categories are linked by a reciprocal need for each other, a fundamental cleavage distances them. There is within the sign a foundational cut between the signifier and the signified. And another such gap separates the sign itself from what is being communicated, the so-called "thing."

That gap, however, that lack, is also "the hole of desire," an erotic formula coined by Noé Jitrik. "I would like to think," writes this Argentinian critic, "that the signifier and the signified seek each other in order to couple, that the sign and the thing court each other in order to meet and engage in a definitive mating."[2] The structural instability of that longed-for fusion is now historically exacerbated by the globalized empire of the simulacrum under universal commodity fetishism. But in between both semiotic impossibilities, Jitrik writes, there is a libidinal space "that is a call and a constant provocation. There everything lies, what is done and what can be done. It is a construction in which although the signification is not actually achieved, something essential remains: the meaning and the sense of that which is attempted, the operation of desire." The hole of desire can be seen as the site of a fantasy thus projected over the very history that conditions it.

Or against that history. "In every speech act there remains a space/scene of loss," Jitrik reminds us. But that is also the site for "the validation of the residue": in the posthumous life of signs, there is the possibility of a *symbolic drift,* an afterlife of signifiers that transcend the devaluation of their first signifieds, acquiring an evocative and melancholy force beyond the pitfalls of history. This remainder is also a reminder, a remnant that is literally utopian (no-place) but that still acts over our subjective beings, as in the phantasmatic return of Marx announced by Derrida, that alleged forefather of deconstruction. The return, too, of certain political emblems densely articulated with essential meanings.

On such elusive grounds this essay proposes a slanted reading of certain Chilean artistic practices which may suggest a subversive twist to Foster's argument: the return of the sign, understood not as the search for essentialist meanings, but as the libidinal recovery of that possibility of signification supposedly lost to the pseudo-aleatory game of forms without content, signifiers without signifieds.

"Where Meaning Collapses"

"The Passion of the sign" is how Foster names some of those trances and transitions that mark the gradual dismantling of the signifying function, of the sign itself, in forty years of artistic and theoretical developments. Baudrillard, Derrida, and Jameson are duly invoked as landmarks in a process of successive signic abstractions, in which the referent is first bracketed, to be later liberated in a radical way by means of its redefinition as merely another signifier.[3] As a parallel to those conceptual processes during the eighties there seemed to evolve an "art of cynical reason." But in reaction to such a dismal state of affairs, in the next decade some cultural operators responded by articulating two critical strategies: *the return of the Real,* on the one hand, and the *turn to the referent,* on the other.

There is no redundancy in that partition, for the concept of the Real here invoked is not related to Marx but to Lacan, in his famous triad that also includes the Symbolic and the Imaginary. Whereas the Symbolic involves the integration of the subject into the cultural web and code, the Imaginary is related to the specular fixation of the child in his own-mirror image, absolutized and complete to itself. "Yet this imaginary unity of the mirror stage," Foster reminds us, "produces a retroactive fantasy of a prior stage where our body was still in pieces, a fantasy of a chaotic body, fragmentary and fluid, given over to drives that always threaten to overwhelm us" (p. 210). This haunting fantasy is part of the Lacanian notion of the Real, a formless and corrosive presence that

Lacanian image-screen. Diagram from Jacques Lacan, *The Four Fundamental Concepts of Psychoanalysis,* translated by Alan Sheridan, p. 91. Copyright 1973 Éditions du Seuil. English translation copyright Alan Sheridan. Used by permission of W. W. Norton & Company, Inc.

cannot be represented or symbolized, acting instead as the very negative of the Symbolic, the reverse of history.

"Repressed by various poststructuralisms," Foster explains, "the real has returned, but as the traumatic real" (p. 239). The Real is a wound and at the same time an arrow that hurls and hurts, rupturing the screen that attempts to contain it by reconfiguring it under a symbolic guise. The Lacanian image-screen must mediate the gaze of the subject with that of the object, for *the object looks back,* and that "pulsatile and dazzling" object-gaze has to be tamed into a cultural image lest it manifests itself as the obscenely blinding presence of the Real—the Evil Eye.

Yet for Foster a decisive portion of contemporary artistic practice "refuses this age-old mandate to pacify the gaze, to unite the Imaginary and the Symbolic against the Real. *It is as if this art wanted the gaze to shine, the object to stand, the real to exist, in all the glory (or the horror) of its pulsating desire, or at least to evoke this sublime condition.* To this end it moves not only to attack the image but to tear at the screen, or to suggest that it is already torn" (p. 145). The artistic focus is thus displaced from the subject to the image-screen, and from there to the object-gaze. This decisive shift is described through the evolution of Cindy Sherman's art, in its transitions from the Imaginary to the Symbolic to the Real: "from the early work, where the subject is caught in the gaze, through the middle work, where it is invaded by the gaze, to the recent work, where it is obliterated by the gaze, only to return as disjunct doll parts" (pp. 149–50).

Lacanian image-screen. Diagram from Jacques Lacan, *The Four Fundamental Concepts of Psychoanalysis,* translated by Alan Sheridan, p. 106. Copyright 1973 Éditions du Seuil. English translation copyright Alan Sheridan. Used by permission of W. W. Norton & Company, Inc.

From the image-screen to its absolute absence, and the absence of all containment. "Sometimes the screen seems so torn that the object-gaze not only invades the subject-as-picture but overwhelms it. And in a few . . . images we sense what it is . . . to behold the pulsatile gaze, even to touch the obscene object, without a screen for protection. In one image Sherman gives the evil eye a horrific visage of its own" (pp. 149–50). The photograph alluded to displays a decomposed visceral mass in which the mucous remains of what once was a human face can be strenuously recognized. We are thus tossed into the realm of the abject, canonically defined by Julia Kristeva as a condition in which subjecthood is troubled, and "where meaning collapses."[4]

"Why this fascination with trauma, this envy of abjection, today?" Foster asks rhetorically. His answers extend from dissatisfaction with the textualist model of culture and the conventionalist view of reality, to "despair about the persistent AIDS crisis, invasive disease and death, systemic poverty and crime, the destroyed welfare state, indeed the broken social contract" (p. 166). Certainly, Foster also takes into account those other artistic efforts in which meaning is reconstructed through social practices and identity politics, but his proposal clearly distinguishes that scene from the one referred to as the return of the Real.

And yet this would not have been the logical choice if the cultural horizon of the book were not limited to the cultural experience of the so-called First World. A broader perspective would have discovered other historical extremities, other traumas, in

which both senses of the Real—the social and the psychoanalytic—are fruitfully articulated and problematized in one and the same artistic practice.

The Resymbolization of the Real

Chile under Pinochet could well be a radical case in point. Socialism and its utopias configured for large portions of that country far more than a political option: a broadly shared cultural common sense inscribed as an inevitable fate in the historical horizon of the twentieth century.

But that capitalized notion of History was brusquely turned into a traumatic cipher by the bloody coup d'état of 1973, fracturing not just a certain political logic but also the cultural logic of meaning itself, of the very act of signification. "There is no history left . . . that is not entirely discredited by the revelation of how its stories are always worked from a narrative of deceit," writes Nelly Richard, an important critic related to the Avanzada, an intense and hermetic avant-garde scene that crystallized during the military regime: "A scene that emerges in the dead center of a catastrophe in which meaning itself is shipwrecked," attempting not to restore the lost identity but "to work over and with the very forms of that disintegration," confronting any grand meanings, any totalizing signified, with "the opaque and prolific play of the signifieds."[5]

A play dominated by ambivalence. Caught between the impermeability of a new authoritarian power and a broken political illusion painfully intent in its own impossible reconstruction, the Avanzada "exploded on the scene in Chile with a body of works which, inscribed in the living materiality of the body and its social landscape, proposed a new typology of the Real. . . . For what was always attempted all through the development of this scene, is to resymbolize the Real in accordance to the new codes not only of social signification but of the reintensification of individual and collective desire" (p. 123).

The resymbolization of the Real is a succinctly fit formula for the complexity of the trance embodied by a movement that would process the Chilean historical trauma largely from the perspective of French poststructuralist thought. Particularly that of Lacan: much of the artistic production coming out of this scene is decisively influenced by the so-called Champ Freudien, not just as a theoretical matrix but more fundamentally as the incarnation (sometimes literally) of an ethical imperative, especially in its more transgressive aspects. The "reintensification of individual and collective desire," not its appeasement and control as an abstract entity. The vindication not of a gratifying *plaisir* but of a mortifying *jouissance*. And all ideologically framed by Richard from the

perspective of a fiercely irreducible specificity of art: "the play of signs that those practices have conceived not just as a means of survival, but also as a strategy of resistance to the hegemonies of meaning, or to their conversion to the realism of the contingency" (p. 121). What is finally at stake in this play, however, is a sacred history and a profane one whose intersection configures the repressed cross of an/other Passion of the sign.

Repressed. In other contexts I have already explored the subterranean presence of a religious phantasm in significative portions of the Avanzada's doings.[6] The wanderings of this phantasm have been signaled by certain prodigally used metaphors found in some parallel texts written by Justo Pastor Mellado.[7] But that spectral presence tends to be muted in Richard's own writings, which admit almost no other transcendence in these artworks than that derived from the artistic discourse itself in the proliferating materiality of its compulsions. History as a capitalized and singular term is confronted with the plurality of other minimal histories: private, personal, passional. "El gesto contra la gesta," to quote one of Richard's untranslatable favorite dictums.

There is in this option a sociability not denied but refused: admitted in its presence but rejected in its solicitations. In its demands and claims that nevertheless emerge tortuously inscribed in the works themselves. And in their codes and registers. And in their bodies: "In the context of a society confronted by the crisis of its codes," Richard writes, "the corporeal is not just the frontier of what can be said, but it becomes the territory of the unsayable. The unspeakable. The corporeal signs symptomatize in the very flesh the violence exerted by and against language, and as such they are also attempts at the recodification of that violence, reediting in that gesturality the pre-symbolic or trans-symbolic charge of the censored contents" (Richard, p. 143). History is somatized and turned into hysteria, in the Freudian sense of the symptom that reveals itself as a word trapped in a body.

Much of the Avanzada's work can be interpreted as the traumatic exorcism of that repressed word: Raúl Zurita masturbates in front of Juan Dávila's paintings and tosses acid on his own face, risking blindness. Diamela Eltit burns her cheek and repeatedly cuts her forearms, exposing them during the public reading of her first novel, *Lumpérica,* in a sleazy whorehouse. Textual writing is confronted by corporeal diswritings; the edifying codes of the Symbolic are challenged by the searing marks of the Real.

Corporeal Overflow ("Borronear los Signos")

But it is probably Carlos Leppe who more radically incarnates all social extremities in what he himself describes as his "corporeal overflow," his almost mythic physical

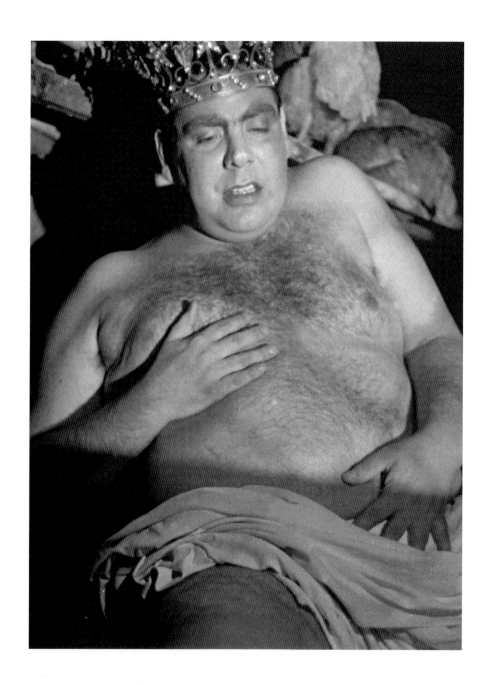

Carlos Leppe's corporeal overflow:
In the Chicken-Coop, 1982,
performance, Havana. Courtesy of
the artist.

immensity: "exterior space pricked and harassed in such a way that it led me to the imperative necessity of letting the body reach the almost uncontrollable, the delirium of blowing up all sense of order. My body worked from the simulacrum, from the crisis of sexual identity, from the gesture and the rictus, from the act of transvestism, from biography itself with all its patches."[8]

The resulting installations and performances have been convincingly theorized in terms of signic destabilization by Nelly Richard. Without pretending to delegitimize that reading, in what remains of these jottings, I will point towards a certain reconstructive undercurrent in the deconstructive landscape of Leppe's praxis.

A resignifying vocation, an anxiety of restored signification. *Reconstitución de escena* was the name of his 1977 show in which Richard started to perceive through Leppe's trajectory the rearticulation of a certain "primary scene for the postulation of sexual (body) and linguistic (discourse) identity. The primary scene of the constitution and insertion of the subject in the frame of the symbolization of society and culture."[9] This perception, however, coexists with others that are not only different from but even contrary to the one just posited, in Richard's own writing as well as in that of other authors related to the Avanzada and its ambivalences.

The problem suggests itself again in a 1998 article by Jaime Muñoz in which the author recalls the performer's comments on his then recent return to painting after several years of taking leave from the artistic scene: "He did not just say that he was painting, but that he *borroneaba los signos.* To erase the signs, is that not the most extreme of silences? To paint as an act of resistance . . . to meaning."[10] "Borronear," however, does not necessarily or exclusively imply *borrar* ("to erase"). It can also allude to the act of scribbling, or sketching in an indefinite and clumsy way, as in the graphic equivalent of phonic mumbling or stuttering, as a child would do when attempting to draft his first letters. Or a writer in her attempts to overcome that creative confusion that is the preliminary stage of the act of writing.

Meaning is extracted even from where meaning itself faints, in the sensorial collapse of all concepts. "My body is the draft-book that collects also what is defeated and failed, the dents and bumps and their reverse," Leppe himself declares.[11] The reverse of a mauled history. But this negative embodiment of the Symbolic may also become the resymbolization of the Real.

The traumatic relationship with that history, or with History in any of its capitalized meanings, is perhaps a main unifying sign for the diversity of the Avanzada scene.[12] Leppe's case is not an exception. In *Cegado por el oro,* an exhibition catalog that

pretends to sum up the whole of the artist's career, more pages are devoted to personal snapshots ("My own private world") than to the modest black-and-white photographs of the new paintings, which are reproduced fragmentarily in details whose dispersion makes impossible the recomposition of the whole. Similarly the sequence of Leppe's performances is not chronological. Dates are randomly provided, with serious mistakes that accentuate the discontinuity of an order that has no pretense of being successive or much less historical. The confusion thus obtained is compounded by the epistolary fiction of an essay by Mellado presented as excerpts of nonexistent letters supposedly sent to a Brazilian curator (Paulo Herkenhoff).[13]

Little help is provided by the curriculum vitae published full page. Literally: save its very diminished margins, the entire surface of this final instance of the catalog is covered by a long sequence of institutional names (museums, galleries, magazines, publications) without any organizing sense of order or punctuation. There is no typographical differentiation, much less a set of dates to historically locate this chaotic maelstrom of misinformation. The only exception is an opening phrase, highlighted in bold letters: "Carlos Leppe was born in Santiago in October 1952"—the personal origin as the single vortex of a decentered social trajectory. And yet in the very same publication, Mellado paraphrases Richard in reminding us that "no hay Origen, sino destino originalizante": there is no Origin, only an originalizing destiny.

The Abject and the Sublime

There is no History, but the eternal return to the Mother. A return eternally frustrated by the crisis of the phallic link, the Name-of-the-Father: paternal authority articulated as linguistic function, in the Lacanian terms assumed by Fredric Jameson.[14] In the intersections of Leppe and Chile there is no phallus, only phallic substitutions that always remain unsatisfactory and unsatisfied. Hence the constant reference to castration in his work, not as a mere physical cut but as a symbolic caesura operated from the very code and register of the cultural.[15] These registers are incarnated by the artist in the successive transvestisms of his made-up and orthopedized body. An early book calls it his "correctional body," in an obvious reference to the authoritarianism of the military regime, but also to Lacan's notion of the ego as an armor aggressively deployed against the return of the Real, against the Real that returns under the guise of the primary fantasy of the body in pieces.

For Lacan the phallus remits to castration as the penis plus the idea of its lack. The emptying out of the *jouissance* of a body that thus enters the Symbolic order through language. But there is no such harmonic cultural resolution of the Oedipus complex in

Leppe's specular identification with his mother (Catalina Arroyo), abandoned by her husband in the fifth month of pregnancy. The artist's birth is left inscribed as a maternal castration mark in his own corporeal memory. The child as the absent phallus, the phallus dislodged from the mother: Catalina Arroyo possessively embraces with both arms the child's apprehensive body in the photograph that Leppe would obsessively incorporate into his artwork. Catalina Arroyo endlessly narrates in those installations and performances the traumatic birth, "with forceps, horrible," of his "little body, so immensely big," that she would never entirely separate from her own, because "I want the only one." "We were a couple," the maternal testimony proclaims. And then she adds, with a condensation of the subject that is a Freudian slip: "When he turned, when we turned, one year old, it was the first cake." The Symbolic is thrown radically back into the Imaginary, only for both to be once again decomposed into the Real.

And from there recomposed: Leppe's body of work, Leppe's body itself, could be seen as another Passion of the sign, represented as in a *Via Crucis* by a furious sequence of performances, "where the dictatorship acted as the foundational paradigm":[16] the dictatorship as a break and disarticulation of culture and of language itself. But its fragmented remains remain: the artist turns the allegorical ruins of unfulfilled desires into a living and throbbing memorial of Desire itself—the unfulfillable yet indeclinable want for a personally reinscribed sense of collective meaning. This meaning is to be retrieved through the debased materiality of installations and performances that permanently oscillate between the primary and the primordial: "Materials, textures, and procedures . . . disturbingly mixing the abject with the sublime."[17]

The abject and the sublime. The Real and the Symbolic. During the 1982 Paris Biennial, Leppe presented his performance in the bathroom of the museum, where he took off his worn-out tuxedo in order to clumsily shave his entire body before cross-dressing as a cheap vaudeville girl, with feathers sporting patriotic colors. After exhaustively dancing Pérez Prado's "Mambo Number 8," he ate and then puked a cake while intoning the national anthem. Finally Leppe crawled out of the bathroom and passed in front of famous paintings calling out for his mother until he reached a tape-recording of Catalina Arroyo's voice singing "El día que me quieras . . ."

Beneath the grand masterpieces, a kitsch tango by Gardel. Amidst vomit and shit, the national anthem. And the national colors over voluminous carnal surfaces in drag. A symmetric transgression had appeared already in *Waiting Room,* a 1979 installation where Leppe offered himself diversely cast in plasters that coerced his body into operatic poses, culturally deformative orthopedics that turned him into a woman successively exposed, pregnant, and sexually denied. His mouth, all made up and forcibly

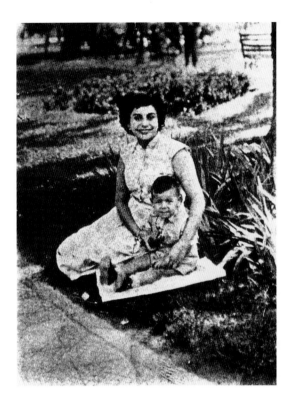

Catalina Arroyo and Carlos Leppe in a photograph included several times in the artist's installations and publications. Courtesy of the artist.

Carlos Leppe, *Pérez Prado's Mambo Number Eight*, 1982, performance, Paris Biennial. Courtesy of the artist.

opened with forceps—with forceps—screamed Wagnerian arias in three simultaneous videos whose backdrop hues—white, blue, red—corresponded *separately* to those of each stripe in Chile's flag.

Separately: a disaggregated national scenography for a dislocated motherland, for the violent childbirth of a transvestite voice. Transvestite and interfered with by the maternal voice of Catalina Arroyo endlessly narrating from a fourth monitor the artist's birth, while a cloth tied on the monitor screen bandaged her breasts. Richard calls this aural intersection vocalic incest. It is vocalic and patriotic: on the floor, a structure made of mud resembling both a TV set and a popular altar sheltered a plaster image of the Christ child held by the Virgen del Carmen, holy patroness of Chile and its armed forces.

But the Virgin is also the immaculate mother. As such, for Lacan she represents the phallus itself, the penis plus the idea of its lack, the signifier for all signifieds— castration and that phallogocentrism in which Lacan links phallus, logos, and voice. Thus

one can explain the unleashed emphasis on the artist's vocal chords, and on the body imprisoned by the plasters, as in a corrective orthopedic that becomes an armor. The armor is that of the Lacanian unconscious, but also that of an excessive national consciousness: the allegory not just of a broken homeland but of an entire symbolic order in ruins. And of its regressive reconstructions.

Patria, Matria, Madre Patria

Galaz and Ivelic are right in perceiving *Waiting Room* as a reedition of the dramatic tension between the social body and the body of the artist.[18] But there is also a more radical tension within the order of signification itself, which is that of the very constitution of the subject. The breast, the feces, the gaze, the voice, have for Lacan conditions both Real and Symbolic. Indeed, they indicate the passage from the Real to the Symbolic, and form part of childhood games of presence and absence. Leppe's performances place in a similar ambivalence the very idea of maternity, and its disturbing liminality.

That maternal-infantile body is also the decomposed one of Leppe himself, in his agonic effort to reconstruct the principle of the Symbolic through the clash and rearticulation of the Real with the Imaginary. This is seen in *Seven Watercolors,* a 1987 performance in which the artist places himself between the "+" and "−" signs (positive and negative, addition and subtraction, presence and absence . . .), auratically configured by neon tubes. From that threshold position, Leppe uses a shoe as a palette and as a cup to prepare different liquid pigments which each time he proceeds to drink and regurgitate, finally coloring with them the cloths he manipulates to gradually bandage his naked leg. "The regularity, the maniac order of the design," writes a fascinated Enrique Lihn, "framed guttural episodes incarnated by sub-beings closer to the body than to the world, extremely local or localized, those that crawl and grovel in the threshold of language and history."[19] Between earth and world, to use the formula with which Heidegger defines the gap from which art emerges. These opposite but complementary terms are translated by Fredric Jameson as "the meaningless materiality of the body and nature, confronted by the meaning endowment of history and of the social."[20]

We are not so much in the ineffable domains of the Real as in its regressive scenic representation. Lihn seems to suggest as much when pondering how "Leppe works in favor of his physical lacks and excesses, physiologically, with a punctilious vigilance on both. He works with the tic, with the voice, with the breath, with the nerves, with the perspiration. His action, and himself, exude a stink of Chile's last marginality, a condition

Carlos Leppe's orthopedized body: *Waiting Room,* 1979, video-installation, Sur Gallery, Santiago de Chile. Courtesy of the artist.

Screenshots of the video showing Catalina Arroyo reading the anxious narrative of Carlos Leppe's birth, included in Leppe's video-installation *Waiting Room,* 1979. Courtesy of the artist.

that could be called prehistoric, latched to matriarchy, constructed—with moans and stumbles—from the Oedipus complex."[21]

"Constructed" is probably the key expression in this last passage, just as "the regularity, the maniac order of the design" is the capital one in the previous quotation. What energizes these performances is not the mere display of the formless and obscene, but its confrontation and transmutation with other registers of meaning: "an acting," Matías Rivas points out, "that insisted on incubating within the dark fringe where so many things mix and intertwine: art, its history, the recognizable icons, the overblown and revulsive body, biography and politics." The Real and the Symbolic:

> this revelation is that of the unnamable, of the animality itself. And it could be reached only through an egomaniac liberation of the precultural by means of a planned design for that overflow. . . . The scream, the breath, the desire, the vomit, the pain, the harm, the language, the representation, the signs, the colors, the memory, the oblivion, the crime, the loss, the solitude. His idea was to . . . freeze the trembling in a pose. Visuality appeared in him transformed by the public quivering and the exhibitionist *desmadres,* which included in their delirium gestures of high actoral precision to be retained via photographs or videos.[22]

The *desmadres,* precisely. The "out-mothering" which implies a violent overflow, a sudden transgression of all norms. This artistic need to reincorporate the Real in the Symbolic comes out of the opposite process: the reinsertion of the Symbolic in the Real through a corporeality made extreme. "The dissolution of the word"[23] in a maternal body that is the artist's own but also that of the Virgen del Carmen, the maternal image of the patriarchal order, of the fatherland itself.

Patria, Matria, Madre Patria: Fatherland, Motherland, Mother Fatherland. The sexual ambivalence of these terms governs a body of work that oscillates between phallic reconstructions and the naturalization of the maternal image through its telluric inscription in the Andes, that essentializing metonymy of Chile that emerges in very precise moments throughout Leppe's works and publications: the photograph in the opening and closing pages of *Cuerpo correccional* shows a fragment of its mountainous profile resembling that of a reclined woman, a "Sleeping Beauty" that the accompanying text identifies with the maternal figure fused with that of a patriotically inscribed nature.

Inevitably one recalls that the installation Leppe mounted in Buenos Aires in 1984 was called *Project for the Demolition of the Andes*. And that its most visible element was a deconstructive interpretation of that city's landmark obelisk: the absent phallus in all the symbolic strain of its imaginary restitution.

Suture/Tonsure (Lone Star)

This phallic anxiety of restored signification erupts like disconnected impromptus throughout Leppe's works, but already by the end of the 1970s had managed to display itself almost programmatically in an exceptional performance: *1919–1979: La estrella*. The reference is to Marcel Duchamp's starry tonsure of a comet recorded by a famous photograph of 1921 (Leppe seems to be confused about this date). But the action offered in Santiago rearticulated those esoteric-artistic meanings in the local and immediate history of a symbol whose alchemical and revolutionary overtones are both displaced by, and condensed in, Chile's national emblem: there is precisely one lone star in that country's flag, profiling a white presence that can however be read also as an absence, a blank cutout in the deep ultramarine blue that surrounds it.

Blank, empty, void, hollow. An absent presence that the artist fills and makes whole, fleetingly but crucially, with his own corporeality. His own body, in order to fulfill its Symbolic function, must first be subject to a subtraction: the ritual castration of the tonsure is performed on his head behind a transparent Chilean flag with only its stripes made evident and no star to be seen. Until, that is, the star's inscribed symbolic presence on the artist's scalp is made to coincide with its imaginary heraldic space, repairing that disturbing absence, that all-too-real (all-too-Real) lack.

That absence, that lack. That break, that cut, that tear: for in that blank banner we might well see a political metaphor for the torn and devalued Lacanian image-screen, dispossessed not only of its symbolic power, but of the power of the symbolic itself, of its very capacity to symbolize and signify. And yet it is repossessed and empowered again by the sacrificial gesture of the artist, by his personal embodiment of a collective want in a healing action that resists and contains the pulsating gaze of the Real, all the better to reinscribe it in its necessary bonds with the Imaginary and the Symbolic. The corrosive puncture in that image-screen, the traumatic hole of the Real, is thus also revealed as the hole of desire—a personally inscribed collective desire that literally incorporates the hole as an integral and constitutive part of the whole. This signifying will assumes and transcends the structural instability of signs.

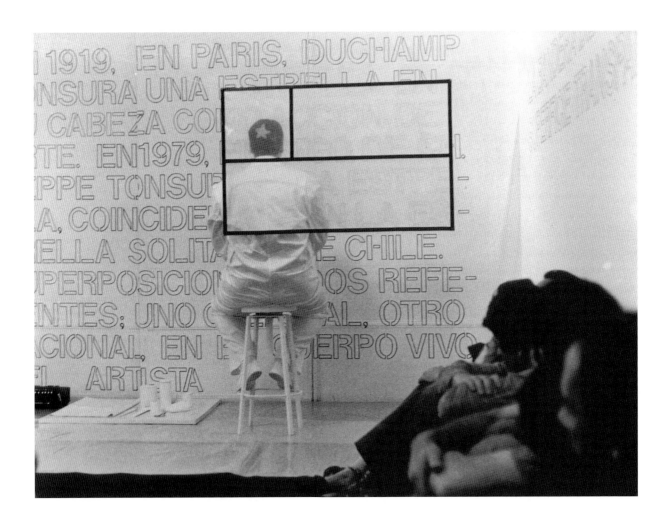

Carlos Leppe, *1919–1979: La estrella [The Star]*, 1979, installation and performance, CAL Gallery, Santiago de Chile. Courtesy of the artist.

The Return of the Sign

In *The Anatomy Lesson* (1985) Arturo Duclós inscribed Chile's national emblem not on a living head but on the dead skulls of anonymous skeletons scattered on the floor of a Santiago gallery as if it were a common grave. There is here, among other things, a lacerating comment on the denied identity of the disappeared that could also be perceived as a messianic sign. Such connotations might also be found in *La estrella*, but troubled by Leppe's double reinscription of the Chilean star: on his own breathing and heaving body, and on the historical body of body-art, its history revitalized through a

dislocating appeal to Duchamp's foundational gesture in all its provocative ambivalence. The ecclesiastic tonsure, related to both celibacy vows and the crown of thorns, is also associated with alchemical bisexual overtones. A second photograph of Duchamp's capillary intervention is signed by Rose Sélavy, his feminine alter ego, in a transvestite gesture that resignifies Leppe's own gesture in appropriating it.

"Superposition of two referents," reads an explanatory text painted on the back of the stage used for *La estrella:* "one cultural, the other national, on the living body of the artist." To cite is to graft, Derrida has said, and Leppe's dermal writing in the end makes

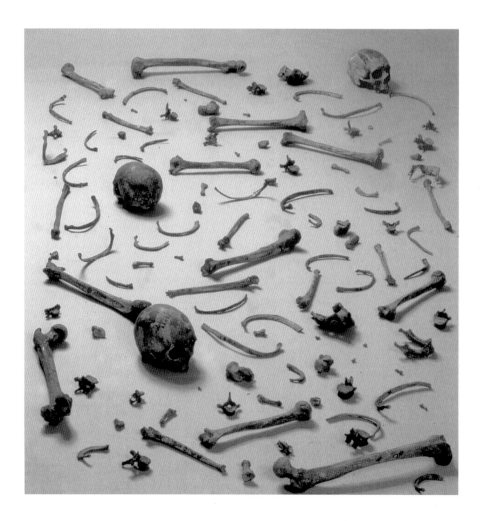

Arturo Duclós, *The Anatomy Lesson,* 1985, installation, oil paint on human bones, Bucci Gallery, Santiago de Chile. Courtesy of the artist.

superfluous such explicit writing on the wall: the final gesture of the artist, after covering the tonsured star with plaster, is to erase those didactic words in what may at first be interpreted as the triumph of the body over the text. History defeated by flesh, the Symbolic by the Real. *But even erased, those signs signify.* And doubly so: in the signification of the very act of their erasure. And in what is still legible in the remnants of their traces.

Remainders/reminders. At some point Foster resorts to Rauschenberg's famous dictum about his attempts to act in the gap between life and art. "Note that he says 'gap,' " Foster comments: "the work is to sustain a tension between art and life, not somehow to reconnect the two."[24] Leppe places himself more radically, not in the *gap* but in the *cut* between the sign and the thing; in the *bar* between the signifier and the signified; in the punctured and puncturing intersection between the Real, the Imaginary, and the Symbolic. And yet, this very placement acts as the suture of that wound. As its corporeal writing. The suture/the tonsure. The return of the sign.

Geneva, 2000

This is a translated and severely abridged version of a longer essay written in Spanish.

1. Throughout this essay (save for some quotations), I capitalize the word "Real" whenever it refers to the Lacanian category. The same applies to the words "Symbolic" and "Imaginary."

2. Noé Jitrik, "Del orden de la escritura," *sYc* (Buenos Aires) 6 (1995).

3. Hal Foster, *The Return of the Real: The Avant-Garde at the End of the Century* (Cambridge, Mass.: MIT Press, 1996), discussion in chapter 3, "The Passion of the Sign." Subsequent passages from this work are cited by page number in the text.

4. Julia Kristeva, *Powers of Horror,* trans. Leon S. Roudiez (New York: Columbia University Press, 1982), p. 2.

5. Nelly Richard, "Margins and Institutions: Art in Chile since 1973," *Art and Text* (Melbourne), no. 21 (May-July 1986), p. 120. Subsequent passages are cited by page number in the text.

6. Gustavo Buntinx, "Identidades póstumas: El momento chamánico en 'Lonquén 10 años' de Gonzalo Díaz," paper presented at the symposium "Beyond Identity: Latin American Art in the 21st Century," University of Texas, Austin, April 1995.

7. "All of Chilean art throughout this decade may well be read as *the dispute of biblical citations.* The foundational stain. The foundational scripture. The whole of Chilean art is a succession of Pietàs, Moises, Via Crucis, Holy Shrouds, highly tensed by the most advanced mechanical technology." Justo Pastor Mellado, "Ensayo de interpretación de la coyuntura plástica," *Cuadernos de/para el análisis* (Santiago de Chile), no. 1 (December 1983), p. 17.

8. Carlos Leppe et al., *Cegado por el oro* (Santiago de Chile: Galería Tomás Andreu, 1998), p. 12.

9. Nelly Richard, *Cuerpo correccional* (Santiago de Chile: Francisco Zegers, 1980), p. 9.

10. Jaime Muñoz, in Leppe et al., *Cegado por el oro,* p. 6.

11. Leppe, in ibid., p. 47.

12. There is probably a symptom in the reduced, dislocated, or ironized place reserved for history in the titles of several exhibitions that helped define that artistic movement. According to certain versions, the Avanzada began with a 1977 show of Eugenio Dittborn dislexically called *De la chilena pintura historia* ("Of history painting Chilean") and culminated in 1982 with a show by Gonzalo Díaz entitled *Historia sentimental de la pintura chilena* ("Sentimental history of Chilean painting"). In 1981 Carlos Altamirano exhibited his *Versión residual de la historia de la pintura chilena* ("Residual history of Chilean painting"). Et cetera.

13. Mellado, "Ensayo de interpretación de la coyuntura plástica."

14. Fredric Jameson, *Postmodernism, or, The Cultural Logic of Late Capitalism* (Durham, N.C.: Duke University Press, 1994), p. 26.

15. Richard, *Cuerpo correccional*, p. 9.

16. Leppe et al., *Cegado por el oro*, p. 14.

17. Ibid., p. 9.

18. Gaspar Galaz and Milan Ivelic, *Chile, arte actual*, 2d ed. (Valparaíso: Ediciones Universitarias de Valparaíso, 1988), p. 204.

19. In Galaz and Ivelic, *Chile, arte actual*, pp. 47–48.

20. Jameson, *Postmodernism*, p. 7.

21. In Galaz and Ivelic, *Chile, arte actual*, p. 204.

22. Matías Rivas, in Leppe et al., *Cegado por el oro*, p. 49.

23. Richard, "Margins and Institutions," p. 143.

24. Foster, *The Return of the Real*, p. 16.

HETEROGLOSSIA:
THE HERMENEUTIC TRAP

The Limits of Cultural Translation

Nikos Papastergiadis

> How many people live today in a language that is not their own?
>
> Gilles Deleuze and Félix Guattari, *Kafka: Toward a Minor Literature*

Much discussion of the concept of culture has so far been confined to how it has been affected by the global changes of mass migration, economic transformation, and the new technologies of communication. However, the deterritorialization of culture requires us to rethink not only the significance of place but also the processes by which cultural change occurs. The displacement of peoples and the greater interpenetration of information and values have led to rapid and profound levels of cultural change. At the forefront of these changes is the dissemination of the icons of Western capitalism, stimulating fears of global consumerism as a new cultural homogenization. Cultures, which were once seen to be meaningful because they were presumed to be discrete, stable, coherent, and unique, are now increasingly seen as interconnected, dynamic, fragmented, and amorphous. If the shape of culture shifts toward flux rather than stability, how does this affect our way of understanding cultural practice?

Cultures were considered significant insofar as they could enable people to gain a clear self-image and present a distinctive worldview. Identity is the process of making sense of oneself, and the system by which this is communicated and shared is culture.

Cultural images and perspectives were said to have been formed over a considerable period of time as unique to a given place. It was thus imperative that a culture be "master" of its own history and geography. With the radical transformations introduced by colonialism and most recently accentuated by globalization, such views of culture have been brought to a crisis.

Globalization has not rendered culture as an obsolete concept. People still form groups and they require symbols and systems with which to communicate. The meanings generated and shared by this process of communication are, as before, an expression of culture. Communities are formed out of these interactions. Even in the extremes of colonization, or the most turbulent phases of globalization, there is the enduring tendency toward forming what Stuart Hall calls "systems of shared meaning."[1] The transformations brought about by globalization may further dismantle traditional structures for shaping cultural systems, disempower key agents, discard earlier forms of knowledge, or even reinscribe the narratives of solidarity and unity, but they may also present new cultural symbols and practices through which individuals come to understand their position in the world. Globalization may present us with a more oppressive and restrictive form of culture, but this new manifestation should not be confused with the death of culture.

To understand the means by which identities are shaped in contemporary society, we must also recognize the ways in which globalization has shifted the boundaries and transformed the media of culture. Different cultures may struggle for ascendancy and domination over each other. Rival interpretations and competing norms may emerge or recede. We have come to appreciate that cultures do not need to be rooted in a given place, that fragments of culture can survive in multiple places, and that cultural meanings may leap generations and transform themselves across the gaps of time. Yet this appreciation of the "diasporization" of culture has been remarkably undertheorized. Tradition and modernity appear to be caught in a duel to death over the identity of culture. The demand is for either the total preservation of the "old" body or the birth of an absolute "new" culture. This contestatory model of cultural struggle obscures the resilience of the old in the form of the new, the unconscious repetition of previous habits within current practices, the subtle transpiration of traditional values in contemporary norms.

Since Edward Said's influential study of orientalism, much attention has been focused on the way colonialism invaded established traditions, introduced new relationships of dependency, and created new hierarchies. The patterns of influence were

considered unidirectional—emanating from the imperial center and dispersed outwardly across the peripheries of the colonies. The new cultural patterns of globalization differ from colonialism, resembling less a center-periphery binarism than a multidirectional circuit board. Again, traditional communities and established customary ways of life are being realigned and displaced according to priorities and desires defined elsewhere. Meanwhile, the metropolitan hierarchies have been significantly reconfigured.

For the concept of culture to continue to be useful, we must recognize the process by which communication occurs across boundaries. To this end I will focus on the concept of translation as a metaphor for understanding how the foreign and the familiar are interrelated in every form of cultural production.

Syncretism and the Signs of Difference

Although mainstream art criticism has shown a reluctance to address the question of cultural difference in Euro-American art, it has enthusiastically greeted the ethnographies of "otherness" in the art practices of non-Euro-American artists. This ambivalence to the domain of culture is symptomatic of a deep-seated belief that Western artists must always transcend their particular context and be representative of a universal perspective. The same status of universality is not extended globally. For instance, Rasheed Araeen who has worked exclusively with the grammar of modernism and championed internationalist perspectives in art discourse, has lived in London for over thirty years but is still referred to as a "Pakistani artist" by critics. Yet when the German artist Lothar Baumgarten quotes from the Cherokee language, or references his experiences in the Amazon, mainstream critics do not dismiss this as quasi-anthropological forays, nor do they question the elasticity of his ethnicity. Reflecting on his own motivations, Baumgarten has claimed: "The spiritual and intuitive force that drives me is rooted in dissatisfaction . . . the dream of creating the world all over again within oneself. . . . Though trapped in my Westerns thought patterns, I have always been interested in the 'Other,' the societies without a state."[2] Such a confession is never interpreted as pure regression but as a legitimate strategy for the search for lost origins. Such "noble" expressions of nostalgia and the hope that the West's own past can be found in the "savage" present of the "Other" presupposes that cultural development follows a universal, linear time-scale. The West can look back at the "Other" because it already believes that modernity is the benchmark of its own myth of human progress, which it has advanced ahead of both the "Other" and its own roots. The "Other" lives in its own

present, but this is also the past of the West. For the "Other" to come to the West and seek to comment on the present of modernity would require a historical leap over its own belatedness. The Western artist can step back into the time of the "Other," but the reverse is not sanctioned: the leap forward is seen as a form of modern-day hubris. The "Other" can only speak with authority about its own past, while the Western artist is imbued with the melancholy privilege of living in the present. It is this burden of dissatisfaction with modernity that spurs the search for its own innocent origins in the "Other."

This binarism between the West and its "Other" is indicative of the implicit hierarchies and the prescribed directions of influence in contemporary art. There is little recognition of the possibility that as modernity has been dispersed across the globe, parallel or even revolutionary expressions of modernism have been articulated in nonmetropolitan cultures. If the sign of difference in origin were no longer discredited, then our conceptual frameworks for cultural translation might be expanded through an understanding of the relationship between different practices in art. Cultural exchange is a precondition of art, and therefore attention to its processes can not just register the transcendental signs of value or taste, but issue an inventory of the dynamics of change. Yet, as Jean Fisher warned, this forward-looking orientation is not without its own traps and limitations:

> The dilemma remains how to express one's worldview, with all the multiple cultural inflections that inform it, without betraying either one's historical or geographic specificity or art, and without being caught in the web of signs that are all too consumable as exotic commodity. Perhaps one needs to think of cultural expression not on the level of signs but in terms of concept and deep structure: to consider both the work's internal movement and what governs the aesthetic choices an artist might make about materials and process, and the material relation the work has with the viewer.[3]

The question I wish to ask is not so much about where culture is located, or what is happening to culture, but how different cultures interact. This will require me to focus more directly on the processes of exchange and translation. My discussion of the limits of translation, and the resistance to exchange, is not undertaken with a view to arguing either the dysfunctionality or the impossibility of cultural interaction, but as a challenge to our very understanding of culture.

The concept of translation has been largely overlooked in the sociological and anthropological literature on culture. With the exception of the anthropological discussion on syncretism, the conceptual frameworks that have sought to address the cultural dynamics of exchange have remained on the fringes of the social sciences. Syncretism has an ambivalent status in the anthropological debates on cultural exchange. It is often used pejoratively to suggest the dilution or corruption of indigenous religious systems through the proselytizing order of Christianity.[4] According to the *Oxford English Dictionary*, one of the accepted meanings of "syncretism" is as a derogatory term for the "inconsistency of accepting incompatible principles or beliefs." The more pragmatically minded missionaries discovered that the road to conversion was not cut open by the absolute abandonment of earlier beliefs, but paved by the mixture and absorption of indigenous rituals and beliefs within Christian structures. Contamination can occur both ways. Missionaries began to tolerate, sometimes even participate in, practices which the dogma of the church deemed pagan. Traditional spirits and animistic beliefs, which were worshiped alongside and through the figure of Christ, represented to some critics the failure of one system to assimilate fully the other according to its own rules and hierarchy. This reconfiguring of the expressions of spirituality was also interpreted as indicating the resilience of traditional cultures in contact with the "repressive" or "modernizing" forces of the West.

These views of syncretism, which tended to accept the colonizer's superiority, did little to break the paradigm of purity/contamination in which the debates on cultural translation tended to be trapped. One notable exception is the work of Marcos Becquer and José Gatti, who attempted to repoliticize the concept of syncretism, not only by retracing the word's etymology—Plutarch first used it to refer to the tactical union of communities of ancient Crete in the face of a common enemy—but also by problematizing its historical deployment.[5] Their reinscription of the concept is presented in conjunction with a critique of the filmic representation of "vogueing." This dance fad, they argue, became a subcultural practice by which poor, young black and Hispanic gays could, in the space of a club, adopt various glamour poses as a symbolic challenge to each other and in general strut out against the status system. "Real" poses from the magazine *Vogue* were exaggerated, inverted, and fused with movements from breakdancing or, in more overt ways of referencing cultural difference, with Egyptian hieroglyphics. There was no effort to mimic the established norms or to present a neat synthesis into a new and unique third form.

The energy of vogueing, like syncretism, Becquer and Gatti argue, challenges the transcendental stability of concepts like identity and difference. When other signs are adopted, there is no attempt to resolve or elevate them into a higher order. Rather, syncretic dynamics are defined in terms of a constantly mobile relation between different signs. By being conjoined or juxtaposed, these new relations operate like a language. These affiliations between difference and similitude are not absolute, but shift according to both context and performance. The tendency within this combinatory logic is toward not an uncritical adoption but a rearticulation of symbols that both reaffirm a suppressed heritage and offer a challenge to the hegemony of the dominant culture. While this representation of vogueing as a syncretic articulation refuses to repeat the essentialist binarisms of identity by proposing a radically heterogeneous concept of agency, it leaves open a number of questions about the politics of transculturation. Through the work of Becquer and Gatti, syncretism becomes a metaphor for a more open-ended understanding of cultural practice. However, all this amounts to little more than a shift away from the laments of degradation, to celebration of a more tolerant mode of resistance and renewal. The processes by which this mixture comes into being still remains undertheorized.

Translation as a Model for Meaning

Language is not only one of the strongest and most resilient media for shaping cultural systems, but can also serve as a model for understanding how meanings are produced and transmitted within culture. Since the pioneering work of Benjamin Whorf and Edward Sapir, we have been aware of the ways in which people who share a language also develop common ways of seeing the world.[6] Whorf used the example of Hopi Indians to demonstrate how even fundamental experiences like the passing of time are understood and communicated in ways that are specific to their respective language. It is for this reason that communities become passionately attached to and fiercely defensive about their language. Many struggles for national independence have been mobilized by the call for the right to maintain one's native language and by the desire to be released from the yoke of the oppressor's language.

Cultures make sense of the world predominantly through the system of meanings that operate in language. These meanings are not fixed or singular. Meanings shift and transform within a given language, and differ between languages. Not even a basic concept like time is identical in all languages. To understand how meaning is secured across these differences, we need not only to consider how culture works like a language, but to expand the conceptual reach of the trope of translation to incorporate

the processes of transculturation and hybridization. We need to investigate the means by which people with different cultural histories and practices can form patterns of communication and establish lines of contact across their differences.

Mary Louise Pratt has argued that the space of colonial encounters bristles with the contradictions and conflicts of uneven exchange, and that these "contact zones" ignite radical and new forms of co-presence between subjects who were previously strangers.[7] It is during these delicate and volatile moments in the "contact zone" that transculturation occurs. The colonized people, who were forcibly brought into contact with the colonial regimes, and its new regimes for social organization, were compelled to both internalize the dominant order and invent new strategies for cultural survival. As most studies of colonialism have tended to either condemn or celebrate the perspective of the colonizer, little attention has been paid to the actual strategies of survival and adaptation by the colonized.[8] For while the colonized had little control over the dominant culture, they were not always willing to reproduce, in either a pure or wholesale manner, a worldview that was alien to them.

The complex and profoundly asymmetrical negotiations that were conducted in these "contact zones" are testament to how cultures are transformed, but not determined, by power relations. They also reveal the subtle mechanisms for resistance and cultural survival that are exercised by subjugated and marginalized people. The concept of syncretism can be radically expanded if it is applied to the broader practices of transculturation. Here we can witness that in every aspect of communication, and not just in religious adoption, there is a process of critical appropriation. The subversive potential of transculturation is particularly apparent in Jean Rouch's film *Les maîtres fous* (1953–54), filmed in the Gold Coast three years before independence.[9] Rouch follows a gang of migrants from the villages of Niger—roadworkers, shopkeepers, and petty criminals—as they leave the city of Accra and take a trail into the jungle. Upon arriving in a remote clearing, they immediately begin to whip themselves into a writhing frenzy and perform mouth-foaming rituals of sacrifice and loyalty. These men, we eventually realize, have created a performance that both mocks and mimics the inauguration ceremonies of the Governor General. The language with which they communicate is a creole that includes both the colonizer's language and their various languages. The symbolic sacrifice of a rooster, and their visual performance of dressing and undressing, jest at the starched and plumed uniforms of their colonial masters. This ceremony is a hybrid cultural form that seeks to reverse the social relations of colonialism. The relationship between the ruler and the ruled, guards and subjects, is played out in a series

of bizarre forms, whereby license is granted for the expression of thoughts and actions unimaginable in the "proper" context of colonialism.

Through the example of this film, we can see the consequence of different cultures interacting within the "contact zone," effects variously referred to as transculturation, creolization, or hybridization. We have noted that in the era of globalization the contact zone has become more jagged. When more people are displaced than ever before, and information networks are moving with greater speeds, the spatial points of contact between different cultures become more dispersed and fragmented, and their duration more contracted and irregular. To examine these processes, we need to return to the concept of translation.

To apply the translation models requires that we wrestle against many of the presumptions that confine translation to the mere communication of meaning from one language to another. The potential for understanding the dynamics of translation is caught between conflicting theories of language. On the one hand, there is the view that the deepest secrets and most intimate expressions in one language can never be communicated in another. On the other, there is the assumption of the existence of universals, which implies that there are corresponding meanings between different languages, and that equivalent transferals from one to another are possible. The latter view stresses that the relationship between the form and content of a word is arbitrary, that the content of a word can be separated from the specific form it takes in a given language, and then transferred to different languages. This approach also presumes that words in other languages will carry foreign concepts, or that an equivalent concept exists in the other language. Either way, the act of transferal is not seen as disrupting or transforming the content. The translation, if executed properly, is seen as either retaining or mirroring back the original meaning.

This was the view adopted by numerous Christian missionaries as they proceeded to transmit "God's words." Their translations of the Bible into other languages were considered to be unproblematical because they believed that there was only one universal truth that could be represented equally in different languages and not transformed or disrupted by the processes of translation. But, as Birgit Meyer has argued, it was not so much a matter of the missionaries giving the word as the converts making it. In her analysis of the syncretic practices between Christianity and the Ewe, she shows that the process of communication is always polysemic and that "as a result of translation terms are transformed; they no longer mean what they meant in either the source or the target language."[10] This does not imply that, because there is no equivalence or

pristine transferal, translation is impossible. Indeed all translators perceive the incommensurability or the intransigence of languages.

But despite this, in practice, translations are still made. Rather than stating their theoretical impossibility, one should wonder what actually happens when meanings practically cross linguistic boundaries. Mutual intelligibility between two languages is neither a given nor an impossibility, but something to be constituted by intersubjective dialogue across cultural boundaries. Translation, then, can be understood as interpreting and transforming the original statement, and thereby creating something of a new statement.[11]

This transformative view of language goes against the grain of the traditional conceptual balance between "fidelity" and "freedom" that underpins most discussions on translation. The conventional role of the translator is to reproduce a text in another language while remaining faithful to the meaning of the original. Such a contract can never be fulfilled in total, for one side always remains in conflict with the other. Nor can the translator assume freedom without sacrificing fidelity to the text. Words in themselves are always in a state of flux. Their meanings change over time, both as they evolve within their own context, and as they are moved to other places and reinterpreted. In Plato's view, there is no objective relationship between a word and its meaning, and therefore translation can only lengthen the shadowy spaces of language.

The irreconcilable tension between fidelity and freedom has been most acutely observed in the translation of poetry. Schopenhauer declared: "Poems cannot be translated, they can only be rewritten, which is always an ambiguous undertaking."[12] Translation is seemingly caught between two impossibilities: that of isolating the essence in the original and that of determining equivalence in the other language. Thus translations can never communicate the exact meanings of a text. Hence, translation would not be the process of connecting together the relationship between languages but a substitution for an otherwise impenetrable silence.

While acknowledging that all languages contain words which are so intricately woven into their context that any attempt to transfer them would rupture the crystalline configuration holding their meaning in place, Walter Benjamin argued against the view that the translator must either seek to reproduce the exact meaning or be condemned to silence. The task of the translator is, he argues, one which consists in "finding that intended effect upon the language into which he is translating which produces in it the echo of the original."[13] This echo comes about not by the translator's assuming the authorial role of initiation and assemblage of the text, but through a structural

approximation of its orientation.[14] From this perspective Benjamin clearly situates the modality of translation as being midway between poetry and doctrine. Benjamin, however, offers two metaphors to express a more ambiguous line between creative independence and rigorous derivation.[15] The first suggests that blind fidelity to the original impedes the rendering of sense, while the second stresses that translation can only succeed when the boundaries of both languages are stretched to the point of touching.

Fragments of a vessel that are to be glued together must match one another in the smallest details, although they need not be like one another. In the same way a translation, instead of resembling the meaning of the original, must lovingly and in detail incorporate the original's mode of signification, thus making both the original and the translation recognizable as fragments of a greater language, just as fragments are part of a vessel. For this very reason translation must in large measure refrain from wanting to communicate something:

> Just as a tangent touches a circle lightly at but one point, with this touch rather than with the point setting the law according to which it is to continue on its straight path to infinity, a translation touches the original lightly and only at the infinitely small point of the sense, thereupon pursuing its own course according to the laws of fidelity in the freedom of linguistic flux.[16]

Translation as a metaphor for the very process of communication—emerging out of fragments, approaching the totality of the other, confronting the foreignness of languages but also regenerating the basis for reciprocity and extending the boundaries for mutual understanding—can also provide an entrance into the mechanisms through which dialogue and negotiation between cultures is possible. To think of translation as neither the appropriation of a foreign culture according to the rules of one's own culture (whereby the original is treated as an inferior source that needs correction), nor as a reproduction which totally reflects the worldview of the other (whereby the translation aims to be identical to the original), but rather as a dynamic interaction within which conceptual boundaries are expanded and residual differences respected may allow for a more radical understanding of the multiple levels and diverse routes of cultural exchange in modern society.

The Politics of Translation

A transformative theory of translation does, however, open up a new set of questions. On what basis do we decide between different translations of the same text? Are all translations equal? If we take the perspective that translation is the condition of all thinking, then we are forced to consider such questions beyond the boundaries of semiotics. Translation occurs in all forms of cultural practice and is implicit in every act of judgment. In everyday life we assume that our responses imply some sort of standard which reflects a set of firm beliefs, and against which actions are judged, values defined. Yet when we are called to define this standard, it appears rather elusive, fragmentary, and incoherent. This gap between judgments based on implicit beliefs or intuitive responses and those which are applications of codified laws or moral maps exposes us to one of the most complex tensions in modernity. As change becomes the predominant feature of social life, it is inevitable that the certitudes underpinning cultural judgment are also fractured.

In philosophical discourse the practices of translation are acknowledged as an integral part of framing judgment. However, the specificity or generality of the translational process is in itself subsumed within a broader consideration of relationship between language and reality. This discussion is formulated from either a universalist or relativist perspective. The unresolved argument between relativism and universalism has been reactivated by the recent philosophical debates over identity politics.

Jean-François Lyotard's concept of the differend addresses the dilemmas that spring from the shortcomings of both the universalist and relativist perspectives in modernity. Lyotard defines the differend "as a case of conflict between (at least) two parties that cannot be equitably resolved for lack of a rule of judgment applicable to both arguments."[17] In this situation the legitimacy of one argument does not imply the illegitimacy of the other. This form of conflict may involve rival claims over an object. If the rule of judgment over this object is applied equally and uniformly to both parties, Lyotard argues that this may still do harm to one. Such conflicts are not resolved by a discourse that can adhere only to one set of rules for defining the rights to that object. A differend emerges when the rules for judging between the rival claims are not equally placed for grasping the specific genres within which the points of contestation are claimed. In fact, the very practice of seeking resolution only compounds the conflict. This is not an isolated or marginal feature of modern life. For despite the intensity and multiplicities of cultural interactions, Lyotard notes that a "universal rule of judgment between heterogeneous genres is lacking in general."[18]

The violent aftermath of colonialism provides countless examples to which Lyotard's concept of the differend can be applied. For instance, a mining company surveys a territory and concludes that the land is both uninhabited and rich in minerals. The company then applies to a governmental agency for the right to exploit these resources. An aboriginal community protests, claiming that the land is actually inhabited by sacred spirits, and asserting their ancestral duty to protect it. Here is a conflict in which at least one party fails to recognize the legitimate claims of the other. How will both parties go before a neutral tribunal that will decide between these competing claims? And if the law is already disposed to measuring the inhabitance of land in terms of dwellings and active utilization, are spiritual claims to be dismissed by the tribunal on the ground that they are intangible and irrational? If the aboriginal community is then forced to defend its claim in terms of its prior right to exploit the resources of this land, will they forfeit their rights of spiritual attachment?

Here the aboriginal community and the mining company are faced with an impasse: there is no common language in which both cases can be simultaneously posed and comprehended. The spiritual cannot be translated into the language of a tribunal that decides land rights in terms of material "development." If the aboriginal community adopts the language of this tribunal, their case vanishes. They remain silenced and defeated. They are faced with the differend of having lost their land and not having a neutral tribunal that can hear their case. The defining feature of their differend is that their case cannot be proven; they feel the double pain of loss—of their land and of their voice—for their case demands to be heard, but it remains mute before a tribunal that cannot translate their words. Yet this practice of silencing is not a negation of the translational process. It may become another sign, a negative space, supporting another line of contestation.

Similar dilemmas can be observed in the field of contemporary art. How will the discourse of contemporary art, which is predominantly Eurocentric and presupposes a break with the past, address non-Euro-American art practices that display a complex negotiation between tradition and modernity?[19] Given that there is genuine interest, an active market, and institutionalized networks that circulate art objects from all over the world and constantly create hierarchies of significance, what frameworks are available for judging between artworks from different cultures? Can practices that were previously categorized as "Other" suddenly emerge within the parameters of modernity's self-identity?

Redefining the Margin

The problems of translating cultural practices previously excluded from the context of modernism into the institutional boundaries of the contemporary can no longer be resolved by repeating earlier strategies that effectively relegated these works to the margins, labeling them "ethnic art" or "neoprimitivism." The problem has been posed in various forms by almost all the major metropolitan art galleries. The two most scrutinized exhibitions were *Magiciens de la terre* in Paris (1989) and the Whitney Biennial in New York (1993).[20] At the center of these critiques is a reexamination of the romantic idea that creativity lies at the margins of social existence. This view has gained greater purchase as the position of the margin has both expanded and become more jagged.

Responding to a conference called "Identity: Postmodernism and the Real Me," the black British cultural theorist Stuart Hall commented: "Now that in the postmodern age you all feel so dispersed, I become centered. What I have thought of as dispersed and fragmented comes, paradoxically, to be the representative modern experience."[21] The irony in Hall's voice is seldom noted. All too often, such comments are interpreted as signs of cultural equality. Further evidence of the greater appreciation of the margin, if not a broader claim that cultural differences are translatable, is the awarding of the highest literary prizes in Britain to writers from the former colonies of Australia, Jamaica, Nigeria, and India. Yet these awards have done little to stimulate a deeper understanding of the complex links between an exilic consciousness and the cultural representations of modernity.[22] Hal Foster has outlined three factors that help explain why the ambivalent social position of the artist from the margin is interpreted as giving rise to a heightened critical perspective.

First, there is the assumption that the site of artistic transformation is the site of political transformation and, more, that this site is always located elsewhere, in the field of the other. Second, there is the assumption that this other is always outside and, more, that this alterity is the primary point of subversion of dominant culture. Third, there is the assumption that if the invoked artist is not perceived as socially and/or culturally other, he or she has but limited access to this transformative alterity and, more, that if he or she is perceived as other, he or she has automatic access to it.[23]

The argument about the need to expand the cultural boundaries of art seems to have been interwoven with a fetishization of the alterity of the artist from the margin. Considerable attention has been given to the powers of the individual artist, in particular those artists who have come from such a space and can translate back, in potent forms, the relationship between center and periphery. However, the means for defining

inclusion and the creation of a framework for understanding the significance of cultural differences have not been so forthcoming. This dilemma was most evident in the curatorial practices that sought to construct a new cultural order by assembling works from cultures about which the curators had only limited knowledge. The failure to question this process, as Gerardo Mosquera contends, implies an acceptance of the curator's capacity to make transcultural judgments and from here the belief in the universality of art. To deny this process would imply an anagnoresis: acknowledging that a selection is made from local criteria (from a particular institution, culture, and aesthetic) leaves behind any globalizing discourse.[24]

Further questions follow from this perspective. Can contemporary art be defined from a universal standard? Does the proliferation of multiple cultural practices and perspectives presuppose the legitimacy of all? If the critical discourse of contemporary art engages with artworks from other cultures, will it also embrace other histories of practice, introduce new conceptual schemes for interpretation and appreciation? In short, how will the foreign suddenly be made familiar? Will the differend between different cultural practices alert us to the silencing that occurs by the very rules of representation in the discourse of art? Or will that which remains untranslatable summon a critique of the very language of art and culture?

Seoul, 1997

Notes

1. Stuart Hall, "New Cultures for Old," in Doreen Massey and Pat Jess, eds., *A Place in the World?* (Oxford: Oxford University Press, 1995), p. 176.

2. Lothar Baumgarten, "Status Quo," *Artforum* 26, no. 7 (March 1988), p. 108.

3. Jean Fisher, "Some Thoughts on 'Contaminations,'" *Third Text,* no. 32 (Autumn 1995), p. 6.

4. Birgit Meyer, "Beyond Syncretism," in Charles Stewart and Rosalind Shaw, eds., *Syncretism/Anti-Syncretism* (London: Routledge, 1994), p. 45.

5. Marcos Becquer and José Gatti, "Elements of Vogue," *Third Text,* nos. 16–17 (Autumn/Winter 1991).

6. Benjamin Whorf, *Language, Thought, and Reality* (Cambridge, Mass.: Technology Press, 1956); and Edward Sapir, *Culture, Language and Personality* (Berkeley: University of California Press, 1956).

7. Mary Louise Pratt, *Imperial Eyes: Travel Writing and Transculturation* (London: Routledge, 1992).

8. Notable exceptions are Ashis Nandy, *The Intimate Enemy* (New Delhi: Oxford University Press, 1983); and Gayatri Spivak and Ranajit Guha, eds., *Selected Subaltern Studies* (New York: Oxford University Press, 1988).

9. See also the film by Gary Kildea, *Trobriand Cricket: An Ingenious Response to Colonialism* (1975).

10. Meyer, "Beyond Syncretism," p. 45.

11. Ibid., p. 62.

12. Quoted in Rainer Schulte and John Biguenet, eds., *Theories of Translation* (Chicago: University of Chicago Press, 1992), p. 4.

13. Walter Benjamin, "The Task of the Translator," in *Illuminations,* trans. Harry Zohn (London: Fontana, 1973), p. 76.

14. A similar point was made by Czeslaw Milosz: "Experience shows that some excellent translations have been done by poets possessing only a limited knowledge of the language of the original or no knowledge at all, while some bad translations are the work of accomplished philologists whose perfect acquaintance with the language they translate from is unquestioned" ("A Symposium on Translation," *The Threepenny Review* [Summer 1997], p. 10).

15. Paul de Man observed that Benjamin's own comments on the impossibility of translation should be so literally confirmed by his own translators. In particular, de Man takes exception to Harry Zohn's rendering of the image of the amphora as a metaphor for the fundamental unity of language. He stresses that in the original the image suggests "a metonymic, a successive pattern, in which things follow, rather than a metaphorical unifying pattern in which things become one by resemblance" (Paul de Man, *The Resistance to Theory* [Manchester: Manchester University Press, 1986], p. 90).

16. Benjamin, "The Task of the Translator," pp. 78, 80.

17. Jean-François Lyotard, *The Differend: Phrases in Dispute,* trans. Georges Van Den Abbeele (Minneapolis: University of Minnesota Press, 1988), p. xi.

18. Ibid.

19. These are questions that preoccupied me throughout my involvement with the journal *Third Text* and were the focus of a number of my essays, in which I examined the strategies of selective representation, the paucity of contextualization, the uneven historical acknowledgment of marginalized practices, and the limits of thematic constructions in "global art" shows. See my *The Complicities of Culture* (Manchester: Cornerhouse Publications, 1994) and *Dialogues in the Diaspora* (London: Rivers Oram Press, 1998).

20. Both exhibitions attracted considerable debate about the pitfalls of identity politics. Critical responses tended to highlight the failure to contextualize non-Western work in *Magiciens de la terre* and the appeal to nonaesthetic criteria for determining selections in the Whitney Biennial. (See the special issue on *Magiciens* in *Third Text*, no. 6 [Summer 1989].) Consequently, the exhibits were dismissed as bad art or, as Luis Camnitzer described the Whitney, "a festival of causes" (see Luis Camnitzer, "The Whitney Biennial," *Third Text*, no. 23 [Summer 1993], p. 128). The problems associated with the mode of critical assessment was acknowledged in the roundtable discussion that the journal *October* initiated after the Whitney Biennial. Rosalind Krauss's concern was focused on the shift of attention from the meaning of the work to the origin of the author, a shift that she described as moving critical attention away from the signifier to the signified. However, what escaped attention was the need to evaluate the framework for interpreting cultural signs rather than privileging either the signifier or the signified. (See *October* 66 [Fall 1993].)

21. Stuart Hall, "Minimal Selves," in *The Real Me: Postmodernism and the Question of Identity,* ICA Documents 6 (London: Institute of Contemporary Arts, 1989), p. 44.

22. Both Terry Eagleton and Raymond Williams have noted that the canon of English literature was formed by exiles and émigrés. See Terry Eagleton, *Exiles and Emigrés*

(London: Chatto & Windus, 1970); and Raymond Williams, "When Was Modernism?" in his *The Politics of Modernism: Against the New Conformists* (London: Verso, 1989).

23. Hal Foster, "The Artist as Ethnographer," in Jean Fisher, ed., *Global Visions* (London: Kala Press, 1995), p. 12.

24. Gerardo Mosquera, "Some Problems in Transcultural Curating," in Fisher, ed., *Global Visions*, p. 136.

Researching Culture/s and the Omitted Footnote: Questions on the Practice of Feminist Art History

Angela Dimitrakaki

The unfolding of the postmodern moment saw a move from culture to cultures as well as from feminism to feminisms. What dictated this double move (whether it was, for instance, an outcome of a wider nexus of developments on a global scale) as well as the meaning it holds are still debated issues. Whatever the case, this double move occurred interactively with scholarly research in and across different disciplines; it certainly left its mark on the discourse on art, one already challenged by feminist politics. In 1987 Griselda Pollock argued that feminist art history has "to critique art history itself, not just as a way of writing about the past but as an institutionalized ideological practice."[1] Defined as a form of practice in its own right, feminist art history remains however institutionalized— perhaps more so now than at the moment of collective rebellion in the 1970s when short-lived feminist art history groups and collectives, emerging out of the women's movement/s in specific geographies, attempted a critical departure from the norm. Feminist art history (and theory, as it is questionable whether you can have the one without the other) continues to be a social practice which, like "art," is entrenched within the university, the museum, publishing houses, the art press, and so on. It is a social practice defined through language, and crucially a particular use of disciplinary and disciplined form of discourse involving terminologies and jargon accessible to culturally located communities of "users."[2]

Academic research, including research motivated by feminist politics, reaches its audiences through discourse in the material evidence of the text. The questions I want

to raise here concern the cultural specificity of discourses and texts, and in particular the production and consumption of feminist art history and theory involving research that can be named "intercultural": research that accepts the reality of cultures instead of culture, and especially research for which such an acceptance holds perhaps a political meaning, parallel to that suggested by the move from feminism to feminisms.[3]

It is imperative to consider briefly what the term "intercultural" entails. Rustom Bharucha problematized current uses of this concept and argued for a distinction between an understanding of interculturalism that uncritically celebrates globalization as a solution to the problem of nationalism (conflated with the idea of the hermetically sealed nation) and one that, in witnessing the significance of locality and borders, seeks to mobilize a "critical internationalism."[4] Although Bharucha does not discuss gender and sexual difference, his insights are highly relevant to the purposes of my argument. They suggest that, in a system of global relations, intercultural research cannot uncritically support a multiculturalism that fails to consider materially grounded cultural hierarchies, especially at the discursive junctions where a critical analysis of gender and culture/s occurs. The questions, then, that need to be raised necessarily revolve around the thorny issue of interaction between cultures which often call attention to their own historically produced conditions of existence, or even claim their "independence," in a framework of global relations of power. How, for example, can the feminist researcher be attentive to the ways cultural hegemony is inscribed in the process of cultural interaction (when intercultural research can be seen as such a process)? How can she or he acknowledge the presence of, and disentangle the links between, hegemonic and nonhegemonic narratives in her or his practice in the first place, given the fact that such a practice is shaped within ideologically determined spaces? These questions are highly relevant to the ongoing project of feminist art history, which has to be critical of its disciplinary premises.

I understand intercultural research to require and be operative within a dialectical form of enquiry that emphasizes process, allowing the researcher to grasp the significance of possibilities, and thus to subject both structures and institutions to often radical forms of critique. In restating the principles of dialectics, David Harvey argues: "The search for . . . possibilities is, given the dialectical rules of engagement, contained within, rather than articulated before or after social practices, including those of the research process. It is never, therefore, a matter of choosing between different applications of neutral knowledge, but always an embedded search of possibilities that lies at the heart of dialectical argumentation."[5] Significantly, the notion of dialectics here

involves the parameters of space as well as time, that is, geography as much as history. Hence the reappraisal of dialectical argumentation in and across the disciplines that have to think the power relations connecting the geographies and culture/s of postmodernity. Nevertheless, despite its focus on the "search for possibilities," dialectical argumentation is not axiomatically free from the workings of ideology. In other words, the search for possibilities emerges and becomes intelligible within and through discursive practices, which are already ideologically mediated.

I understand ideology to be "the more or less *unconscious* medium of habitual behavior" (emphasis mine).[6] It is a definition grounded upon Althusser's formulation which became influential in the 1970s and 1980s in the West, precisely when the history of art, as a discipline, faced the challenge of cultural studies—and quite rightly so. Yet as Terry Eagleton has argued, "ideology contributes to the construction of social interests, rather than passively reflecting pre-given positions; but it does not, for all that, legislate such positions into existence by its own discursive omnipotence."[7] Ideologies and systems of values are implicated in the very process of research in which Harvey locates the "search for possibilities." Research as a cultural practice is effected through and because of material relations, while it also produces material effects. History is written by specific social subjects, marked by specific education systems, thinking through specific languages; social subjects which are gendered, with specific class interests or allegiances, belonging in specific ethnic groups—and academic communities, for that matter. These are of course my own observations. In the past thirty years, feminist theory itself has aptly demonstrated that the production (and consumption) of knowledge and meaning is not value-free. But how is this knowledge implicated in intercultural research—not in the outcome of research but in *research as a process that involves "real" subjects?*

I would like to consider two intercultural, comparative research projects in which I was recently involved; or, more accurately, I would like to consider aspects of how I was involved in these projects. The reasons for this emphasis on personal experience are twofold. First, the issues that need to be addressed are rarely, if at all, mentioned in writing, that is, in whatever comes to be "published research." The latter always reaches its audiences in the form of the edited text. This editing is a complex process also mediated by ideologically determined discourses that discipline the language of the scholarly text. Despite feminism's emphasis on the importance of experience, one rarely encounters feminist texts, which, for example, incorporate and discuss the experience of a researcher trained in the former Soviet Union who has to travel to California to gather material about a curatorial project on feminist art from the United States. What are the

cultural dynamics informing the discussions with the artists in this case? How does the researcher experience the encounter with this "other" culture, and does this experience play a role in the research process? It is unlikely that the readers will come upon any observations on such issues in the researcher's art historical essay that will reach the catalog (although if the researcher is writing a book, we are likely to be offered information about her ethnic origins and frequent "moves between cultures," personal commitment to this or that political perspective; but all this will be included in the introduction to the main corpus of research that is "history proper"). Such observations are either seen as of a practical nature and too "pragmatic," or even trivial, to be taken seriously as an aspect of the always located practice of history and theory, or they belong to an experience that the researcher would rather forget—maybe they are reserved for the more private space of the researcher's diary and are to resurface later in the form of "memoirs." But ideology resides typically in the trivial, the practical, the pragmatic, and the seemingly irrelevant: to exclude experiences by naming them "irrelevant" implies a form of repression. Precisely for this reason, a reflection on these issues is imperative—especially since, despite the frequently reiterated deconstructionist emphasis on the significance of omissions, footnotes, and the potentially destabilizing "supplement," current processes of editing out the feminist art historical text remain largely unchallenged.

When I started researching for the projects I will be discussing here, I was aware of what research is supposed to do and how it is mediated by ideology, but this did not prevent the emergence of "difficulties" that were closer to contradictions than potentially resolved conflicts. I believe that the difficulties I faced, and the questions generated, are of a more general relevance. What these questions effectively ask is whether the notion of "independence" can have any meaningful application at all in the context of feminist intercultural research. If not, there is an urgent need to confront and reflect on the nature of the dependencies that frame such research, and especially those dependencies that are edited out in the process. Crucially, both my case studies concern Europe, a geographical destination not merely burdened with the dark legacy of Eurocentrism and imperialism, but also a precarious cultural construct in its own right nowadays. It is needless to add that the battles of identity in the cultural spaces designated as "Europe" are not only ideological (or has Kosovo been already forgotten!). To concern ourselves with "history and theory" has perhaps emerged as a luxury pursuit, conveniently situated outside, or at the fringes of, the war zone. Nonetheless, history and theory, as much as artistic practice, are part of a communication process among social groups of possibly different interests

and therefore are not entirely irrelevant to current situations where the very act of communication is constantly and persistently challenged.

Both case studies concern Europe's internal others, which frequently go unidentified before the various permutations of an abstract meta-European subject, often positioned against anything which is not of European "origin." Both case studies concern "the writing of art's histories."[8] But speaking about case studies immediately triggers the charge of empiricism, when in our (provisionally global) age of postmodern particularism, the relationship of the "particular" and the local to emerging or redefined forms of universalism is at best debated and at worst disavowed. The ambiguity characterizing current modes of discourse on cultural interaction and hegemony is the historically generated burden of the historian of the postmodern age. It cannot be transcended through older forms of response but requires, instead, an active search for a method that can potentially unlock the dynamics of the dilemmas faced by the researcher. But these dilemmas have to be considered in ways that do not posit the possibility of "relational thinking"[9] against the possibility of confronting the realities of conflicts and contradictions. I turn, then, to two omitted footnotes.

Omitted Footnote 1:
East, West, and Writing about Women in "Contemporary" Art

In 1998 I visited Tallinn, the capital of Estonia, as part of the British team in a British-Estonian collaboration. This involved an exhibition with artists of both countries and the production of a book to examine the issues raised. The exhibition came to be called *Private Views: Space Re/cognised in Contemporary Art from Estonia and Britain,* and brought together media work by women artists (and one man). I was invited as an art historian to witness this exchange of ideas, and finally to write an essay contextualizing the works on show. It is this aspect of the project I wish to discuss first. What exactly was it that I witnessed, and what sort of problems did I face when I attempted to write as a feminist art historian about works from two different social/political realities in a shared context?

What I first witnessed was a feeling of culture shock among the members of the British team, myself included. The feminist ethos of a loose sisterhood at the end of the 1990s did not prevent the expression of a cultural bias toward what amounted to the "alien" everydayness of the Estonian capital (at the antipode of this was an enthusiasm in witnessing "difference" to the extent of exoticizing our new surroundings). Moreover, I kept being asked about the "young British artists," "new British painting," and the

possibilities of getting such an exhibition in Tallinn. Did this question imply that the artists coming to that specific show had brought along work that did not seem to fit comfortably into whatever was apprehended in Estonia as "contemporary" British art? The work that was to form the British part of the show would perhaps have been of a variety unknown to those who had identified contemporary British art with the so-called Brit-pack, one of Britain's key export products and concepts in the 1990s (and this says a lot about how national art scenes continue to be constructed and promoted). Finally the show was on, and I had to go around and take notes. I should clarify at this point that, although I was not the curator, the emphasis on the re/cognition of "space" was my suggestion: I thought that the currency-cum-open-endedness of the term could provide an expanded frame of references for work by contemporary media artists, from the problematic geography and cultural amalgamation in crisis known as Europe, interested in the spaces where the complex articulations of difference are inscribed.

Nothing had prepared me for my own reaction to what I initially perceived as a semiological abyss separating the British and Estonian responses. When I attempted to write about the works by the British artists, it all seemed clear. These works had apparently absorbed and reworked the meanings and methods of the culture wars of the past three decades, expanding on the dialogues around the body, fragmentation, the production of the image, and so on. To me they were intelligible and asked the "right" questions. Despite their diverse approaches to such questions, they could be discussed in a shared discursive context because of their points of reference. The term "postfeminist" could not adequately function as a broad definition of the approaches taken by the British artists, and this testified even more to their currency. By 2000 postfeminism already appeared outdated, failing to designate an emerging form of political engagement among artists in Britain (this being the optimistic side of things).

My awareness that the culture wars these works seemed to take on had not been an ubiquitous (read: universal) cultural manifestation did not help me to confront and negotiate the real conditions in which this "difference" was articulated. The majority of the Estonian works focused on issues that I could not clearly grasp or could grasp too clearly, I thought, because in the course of my culturally located training as an art historian, the issues these works tackled (such as cosmetic surgery, globalization as McDonaldization, and the invasion of television culture) seemed already exhausted. That is, art historians of a generation ago in the West had written on these issues to the point of exhaustion. To suggest that cosmetic surgery and television culture (let alone the fact that the acoustic and visual sign "McDonalds" seems currently to hold a more universal

meaning than human rights) are no longer relevant references sounds like being in denial. But even feminist art history suffers from the curse of the new, from internal trends and the pressure of academic fashion. If not exhausted, the references of some Estonian artworks seemed to ignore conspicuously the protocol of political correctness. One work in particular left me speechless. Not even the bad girls of the early 1990s, in all their antiacademy fervor, had dared produce a work entitled *Natural Law* in which a young, white, fashionably slim, naked woman played mother to several puppies while the real mother's desperate howling filled the gallery space.[10] There was the issue of animal rights, if not of an essentialist approach to motherhood. After all, how could an Estonian woman artist move on to postfeminism in 1998 when the first feminist shows in Estonia took place only in the mid 1990s?[11] It took a while before I finally came to address the problem—what had produced the "problem" I thought I was facing—which was my ready-made expectations regarding the enquiry of which this work was part. The question that has preoccupied me since is, Why should the artist be aware of the debates that had emerged in the geographies where my feminist art historical training was provided? And more importantly, Is it inevitable (because it certainly is possible) that such debates, despite their subversive intent, contribute to the peripheralization, in spatial but also temporal terms, of certain positions, arguments, and iconographies?

In one way then, cultural difference emerged as difference in terms of time. Fortunately, cultural theory already had some arguments in place: Homi Bhabha in *The Location of Culture* discussed this temporal warp and its discontents in relation to geographies of difference.[12] Unfortunately, this approach problematizes the whole construct of "contemporary art." Who sets the standards of what is contemporary or not, if cultural frames are seen as time frames? Paradoxically, the British works did not comply with the image of "contemporary British art" for those exposed to the international campaign of the Brit-pack, and neither did the Estonian works fit the description of "contemporary (feminist or postfeminist) art" for those who implicitly, and often unwittingly, identified postfeminist art with developments in the dominant spaces of the West. The British-Estonian collaboration was meant to yield a much-desired interaction among artists as well as between artists and viewers (and, yes, local communities of viewers were actually shocked by the explicitness of the cosmetic surgery images). Yet the project made manifest that cultural hierarchies, centered on the notion of the contemporary, could not simply be evaded as a matter of course, despite awareness of the issues surrounding the discourse of a multicultural Europe, when the latter is considered

to be the cumulative effect of independent cultural paradigms claiming their right to exist in the best of all possible worlds.

When the essays by the Estonian writers to be included in the book began to appear, new problems emerged that also had to do with the cultural translation of meaning. Funded by British cultural institutions, the book was to be published in Britain and in English. Crucially, it had to appeal to an audience with an interest in the issues defining the "contemporary" art scene. The editorial team, including a British artist, an Estonian artist (the show's curators), and me, engaged in endless debates about the use of specific terms in the Estonian and UK-based writers' texts: feminism, gender, feminist art, postfeminism, socialism, communist state, capitalism, class, equality, national identity—they all seemed to mean different things to those educated in Britain, or at least in the West, and to those educated in Eastern Europe. The often-positive emphasis on national identity in the Estonian texts became the topic of heated discussions and so were the references to the gender equality policies of the Soviet Union. To give one example, I tried to explain that feminism in the late-twentieth-century West had mutated to "feminisms," and that "feminism," in any case, was not identified with equal access to institutions, especially with regard to representation practices such as art. If arguments in the Estonian texts did not take account of this, would prospective readers (ideologically constituted subjects as much as the authors and editors) be alienated?

And this is precisely the problem that needs to be identified. It is doubtful that the cultural gap (not between social subjects but between hegemonic narratives) in that instance could have been bridged. Good intentions and a claim to "independence" would not have been enough. At the same time, whether the Estonian texts perhaps suffered a certain violation has to be considered. A realization that emerged was that to write and, significantly, communicate ideas about cultural difference to culturally specific audiences is not only a process subject to the workings of ideologies but is also a process potentially requiring an active, conscious and unconscious, form of compromise which potentially implies suppression. The bringing together of two different cultures even in the context of an intentionally destabilizing discourse does not necessarily lead to the generation of a new shared temporality able to contain both; instead, it frequently allows for the prioritization of the dominant temporality over the other. The hegemonic paradigms providing the horizon of limits of such destabilizing discourses have then to be rigorously rethought.

This constitutes a problem without solution at the moment. Cultural difference structures the production of feminist art history and theory as practice, especially with

regard to the intelligibility of the so-called "contemporary." It also crafts specific forms of desire: of belonging, rather than nonbelonging. The problem is adequately summarized by co-editor and artist Mare Tralla in an interview where she discusses the conception of the first feminist show in Estonia: apart from any other considerations, it was clear to the Estonian curators that it would make the Estonian scene appear more informed and, ultimately, contemporary.[13] This certainly explains how it is possible to get from feminist to postfeminist art and shows in a span of four years. Evidently the aspirations of an allegedly more democratic postmodernism have not managed to transform an increasingly multicultural international art scene into a shared-vision-based-on-difference love parade. At the moment, this seems more of a race toward the contemporary.

Omitted Footnote 2:
Geographies, Vital Debates, and Asking Questions

The second "absent" footnote concerns the research I carried out for my doctoral thesis. In relation to the problems that emerged, I occupied a different subject position to the one described in the first case study. The thesis was entitled "Gender, Geographies, Representation: Women, Painting, and the Body in Britain and Greece, 1970–1990." I undertook this project in part because, during my M.A. studies in Britain in the early 1990s, I never happened to come across the name of a single Greek woman artist, living and working in Greece, in the body of writing called feminist art history. The fact puzzled me (to an extent, as I knew that outside some narrow commercial circles, no one bothered with Greek artists who did not have the decency to emigrate at the right time to the right place, as Chryssa, Takis, and Kounellis once had). Nevertheless I knew there were artists who engaged with gender issues in Greece, where I come from, and yet they were completely unknown in this framework of critical revisions. Significantly, although one would occasionally encounter references to French or British or American theory, the propositions of feminist art history concerned a more or less undefined context, where difference, although named (as in black, white, heterosexual, working class), managed to remain abstract at the same time. There were "black women artists," "lesbian artists," and so on. Or the opposite: there were cases where arguments about black women artists would center, for example, on merely one black woman artist, who more often than not was a black artist of the diaspora, living and working in the West.

What is known as the postcolonial critique of Eurocentrism made things more perplexing regarding Europe's internal paradigms of exclusion. Regarding the emphasis

of feminist art historians on visibility and identity, I faced a paradox: were Greek women artists, also white, European, and probably looking at the Parthenon outside their studio window, considered to be too visible, as opposed to black women artists? Greek women artists seemed to lack classification in the context of feminist critique. By lacking classification, they seemed to also lack identity. And how could one begin to theorize the premises of such an identity, or even the premises of their exclusion from mainstream and oppositional discourses alike? Eventually, I realized that this group (Greek women artists) stood in that oblique no-woman's land: not exactly First World, not exactly Third World, and not exactly Second World either.

As my research was progressing under the auspices of a British university in the second half of the 1990s, the situation got to be almost embarrassing. The body of theory available suggested a framework of acceptable approaches that proved increasingly problematic for the kind of questions dictated by my "comparative" research framework. The dominant psychoanalytic approach could not help explain if and how distinct encodings of images of the body, produced and received by gendered and classed subjects, were rooted in specific national/cultural contexts; if and how these national/cultural contexts were connected in a global narrative and how this affected the practice of art and art history in each of them; the possibly different hegemonic understandings of the political in each social formation; the rejection of postmodernism as reactionary in Greece and its embrace as (mostly) "critical" in Britain; the emergence or absence of new social movements and debates. In short, comparative, intercultural research in feminist art history seemed to hold no methodologies capable of tackling such problems systematically. If anything, methodology and its distinction from theory seemed to be the issue.

One of the main problems I encountered was that, although feminist artists existed in Greece, feminist art historians/theorists did not (again, as a consequence of historical processes). As a result, the way questions were formulated in my research was culturally specific: that is, they were not just informed but shaped by the insights, shortcomings, and debates of Anglo-Saxon critical theory and its references—including, for example, French feminist theory. Self-reflexivity is useful but does not always help one go beyond certain assumptions. It took a few years before I realized that the whole of twentieth-century art history in Greece had been written, and even thought, in a language and terminology of a rather peculiar nature: not sufficiently local and not sufficiently global. Modernism/postmodernism, feminism/postfeminism, to give two examples. But the historian cannot easily depart from the specific meanings these terms

hold in specific contexts. And indeed, why did Greek women artists, critics, and historians not concern themselves with "race"? This issue in particular came to be of major concern in conference presentations (obviously not in Greece), where history sometimes is delivered in the form of a public apology.

Questions such as those (schematically articulated here) may sound unbiased but, of course, are not: they would occur to a researcher familiar with the issues raised in the context of "Western" feminist art history and theory. This problem became highly visible when I prepared for the interviews with artists in Greece. Formulating the questions already involved a frame of references to debates that were not necessarily part of both cultural contexts—the debate about painting, the body, and the feminist politics of representation being a case in point (Greek women painters of the late 1970s and 1980s never had to face the dilemma "to paint or not to paint"). In every interview I conducted in Greece, I invariably had to explain to the artist the intricacies of what had come to be known as the feminist politics of representation. But although I would openly claim the cultural specificity of the debates, my familiarity with the issue already shaped the dynamics of the interview. This is not a problem of possible suppression such as the one identified in the case of the British-Estonian project but instead is one that corroborates the Foucauldian proposition that we can think only through discursive practices that already exist as a system of values that fix meaning and exercise power. (The exclusion of Greek women artists from feminist art histories might very well have to do with the absence of certain debates from the cultural framework in which they had to work. This made them, predictably, less "contemporary.") But although from a materialist feminist standpoint, the reality of culture/s is not exclusively produced through discourse—instead, discourses are part of "reality"—the actual relation between this reality and its re/construction in discourse is far from settled. Practices of representation are always ideologically mediated. And, let's not forget, the practice of history and theory is a practice of representation. So, what can be translated from one culture to another depends upon the cultural hierarchies that structure the relationship of one culture to another.

Feminism, either as a post-Enlightenment emancipatory project or as a postmodern destabilizing enterprise, has partly operated as a political, though not necessarily programmatic, form of intervention at the level of material relations. This encompasses issues such as institutional access and the encoding of gender difference in the spaces of representation. But feminism has not—and could not have—abolished the constraints set by existent social power dynamics shaping the lives and consciousness of

the social agents who are subject to them, including those who have the privilege to intervene in the discursive spaces where meanings circulate. In 1988 Nancy Fraser and Linda Nicholson concluded their discussion of feminism and postmodernism by inferring certain definitions of a "postmodern feminist theory" which should be "explicitly historical . . . , nonuniversalist . . . , comparativist . . . , pragmatic and fallibilistic." The pragmatism of this form of social criticism would allow it to "tailor its methods and categories to the specific task at hand."[14] This optimistic definition of a timely version of feminist theory (which brings the issue of method center stage) can be of particular interest to the shaping of feminist art historical directives.

 Setting the task at hand, however, presupposes a political choice in the first place. This political choice, through which power is exercised, often prescribes the making of traditions but also the premises upon which new canons are established. And these new feminist canons often fail to reflect on how ideologies mediate even the "practical" aspects of research, those normally excluded from the edited text. The writing of comparative histories can be of vital importance by settling and ensuring the very premises of feminist dialogue while potentially countering the postmodern insistence on the local which has been a politically inadequate strategy under the current configuration of multinational capitalism and models of patriarchy. But intercultural research need not be synonymous with the often uncritical valorization of cultural difference, as sometimes happens in the discourse of multiculturalism which disavows the reality of power structures and favors the illusion of "independence" in terms of a peaceful coexistence—because let us not forget: today more than ever before, capitalism binds us in our global condition. Intercultural research can, instead, demonstrate the need to make connections between the conditions of visibility of some feminisms and the invisibility of others. It also suggests that researching different cultures requires the development of discursive frameworks that can politically accommodate the frequently dismissed trivialities of research—an original insight of second-wave feminism that dominant end-of-millennium feminisms seem to have conveniently forgotten.

 How then can the problems pinpointed above begin to be approached? Against the tendency of current forms of political correctness, which suggest, for instance, that "racism" exists when you begin to name it as such, I would see this process of openly naming the problems as a crucial first step. The intricate interlacing of ideologies, in which discourses are shaped, makes it imperative that we relentlessly analyze our own culturally and socially determined positions, without entertaining the illusion of a practice of feminist art history and theory that does not entail its own dependencies:

primarily on fixed, rather than unfixed, meanings captured by and propagating the unspoken conventions of disciplinary research. This way, if problems emerge, as they are bound to, at least one cannot be accused of being unaware of their origins, dynamics, and effects. Otherwise, it may appear as if we are simply wishing the complexity of social life away by not naming it, or by editing out the "trivial" residue of power relations.

Brussels, 1997

I would like to thank Pam Skelton for her insightful comments on this essay, as well as Dawn Ades, Alex Potts, and Susan Malvern, who encouraged me to discuss further the dynamics of my interviews with Greek women artists.

1. Griselda Pollock, "Women, Art, and Ideology: Questions for Feminist Art Historians," in Hilary Robinson, ed., *Visibly Female: Feminism and Art Today, an Anthology* (London: Camden Press, 1987), p. 207.

2. As David Sibley argues, "disciplines" is "a term suggesting that problems are taught and researched according to sets of rules" (Sibley, *Geographies of Exclusion: Society and Difference in the West* [London: Routledge, 1995], p. 115).

3. Sandra Kemp and Judith Squires have stated: "The plural of our title (feminisms) reflects both the contemporary diversity and motivation, method, and experience among feminist academics, and feminism's political commitment to diversity—its validation of a multiplicity of approaches, positions and strategies" (Kemp and Squires, eds., *Feminisms* [Oxford: Oxford University Press, 1997], p. 3).

4. Rustom Bharucha, "Interculturalism and Its Discriminations: Shifting the Agendas of the National, the Multicultural, and the Global," *Third Text,* no. 46 (Spring 1999), p. 10.

5. David Harvey, *Justice, Nature, and the Geography of Difference* (Oxford: Blackwell, 1996), p. 57.

6. Michael Payne, ed., *A Dictionary of Cultural and Critical Theory* (Oxford: Blackwell, 1997), p. 252.

7. Terry Eagleton, *Ideology: An Introduction* (London: Verso, 1991), p. 223.

8. See Griselda Pollock, *Differencing the Canon* (London: Routledge, 1996).

9. See Rosemary Hennessy, *Materialist Feminism and the Politics of Discourse* (London: Routledge, 1993), p. 6.

10. I refer to Ene-Liis Semper's video installation *Natural Law* (1998). I am indebted to the artist for showing me her earlier work, which helped me to approach this particular piece. The conversations I had with Susan Brind, a British artist exhibiting in the show, also played a significant role in shaping my understanding of *Natural Law.*

11. These were *Kood-Eks* in 1994 and *Est.fem* in 1995.

12. Homi Bhabha, *The Location of Culture* (London: Routledge, 1994).

13. See Pauline van Mourik Broekman, "State of Play: An Interview with Mare Tralla," in Angela Dimitrakaki, Pam Skelton, and Mare Tralla, eds., *Private Views: Space and Gender in Contemporary Art from Britain and Estonia* (London: Women's Art Library, 2000), p. 18.

14. Nancy Fraser and Linda Nicholson, "Social Criticism without Philosophy: An Encounter between Feminism and Postmodernism," in Thomas Docherty, ed., *Postmodernism: A Reader* (London: Harvester Wheatsheaf, 1993), p. 429.

Der Glauber Have Sept Cabeças

José Gatti

> Metaphor is the primary language of prophets: Cyrus of Persia, Mohammed, Christ, Confucius, Buddha, they all spoke through metaphors; people will understand metaphors only when they refer to the collective unconscious. . . . And metaphoric discourse can deepen the real; when it goes beyond direct information with a historically freer sense, it can reinstate the past into the future, the known into the unknown, that is: when discourse becomes metaphor it reaches a more totalizing language.
>
> *Glauber Rocha*[1]

This essay contributes to the discussion about the representation of ethnicities and races in the film *Der Leone Have Sept Cabeças,* directed by Brazilian filmmaker Glauber Rocha in Congo-Brazzaville in 1969, with the support of Italian producer Gianni Barceloni. It would be impossible to detect all the ethnic presences in the film, whose characters (as well as makers) include representatives of various African ethnicities and European nationalities. I will concentrate instead on one particular character within the net of ethnic and national relations in the filmic text, and on some of the possible readings his presence in the mise-en-scène can suggest. But first it is important to contextualize *Der Leone Have Sept Cabeças* within the period of its production.

Der Leone Have Sept Cabeças is a chimeric portrayal of the revolutionary moment that marked the end of the old colonialism in Africa. In many African regions, that meant merely the subtle transition toward *neo*colonialism.[2] In the former Portuguese colonies, however, such transition pointed to the possibility for a new alignment, one that reserved a key role for international socialism. This struggle was a source of inspiration for Rocha's work in Africa; at the time *Der Leone Have Sept Cabeças* was being shot in the Congo, the fight of the revolutionaries led by Guinean-Caboverdian Amílcar Cabral had already been going on for ten years.[3]

Many Brazilians who learned that Rocha was filming in Africa were frustrated: after all, he was an artist working in a situation of exile, one whose work would probably never be shown in the military-controlled Brazil of the 1970s. That was a time of controversial, contradictory, and especially censored news. The one-time *enfant terrible* of the Cinema Novo movement, who had invaded the pages of weekly magazines and dailies in the 1960s, was now far from the Brazilian media. Frustration produced cognitive dissonances, even in Paulo Emílio Salles Gomes's otherwise pondered discourse. He wrote, in 1975: "Acquaintances go abroad, sometimes we go ourselves, and all of a sudden, watching *Der Leone Have Sept Cabeças* we realize it was worth waiting a few years for it: one cannot but recognize the public was not ready for it at the time of its completion."[4] Salles Gomes for his part left us all frustrated: he didn't have time to continue writing about *Der Leone,* due to his untimely death two years later.

The film was screened at a few European shows and then shelved for a number of years until its liberation in Brazil, after the fall of the military dictatorship in the 1980s. When a festival of Rocha's works hit the Brazilian state capitals, *Der Leone Have Sept Cabeças* had been rarely seen and largely ignored by critics abroad. *Der Leone* is still one of the least-known works by Rocha. One of the few references one can find to it is in Roy Armes's comprehensive *Third World Filmmaking and the West* (1987). Armes described its narrative as follows: "The film is as fragmentary and ungrammatical as its title would suggest, shot in long sequence shots during which isolated and largely incomprehensible symbolic actions are performed in interminable real time by characters lacking individualization and depth."[5]

Armes's approach seems to imply a desire for a cinema aligned with narratives that appeal to the gaze of a *Western* consumer—whatever "Western" may mean (as for us, we have already learned from Salles Gomes that we all are, at once, *occupied* and *occupiers,* no matter what hemisphere we are from).[6] Within that scope, Armes is "right": the scenes of *Der Leone Have Sept Cabeças* do not follow a necessary order, one which leads spectators towards the clear unfolding of actions that imply definite consequences.

But should such filmic discourse be considered at fault, as the terms "isolated" and "incomprehensible" seem to suggest? Moreover, do characters *have* to display "individualization and depth"?

Indeed, the narrative of *Der Leone* has little in common with the conventional, linear narratives of hegemonic cinema. It shares, instead, the spirit of experimentation featured in avant-garde literature. From this perspective, Rocha's film can be seen as an experiment not unlike Julio Cortázar's 1962 novel *Hopscotch*, which presents interchangeable chapters that can be reordered by the reader, though the sequences of a film can hardly be manipulated like the chapters of a novel (this has only become possible in recent years, with video and digital technology). Other authors who might be referenced in this context are Mallarmé, the dadaist writers and, in Brazil, the concretist poets and João Guimarães Rosa. Thus Armes's definitions, apart from framing the work in a (restricted) critical category, suggest a rhetorical device summoned to resolve a critical failure. In other words: unable to approach the text, the critic disdains it as "unapproachable."[7] It is not surprising then that this type of narrative is not easily metabolized by audiences nourished on a single form of entertaining cinema. For the so-called Western critic, the allegorical nature of the characters, for example, can be rather boring and uncomfortable. However, Rocha is experimenting here with a didactic narrative that takes an openly anticolonialist stance and presents itself as an alternative to the form of the classical fiction film. It is somewhat useless for the critic to "long for" something that was rejected a priori. Rocha himself described the work as "a radical film, because I created a centralization in the sense of truly synchretizing action, that is, making each shot an act full of information. . . . Each shot can be seen alone or articulated with the others in a dialectical montage."[8] My reading of the film will not highlight scenes from *Der Leone*'s narrative as parts of a dialectical montage, as Rocha wanted. Even though I run the risk of disagreeing with him, I prefer to see the film as a succession of shots articulated in a *dialogical montage* (and not necessarily dialectical), one that can produce *syncretic alignments* (and not necessarily syntheses).[9] The syncretic situation allows for the reading of the dialogue of elements that, at a closer viewing, relate through *antagonism*, not opposition.[10] In the antagonistic relation, differences between parts are maintained, since the very relationship of these parts depends on their maintenance, not on their dissolution, as in a dialectical development. In this sense, the syncretic situation does not lead to the fusion, absorption, or annihilation of the elements in order to allow for the survival of the other. At the same time, the maintenance of distinct elements necessarily implies their mutual modification. Hence the myriad of apparently contradictory elements that may clash but not necessarily disappear in Rocha's narratives.

As for the seemingly enigmatic/faulty/polyglot title (one of Rocha's most accomplished poetic creations), its efficacy as a condenser of meanings is perhaps best proven by the (neo)colonialist reader himself, who inscribes it in the ranks of "ungrammaticality." The critic may have been puzzled by the fact that the film is titled *Der Leone HAVE Sept Cabeças,* which may sound too broken for academic Anglophone ears. On the other hand, the fact that such a film has a mutating polyglot title—featuring the languages of the major colonial powers in Africa—seems to agree with its militant character.

However, *Der Leone Have Sept Cabeças* must not be seen merely as a militant act, a pamphlet that serves as the stage for a few allegorical characters to recite their political rhetoric. The film indeed conflates the emblematic trajectories of a handful of European mercenaries led by an American agent, and African rebels led by a reincarnated Zumbi (the celebrated black hero of the maroon community of Palmares in seventeenth-century Brazil)[11] and supported by Pablo (a direct reference to Che Guevara). Such neatly designed allegories are confronted by other, distinctly ambiguous characters: a European priest wearing a soiled white cassock who seems to oscillate between the theology of liberation and a simply psychotic, whining mysticism; and Marlene, a sexy blonde who also oscillates and who can be seen variously as aligned with the soldiers of fortune, in repentance before the priest, or in open solidarity with the rebels. And even the more simple allegories might have surprised the audiences at the time of the film's release: *Der Leone* must have seemed senseless to spectators who could never have imagined that Cuba would send troops to Africa seven years later, as the Latin American character in the film seems to suggest. The film is, above all, a complex tableau with a disarmingly simple mise-en-scène that may, at times, surprise and confuse the audience, as Rocha's films usually do. Whether through filmed or written antigrammar, or prophetic political alignments, Rocha's films reveal a multiheaded author.

Filmic Séance and Massacre

Rocha defined his African film as a séance, whose mise-en-scène is marked by both possession rituals and guerrilla tactics:

> It is the story of Che Guevara and Zumbi dos Palmares in Africa, but they descend through the materialization of the blacks. I think the Europeans did not understand why the myths descend, act out, and go away. The film is entirely magical in this sense, but it is also materialist, it is utterly rigorous in its

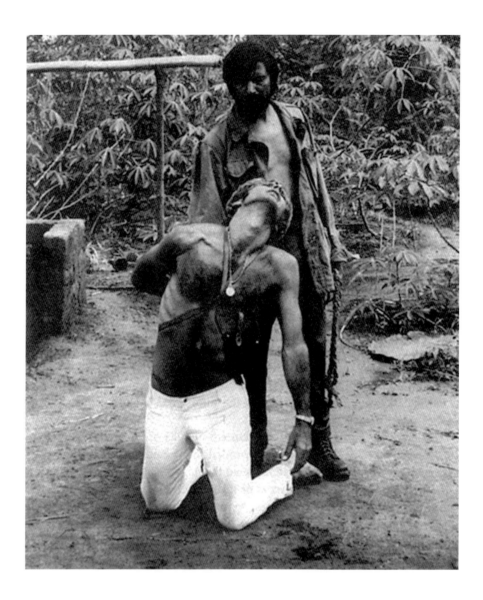

Still from *Der Leone Have Sept
Cabeças* (1970), dir. Glauber Rocha.
Courtesy of Glauber Rocha Estate.

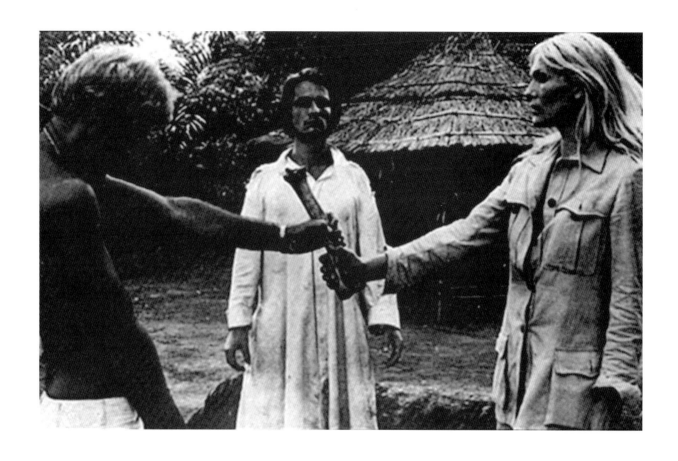

Still from *Der Leone Have Sept Cabeças* (1970), dir. Glauber Rocha. Courtesy of Glauber Rocha Estate.

political discourse, that is, the dialogue is rigorously didactic, but all the mise-en-scène stuff is entirely magical as if it were a *macumba* summoning; there is the mourning ritual at the start, upon which Zumbi descends, and there is the resurrection ritual at the end, when the Che [character] is revived by the magic of the blacks, and there is the transformation of the *macumbeiros* into the guerrilla of Amílcar Cabral. For Zumbi, in the film, was referring to Amílcar Cabral, who died. The film, by the way, is an homage to Amílcar Cabral.[12]

For those who have not seen *Der Leone Have Sept Cabeças,* Rocha's description may suggest a work full of special effects, but this is not the case. *Der Leone* is staged as a Brechtian drama, with hardly any props. The sequence shots compose tableaux or sketches that encapsulate short narratives articulated through the editing. The so-called magical characters walk in and out of the scene as if they were approaching the edge of the stage in order to utter their lines. That is how Zumbi, Che, and the others "descend." The camera is constantly addressed by the characters, in a move that breaks the usual "fourth wall" of dramatic fiction. And similar to epic drama, *Der Leone Have Sept Cabeças* is clearly presented as a manifesto, as a weapon for struggle.

One of the scenes exemplifying this theatrical simplicity is the sequence shot that frames a huge tree on whose branches a group of Africans joyfully sing and clap to the rhythm. The camera performs a slow circle around the tree until a jeep full of mercenaries, far away in the background, slowly approaches the setting, arrives, and parks in the shade. The Europeans gesture for the Africans to get down out of the tree. One by one, they descend to have their hands shaken, in a friendly way, by the commander of the mercenaries. The scene exudes a candid tone—emphasized by the music the Africans sing—which is gradually replaced by a serious silence as each African who alights from the tree stops singing. One by one, the Africans are aligned neatly in a row. When the row is complete, one of the mercenaries shoots each African in the back, in a move that does not allow time for any possibility of justification or preparation. There is no build-up of tension whatsoever: it is just "another" massacre, a genocide without warning, both for the characters who stand for the "Africans" as well as for the spectators, all of us caught by surprise. In a Brechtian tone, the scene emphasizes racial difference and gives political content to the massacre. The jeep leaves the scene and the camera remains, under the now absolutely silent tree.

The Colonized Polyglot

In this reading I will focus upon the character Dr. Xobu, the African chieftain who is made "president" of the nation forged by the colonialists. The way Xobu is presented in

the film condenses, in a few shots, the formation of alliances that allowed for five centuries of European exploitation of the African people. Xobu is seen sitting royally in the center, surrounded by a Portuguese colonizer, a German mercenary, and an American agent. Their dialogue displays two discursive levels of *Der Leone*'s narrative: polyglossia, made evident by the film's very title; and heteroglossia, which, as Mikhail Bakhtin defines it, is the discursive diversity that foregrounds social (or ethnic) differences among the characters.[13] The multiplicity of discourses featured in this scene is further enhanced by the casting and the unfolding of unexpected accents: Xobu is played by African actor André Segolo; the Portuguese colonizer by Brazilian actor Hugo Carvana; the German mercenary by German actor Reinhard Kolldehoff; and the American agent by Italian actor Gabriele Tinti, whose dark hair was dyed blond for the part. The agent speaks in French, with a heavy Italian accent:

> Now listen, doctor Xobu. You are the richest and most important man in the region. You are the most important representative of the local bourgeoisie. It is a must to fight communism. That is why you will be the new president of . . .

Xobu replies, in English:

> I am sorry, I don't understand . . .

The Portuguese colonizer intervenes, stressing (in French) to the American agent that

> You don't know these people very well. . . . Leave it to me.

The Portuguese then whispers in Xobu's ear. The latter reacts, now in French:

> O, I understand. . . . It's independence with friendship!

The Europeans confirm: the American agent promises technical and economic protection; the German mercenary promises military protection. The Portuguese, in his turn, promises "racial integration" and "liberty."

The dialogue thus refers to the ideologies that were cultivated by the Portuguese dominant classes from the fifteenth century up to the early 1970s. They asserted Portugal's proximity to Africa, Portugal's pioneering navigations around the continent, and most important, Portugal's acknowledged kinship ties with Africa—an element often invoked in discourses that were meant to justify the Portuguese colonial presence

there. Brazilian sociologist Gilberto Freyre, for instance, notes that in northern Europe the Portuguese have been considered a miscegenated people, due to their geographical position and the influence of Arab control of their territory for many centuries.[14] Such reasoning emerged in the discourses that justified King Sebastião's ill-fated campaign against Morocco in 1578. It emerged again in the discourses that wrapped the military operations of Salazar's dictatorship from the 1950s to the early 1970s, which marked Portugal's very last attempt to hold on to the African colonies. Portuguese propaganda films showed military commanders in Africa alongside African chieftains asserting their belonging to one, indivisible "nation."[15] On the other hand, the "kinship discourse" that was so often used by the Portuguese colonizers did not threaten their own convictions of ethnic superiority over the Africans. For instance, it did not keep Portuguese soldiers from playing soccer with the severed heads of African prisoners during the colonial wars.[16]

After having toasted his presidential title, Xobu makes his first demands:

> Well . . . this is it . . . and I am the first president. . . . Well . . . will you excuse me. . . . I want a gala uniform for President. . . . I also have to prepare my first speech. . . .

The apparently hesitant tone of his voice may sound natural for a first-time president. On the other hand, Xobu summons here the behavior of the subservient slave, who has to excuse himself repeatedly in order to enter the master's grounds: as the racist saying goes in Brazil, he is "the black who knows where his proper place is."

Der Leone Have Sept Cabeças thus makes it clear that Xobu—despite his title of "doctor"—will *not* be an effective member of the neocolonial group, ethnically defined as European. His mere supporting role in the Eurocast is emphasized by the parodic treatment he undergoes in the mise-en-scène. The historical model for this allegorical character was only budding at the time *Der Leone* was being produced, suggesting another prophetic statement by Rocha: the real-life model was Emperor Bokassa, the autocratic Central African ruler. His name hit the press in the early 1970s, when he crowned himself emperor of his country and ordered a replica of Napoleon's throne for the ceremony. This figure of French neocolonialism is visually rendered and clearly suggested in another scene in *Der Leone*. When the Latin American rebel is being tortured by the mercenaries, the American agent dons a typical African dashiki, or loose shirt with colorful patterns. This act could stand for the possible Africanization of the agent, but instead his dashiki reveals the type of alliance the agent promotes in Africa—

for the cloth bears the effigy of Bokassa. That kind of cloth, which carries a black-and-white photographic imprint of a government leader, is quite popular in Africa. But the presence of Bokassa's image in the film, at this point, is especially telling: the agent's clothing bears the image of one of the most successful Dr. Xobus of the African continent.

The sequence that depicts Xobu's inauguration is a tragicomic collage of distinct audio/visual signifiers that produces a clash of meanings. Rocha's films are often considered contradictory, and this sequence from *Der Leone Have Sept Cabeças* may very well be used to support that judgment. According to René Gardies, "Rocha's characters are the site of a multidimensional juxtaposition of codes."[17] On the other hand, if one considers the dialogical relations of the characters and the narrative strategies that produce them, they can be seen perhaps as the result of *articulation* and not "juxtaposition." Thus, if a reading accounts for the articulatory possibilities in this sequence, it may be possible to envisage all these apparently contradictory elements as engaging not only in oppositionalities but also in *alignments*. The narrative strategies function here as part of a centrifugal system that can yield different meanings at once. This sequence—perhaps one of the most elaborate and complex of Rocha's filmography—in fact *requires* an articulation, one which attempts to disclose significations that, at a first sight and hearing, may seem simply contradictory. This articulatory reading takes into account the centrifugal quality of the signifiers that point to as many directions as are possible significations.

It would be impossible, however, to apprehend all significations. One of the premises of such a reading is, not surprisingly, the recognition of the limitations of such a search. This operation also requires the articulation of a reading of the provisionally "fixed" positionalities of the elements with a reading of their contextualization in a shifting flow of signifiers, whose dialogical relations can suggest the unfolding of new meanings.

The Enslaved Gentleman

Xobu's inauguration is set up as a ticker-tape parade orchestrated by the Europeans. Framed by an unstable handheld camera, Xobu rides in an open white car and waves to the few people who applaud. Most people walk around and seem to ignore the show. Xobu wears the outfit of an (evidently white) eighteenth-century European nobleman, complete with white-powdered wig and tricorne hat, and he carries a scepter. Near Xobu's car, the American agent pulls the Che character by a rope while the mercenaries,

carrying machine guns, celebrate with much dancing and howling. Leading the parade are three black saxophone players, who open up the way through the crowd.

The first element to consider here is the figure of Xobu, the puppet-president put in power by the neocolonialists. The parade he stars in is just a parody of the parades that are meant to salute heroes: Xobu is not a hero, and this was made clear from the very moment the Europeans approached him. Accordingly, very few passers-by dance to the music of the saxophones. The timid—or indifferent—reaction of most people in the crowd reinforces Xobu's status as a political puppet. And, as if contributing to the parodic atmosphere, the music itself is joyful and jazzy, having nothing to do with the solemn marches usually played at events celebrating the civic rituals of African nations.[18]

Rocha's depiction of Xobu's inauguration has, indeed, all the elements of a parodic, carnivalesque event. This approach is highlighted by Xobu's outfit, which at first sight is just one more carnivalesque element. His (Euro)aristocratic appearance can be seen as foretelling the emergence of Bokassa's vanity. To an international audience, the image of an African wearing the clothing of a European aristocrat (or sitting on a European throne, for that matter) is scandalous in itself, since it meshes two apparently irreconcilable signifiers: that of a (pitch) black man hopelessly trying to pass as (milky) white. The obviousness of the farce is further reinforced by the image of Xobu brandishing a bone instead of a scepter.

The implications of such a depiction in the general context of ethnic representation in the film can lead to passionate reactions. Marcel Piault, a filmmaker and anthropologist from the Musée de l'Homme in Paris, who debated with Rocha in the late 1960s, simply framed *Der Leone Have Sept Cabeças* as a racist film, *tout court*.[19] René Gardies, on the other hand, described Xobu as a narrative strategy "to denounce the servile imitation of the European model in Africa . . . [thus] Rocha adds, to Xobu's grotesque outfit, the exaggerated emphatic tone with which [the character] destroys, like a parrot, a mixture of French poetry clichés."[20]

When read from a Brazilian perspective, however, Xobu's outfit clearly evokes carnivalesque celebrations, but with completely different resonances. It resembles the outfits donned by the performers of the traditional parades of Rio's *escolas de samba*. Xobu's costume is modeled after those worn by eighteenth-century slave masters, who themselves mimicked the Parisian style, that is, the style worn by the French court, which signifies (definitely "white") nobility, aristocracy, and monarchy. In the first half of the nineteenth century, French artist Jean-Baptiste Debret noted in the carnivalesque celebrations of Rio, "groups of blacks [who paraded] wearing masks and costumes of

old-time Europeans, graciously imitating their gestures and greeting people installed up on the balconies."[21] In this sense, as Mikhail Bakhtin has taught us, those men would be performing a typical carnivalesque inversion, in terms of social class, race, and ethnicity.

Ancien régime costumes, however, also echo the eighteenth-century-style outfits that were donned by (black) lackeys and butlers in Brazilian bourgeois households throughout the *nineteenth* century. In this context, such outfits might signify not only inversion but also a *continuum* between the workplace (where the costume denoted subalternity) and the streets taken over by carnival celebration. The streets, in this sense, become a stage where the costume can be read as a re-keyed signifier, with a new signified. From this perspective, Xobu's outfit can mean both the assertion of "white" superiority and dominance *as well as* the ascension of blacks to a status of nobility. Such an operation emphasizes a "serious" meaning, which somehow seems to defeat the intentionally "parodic" overtones of carnival. Indeed, Brazilians have often regarded carnival as the opportunity for the subaltern to display their potential "dignity," otherwise pulverized by a cruel everyday. This view was often stressed in popular songs of the late 1960s, which refer to the tragic dignity of carnival performers. The reference to these performers in songs by Geraldo Vandré and Chico Buarque, for example, often served as a device to *allegorize* working-class characters, which were regularly censored from the lyrics by the military dictatorship if they sounded too literal. Many of those songs refer not only to "tomorrow" as standing in for the "revolution," as Gilberto Vasconcelos has noted, but also to carnival personages as standing in for the rebelling proletarian or peasant.[22]

Until the 1960s, the pageants of samba schools (carnivalesque social clubs known as *escolas de samba*) usually featured hundreds of (mostly black) performers donning that style of dress (as can be seen in Marcel Camus's film *Black Orpheus,* which was shot in 1958 in Rio de Janeiro), in a tournament that gathered all the schools in a competition. That style predominated for several years, even when the diegesis suggested by the *enredo* (or plot) of the parade referred to a historical period other than eighteenth-century Western Europe.[23] A samba school, for example, might narrate the sixteenth-century "discovery" of Brazil by the Portuguese with the performers wearing eighteenth-century outfits, in an operation that meshes different times and creates unexpected chronotopes. That style—with the mandatory white-powdered wig— seemed to be consecrated as the utmost sign of nobility (even though white). From this perspective, the appropriation of eighteenth-century-style outfits by samba school performers in the twentieth century can also be read as a sign of (re)conquered dignity,

one that refers to the dignity of (undefined) old times, before slavery proper. Moreover, that type of outfit has little to do, today, with the uniforms of house servants, since the old-style outfits are no longer worn in bourgeois households.

Today, most samba schools feature diverse styles of clothing according to the plots they present. However, the power of that icon from the eighteenth century is still felt, for all samba schools are required (by official tournament regulations) to present an emblematic pair of dancers, the *mestre-sala* and the *porta-bandeira,* who are invariably dressed up in that same old style. Their performance is especially highlighted in any parade, and both compete for prizes in a special category that compares the *mestre-salas* and the *porta-bandeiras* of all schools. *Mestre-sala* refers to the man who is symbolically a master of ceremonies, as if the success of the parade depended on his leading; *porta-bandeira* identifies the woman who carries the school's flag. Their dancing involves particular accessories that contribute to a specific choreography, such as the flag itself, whose pole is always placed on the woman's hip, and the fan, which is carried and flapped by the man. The maintenance of the style for these (noble) roles suggests the seriousness of the appropriation. Today, the *mestre-sala* does not suggest parody at all—he is instead seen as a symbol of black nobility and, as I have noted before, his performance can be seen as the suspension of his subalternity as a black. Thus Xobu, in the context of the Brazilian imaginary, is directly related to the *mestre-sala.* In this sense, Xobu's figure accumulates disturbing possibilities for dissonant readings, ranging from those that detect overt parody to those that recognize legitimate symbols of (a preslavery, lost and demanded) dignity.[24]

Tunes of Revolution, Lyrics of Colonialism

But the sequence of Xobu's inauguration becomes even more complex: the parade in *Der Leone Have Sept Cabeças* comes to a halt when the car stops, the saxophones stop playing, and Xobu delivers his "Independence Address." Xobu stands inside the convertible, framed from a low angle. The scene is complicated by the multiple aural code. At first, the diegetic trio of saxophones only punctuates the phrases of Xobu's speech, standing for the predictable applause that usually reinforces the performance of populist speakers. The musical phrasing of the saxophones sometimes covers and fragments Xobu's procolonialism discourse:

> It is a must to remember that colonization brought us the true face of
> Christianity. It brought us the civilized languages, science, the knowledge of the

arts. It brought us from the United States of America our economy. Brothers. Colonialism is our strength.[25]

Xobu's speech becomes totally inaudible when it is covered, extradiegetically, by a voice offscreen that begins to sing, a cappella, a Portuguese-language version of "La Marseillaise." The voice, recognizable to Brazilian audiences, is that of celebrated (black) singer Clementina de Jesus.[26] The inclusion of "La Marseillaise" in the soundtrack may seem, at first hearing, suitable for a celebration of independence, one in which a colony declares its autonomy. The anthem would apparently contradict one of the signifieds of Xobu's *ancien régime* outfit: that which connects it to the very aristocracy that was ousted by the revolution that had "La Marseillaise" as one of its emblems. But Xobu's speech is *not* declaring national autonomy, but rather reinforces (neo)colonialist ties. Another complicating factor is the fact that the lyrics sung by de Jesus have nothing to do with the original French words of "La Marseillaise." That version in Portuguese, in obvious contradiction to the original verses, sounds more like an homage to a nineteenth-century Napoleonic France:

> Country of light, of sublime light,
> You are our sister country.
> Cradle where Lamartine was born,
> Cradle where Napoleon was born.
> Country of light, Mother of civilization.
> You are and will be our Hope,
> You are and will ever be the Sun.
> In our heavens, in glory,
> Your great God, glorious France.
> To arms, citizens![27]

By emphasizing romantic nationalism and placing France at the center of European civilization, these verses echo the discourses that justify imperialist intervention in African affairs and thus agree with the contents of Xobu's discourse. Similar to the Portuguese and other colonial powers, the French justified their interventions with ideologies of racial and historical superiority, and these lyrics in Portuguese seem to confirm that fact.

Xobu's speech ends with the sound of applause off-camera, which is, in fact, the recorded sound of applause at Clementina de Jesus's live performance. This adds to Xobu's inauguration an eerie effect that foregrounds its falsity.

The repercussions of this semantically dissonant rendering of "La Marseillaise" in the film are multiple. On the one hand, the tune connects the event to the French Revolution—and that may very well be the effective reception for most non-Lusophone audiences. On the other hand, the lyrics connect it to the ideologies that endorsed the nineteenth-century Restoration and its historical consequences. Furthermore, the voice that sings the anthem connects it to a context of African(-Brazilian) reappropriation, refracted in Xobu's outfit of *mestre-sala.* That voice can be heard, from this perspective, as a device that recontextualizes and complicates Euroconnotations.

The apparently good-humored carnivalesque confusion that stems from this scene can function, in fact, as a smoke screen for the representation of ideological operations that have been in effect since the early days of colonialism. Moreover, the dance of signs in this sequence point to iconic articulations that reveal possibilities of oppositions *and,* at the same time, of syncretic (re)alignments. This scene, which can be taken as emblematic of the narrative strategies of *Der Leone Have Sept Cabeças* as a whole, defies univocal readings as it presents signifiers that point to multiple signifieds, in a centrifugal movement of dissonant polyphonies that prevents closure.[28]

Berlin, 2002

Der Glauber Have Sept Cabeças

1. As told to Raquel Gerber, in *Glauber Rocha* (Rio: Paz & Terra, 1977), p. 34. Unless otherwise noted, translations are mine.

2. A parodic portrayal of that transition can be found in the opening of *Xala* (1975), a film directed by Ousmane Sembene.

3. See Gerber, *Glauber Rocha*, in which Rocha refers to Cabral's assassination in 1973, in Conakry. The struggle for independence in Guinea-Bissau and Cape Verde was essential to the rise of similar movements in Angola and Mozambique.

4. Paulo Emílio Salles Gomes, "Nota Aguda," in Carlos Augusto Calil and Maria Teresa Machado, eds., *Paulo Emílio, um intelectual na linha de frente* (São Paulo: Brasiliense, 1986).

5. Roy Armes, *Third World Filmmaking and the West* (Berkeley: University of California Press, 1987), p. 266.

6. These terms were coined by Salles Gomes in his influential essay "Cinema: Trajectory in Underdevelopment," in Randall Johnson and Robert Stam, eds., *Brazilian Cinema* (Austin: University of Texas Press, 1986).

7. Armes's work does not encourage a further examination of the film. It should be remembered that his book is aimed at Anglophone college students and faculty members, who form the very public that could develop some interest in Rocha's works.

8. Glauber Rocha, *Revolução do cinema novo* (Rio: Alhambra/Embrafilme, 1981), p. 150.

9. See Marcos Becquer and José Gatti, "Elements of Vogue," in Ken Gelder and Sarah Thornton, eds., *The Subcultures Reader* (London: Routledge, 1997); and for an enlarged version, *Third Text 16/17* (London: Kala Press, 1991).

10. For a discussion of these concepts and their role in the works of Hegel and Gramsci, see Chantal Mouffe and Ernesto Laclau, *Hegemony and Socialist Strategy* (London: Verso, 1986).

11. *Der Leone Have Sept Cabeças* shows that character-naming can be a very risky enterprise, for non-Brazilian audiences may associate Zumbi with the pejorative resonances imprinted by Hollywood films that convey caricatures of Haitian religion.

12. Quoted in Gerber, *Glauber Rocha,* p. 35. Cabral seems to represent here the nonmystical element, the physical level of the struggle in the world. Cabral himself, in his writings, stressed the importance of reason over mysticism, choosing a frankly materialist stand. At the same time, he instructed his fellow fighters to respect the religious traditions of the people, as an expression of difference, which was to play a central role in the struggle against colonialism. See Amílcar Cabral, *Análise de alguns tipos de resistencia* (Bolama: Imprensa Nacional da Guiné-Bissau, 1979).

13. See Mikhail Bakhtin, "Discourse in the Novel," in *The Dialogic Imagination* (Austin: University of Texas Press, 1981), p. 263.

14. See Gilberto Freyre's major work, *The Masters and the Slaves/Casa grande e senzala*, trans. Samuel Putnam (Berkeley: University of California Press, 1987).

15. This scene, taken from a piece of official Portuguese propaganda, is featured in the first documentary ever made in independent Mozambique, titled *25* (1975), a compilation conceived and directed by Brazilian filmmakers José Celso Martinez Correia and Celso Lucas.

16. That was another scene registered by Portuguese cameras and featured in *25*'s special three-hour version, which unfortunately was not widely distributed. This version was screened at the 1979 São Paulo International Film Festival.

17. René Gardies, in Gerber, *Glauber Rocha*, p. 55.

18. Most African nations—whether aligned with the left or the right—seemed to strive to build up a serious, European-style image for their state apparatuses. I have already referred to *Xala*'s allegorical depiction of the Europeanized bureaucracy. Another (extreme but quite emblematic) example is that of Bokassa. And the inauguration of Samora Machel as Mozambique's first president in 1975 featured a regular European-style band that played military pieces, also European-style. Mozambique's national anthem also has all the elements of European martial music. The training of Mozambique's military forces, however, has little in common with the rigid routines of European-style armies: soldiers present their arms in a choreography to the sound of popular African rhythms. Machel's inauguration, the presentation of the anthem, and scenes of military drills are carefully depicted in *25*.

19. Piault exposed his arguments at a screening of *Der Leone* at a meeting of ABA-Sul (Brazilian Anthropological Association, Southern Chapter) in September 1995.

20. Gardies, in Gerber, *Glauber Rocha*, p. 45.

21. Quoted in Ana Maria Rodrigues, *Samba negro, espoliação branca* (São Paulo: Hucitec, 1984), p. 80.

22. Gilberto Vasconcelos, *De olho na fresta* (São Paulo: Graal, 1978).

23. For many decades samba schools were forced to use episodes of Brazilian history for their parade themes, due to a decree of the Vargas dictatorship in the late 1930s. Because the government was concerned with themes that dealt with present-day social issues, the decree sought to link social criticism to issues of the past.

24. So goes the line of Aldir Blanc and João Bosco's hit song of the 1970s, "Mestre-Sala dos Mares": "He had the dignity of a *mestre-sala*."

25. Xobu's speech goes against the directives of African intellectuals—such as Cabral—who claimed the use of the colonizers' language as a weapon *against* colonialism, *not* as a tool for the (re)affirmation of colonialist values.

26. De Jesus, who died in 1983, was responsible for the recording of many old sambas and slave chants. She became a central figure in African-Brazilian culture in the 1960s, when she began her public performing career at an already advanced age.

27. My translation.

28. After *Der Leone Have Sept Cabeças*, Rocha went on to experiment further with film narrative. But it was in his only novel, *Riverão Sussuarana* (Rio de Janeiro: Record, 1977), that such textual meshings were truly radicalized. Largely ignored by the critics, that novel displays many narrative strategies that would be transposed to film in *Age of the Earth*, Rocha's last work before his death in 1981.

The Museological Unconscious

Victor Tupitsyn

To begin, I will refer to Karl Jaspers's museological dream revealed in the introduction to his book *The Great Philosophers*.[1] This text can be described as a museification project—the museification of a historico-philosophical space. Whereas Lacan's vision of the unconscious is bound to the three registers, the residents of Jaspers's philosophical museum are partitioned into several (fraternal) groups and subgroups.[2] Their members are *present* there only in the sense that they re-*present* the symbolic function. Jaspers projected his philosophical "hall of fame" as the place suitable for a successful combination of the dead and the living. One may argue that similar combinations take place in the Symbolic register (due to the transfer of "the name of the Father"). In a way, Jaspers's museum resembles both Dante's *Inferno* and Raphael's *The School of Athens*. The similarity lies in what Bakhtin attributes to *verticality* (the "chronotope of vertical time"). When time is vertical, all events occur simultaneously; deferred histories become synchronized; thoughts and visions attain the state of timelessness. Hence, vertical is synonymous with ahistorical, which partially explains why our eagerness to verticalize history culminates in erecting museums. This is particularly true of Jaspers whose "Die massagebegen Menschen" seems inconsistent with his own horizontalist agenda, with what he called "the all-embracing historicity." It also shows how comfortably the ahistorical "hides its ass" beyond the looking glass of historicity: their longing for one another should be viewed as a tradition rather than a chancy outcome.

Yet another tradition has been revived; artists are co-sponsoring publications about themselves, in which they control not only the selection of material but also its

interpretation. Examples of these include Ilya Kabakov's memoirs, *The '60s and '70s,* as well as his notebooks (texts, designs, and projects which, for one reason or another, were not featured in his exhibition catalog); Vladimir Nemukhin's *Monologues* dedicated to the lifestyles of unofficial Moscow artists; Igor and Svetlana Kopystyansky's archives (annotated by themselves);[3] Leonid Sokov's book project that aims at publicizing his sculptural oeuvre; the conceptual editions of Vadim Zakharov; and the Collective Actions Group's six-volume chronicle, *Poezdki za gorod* (Ad Marginem, 1998), which looks as if it were authored by the subject matter itself.[4]

The eternal Russian question, which apparently has no answer, is "What is to be done?" In this case it is, What is to be done with art that has not realized its museological function in time, even if this is through no fault of its own?[5] The museological function has a communicative dimension; it generates the illusion (comparable with children's reliance on the power and accessibility of a spoken word) that every creative act is common property. This falls under the definition of egocentric speech, or, more specifically, the egocentric speech of the signified.[6] Thus, the principal purpose of the publications mentioned above confirms their egocentricity: they are attempts to reproduce the museological function at the artists' own expense and on their own terms.[7] Understandably, the embryonic state of the museological function creates unbearable psychic discomfort, whether we admit this or not. Many feel a desire to compensate for this yawning gap, often by publishing collections of old articles or old art projects. In all such projects the artists lay out their creative biographies (and their oeuvre) in a direction deviant from signification.[8] What takes place in these antisignification plots is the return of the author, hitherto "buried" by Barthes and Derrida.[9] This return is expressed, above all, in the attempt by the art practitioners to redefine their function: to become psalmodists of their own "scripture," their own visual *texts.* To *read* them in a direction deviant from signification means to engage in an egocentric reading which (in the West) is regarded as an alternative to an institutional one. Egocentric readings, as opposed to resisting institutional control over the formation of meanings, can compensate for the absence of institutions. The important points for the majority of Russian artists today are not the subversion of the mechanisms of signification or the disassembly of the museological function, but their renewal, upgrading, and re-creation.

A passion for an egocentric reading of one's own text—be it an artwork, critical inquiry, or theoretical investigation—can only be matched by some authors' ability to constitute the unity of what they think and how they look. In "Marcel Duchamp in America: A Self Ready-Made," Moira Roth argued that "Duchamp's choice of America in 1915 was the right one for a man obsessed with the making of his own image, the perpetuation of that image, and total control over its reading."[10] Vladimir Nemukhin

remembers an episode that involved one of his friends, the Moscow artist Vladimir Yakovlev, at the sculptor Ernst Neizvestny's birthday party in 1975. The celebration reached its peak when the wife of the film director Youtkevich informed the guests that she had a *big* Picasso in her possession. "I have a *big* dick," said Yakovlev in response. "I beg your pardon?" she inquired and then turned to the host for help. "He too has a *big* Picasso," explained Neizvestny. This carnivalesque nondifferentiation between sexual organ and masterpiece reveals the libidinal subtext of museification, thereby indicating that the latter is a phenomenon of phallic origin.

However obsessive, Duchamp's desire to control and to "museify" his image pales in comparison with Clement Greenberg's eagerness to control the image of American abstract painting.[11] In a desperate attempt to run ahead of signification, Greenberg—in his 1948 article "Situation at the Moment"—wrote that "the future of Western art . . . depends on what is done in this country [the United States]." Ironically, Greenberg's statement fits his own definition of vulgarity, as "the truly new horror of our times [which] totalitarianism . . . is able to install in places of power."[12] The fact that this definition was attributed to Russian art calls for its reassessment, especially after its retreat from the "places of power."

Our cultural memory can also be reassessed, in relation to which two parallel observations must be made. First, the past is a construct created here and now, mostly in our imagination (on the basis of one or another set of facts). We cannot "encompass" the anterior, that is, know "the entire truth" about its lost context, criteria, etc. To compensate, a model of *temps perdu* is created, which we then mentally pitch into one or another historical range in order to convince ourselves and others that "that's exactly how it was." Secondly, the "authentic past"—if it is appropriate to even speak of such a thing—has always been subjected to repression. In this sense, the past is a psychoanalytic concept. What has always reigned and still reigns in place of the past is a representation acceptable to those who have a stake in constructing a linear model of cultural identity. They use this construct as an ideological alibi, as well as for didactic purposes—a warning, a lesson, a moral. Nothing is so prostituted as the past. But to rescue it from the present (especially, in "one piece") is an enormous task, a utopian project of immense proportions even if we agree (following Husserl's footsteps) on the existence of the irreducible horizon, common to all empirical contexts. At the same time, the health of culture can be improved by an awareness not only of connections to the past but also of those breaks from it which contribute to contact with *le réel*. That is why I completely understand Kabakov, Zakharov, Sokov, or the Collective Actions Group when they break with the institutional historical function which, in the case of most Russian artists, does not work.

Both inside ex-Soviet territory and outside its borders, Russians utter the phrase "Museum of Contemporary Art" in a special, dreamy, breathless way. There have been and continue to be attempts to create a contemporary art museum based on some private collections.[13] At least 90 percent of the work in these collections is trash; but trash (for example, primordial dust), as we know, is the best material for creating a world. With each attempt we are witnesses to a cosmogonic act. The birth of a museum is like the beginning of time; time is counted from that moment on. The museum's founders and the artists whose works are in the permanent collection behave accordingly. One gets the impression that the museum is a maternity ward of the referent, that is, of art itself, *art-as-such*. The proximity of the referent or the imprints of its "presence" (on the museum walls or in the storage room) are treated as absolute knowledge of it. Interpretations by outsiders and the prior state of discourse are either ignored or annulled. Although people involved in such cosmogonic ventures often leave one with a dismal impression, they apparently cannot be treated as ordinary members of the *clergy:* they have been "canonized" and made into "saints."[14]

It is a well-known fact that museums are a phenomenon that date back to the late eighteenth or early nineteenth century. The museological function, however, is far older as is, for that matter, the museological unconscious. No one was present at its birth, and how it appeared remains a mystery. Lacan believed that the unconscious is the discourse of the Other. For artists residing in the former USSR, the image of the institutional Other was (until the turn of the century) firmly fixed on the absent museum of contemporary art. The evidence and the signs of this absence have constituted the psychedelic repertory of visual culture in Russia, and can be regarded as the language that structures the museological unconscious. This caesural language, the language of displacement and anticipation, is far from being the only architectural principle on the basis of which invisible museums, libraries, and archives are created. In addition there are other, compensatory languages that allow the individual to comprehend his or her own thoughts, actions, and psychic impulses as something "always already" depicted (or instantaneously appearing) on the canvas of Being. This understanding gives way to an aesthetic evaluation conditioned by contemplating the events from several standpoints: that of the character, that of the author, that of the viewer, and most importantly that of the connoisseur. When that last standpoint prevails, we can speak of the phenomenon of museification—museification of the individual's inner world and of the collective psyche. Through these the museological unconscious manifests itself. In essence, our ability to perceive life as a work of art, along with the ability to transfer this perception from ourselves to others and from others to ourselves, is quite consistent with Lacan's notion of the transition from the mirror stage to the Symbolic Order.

On the level of "individual history" (the subject's self-history), the origin of the museological unconscious can be traced back to early childhood. According to Freud, the child's passion to retain feces and delay the process of evacuation in order to receive greater pleasure while performing it turns, in the adult (whose anal eroticism is displaced into the unconscious), into the passion to retain and accumulate gold (money) which resembles (in color) infant's feces. Given the extent of the symbolic in our lives, it is clear that a symbolic function ensures the transfer of the image from one context to another, from one visual narrative to the next. This is why some of us value art as much as other people value gold: both are metaphors substituting for something else, including shit. In its latest, narcissistic stage, the museological unconscious might also be linked to coprophagy, or fecal economy (production and consumption of shit), which comes to mind when we think of Benjamin's notion of "the author as producer," especially in the case of writers and artists like Sade, Pasolini, Manzoni, and Beuys. Among the most recent examples is Paul McCarthy and Jason Rhoades's *Shit Plug* (2002): the shit collected from critics, visitors, artists, and curators in the public toilets during the opening weekend of Documenta XI and then "pressed in a suitable form"—a sex toy to which *Shit Plug* bottles make formal reference.

In *Aesthetic Theory* (1970), Adorno argues that "through its objectification [*Vergegenständlichung*] aesthetic expression becomes a nonobjective substance."[15] Given the analogy between "nonobjective" and "abstract," this brings to mind Robert Smithson's "abstract geology" which accentuates the similarity between "one's mind and the earth." Smithson's *Spiral Jetty* (1970) was an attempt to organize a "mess of corrosion into patterns, grids, and subdivisions." The side effect of this and many other "liberatory" efforts (related to earth works) is that in the course of such actions, the primordial and cosmogonic become museologically objectified. Now, more than thirty years later, objectification and the departure from it can no longer be seen as mutually deferred phenomena. This makes it difficult to justify Adorno's belief that art objects are "after-images of the empirically living," but not the other way around (that *die Empirie* is an after-image of the artistic).

Since the time when *Aesthetic Theory* was written, the relations between "autonomous art" and "its *other*" have entered an entirely new phase of instant reciprocation.[16] Apparently, the "de-reified activity" (associated with the autonomous and negative aesthetic vision) and "the universal mediation of life through commodities" can no longer be sequentialized in any orderly fashion. The immense speed of reciprocation has finally turned these phenomena into masks or gloves one can rapidly take off or put on. The transfer from one personality to another, from one optical register to the next takes virtually no time.

It makes sense to compare the publications under discussion (I am referring to the *book-as-diary, book-as-museum, book-as-ark*) to Gerhard Richter's *Atlas* (1962–96).[17] In *Atlas*, almost all the fragments are asignificative and lack autonomous artistic merit or self-sufficiency. The museological emphasis in this work is placed on its mesmerizing comparability to life, its temporal, spatial, and bodily aspects, its duration and finality. And that's what underlies our vote of confidence. We forgive Richter the tediousness, the pedantry, and the excessive length of his boring enterprise only because we recognize ourselves in all of it. The point, however, is that to recognize ourselves in *all of it* is not, in this case, an ordinary or a routine act of reciprocation. Rather, it is an opportunity for Richter and his audience to rejoice in a cliché, and—above all—to rejoice in it under the museum roof. For, once inside, we reexperience sameness in a different way, different in the sense that in a temple of art—unlike in a shopping mall or in a subway—our reflections are mediated by the aesthetics of the Sublime. Thus, with *Atlas* (as an exemplary work of art in the age of museological reproduction), our craving for all kinds of unifying clichés and, more, for presenting them in an affirmative way becomes legitimized on the highest secular level, that is, through the museum.

To follow up on the theme of rejoicing in a cliché, I will cite Kabakov in whose opinion, "we all have a mysterious capability to merge with the inner vision of writers, poets, and artists. Such a merging is possible because somehow and for some reason, the vision of the *other* turns out to be absolutely contagious, infectious."[18] In his unpublished 1998 text "Painting Is dead! Long Live Painting," the artist Eric Bulatov writes: "Whatever is depicted on a picture creates in the viewer's mind a picture of his own life." The way the word "own" is used in this quotation seems questionable, for to determine what borrows from what—a picture from life or life from a picture—is hardly clear-cut. Ultimately, visual culture has affected us in such a way that we have started to see the world, and ourselves in it, through the lens of representation. "Thanks" to the mass media, this phenomenon has become universal. Jeff Wall's photographs *Mimic* (1982) and *The Sudden Gust of Wind* (1993) share compositional similarities with *Paris Street, Rainy Day* (1877), a painting by Gustave Caillebotte, and Hokusai's *Travelers Caught in Sudden Breeze at Fujiri* (1832). These similarities suggest the possibility that the photographer is merely explicating the functioning of the museological unconscious which, a priori, even before the moment of contemplation, impels us to perceive reality as the product of a mimetic act, as a replica of art.

One can imagine a soap opera in which the action takes place in a museum and refers to the works of art as if it were inspired by the subject matter, the iconography, and physiognomic plasticity of the paintings hanging on the walls. Guy Debord's term "Society of the Spectacle" does not seem entirely appropriate for characterizing such an

act of psychomimetic reciprocation; it would be more accurate to speak of a "Society of the Museological Spectacle." Generally, in a society of actors and spectators, membership in either of these groups is a pure formality: the spectators are merely playing the role of spectators, while the actors are avidly watching their performance from the stage.

The individual's museological "I" is less a museum than a "private collection." In this case, the museological "I" appropriates all roles, functions, and prerogatives: it is the author and (simultaneously) the creation, the collector and the collection, the archivist and the archive, the exhibition space and the exhibition, the art connoisseur and the work of art. In the case of a plural "I," we are dealing with a "corporate museum," and thus with a collective author. At any rate, art whose time has gone (and, accordingly, its connection to referential space) compensates for it with "museological time."[19] It is not in anyone's power to hinder or help this process. Be it as it may, the concepts of "museological time" and "museological merit" are the surplus value acquired by a work of art when it has been emptied of its content and its connection to the unique cross-section of the circumstances which generated it. To mention such circumstances, if only in passing, the build-up of the socialist culture industry in the 1920s was a decisive factor contributing to the avant-garde's transformation into socialist modernism.[20] Another example (attesting to a different tendency) is the unwillingness on the part of the post-Soviet (capitalist) culture industry to absorb the domestic vanguard art of the 1990s.

Although the role of the media in the creation of significations is obvious, they simultaneously retard this process, fitting everything that emerges on the horizon of culture into the procrustean bed of anticipation, that is, of ready-made beliefs, stereotypes, and evaluations. This is especially true of artists who become *representatives* of a different context, and whose works are viewed as "test samples" representing a different referential environment.[21] By different context, I mean something outside the "authority" that is supposed to register, evaluate, and judge cultural phenomena, and then find them a "proper place" in the inventory of other (already museified) items or entities. This process always culminates in displacement. Displacement is not only the inevitable companion of signification but also a precondition of its emergence. This is nothing to complain about; it is a law of sign formation that is particularly true when new significatory paradigms—interpretive, interdisciplinary, etc.—are born. It is much worse if they are not born. Then, a new phenomenon is squeezed into existing (that is, old) packaging: it is shaped to fit the stereotype, acquiring a secondhand signification which is alien to it. Currently, something like this is happening everywhere. I am referring to sign formation without enrichment, displacement as a result of the substitution of value content with a devalued and often content-free enumeration of commonplace

truisms. These truisms are anticipatory in nature; they are the most easily discernible objects in the act of cognizance. Visual experience is no exception: the answer to the question, "Exactly what do I want reality to be like?" is simple: museified as much as possible and in harmony with its representation (*imago*) in my museological unconscious.

I am reminded of my search for a drugstore in a large, unfamiliar, and unusually deserted city. After wasting an hour on endless wanderings, quite exhausted, I finally saw a neon sign that said "Pharmacy." Inside, disappointment: it was a stationery store. On my way out, I glanced back at the treacherous sign which now read "Stationery." My desire to find a pharmacy had been so great that unconscious optics had overcome the usual visual reflexes and produced a wished for sight.[22] Anticipation proved stronger than reality. Reality, it turned out, can easily be washed off the mirror surface, which then reflects the *idée fixe*—exactly as I imagined it, even though such an anticipatory image is nothing more than an optical illusion. The same applies to a wide range of phenomena and activities. In modern societies, virtualization has risen to such a level that optical illusion has become a "normative" phenomenon. Aside from the fact that a mirror reflection of oneself is frequently substituted for the image of the Other, these reflections are often framed—not in a baroque frame like a work of art, but in a "museological" one. Thus, thanks to the "museological unconscious," we have become a part not only of the spectacular but also of the specular order.[23]

Another example is suggested by my encounters with several Western intellectuals whose ideas and/or opinions had already been "museified." As a rule, nothing extraordinary can be heard from them at a dinner party, theatrical performance, or exhibition opening. Regardless of one's access to the "champions of mind games," it is unthinkable to engage them in a professional conversation if its context fails to qualify as sufficiently museological—if it is not comparable to a showcase or a museum wall suitable for displaying the masterpieces of their thinking, whether rhetorical statements, viewpoints, or interpretations. But once the museological function is activated, the behavior of "paradigmatic" individuals suddenly changes, as if they have been caught in the auction house. In a split second these people become fully engaged and ready to put all their lexical artifacts on the counter.[24] This degree of receptiveness in regard to market value—be it monetary or Symbolic—is a "family trait" of the museological unconscious.

In my 1997 book *The Other of Art,* I discussed the colonization of the Other, the tempo of the artistic appropriation of all of its spheres and territories, including the unconscious. The following passage is also pertinent to my present argument:

> The modernist era, for the duration of which visual art was liberated step by
> step from guild, genre, criteriological, and other (professional) characteristics,

blurring the lines between itself and life, has culminated in a situation in which anyone can now be an artist, and anything can be a work of art. In other words, art has replaced itself with creativity, and creativity at present has no Other. Everything has become creative: work and leisure, trust and fear, violence and retribution, exchange and deceit. Politicians declare themselves to be practitioners of the art of Power; insurance agents describe themselves as virtuosos of their craft. Our perception not only of the outside world but of our own selves is hopelessly artified—not to mention the fact that the mentality and terminology of art have taken root in every sphere of life, without exception. Art has successfully completed the infiltration of its Other: for all intents and purposes, it has no Other any more.[25]

If one were to imagine a person who, from the moment of birth, was known to be completely devoid of the creative reflex, such a mythical character would have undoubtedly become an important cultural phenomenon. The media would follow every moment of his or her life, attesting that as months and years go by, he or she never sets out to create a painting, a poem, a novel. Merely by lying on the couch, this person would be seen as engaged in a struggle for the liberation of humanity from a "bad habit"— creativity—while the couch itself would become a laboratory for achieving the noncreative state. The question then arises: How would such a character be substantively different from all those whose principal pastime is doing nothing? The difference is that many such people know nothing about their potential; on the other hand, in the example I have given, the inability to create would be a "scientifically proven phenomenon." Since there are, of course, no such scientific criteria, this entire situation should be regarded as purely hypothetical, if not hallucinatory. Nonetheless, if someone among us could attract attention as a bearer (or "creator") of the noncreative condition, not only that person's biography but the person himself or herself would become museologically objectified and absorbed into the culture industry.

The reference to a fictional hero (the person who lacks creativity) is hinted by the questions related to Moscow communal conceptualism. Among such questions is the notion of "character" posited as the incarnation of the communal (or extracommunal) speech. In the present text, however, the emphasis is placed on yet another kind of dramatis persona—the visual. We tend to speak of the visual in passive terms, forgetting that we not only look but also produce vision. I am referring to the numerous clichés of seeing—the scenes and images that are present in ourselves, and in the image and

likeness of which we "see." In Adorno's time, "the consumer [was] allowed to project his mimetic residues onto anything he please[d], including art."[26] Today, "I-presentation" of an exemplary artist can be characterized as either an "afterimage" or a "counterimage" of culture industry. It may well be seen as a psychomimetic event scarcely related to what we naively regard as "direct visual experience."

To conclude, I will cite Pavel Pepperstein's essay "Filosofstvuyushchaya gruppa i filosofskii muzei," in which philosophical categories are compared with Fabergé eggs, while philosophy itself is regarded as "Fabergé discourse."[27] "From a political point of view," writes Pepperstein, "these luxurious eggs are reactionary. With all their precious scales, pearls and diamonds, they endlessly multiply reflections of that spark which lights up the very heart of reaction. I am speaking of a categorical need for tranquility, of an exemption from disturbances."[28] Pepperstein also suggests that "instead of philosophy, any philosophizing group of people unavoidably creates a philosophical museum [which] must be incredibly expensive, for one needs all the riches in the world in order to buy some peace of mind."[29]

Lima, 2000

Notes

1. See Karl Jaspers, *The Great Philosophers: The Foundations*, ed. Hannah Arendt, trans. Ralph Manheim (New York: Harcourt, Brace & World, 1962).

2. Although Jaspers uses the word "exposition" rather than "museum," the place's museological lineage reveals itself when the philosopher describes "expositions" in terms of "a history of art" (*The Great Philosophers*, p. 5).

3. See Ilya Kabakov, *The '60s and '70s*, Wiener Slawitscher Almanach, Sonderband 47 (Vienna, 1999); Mark Uralsky, *Nemukhin's Monologues* (Moscow: Bonfi, 1999); and Igor and Svetlana Kopystyansky, *Dialog* (Stuttgart: Institut für Auslandsbeziehungen, 1999).

4. This Moscow performance group was founded in 1976 and now consists of A. Monastyrsky, N. Panitkov, G. Kizevalter, E. Elagina, I. Makarevich, S. Romashko, and S. Haensgen.

5. The museological function makes possible the transfer of the instinct of self-preservation from the individuals' physical bodies to the fruits of their labor, their merits and achievements in culture, science, etc.

6. I am referring to Piaget's description of the "egocentric speech" detectable in every creative gesture or event, including the results and the traces of one's artistic quest—archival photographs, letters, drafts, early versions, and fragments.

7. Before making their way to the West, Kabakov, Zakharov, Sokov, and the Kopystyanskys had lived and worked for many years in a country that had no demand for experimental art.

8. Here, "deviant" means either opposite to signification or perpendicular to it, or heading the same way, but with a delay (deferred signification). Although egocentric reading usually takes an orthogonalist attitude to signification, one should realize that things horizontal in one cultural context may turn vertical in another.

9. Foucault was right when he defined the author as "a certain functional principle by which in our culture, one limits, excludes, and chooses." For him—unlike for Barthes and Derrida—the author is not an anonymous figure, and thus cannot be separated from the ideological function he or she performs. See Michel Foucault, "What Is an Author?" in *The Foucault Reader,* ed. Paul Rabinow (New York: Pantheon Books, 1984), pp. 118–19.

10. Moira Roth, "Marcel Duchamp in America: A Self Ready-Made," *Arts* 51, no. 9 (May 1997).

11. Duchamp's desire to museify his image is comparable with Marcel Broodthaers's "self-museologizing," which Rosalind Krauss describes as "a way in which he [Broodthaers] conducted a form of *détournement* on himself." See Rosalind Krauss, *"A Voyage on the North Sea": Art in the Age of Post-Medium Condition* (London: Thames & Hudson, 1999), p. 34.

12. See Greenberg's article "Irrelevance versus Irresponsibility," *Partisan Review* (May 1948).

13. Alexander Glezer's Museum of Contemporary Russian Art in Exile was founded in France in the mid 1970s; it existed on paper, rather than in reality and was last heard of in 1992. Norton Dodge has finally "exiled" his Russian collection under the aegis of Rutgers University Art Museum in New Jersey. The Tseritely collection in Moscow (Petrovka Steet) is a museum in appearance (or in outer crust) only.

14. In the West, an "exemplary" art museum is no longer a temple, but a culture industry showroom.

15. See T. W. Adorno, *Aesthetic Theory* (New York: Routledge, 1984), p. 163.

16. Psychoanalysis has long ceased to be an idiom of "reducing art to an absolutely subjective system of signs." In this respect, Adorno's dismissal of psychoanalytical theory (as too individualistic, nonnegative, and uncritical) is what largely contributed to shortsightedness in his analysis of the relationship between art and the culture industry. In effect, it prevented him from facing the austerity of the situation and from foreseeing its further development. (For details, see Adorno, "Critique of the Psychoanalytical Theory of Art," in *Aesthetic Theory*.)

17. The key factors in this comparison would be the deficit of signification in contemporary Russian art and its overabundance in the West. Richter's, *Atlas* is an equilibrium between (a) egocentric speech of the signified, and (b) the image of an institutionally accepted artist, canonized during his lifetime.

18. Ilya Kabakov and Victor Tupitsyn, "The Piper of Disaster: Boris Mikhailov and His 'Calm' Photographs," in *Boris Mikhailov: Case History* (Zurich: Scalo Verlag, 1999).

19. To create a museological situation, one would have to combine affirmative narratives with negative opinions and evaluations. However ephemeral, these criteriological cinderblocks constitute the premises on which the museological function enters the realm of representation in the form of visual image or "lexical artifact." At times, such "premises" themselves become a target of museification. The fact that the meaning of any text is deferred may also be viewed as the prerequisite for this *deférrance* to be filled by the museological time.

20. Later, as the result of Stalinist cultural revolution, socialist modernism was replaced by socialist realism.

21. No one is eager to be reduced to the level of a representative. It is even worse when what one represents is not the context itself, but the clichés about it. On the other hand, in the globalized cultural environment, artists are left with no choice but to be representatives of representation.

22. Unconscious (or predicative) optics are a visual analogue of inner speech, of which Lev S. Vygotsky wrote.

23. "Spectacular order" is an allusion to Guy Debord's *Society of the Spectacle.*

24. The same is true of media icons, such as famous athletes and fashion models, who tend to display not "lexical" but bodily "artifacts."

25. Victor Tupitsyn, *The Other of Art* (Moscow: Ad Marginem, 1997), pp. 346–47.

26. Adorno, *Aesthetic Theory* ("On the Critique of the Culture Industry"), p. 26.

27. See Pavel Pepperstein, "Filosofstvuyushchaya gruppa i filosofskii muzei," *Mesto Pechati,* no. 11 (Moscow: Obscuri Viri, 1998), pp. 73–79.

28. Ibid., p. 78.

29. Ibid.

Selected Bibliography

Across the Pacific: Contemporary Korean and Korean American Art. Exh. cat. New York: Queens Museum of Art, 1993.

Agamben, Giorgio. *The Coming Community* (1990). Trans. Michael Hardt. Minneapolis: University of Minnesota Press, 1993.

Agamben, Giorgio. *Means without End: Notes on Politics.* Trans. Vincenzo Binetti and Cesare Casarino. Minneapolis: University of Minnesota Press, 2000.

Ante América. Exh. cat. Bogotá: Biblioteca Luis Ángel Arango, 1992.

Armes, Roy. *Third World Filmmaking and the West.* Berkeley: University of California Press, 1987.

Asia/America: Identities in Contemporary Asian American Art. Exh. cat. New York: Asia Society, 1995.

"Asian Ways: Asian Values Revisited." *Sojourn* 14, no. 2 (October 1999).

At Home and Abroad: Twenty Filipino Contemporary Artists. Exh. cat. San Francisco: Asian Art Museum, 1998.

Atkinson, Brenda. "Behind the Biennale Blues." *Electronic Mail and Guardian,* 11 December 1997, <http://www.chico.mweb.co.za/mg/art/reviews/97dec/11dec-biennale.html>.

A través de la frontera. Centro de Estudios Económicos y Sociales del 3er. Mundo. Mexico City: A.C./Instituto de Investigaciones Estéticas, UNAM, 1983.

Bakhtin, Mikhail. "Discourse in the Novel." In *The Dialogic Imagination.* Austin: University of Texas Press, 1981.

Bataille, Georges. *Documents: Archéologie, beaux-arts, ethnographie, variétés 7* (1929). Reprinted in *Documents.* Vols. 1 and 2. Paris: Jean Michel Place, 1991.

Baudrillard, Jean. *Pour une critique de l' économie politique du signe.* Paris: Gallimard, 1972.

Becquer, Marcos, and José Gatti. "Elements of Vogue." *Third Text,* nos. 16–17 (Autumn/Winter 1991).

Benjamin, Walter. *Illuminations.* Trans. Harry Zohn. London: Fontana Press, 1992.

Benjamin, Walter. *The Origin of German Tragic Drama* (1925). Trans. John Osborne. London: NLB, 1977.

Bergero, Adriana, and Fernando O. Reati, eds. *Memoria colectiva y políticas de olvido: Argentina y Uruguay 1970–1990.* Rosario, Argentina: Ediciones Beatriz Viterbo, 1997.

Bey, Hakim. *Temporary Autonomous Zone.* Brooklyn, N.Y.: Autonomedia, 1985.

Beyond the Future: The Third Asia-Pacific Triennial of Contemporary Art. Exh. cat. Brisbane, Australia: Queensland Art Gallery, 1999.

Bhabha, Homi K. *The Location of Culture.* London: Routledge, 1994.

Bhabha, Homi K., ed. *Nation and Narration.* London: Routledge, 1990.

Bhabha, Homi K. "Remembering Fanon: Self, Psyche, and the Colonial Condition." In *Remaking History,* ed. Barbara Kruger and Phil Mariani. Seattle: Bay Press, 1989.

Bharucha, Rustom. *Consumed in Singapore: The Intercultural Spectacle of "Lear."* Centre for Advanced Studies Research Paper Series. Singapore: CAS and Pagesetters, 2000.

Bharucha, Rustom. "Interculturalism and Its Discriminations: Shifting the Agendas of the National, the Multicultural, and the Global." *Third Text,* no. 46 (Spring 1999).

Blanchot, Maurice. *La communauté inavouable.* Paris: Éditions de Minuit, 1983.

Bloom, Harold. *The Anxiety of Influence.* Oxford: Oxford University Press, 1973.

Bond, Anthony. *TRACE: The International Exhibition.* Exh. cat. Liverpool: Liverpool Biennial of Contemporary Art, in association with Tate Gallery, Liverpool, 1999.

Bourdieu, Pierre. *La distinction.* Paris: Éditions de Minuit, 1979.

Bourdieu, Pierre. *Las reglas del arte: Génesis y estructura del campo literario.* Barcelona: Anagrama, 1995.

Brea, José Luis. *La era post-media: Acción comunicativa, prácticas post-artísticas y dispositivos neomediales.* Salamanca, Spain: Centro de Arte de Salamanca, 2002.

Bright Paradise. Exh. cat. First Auckland Triennial. Auckland: Auckland Art Gallery, 2001.

Buntinx, Gustavo. "Identidades póstumas: El momento chamánico en 'Lonquén 10 años' de Gonzalo Díaz." Paper presented at the symposium "Beyond Identity: Latin American Art in the 21st Century," University of Texas, Austin, April 1995.

Cabral, Amílcar. *Análise de alguns tipos de resistencia.* Bolama: Imprensa Nacional da Guiné-Bissau, 1979.

Cacciari, Massimo. *Dell'inizio.* Milan: Adelphi, 1990.

Cacciari, Massimo. *The Necessary Angel.* Trans. Miguel E. Vatter. Albany: State University of New York Press, 1994.

Carter, Paul. *The Lie of the Land.* London: Faber and Faber, 1996.

Caruth, Cathy, ed. *Trauma: Explorations in Memory.* Baltimore: Johns Hopkins University Press, 1995.

Chatterjee, Partha, ed. *Wages of Freedom.* New Delhi: Oxford University Press, 1998.

Cheah, Pheng, and Bruce Robbins. *Cosmopolitics: Thinking and Feeling beyond the Nation.* Minneapolis: University of Minnesota Press, 1998.

Chicano Art: Resistance and Affirmation, 1965–1985. Exh. cat. Los Angeles: Wight Art Gallery, University of California, 1991.

Clark, John. "Dilemmas of [Dis-]attachment in the Chinese Diaspora." *Visual Arts + Culture* 1, no. 1 (1998).

Clifford, James. *Itinerarios transculturales.* Barcelona: Gedisa, 1999.

Cohen, Phil. "In Visible Cities: Urban Regeneration and Place-Building in the Era of Multicultural Capitalism." *Communal/Plural* 7, no. 1 (1999).

Coles, Alex, and Alexia Defert, eds. *The Anxiety of Interdisciplinarity.* London: Backless Books, 1998.

Critical Art Ensemble. "Utopian Promises, net.realities." <www.critical-art.net>.

Danto, Arthur C. *After the End of Art: Contemporary Art and the Pale of History.* Princeton: Princeton University Press, 1997.

Danto, Arthur C. "Mapping the Art World." In the "Essays" link of the official Internet archive of *Africus '95,* Johannesburg Biennale, <http://sunsite.wits.ac.za/biennale/essays/danto.htm>.

Danto, Arthur C. *The Wake of Art: Criticism, Philosophy, and the Ends of Taste.* Amsterdam: G&B Arts International, 1998.

Debord, Guy. *Commentaires sur la société du spectacle.* Paris: Éditions Gérard Lebovici, 1988.

Debord, Guy. *The Society of the Spectacle* (1967). Trans. Donald Nicholson-Smith. New York: Zone Books, 1995.

Deleuze, Gilles. *Cinema 1: The Movement Image.* Trans. Hugh Tomlinson and Barbara Habberjam. Minneapolis: University of Minnesota Press, 1986.

Deleuze, Gilles. *Cinema 2: The Time-Image.* Trans. Hugh Tomlinson and Robert Galeta. Minneapolis: University of Minnesota Press, 1989.

Deleuze, Gilles, and Félix Guattari. *Kafka: Toward a Minor Literature.* Trans. Dana Polan. Minneapolis: University of Minnesota Press, 1986.

Deleuze, Gilles, and Félix Guattari. *Rhizome: Introduction.* Paris: Éditions de Minuit, 1976.

De Man, Paul. *The Resistance to Theory.* Manchester: Manchester University Press, 1986.

Derrida, Jacques. *Cosmopolites de tous les pays, encore un effort!* Paris: Galilée, 1997.

Derrida, Jacques. *De la grammatologie.* Paris: Éditions de Minuit, 1967.

Derrida, Jacques. *De l'hospitalité.* Paris: Calmann-Lévy, 1997.

Derrida, Jacques. *Politiques de l'amitié, suivi de L'oreille de Heidegger.* Paris: Galilée, 1994.

Derrida, Jacques. *Spectres de Marx: L'état de la dette, le travail du deuil et la nouvelle Internationale.* Paris: Galilée, 1993.

Derrida, Jacques. *The Truth in Painting.* Chicago: University of Chicago Press, 1987.

Dimitrakaki, Angela, Pam Skelton, and Mare Tralla, eds. *Private Views: Space and Gender in Contemporary Art from Britain and Estonia.* London: Women's Art Library, 2000.

Doble_vínculo, una constelación de comunidades web. <www.aleph-arts.org/doble_vinculo/>.

Documenta 11, Platform 5: Exhibition. Kassel: Museum Fridericianum; Ostfildern-Ruit: Hatje Cantz, 2002.

Eagleton, Terry. *Exiles and Emigrés.* London: Chatto and Windus, 1970.

Eagleton, Terry. *The Function of Criticism: From the Spectator to Post-Structuralism.* London: Verso, 1996.

Eagleton, Terry. *Ideology: An Introduction.* London: Verso, 1991.

Engwicht, David. "How the 'Art of Public Places' Debate Shackles Creative Genius." *Artlink* (Australia) 18, no. 2 (June-August 1998).

Enwezor, Okwui, ed. *Trade Routes: History and Geography.* Exh. cat. Second Johannesburg Biennale. South Africa and the Netherlands: GJMC and the Prince Claus Fund, 1997.

Fanon, Frantz. *Black Skin, White Masks.* London: Pluto Press, 1986.

Fei Dawei, ed. *Art chinois: Chine demain pour hier.* Exh. cat. Aix-en-Provence: Les Domaines de l'art and Éditions Carte Segrete, 1990.

Felman, Shoshana, and Dori Laub. *Testimony: Crises of Witnessing in Literature, Psychoanalysis, and History.* New York: Routledge, 1992.

Ferguson, Russell, et al., eds. *Out There: Marginalization and Contemporary Cultures.* New York: New Museum of Contemporary Art; Cambridge, Mass.: MIT Press, 1990.

Finci, Predrag. "The Work of Art in the Time of War Destruction." *Third Text,* no. 24 (Autumn 1993).

Fisher, Jean, ed. *Global Visions: Towards a New Internationalism in the Visual Arts.* London: Kala Press, 1994.

Fisher, Jean, ed. *Re-verberations: Tactics of Resistance, Forms of Agency.* Maastricht: Jan van Eyck Akademie, 2000.

Fisher, Jean. "Some Thoughts on 'Contaminations.'" *Third Text,* no. 32 (Autumn 1995).

Foster, Hal. *The Return of the Real: The Avant-Garde at the End of the Century.* Cambridge, Mass: MIT Press, 1996.

Foucault, Michel. *The Foucault Reader.* Ed. Paul Rabinow. New York: Pantheon Books, 1984.

Freyre, Gilberto. *The Masters and the Slaves/Casa grande e senzala.* Trans. Samuel Putnam. Berkeley: University of California Press, 1987.

Friedman, Hazel. "The Curator as God." *Electronic Mail and Guardian,* 9 October 1997, <http://www.chico.mweb.co.za/mg/art/reviews/97oct/9oc-biennale2.html>.

La frontera/The Border: Art about the Mexico/United States Experience. Exh. cat. San Diego, Calif.: Centro Cultural de la Raza and San Diego Museum of Contemporary Art, 1993.

García Canclini, Néstor. *Culturas Híbridas II: Estrategias para entrar y salir de la modernidad.* Serie Los Noventa. Mexico: CONACULTA/Grijalbo, 1989.

García Canclini, Néstor, and Patricia Safa. *Tijuana: La casa de toda la gente.* Mexico: CONACULTA, 1986.

Gelder, Ken, and Sarah Thornton, eds. *The Subcultures Reader.* London: Routledge, 1997.

Gerber, Raquel. *Glauber Rocha.* Rio de Janeiro: Paz and Terra, 1977.

Giddens, Anthony, and Will Hutton, eds. *On the Edge: Living with Global Capitalism.* New York: Jonathan Cape, 2000.

Gilroy, Paul. *Small Acts: Thoughts on the Politics of Black Cultures.* London: Serpent's Tail, 1993.

Glissant, Édouard. *Poetics of Relation.* Trans. Betsy Wing. Ann Arbor: University of Michigan Press, 1997.

Gorodezky, Sylvia M. *Arte chicano como cultura de protesta.* Mexico City: Universidad Nacional Autónoma de México, 1993.

Guha-Thakurta, Tapati. "The Museumised Relic: Archaeology and the First Museum of Colonial India." *Indian Economic and Social History Review* 34, no. 1 (1997).

Guppy, Marla. "Negotiating Locality in the Global City." Paper given at the conference "An Art of Interruption," School of Fine Art, University of Newcastle, Newcastle, New South Wales, 20 May 2000.

Hall, Stuart. "Minimal Selves." In *The Real Me: Postmodernism and the Question of Identity*. ICA Documents 6. London: Institute of Contemporary Arts, 1989.

Harvey, David. *Justice, Nature, and the Geography of Difference*. Oxford: Blackwell, 1996.

Hirano, Akihiko, and Takeuchi Hiroko, eds. *Cai Guoqiang: From the Pan-Pacific*. Trans. Margaret E. Dutz. Iwaki: Iwaki City Art Museum, 1994.

Hoffmann, Frank. "Monoculture and Its Discontents." *Art in America* (November 2000).

Horne, Donald. "Constructing a National Past." *Art Monthly* (Australia), no. 1 (June 1987).

Hou Hanru. *On the Mid-Ground*. Ed. Yu Hsiao-Hwei. Hong Kong: Timezone 8, 2002.

Hou Hanru. *Parisien(ne)s*. Exh. cat. London: Camden Arts Centre and inIVA, 1997.

Hou Hanru and Hans Ulrich Obrist. Introduction to *Cities on the Move* (Bangkok), available online at <http://www.art4d.com/bangkokonthemove/2542/city/index_1.html>.

Jameson, Fredric. *The Cultural Turn: Selected Writings on the Postmodern, 1983–1998*. London: Verso, 1998.

Jameson, Fredric. *Postmodernism, or, The Cultural Logic of Late Capitalism*. 1991; Durham, N.C.: Duke University Press, 1994.

Jameson, Fredric, and Slavoj Žižek. *Estudios culturales: Reflexiones sobre el multiculturalismo*. Buenos Aires: Paidós, 1998.

Jiang Dahai. Exh. cat. Taipei: Chengpin Hualang, 1999.

Jitrik, Noé. "Del orden de la escritura." *sYc* (Buenos Aires) 6 (1995).

Jodogne, Lucas. *Singapore: Views on the Urban Landscape*. Antwerp: Pandora, 1998.

Johnson, Randall, and Robert Stam, eds. *Brazilian Cinema*. Austin: University of Texas Press, 1986.

Johnston, Pam. "Seize the Walls." Paper given at "Watch This Space: Conference on Public Art," organized by Australian Journal of Art and School of Fine Art, University of Newcastle, Newcastle, New South Wales, September 1999.

Jouanno, Evelyne, and Hou Hanru. *Paris pour escale*. Exh. cat. Paris: ARC-Musée d'art moderne de la Ville de Paris, 2000.

Karp, Ivan, Christine Mullen Kreamer, and Steven D. Lavine, eds. *Museums and Communities: The Politics of Public Culture*. Washington, D.C.: Smithsonian Institution Press, 1992.

Kemp, Sandra, and Judith Squires, eds. *Feminisms*. Oxford: Oxford University Press, 1997.

al-Khâlidî, Walîd. *Kay lâ nansâ: Qurâ Filastîn al-latî dammarathâ Isrâ'îl sanat 1948 wa-asmâ' shuhadâ'ihâ (All That Remains: The Palestinian Villages Occupied and Depopulated by Israel in 1948)*. 2d ed. Beirut: Institute for Palestine Studies, 1998.

Kluge, Alexander. "On Film and the Public Sphere." Conversation with Klaus Eder. *New German Critique,* no. 24 (Fall 1981).

Knowbotics Research. *IO_Lavoro_inmateriale.* <www.krcf.org/krcfhome/ 1IOdencies5d.htm>.

Koolhaas, Rem. *Delirious New York.* Rotterdam: 010 Publishers, 1994.

Köppel-Yang, Martina. "Zheng Shengtian: 'Youjian Bali, Youjian Bali.'" *Dian Zang jin yishu,* no. 104 (May 2001).

Krauss, Rosalind. "Notes on the Index: Seventies Art in America." *October* 3 (1977).

Krauss, Rosalind. *"A Voyage on the North Sea": Art in the Age of the Post-Medium Condition.* London: Thames and Hudson, 1999.

Krishnan, Sanjay. "Singapore: Two Stories at the Cost of One City." *Commentary* (National University of Singapore Society) 10 (1992).

Kristeva, Julia. *Powers of Horror.* Trans. Leon S. Roudiez. New York: Columbia University Press, 1982.

Kwangju Biennale Web site. <http://www.gwangju-biennale.org/last-biennale/2000/ english/>.

Leppe, Carlos, et al. *Cegado por el oro.* Santiago de Chile: Galería Tomás Andreu, 1998.

Lewis Herman, Judith. *Trauma and Recovery: From Domestic Abuse to Political Terror.* London: Pandora, 1994.

Lowe-Ismail, Geraldene. *Chinatown Memories.* Singapore: Singapore Heritage Society, 1998.

Lyotard, Jean-François. *The Differend: Phrases in Dispute.* Trans. Georges Van Den Abbeele. Minneapolis: University of Minnesota Press, 1988.

Lyotard, Jean-François. *The Postmodern Condition: A Report on Knowledge.* Manchester: Manchester University Press, 1986.

Maciel, David R., and María Herrera-Sobek. *Culture across Borders: Mexican Immigration and Popular Culture.* Tucson: University of Arizona Press, 1998.

Maffesoli, Michel, interview by N. Bourriaud and Philipe Nassif. "L'interprétation des raves." *Artpress,* special issue no. 19 (1998).

Mainardi, Patricia. *Art and Politics of the Second Empire: The Universal Expositions of 1855 and 1867.* New Haven: Yale University Press, 1987.

Malagamba, Amelia, ed. *Encuentros: Los Festivales Internacionales de La Raza.* Tijuana: CREA/Secretaría de Educación Pública/El Colegio de la Frontera Norte, 1988.

Massey, Doreen, and Pat Jess, eds. *A Place in the World?* Oxford: Oxford University Press, 1995.

Mellado, Justo Pastor. "Ensayo de interpretación de la coyuntura plástica." *Cuadernos para el análisis* (Santiago de Chile), no. 1 (December 1983).

Milosz, Czeslaw. "A Symposium on Translation." *Threepenny Review* (Summer 1997).

Mollard, Claude. *L'ingénierie culturelle.* Paris: Presses Universitaires de France, 1999.

Mosquera, Gerardo. ed. *Adiós identidad. Arte y cultura desde América Latina.* I and II Foros Latinoamericanos. MEIAC. Badajoz: Editions Junta de Extremadura, Consejería de Cultura, 2001.

Mosquera, Gerardo, ed. *Beyond the Fantastic: Contemporary Art Criticism from Latin America.* London: inIVA, 1995.

Mosquera, Gerardo. "Infinite Islands: Regarding Art, Globalization, and Cultures, Parts I and II." *Art Nexus* (Bogotá), nos. 29 and 30 (1998).

Mosquera, Gerardo. "Power and Intercultural Curating." *TRANS> arts, cultures, media,* no. 1 (Spring 1995).

Mouffe, Chantal, and Ernesto Laclau. *Hegemony and Socialist Strategy.* London: Verso, 1986.

El nacionalismo y el arte mexicano. IX Coloquio de Historia del Arte. Mexico: Universidad Nacional Autónoma de México (UNAM), 1986.

Nandy, Ashis. *The Illegitimacy of Nationalism.* New Delhi: Oxford University Press, 1994.

Orvell, Miles. *After the Machine: Visual Arts and the Erasing of Cultural Boundaries.* Jackson: University Press of Mississippi, 1995.

Owens, Craig. "The Allegorical Impulse: Toward a Theory of Postmodernism." *October* 12–13 (Spring 1980).

Papastergiadis, Nikos. *The Complicities of Culture.* Manchester: Cornerhouse Publications, 1994.

Papastergiadis, Nikos. *Dialogues in the Diaspora.* London: Rivers Oram Press, 1998.

Papastergiadis, Nikos, ed. *Mixed Belongings and Unspecified Destinations.* London: inIVA, 1997.

Patnaik, Prabhat. "A Note on the Political Economy of the 'Retreat of the State.'" *Whatever Happened to Imperialism, and Other Essays.* New Delhi: Tulika, 1995.

Peers, Juliet. "The Public Interest: Is There Any?" *Artlink* (Australia) 18, no. 2 (June-August 1998).

Pepperstein, Pavel. "Filosofstvuyushchaya gruppa i filosofskii muzei." *Mesto Pechati* (Moscow), no. 11 (1998).

Pollock, Griselda. *Differencing the Canon.* London: Routledge, 1996.

Power, Kevin, and Fernando Castro, eds. *Diálogos iberoamericanos: Continente de crisis y promesas, puzzle no resuelto.* Valencia: Generalitat Valenciana, 2000.

Pradhan, Sudhi, ed. *Marxist Cultural Movement: Chronicles and Documents.* Calcutta: Pustak Bipani, 1985.

Pratt, Mary Louise. *Imperial Eyes: Travel Writing and Transculturation.* London: Routledge, 1992.

Ra ʿd, Walîd. "Bidâyât ʿajâʾibiyya—miswadda" (Miraculous beginnings: A draft). *Public* (Toronto) 16 (1998).

Richard, Nelly. *Cuerpo correccional.* Santiago de Chile: Francisco Zegers, 1980.

Richard, Nelly. "Margins and Institution: Art in Chile since 1973." *Art and Text* (Melbourne), no. 21 (May-July 1986).

Robinson, Hilary, ed. *Visibly Female: Feminism and Art Today, an Anthology.* London: Camden Press, 1987.

Rocha, Glauber. *Revolução do cinema novo.* Rio de Janeiro: Alhambra/Embrafilme, 1981.

Rodrigues, Ana Maria. *Samba negro, espoliação branca.* São Paulo: Hucitec, 1984.

Rosique, Roberto, ed. *Emigrarte.* Tijuana: Consejo Nacional para la Cultura y las Artes/ Centro Cultural Tijuana/Academia de Derechos Humanos de Baja California, 1997.

Rowse, Tim. "Doing Away with Ordinary People." *Meanjin* 42 (September 1983).

Roy, Arhundati. "The Algebra of Infinite Justice." *Guardian,* 29 September 2001.

Said, Edward. *Orientalism.* London: Routledge, 1978.

Sapir, Edward. *Culture, Language and Personality.* Berkeley: University of California Press, 1956.

Schulte, Rainer, and John Biguenet, eds. *Theories of Translation.* Chicago: University of Chicago Press, 1992.

Sennet, Richard. *The Fall of Public Man.* New York: Alfred A. Knopf, 1977.

Shakar, Tuni. *Al-Âdâb* (Beirut) (January-February 2001).

Shanghai Biennale. Exh. cat. <http://www.sh-artmuseum.org.cn/double/msg2000/ e-jihua.htm>.

Sibley, David. *Geographies of Exclusion: Society and Difference in the West.* London: Routledge, 1995.

La Société Anonyme. "A Redefinition of Artistic Practices (LSA47)." *Parachute* (Canada), no. 109 (February 2003).

Stallabrass, Julian. *Gargantua: Manufactured Mass Culture.* London: Verso, 1996.

Stewart, Charles, and Rosalind Shaw, eds. *Syncretism/Anti-Syncretism.* London: Routledge, 1994.

Thompson, Edward. *Making of the English Working Class.* New York: Pantheon Books, 1964.

Toufic, Jalal. *Forthcoming*. Berkeley, Calif.: Atelos, 2000.

Toufic, Jalal. *Over-Sensitivity*. Los Angeles: Sun and Moon Press, 1996.

Tupitsyn, Victor. *The Other of Art*. Moscow: Ad Marginem, 1997.

Uralsky, Mark. *Nemukhin's Monologues*. Moscow: Bonfi, 1999.

Vasconcelos, Gilberto. *De olho na fresta*. São Paulo: Graal, 1978.

Weiss, Rachel. "The Sixth Havana Biennial." *Art Nexus,* no. 26 (October-December 1997), available online at <http://www.universes-in-universe.de/artnexus/no26/weiss_eng2.htm>.

Whorf, Benjamin. *Language, Thought, and Reality*. Cambridge, Mass.: Technology Press, 1956.

Williams, Raymond. *Marxism and Literature*. 1977; New York: Verso, 1989.

Williams, Raymond. *The Politics of Modernism: Against the New Conformists*. London: Verso, 1989.

Williamson, Sue. "South African Art in the Nineties." <www.artthrob.co.za/oojan> and <www.artthrob.co.za/oofeb>.

Zeki, Semir. *Inner Vision: An Exploration of Art and the Brain*. Oxford: Oxford University Press, 1999.

Zeplin, Pamela. "Connections and Enlargements or Swollen Joints?" *Art Monthly* (Australia), no. 123 (September 1999).

Seoul, 1997

Reprint Sources

Contributors

Rustom Bharucha is an independent writer, theater director, cultural critic, and playwright based in Calcutta. Among his books are *Theatre and the World* (1990), *The Question of Faith* (1993), *Chandralekha* (1995), *In the Name of the Secular* (1998), and *The Politics of Cultural Practice* (2000). He is a member of the International Advisory Council of the Prince Claus Fund for Culture and Development.

José Luis Brea is a professor of aesthetics and theory of contemporary art at the University of Castilla–La Mancha. He has been dean of the Fine Arts Academy of Cuenca and director of exhibitions for the Ministry of Culture of Spain. He is the editor of *Aleph* and *Acción Paralela*. Brea is the Spanish correspondent for *Artforum* and the regional editor for *Rhizome*. He has organized several shows as well as published books including *Las auras frías* (1991), *Nuevas estrategias alegóricas* (1991), and *La era postmedia: Acción comunicativa, prácticas (post)artísticas y dispositivos neomediales* (2002).

Gustavo Buntinx is an art critic, art historian, and curator. Among his books and catalogs are *Moico Yaker: The Paintings 1986–1994* (1996), *Mallki: La exhumación simbólica en el nuevo arte peruano (1980-2002)*(2000), and *Mario Urteaga: Nuevas miradas,* in collaboration with Luis Eduardo Wuffarden (2003).

Chang Tsong-zung is a curator and critic based in Hong Kong. Among his exhibitions are *Paris-Pekin* (2002), *Power of the Word* (1999–2002), and *China's New Art Post-1989* (1993–1997). He also curated the first Chinese contemporary exhibition at the São Paulo Biennial (1994), and the first Hong Kong exhibition at the Venice Biennale (2001). Chang is the curatorial director of Hanart T Z Gallery and a founding director of the Asia Art Archive, both in Hong Kong.

John Clark was elected a fellow of the Australian Academy of the Humanities in 2001 and awarded a personal chair in art history and theory at the University of Sydney in 2003. His books include *Modern Asian Art* (1998).

Angela Dimitrakaki is lecturer in art history at the University of Southampton and course leader of the M.A. in modern and contemporary art. She co-edited *Private Views: Spaces and Gender in Contemporary Art from Britain and Estonia* (2000), *Independent Practices: Representation, Location, and History in Contemporary Visual Art* (2000), and *ReTrace: Dialogues on Contemporary Art and Culture* (2002).

Jean Fisher is a freelance writer and reader in art and transcultural studies at Middlesex University. She is the former editor of *Third Text*, editor of the writings of Jimmie Durham (*A Certain Lack of Coherence*, 1993) and Lee Ufan (*Selected Writings 1970–1996*, 1996), and editor of the anthologies *Global Visions: Towards a New Internationalism in the Visual Arts* (1994) and *Re-verberations: Tactics of Resistance, Forms of Agency* (2000). She was a contributor to the Documenta 11 catalog (2002) and is author of the book *Vampire in the Text* (2003).

José Gatti is a writer, critic, and professor at Universidade Federal de São Paulo and other universities in Brazil. He is the author of the book *Barravento: A estréia de Glauber* (1988) and the founder and director of SOCINE (Sociedade Brasileira de Estudos de Cinema).

Édouard Glissant is Distinguished Professor of French at City University of New York, Graduate Center. His many books include poetry, novels, and works for theater. He is a major theorist in Caribbean studies and postcolonial literature.

Pam Johnston is a visual and community artist and a cultural critic. She obtained her Ph.D. at the University of Wollongong in New South Wales, Australia, the first Aboriginal

person to do so. Johnston has been teaching in prisons extensively since 1989. She is a well-known and vocal member of the inner Sydney community of Woolloomooloo but spends a large amount of time in the desert region of Australia, particularly Lake Mungo National Park, from where her current work emanates.

Geeta Kapur is an art critic and historian who has written extensively on contemporary art and the cultural politics of modernism in India and the Third World. She is the founding editor of *Journal of Arts and Ideas,* Delhi. Among her books is *Contemporary Indian Artists* (2000).

Lee Weng Choy is artistic co-director of the Substation Arts Center in Singapore, and has written for many publications. Among his articles are "Authenticity, Reflexivity & Spectacle: or, The Rise of the New Asia Is Not the End of the World" (2004), "Biennale Time and the Spectres of Exhibition" (2002), "A Taste for Worms and Roses" (2002), "McNationalism in Singapore" (2001), "Citing and Siting" (2001).

Gerardo Mosquera is an art critic, historian, and curator who lives in Havana. He is adjunct curator at the New Museum of Contemporary Art, New York, and adviser at the Rijksakademie van Beeldende Kunsten, Amsterdam. He was a founder of the Havana Biennials and has curated many exhibitions, including *Ante América* (1992–1994). Author of numerous texts and books on contemporary art and art theory, in 1995 Mosquera edited *Beyond the Fantastic: Contemporary Art Criticism from Latin America.*

Everlyn Nicodemus is an artist, poet, and cultural critic who has published in *Third Text* and *Nka,* as well as in several anthologies on issues of contemporary art.

Nikos Papastergiadis is a cultural critic and senior lecturer at The Australian Centre, University of Melbourne. Among his books are *Modernity as Exile* (1993), *The Complicities of Culture* (1994), and *Dialogues in the Diasporas* (1998).

Marian Pastor Roces is a critic, art historian, and curator. Among her exhibitions are *Sheer Realities: Power and Clothing in 19th Century Philippines* (2000) and *Science Fictions* (2003). She is the head of TAO Inc., a cultural planning firm.

Gabriel Peluffo Linari is an art historian, critic, and architect. He is director of the Juan Manuel Blanes Municipal Museum of Fine Arts in Montevideo. Among his books are *Historia de la pintura uruguaya* (2002) and *El paisaje a través del arte en Uruguay* (1995). He received a Guggenheim Fellowship in 1995.

Carolina Ponce de León is executive director at the Galería de la Raza in San Francisco. She was curator at the Museo del Barrio, New York (1996–1998), and at the Luis Ángel Arango Library, Bogotá (1984–1994). She has written texts for catalogs and articles including "TransAmerica" (1999) and "Beatriz González: Social Critic" (1996).

Apinan Poshyananda is an art historian, critic, artist, and curator. He is the vice-dean for research and foreign affairs, Faculty of Fine and Applied Arts at Chulalongkorn University, Bangkok. He was chief curator of the exhibition *Contemporary Art in Asia: Traditions/Tensions* (1996), and has been involved with many international exhibitions, including several biennials. Among his books are *Modern Art in Thailand* (1992), *Western-Style Painting and Sculpture in the Thai Royal Court* (1993), and *Thai-ness in Transition: Five Decades of Contemporary Thai Art* (1999).

Kathryn Smith is an independent curator, critic, and visual artist, and director of The Trinity Session, a Johannesburg-based contemporary art consultancy. She has curated numerous exhibitions and has written for magazines, journals, and exhibition catalogs. Smith was recently the first recipient of the Wits Alumni Bright Star Award for outstanding contribution to the arts and humanities.

Jalal Toufic is a writer, film theorist, and video artist. His books include *Undying Love, or Love Dies* (2002), *Forthcoming* (2000), *Over-Sensitivity* (1996), *(Vampires): An Uneasy Essay on the Undead in Film* (1993), and *Distracted* (1991). Toufic is a member of the Arab Image Foundation. He has taught at the University of California at Berkeley, the California Institute of the Arts, and DasArts, Amsterdam.

Victor Tupitsyn is a critic and cultural theorist. He is professor at Pace University, Westchester County, New York. Among his books: *The Communal (Post)modernism* (1998) and *The Other of Art* (1997). Tupitsyn edited the "Russian Issue" for *Third Text* (2003).

José Manuel Valenzuela Arce is a doctor in social sciences at the College of Mexico, and is a researcher of the Department of Cultural Studies at the School of the North Border, Mexico. He received the Premio Internacional Casa de las Américas, Havana, 2001. His publications include "¡A la brava, ése! Identidades juveniles en México: Cholos, punks y chavos banda" (1997), which received Honorary Mention, National Prize Fray Bernardino de Sahagún in Social Anthropology, 1990; "El color de las sombras: Chicanos, identidad y racismo" (1998), which received the same award; and "Jefe de jefes: Corridos y narcocultura en México" (2002).

Carlos Vidal is an artist, writer, and professor at the School of Fine Arts, University of Lisbon. He has published many essays and the books *Democracia e livre iniciativa: Política, arte e estética* (1996), *Definição da arte política* (1997), *Imagens sem disciplina* (2002), *A representação da vanguarda: Contradições na arte contemporânea* (2002), *O corpo e a forma* (2003), and *João Onofre: Aquilo que nunca acontece/João Onofre: That Which Never Happens* (2003).

Paris, 2001

Contributors

Index

Page numbers in boldface indicate illustrations.